17 [1979]
 1st edition

£12 . 50

CW00821563

Chinese Lacquer

THE ARTS OF THE EAST
edited by Basil Gray

CHINESE AND JAPANESE CLOISONNÉ ENAMELS
by Sir Harry Garner

CHINESE LACQUER
by Sir Harry Garner

THE ARTS OF THE JAPANESE SWORD
by B. W. Robinson

ANCIENT CHINESE BRONZES
by William Watson

CHINESE LACQUER

Sir Harry Garner

FABER AND FABER
London · Boston

First published in 1979
by Faber and Faber Limited
3 Queen Square London WC1
Printed in Great Britain by
Ebenezer Baylis and Son Ltd
The Trinity Press, Worcester, and London
All rights reserved

© *Lady Garner, 1979*

British Library Cataloguing in Publication Data

Garner, *Sir* Harry
 Chinese lacquer.
 1. Lacquers and lacquering – China – History
 I. Title
 745.7′2 NK9900.7.C6

ISBN 0-571-11286-2

Contents

Colour Plates

Foreword

This book represents the ripest fruit of Sir Harry Garner's scholarship. His special interest in Chinese lacquer can be seen already in the 1958 commemorative catalogue of the exhibition of the Arts of the Ming Dynasty, held the previous winter under the auspices of the Oriental Ceramic Society and the Arts Council of Great Britain at 4 St. James's Square, to which he contributed a ten-page discussion of lacquer. The committee, of which he was the chairman, had selected on that occasion 'the finest group of carved lacquers ever brought together in the West'. Already in this paper Sir Harry had laid down the basic outline followed essentially in this volume. But he felt the need to clear the ground in several preliminary studies—which eventually numbered seven—published between 1966 and 1973: they are listed in the bibliography.

At the end of 1973, Sir Harry and Lady Garner gave to the national museums in London the whole of their unrivalled collection of Far Eastern lacquer after it had been exhibited for two months as a whole that autumn in the British Museum. The catalogue, for which Sir Harry himself wrote the introduction and descriptions, shows how it covered the whole spectrum of Chinese lacquer with subsidiary sections of Ryukyu and Korean lacquer and some Japanese pieces related to the main story. Many of the illustrations reappear in this volume by arrangement with the Museum publications department. This act of enlightened generosity was characteristic of their single-minded fostering of the study and enjoyment of oriental art in this country and of their cordial relations with the staffs of the two museums.

It has been my privilege to follow closely Sir Harry's researches into the problems of the techniques, chronology and attribution of lacquer, and thus to be constantly aware of his meticulous standard of accuracy. So too from the time when I was preparing for publication Sir Percival David's edition of the *Ko-ku yao-lun* and benefited from Sir Harry's study of the crucial section of this book on 'Ancient Lacquer' I have followed his rigorous assessment of the Chinese texts. He in his turn also naturally followed critically the publication of archaeological research in the People's Republic of China; but we agreed that a line must be drawn if the book were to be finished, and thus no finds have been considered which were made after 1974. How wise was this decision is shown by the fact that Sir Harry was just able to bring the work to completion ready for the press before his final illness in the summer of 1977. That would have been impossible without the constant support of Lady Garner, who shared his determination that the book should be finished. Consequently, my duty has been only to see the book through the press, in which task I have tried to observe the author's own standards.

Foreword

It may be added that the most noteworthy discovery in Chinese lacquer since 1974 was in a wrecked vessel located off the southern Korean coast at Sinan in January 1976. Much of the cargo of Chinese porcelain and certain other artifacts were subsequently retrieved between October 1976 and July 1977. Many of these finds were exhibited in Seoul in October 1977 and discussed with an international group of experts who were agreed in the preliminary assessment of the date of the wreck as about 1320. Among the finds are several pieces of lacquer including a well-preserved covered jar carved in red lacquer—with a carved peony design. This find substantiates Sir Harry's attribution of the beginning of this technique to the Yüan dynasty. The style of the design is indeed close to some of the work given to the early fifteenth century (e.g. plate 32 and figure 35 in the British Museum catalogue), thus again bearing out Sir Harry's belief that fourteenth-century types were still being made in the fifteenth century.

June 1978 BASIL GRAY

Preface

The writing of a book on Chinese lacquer at the present time is unusually diffi-
cult because of the new information that is coming continuously from Chinese
excavations. As far as the main field covered by this book, the study of the lacquer-
wares from the Yüan dynasty onwards, is concerned, the amount of new informa-
tion that has come to light recently is relatively small. But it is important to fit a
treatment of the later lacquerwares into the general picture of lacquer developments
from early times, because many of the techniques of the later wares were first
introduced very much earlier than the Yüan dynasty, and here the amount of
information coming from China is more important. However, even in the early
wares, a careful study of all the information available has convinced me that the
general conclusions reached by Western and Japanese research workers, based on
excavations stretching over some fifty years, have proved to be sound. Thus
although there are likely to be some new advances in the future I am hopeful that
the account of the early wares I have given will not need to be greatly modified.
At the same time, the many important finds will enrich our knowledge and, because
of the greatly improved conservation methods adopted in China today, will reveal
the early lacquerwares in far better condition than was achieved in the pieces
excavated earlier.

In such a subject as lacquer, with its complex historical, geographical, stylistic
and technical problems, no single writer can expect to cover the whole field himself
and I am indebted to many experts for assistance in the preparation of this book.
One essential was a study of the Chinese literature and this involved the assistance
of sinologists, particularly those with knowledge of lacquer techniques so alien to
Western civilization. Dr. Joseph Needham has helped to sort out the various
materials used in lacquer manufacture, many of which have been wrongly trans-
lated in the past by sinologists who had no scientific knowledge of mineral and
vegetable products. Mrs. Hin-cheung Lovell, who made a complete translation
of the *Hsiu shih lu*, Professor William Watson and Miss Margaret Medley have
given invaluable help in the presentation of the Ming works on lacquer. Finally,
I owe a good deal to Dr. Roderick Whitfield for help in the presentation of the
Chinese literature and particularly for the production of the Chinese characters
used in the text.

Many pieces of Chinese lacquer of the Yüan and Ming dynasties have been pre-
served in Japan, some types of which are virtually unknown in China itself. This
makes it essential for the Japanese material to be studied in depth. The great
contributions to our knowledge made by Sir John Figgess in this field through his

published papers are well known to Western students. I am greatly indebted to him not only for these but also for many personal contributions. The account of the Korean lacquers owes much to Mr. Godfrey Gompertz who discussed problems relating to them with me in the light of his unrivalled knowledge of the arts of Korea.

I must express my thanks to many museums and private individuals all over the world for permission to publish objects from their collections and for providing much needed information about them. In particular the book has drawn heavily on objects in the British Museum and the Victoria and Albert Museum, and I should like to thank Mr. Douglas Barrett of the former and Mr. John Ayers of the latter for their unfailing help on matters dealing with their pieces.

In a previous book in the Faber and Faber Series of Monographs, *Chinese and Japanese Cloisonné Enamels*, I had occasion to refer to the great help I had received from Mr. Basil Gray, the Editor of the Series on Chinese Art. I owe him an even greater debt for his help in bringing to fruition this book on Chinese lacquer. His wide knowledge of Chinese art generally and in particular the part he played in the publication of Sir Percival David's book, *Chinese Connoisseurship*, dealing with the *Ko-ku yao-lun*, by far the most important Chinese publication on the later lacquerwares, made him an ideal editor for this particular book and my gratitude to him can hardly be adequately expressed.

<div align="right">Harry M. Garner</div>

CHAPTER 1

Introduction

W e may conjecture that lacquer, readily available as a natural product to the natives of all the countries of East Asia, was used by them in prehistoric times as a means of providing a durable waterproof covering for such materials as wood, basketry and textiles. Very little evidence is available, however, to support this conjecture. The lack of durability, not of the lacquer, which when set is one of the most durable of all vegetable products, but of the materials to which it was applied, must have caused the destruction of most of the artifacts exposed over the centuries to changeable atmospheric conditions, particularly in tropical and sub-tropical countries. In China, no evidence, up to the present, seems to have come to light on prehistoric lacquer.[1]

It is not too much to hope that, sooner or later, evidence of prehistoric lacquer in China will emerge. Fortunately, when we come to the early civilization in China, certainly by the fourteenth century B.C. if not earlier, the conditions were much more favourable for the preservation of lacquer. The practice of burying ritual objects in well constructed tombs enabled lacquer artifacts to be kept in more uniform conditions, both in temperature and humidity, than those of a casual burying. Even so, the decomposition of the wooden base to which the lacquer was generally applied was such that there was nothing left but an earth impression covered with a thin skin of lacquer or, worse still, only the skin itself. But, with the use of modern techniques, some ideas can be formulated about the shape and decoration of the original lacquer artifacts.

In the past many objects that were excavated in a fragile state afterwards deteriorated in the hands of ignorant excavators and dealers to such an extent that the most devoted care afterwards could do little to preserve them. Nor were the conditions for conservation so well understood as they are today. It is only in the last twenty or thirty years that steps have been taken in China to ensure that any lacquerwares uncovered were brought to the museum laboratory without suffering any further deterioration and then treated by modern conservation methods so that their permanent preservation was assured.

The development of Chinese lacquer, stretching over a period of more than three thousand years, can be divided into two phases. In the first the Chinese had the whole field of manufacture of lacquer, in any sophisticated form, to themselves. The surviving material from this phase has been obtained entirely from excavations.

[1] In Japan a number of crude lacquered artifacts made round about the beginning of the Christian Era have been excavated recently. These are prehistoric in the Japanese civilization, but are more than a thousand years later than the date of manufacture of the earliest fine lacquerwares in China.

In the second phase, manufacture spread to the other countries of East Asia, first to Korea and Japan and later to South–East Asia and the Ryukyu Islands. In Japan the first objects of importance were made round about the seventh century A.D. and this date is generally regarded as separating the two phases.[2] The influence of the Chinese on the developing Japanese culture was enormous and it is likely that the earliest lacquerwares in Japan were made by Chinese or Korean craftsmen. But soon a distinctive style had developed in Japan and from then onwards the greater part of Japanese lacquer was independent of outside influence.

In China itself, the splendid lacquerwares of the T'ang dynasty decorated with mother-of-pearl, which had launched the Japanese lacquerers on a highly distinctive style, in which decoration in gold in many techniques was added to decoration in mother-of-pearl, were superseded by the simple undecorated lacquerwares of the Sung dynasty, dependent, like much of the Sung ceramics, on form, colour and texture for their appeal. Beautiful as these are, they are only an interlude in the development of Chinese lacquer, and they were superseded by a bewildering variety of styles and techniques after the conquest of China by the Mongols in the twelfth and thirteenth centuries.

The development of lacquer manufacture in the Yüan dynasty is similar in many ways to that of ceramics. In the latter, the thirteenth and fourteenth centuries were periods of intense experimentation which led, in the fifteenth century, to the establishment of a few main types of porcelain which persisted during the whole of the Ming and Ch'ing dynasties. The decorative blue and white and polychrome porcelains dominated the ceramic field in the Ming dynasty and it was not until the Ch'ing dynasty that monochrome porcelains, including a large variety of new colours, came back into favour. In lacquer, the dominating type in the Yüan and Ming dynasties was carved lacquer, first in single colours and then in polychrome, and carved lacquer remained popular down to the reign of Ch'ien-lung (1736-95), when vast amounts were made for the court. In addition to carved lacquer, another innovation of the Yüan dynasty was an entirely new style of decoration in mother-of-pearl inlay, with delicate depiction of landscape and flowers based on Sung and Yüan paintings, very different in style and technique from the formal decoration of the T'ang dynasty. *Ch'iang-chin* decoration, with linear incised designs filled in with gold, was an entirely new type, important in its own right but also because it formed the basis for the so-called filled-in lacquer, a brilliant type of lacquer in many colours which was well established in the fifteenth century and became very popular in the sixteenth. Without this embellishment of colour, the more simple *ch'iang-chin* lacquer was introduced by the Chinese to Okinawa, where the Ryukyu craftsmen, under Chinese guidance, produced a very individual style of decoration in the fifteenth century which continued down to the nineteenth century.

To these new types of lacquer that originated in the Yüan dynasty a number of others were added later. In the Ming dynasty painted lacquerwares of a type not previously known, often associated with basketry, and inlays with materials other than mother-of-pearl were added. One might have expected that all the possible techniques in lacquer manufacture would have been exploited by the end of the

[2] But there is increasing evidence that in Korea lacquer objects of distinction were made earlier than this.

Ming dynasty, but the manufacture of an entirely new type incorporating both carving and painting techniques, the so-called 'Coromandel' lacquer, in the seventeenth century, showed that the Chinese inventive genius was by no means exhausted.

This book deals mainly with the development of the Chinese lacquerwares made from the Yüan dynasty onwards. These have almost all survived above ground, although a few have been excavated in China. A large proportion of the wares, and particularly those belonging to the fourteenth and fifteenth centuries, have been handed down in Japan, where they have been greatly treasured. One of the most important types, the *ch'iang-chin* lacquer of the Yüan dynasty, is quite unknown in China today, although no less than nine large sutra boxes in this technique have been handed down in various Japanese temples. The preservation of so many pieces in Japan was hardly known to the Western world until about twenty years ago, when a flood of Chinese lacquerwares of high quality from Japan began to reach Western museums and collectors. We owe a good deal of our understanding of the Japanese scene to Sir John Figgess, who has written a number of papers on various aspects of Chinese lacquer in Japan.[3] A contributing factor to the preservation is the moist climate of Japan. This, and the method of storing the lacquerware in wooden boxes when not in use, have ensured that the pieces have survived in very good state.

Although the subject of this book is the later lacquerwares, it has been necessary to say something about the earlier wares, since the development of many of the types originated long before the Yüan dynasty. This is all the more important since no Western writer has attempted to cover the subject of the earlier lacquerwares in a general way. The most important contributions on these, and then only in special groups, have been made by Japanese scholars such as Umehara, to whom we owe most of the information available on the inscribed and dated lacquerwares of the Han dynasty.[4] But even if any general account had been written it would, in the light of recent excavations in China, have needed considerable revision today. Indeed, it is probably too early yet for an authoritative account to be written. Such an account would probably need to compare the decorative motifs of early painted lacquer with those of the closely associated painted textiles and inlaid bronzes.[5] It cannot be claimed that the account of the earlier lacquerwares in Chapter 3 of this book is more than a mere sketch of our present knowledge, but it is supplemented by information on individual techniques in other chapters. For example, Chapter 5 deals at length with the origins of carved lacquer, in which the earlier attempts at three-dimensional representation are discussed.

The decision to confine this book mainly to the development of lacquer from the Yüan dynasty onwards still left unsettled the question of whether lacquerwares made outside China should be included. Every student of the later lacquerwares soon discovers that there are many pieces that show strong Chinese characteristics but cannot be positively attributed to China. Until recently the only lacquerwares attributed to the Ryukyu Islands were crude wares in Japanese style not considered

[3] See Bibliography, Refs. E23, E26 and E31.
[4] Umehara Sueji, *Shina Kandai Kinemei Shikki Zusetsu*, Kyoto, 1943.
[5] The section in W. Willetts, *Chinese Art*, Vol. 1, 1958, dealing with lacquer and silk in the Han dynasty, is a very good summary for its date.

sufficiently notable to be ascribed to Japan. We know that there are many pieces of fine quality made in the Islands that have in the past been attributed either to China or Japan. The amount of lacquer that has survived in South-East Asia is very small, and most of it is late, but the development of this from its undoubted Chinese origin needs study. Finally, the development of Korean mother-of-pearl lacquer, with its association with China on the one hand and Japan on the other, presents fascinating problems which demand careful scrutiny. It seemed essential therefore that some attempt should be made to study all the lacquerwares showing Chinese influence with a view to determining their real provenance. On the other hand, by far the greater part of Japanese lacquer pursued its independent existence and is therefore outside the scope of this book.[6] Writers on Japanese lacquer have generally ignored the wares made in Japan that show strong Chinese influence. Thus any attempt to classify these lacquerwares is breaking new ground and is fraught with considerable uncertainty. The discussion of these has proved to be the most difficult part of the book.

The variety and complexity of the lacquerwares from the Yüan dynasty onwards has made it desirable to adopt a treatment based on techniques. Thus individual chapters, each dealing with a particular technique, are devoted to such subjects as carved lacquer, lacquer inlaid with mother-of-pearl and other materials, gilt-incised lacquer (*ch'iang-chin*) and painted lacquer. In these chapters the pieces discussed may range from country to country. Under this arrangement there has been of necessity a certain amount of repetition from chapter to chapter. This however has the compensation that the reader can consult the separate chapters on particular types without the need to refer to the rest of the book.

There is an extensive Chinese literature on lacquer which has demanded much study. Some of it is of great importance, but much of it is of little value, although in the past it has gained a high reputation among Chinese scholars. One objective has been to sort out the reliable from the unreliable accounts, thus enabling the student to concentrate on the relatively few important works. The literature is discussed in Chapter 4 and it is supplemented in the Chinese Bibliography (with the items listed under letter C), which gives full reference to Chinese works, including the relevant Chinese characters, so that the student who wishes to go into any aspect of lacquer in detail is given enough information to enable him to do so. By this arrangement the need for Chinese characters in the rest of the book has been avoided except in a few places. As for Chinese terms, in Romanized form, these are so complex and often so vague that their use has been reduced to a minimum. The use of Japanese terms to describe types of Chinese lacquer is still less desirable, although the term *guri* for carved marbled lacquer is so well established that its use in a Chinese con-text is difficult to avoid. The extensive literature in European languages is listed in the Bibliography under letter E. This has enabled the references in the text and footnotes to be kept as short as possible, so that the general reader can follow the text more easily. The specialist reader can follow up the argument, particularly in the Chinese references, at some length. References to the Japanese literature are given throughout the text.

[6] The best account of Japanese lacquer by any Western writer is that of Beatrix von Ragué (Ref. E30), but this barely touches the pieces made under Chinese influence.

CHAPTER 2

The Nature of Lacquer and the Distribution of Lacquer Trees in East Asia

The term 'lacquer', which so spelt seems first to have occurred in English in 1697, is used today to describe many types of protective covering applied to wood, fabric, metal and other materials. The word 'lac' is of Hindustani origin and its first use in English, probably derived from the Portuguese word *lacca*, occurred in 1553. At this time it was used to describe a material produced from certain Indian and Indo-Chinese trees by the insect *Coccus lacca*,[1] which pierced the bark and exuded a dark red gum which was collected as a solid resin from the twigs of the tree. In the eighteenth century the word 'shellac' was used to describe layers of the dried material prepared for commercial use and this is the term used to describe the material today.

One of the earliest uses of this 'lacquer' was to dye silk a crimson colour and it was sent to China from Annam for this purpose during the T'ang dynasty.[2] It was also used as an adhesive by the T'ang jewellers and in the manufacture of cosmetic rouge. There is no evidence that it was ever used in China to produce a covering for wood or any other material, as it was in Europe for the decoration of furniture in the seventeenth and eighteenth centuries. Indeed, the Chinese had evolved, long before the Christian era, a far more durable material for this purpose. It is this lacquer that forms the subject of this book.

The lacquer of the East Asian countries, including Vietnam (Annam and Tong-king), Formosa and the Ryukyu Islands, Cambodia, Thailand and Burma as well as the major countries China, Japan and Korea, is derived from the sap of a lacquer tree. There are many species of lacquer tree, by far the most important being *Rhus verniciflua*,[3] a native of China which is said traditionally to have been transplanted first to Korea and then to Japan. The date at which it reached Japan has been variously stated to be from the third to the seventh century A.D. I have been unable to find any positive evidence to support this tradition except that of Rein whose account in his *Industries of Japan*[4] was summarized long ago by Bushell.[5] Rein stated that *Rhus verniciflua* has not been found growing wild in Japan and then goes on to say that 'we may be safe in concluding that the lacquer art and probably the lacquer tree with it became known to the Japanese from their western neighbours

[1] Sometimes known as *Laccifer lacca* or *Carteria lacca*.
[2] E. H. Shafer, *The Golden Peaches of Samarkand*, 1963.
[3] Previously known as *Rhus vernicifera*, *Rhus verniciflua* is the correct botanical name.
[4] J. J. Rein, *Industries of Japan*, London, 1889.
[5] S. W. Bushell, *Chinese Art*, Vol. I, 1904.

just after the commencement of the third century, or after their first expedition to Korea.'

The comparatively recent excavation of simple lacquer artifacts in Japan, which have been dated to prehistoric times, between the third century B.C. and the fourth century A.D., raises problems in connection with the tradition of importation to Japan of *Rhus verniciflua*. Dr. von Ragué has assumed that the results of the excavations conflict with the tradition.[6] But this ignores the fact that there are indigenous species of lacquer trees that could have been used for the manufacture of the prehistoric artifacts. There are nine species of the *Rhus* family that grow in Japan and at least three of them are suitable for the manufacture of lacquerwares.[7] These are *Rhus succedanea*, *Rhus ambigua* (or *orientalis*) and *Rhus trichocarpa*. The first grows in South-East Asia as well as Japan and the Ryukyu Islands and provides the standard material for the manufacture of the Annamese lacquerwares today. The second grows in Formosa and the Ryukyu Islands as well as Japan and is said to have been used for the manufacture of lacquer in Formosa.[8] The third grows in China, Korea and Japan and Dr. Makino has suggested that it may have grown in Neolithic times in North Japan, where most of the prehistoric wares were excavated.[7] It can be seen from all this that the composition of the artifacts and the reliability of the Japanese tradition are both uncertain. In the absence of chemical examination of the prehistoric artifacts, which would identify the molecular structure of the lacquer and hence the species of lacquer tree, a problem of great difficulty, we would have to rely on the views of botanists on the various indigenous lacquer trees and would need to have information on the climatic conditions in North Japan some three thousand years ago, which may have been very different from those pertaining today. It seems, however, to be firmly established that all the Japanese lacquer wares of historic times were made from *Rhus verniciflua*, as were all the Chinese and Korean wares.[9]

Other species known to have been used for the manufacture of lacquer are *Melanorrhoea laccifera* and *Melanorrhoea usitata*, both of which are natives of South-East Asia. The former is used in Cambodia and the latter in Burma and Thailand for the manufacture of lacquerwares today.

The chemical properties of the raw lacquer obtained from trees of different species differ a good deal and they may affect the setting qualities to some extent, so that the techniques needed to deal with the different types may vary from country to country. But broadly the methods adopted in China to collect, purify and store the raw lacquer from *Rhus verniciflua* are similar to those used in other countries for lacquer from trees of different species. The Chinese lacquer tree grows wild over a large area of China today up to altitudes of five hundred metres and there is evidence that at one time it grew over a still larger area. There is an extensive Chinese literature on the cultivation of the lacquer tree and the methods of extracting and

[6] Beatrix von Ragué, *Geschichte der Japanischen Lackkunst*, 1967, pp. 1–2.

[7] Tomitaro Makino, *Shippo Nippon Shokubutsu Zukan* (New Illustrated Flora of Japan), 1964 (in Japanese).

[8] T. Hedley Barry, *Natural Varnish Resins*, 1932.

[9] But we cannot rule out the possibility that lacquerwares were made in the extreme south of China from *Rhus succedanea*, the species used for the Annamese wares.

preserving the raw material, but the most informative account available to the Western reader is that given by the Jesuit priest Père d'Incarville, who lived in Peking for seventeen years and sent a long account on lacquer to the Academy of Sciences in Paris just before his death in 1757. The paper was published in 1760.[10] D'Incarville was a distinguished botanist and his descriptions, from observations at first hand, are clear and precise. Only when he is dealing with details of manufacture, at second hand, do we detect some uncertainties in his account.

A general study of the Chinese literature on lacquer and the methods of extracting and preserving it suggests that the methods of the eighteenth century described in detail by d'Incarville agree substantially with those used in China from early times. It seems likely that at first lacquer was collected from wild trees but cultivation must have been introduced well back in the first millennium B.C. There is a description of the cultivation of lacquer trees in the *Ch'i min yao shu*, written by Chia Ssu-hsieh under the Northern Wei (c. A.D. 540), at a time when attempts were being made to reintroduce lacquer trees into parts of Honan where they had formerly flourished.[11]

The raw lacquer is tapped by cutting notches in the bark of the tree and placing small containers to receive the viscous liquid, or latex, that trickles from the cuts.[12] When it first exudes from the tree it is creamy-grey in colour, but on exposure to light and warmth it turns dark brown and later still dull black. After being strained to remove solid particles the latex is generally stored in air-tight containers until it is required for use. Under suitable conditions the latex can be preserved without change for several years. Some lacquer of inferior quality is obtained by boiling small branches of the tree in water. The quality of the lacquer varies according to the district in which the tree is grown, the time of year at which tapping takes place and other factors. Lacquer was always a valuable product and to eke it out the best grades were often adulterated by the addition of other materials such as *t'ung* oil, oil of tea (derived from the fruit of a variety of tea-tree) and pig's gall.[13] For special types of lacquer the material had to be of high quality and then little adulteration was added; for others a considerable amount of adulterant was permissible.

In its raw state lacquer is poisonous to people handling it, causing severe inflammation of the skin. The component that produces this dermatitis is, in the lacquer

[10] 'Mémoire sur le vernis de la Chine', *Mémoires de Mathématique et de Physique, présentés à l'Académie Royale des Sciences*, Tome III, Paris, 1760. The paper was afterwards published as a chapter in Watin, *L'Art du Peintre, Doreur, Vernisseur*, and appeared in many editions from 1772 onwards. Earlier short accounts on lacquer are given by Louis le Comte, *Nouveaux Mémoires sur l'État présent de la Chine*, Paris, 1696 and J. B. du Halde, *Description de l'Empire de la Chine*, Paris, 1735.

[11] See Soame Jenyns, 'Chinese lacquer', *Transactions of the Oriental Ceramic Society*, 1939-40, for further particulars of early cultivation of lacquer trees in China. See also William Willetts, *Chinese Art*, I, 1958, pp. 188-93 for information on the distribution of the lacquer tree and lacquer factories during the Han dynasty.

[12] The techniques adopted in Japan differed from those in China in some details. See note 4 above for information on Japanese techniques.

[13] But it should be noted that some of the added materials are said to improve the lacquer for specific purposes. According to the *Hsiu shih lu* (Ref. C7, Section 81), *t'ung* oil improves the colour of all kinds of lacquer except black. *T'ung* oil and other additives may also improve the setting qualities.

derived from *Rhus verniciflua*, urushiol. Much study has been given by research chemists to this and allied components (laccols) derived from various species of lacquer tree, as well as from poison ivy and some kinds of mushroom, which have similar properties. The Chinese found out at an early date that the tissues of crabs and shell fish provided a good antidote to the poisoning and there are many references in Chinese literature to the cures affected. Crab tissues were also believed to cure the urushiol allergy and to enable traces of lacquer to be readily removed from the skin. Sinologists were inclined to regard the Chinese accounts of cures as old wives' tales until Needham and his colleagues established the sound scientific basis of the Chinese records.[14]

Lacquer, when applied in the form of thin layers to a material such as wood or fabric, sets to form a hard glossy surface that is very durable. It is suitable for domestic vessels, being impervious to liquids and unaffected by the temperatures needed for serving hot foods and liquids. Until recently it was used extensively for domestic purposes in China and Japan, and it has only partially been superseded during the last thirty years by the cheaper plastics that have become available. It is still the usual surface for laboratory benches in East Asia, because of its resistance to strong acids.

The chemical process by which lacquer, a poisonous viscous liquid, is changed to a harmless solid is a complex one. The process is one of polymerization, such as occurs in the manufacture of plastics. Indeed the process has been described as 'the most ancient industrial plastic known to man'.[15] An enormous amount of research has been devoted to the understanding of the process, in Japan, China and Indo-China, as well as many European countries and the United States, but in spite of this it cannot be claimed that all the factors influencing the setting qualities of lacquer have been identified.[16] The simplified description given below of what actually happens is necessarily sketchy.

The main constituents responsible for the polymerization of Chinese and Japanese lacquer are urushiol,[17] the component that causes dermatitis, and the enzyme laccase. The chemical action that takes place differs from that of an ordinary plastic in that the presence of oxygen is essential. Experiments show that lacquer will not set in an atmosphere of nitrogen or carbon dioxide. The degree of humidity of the atmosphere also has to be between certain limits and we have the state of affairs, curious to the casual observer, that setting will not take place if the conditions are too dry.[18]

[14] Ts'ao T'ien-ch'in, Ho Ping-yü and Joseph Needham, 'An early mediaeval Chinese alchemical text on acqueous solutions', *Ambix*, Vol. VII, No. 3, 1959, pp. 122–53.

[15] Note 14 above.

[16] Seventy-eight references to scientific work on lacquer have been recorded by Dr. Victor A. Moss in an unpublished paper, and these could be extended. A few of the more important references are given in the Bibliography.

[17] In *Rhus succedanea* the analogous compound is laccol, in *Melanorrhoea usitata* it is thitsiol and in *Melanorrhoea laccifera* it is moreacol.

[18] An essential part of the chemical process is the presence of minute amounts of copper in the laccase, one of a group of copper-containing enzymes which are responsible for oxidation in plants and animals. At one time it was thought that the active element was manganese. Only extensive research by a number of chemists has finally settled this point.

The need for oxygen to enable polymerization to take place imposes an important limitation on the method of application of lacquer. Indeed, it may be said to dictate the whole of the manufacturing process of carved lacquer. The oxygen comes from the air and it is not able to penetrate far into the layer, so that the layer has to be very thin if the lacquer is to set properly. If the layer is too thick a skin forms on the outside and the inside remains liquid. There is then no remedy but to remove the layer and start afresh.[19] The maximum thickness that can be successfully applied is influenced by a number of factors, such as the quality of the lacquer and the amount and composition of solid matter, such as ash and pigment, in suspension. The individual layers of carved lacquer made in the Ming and Ch'ing dynasties are always very thin. Measurements of sections of Ming lacquer show that the thickness of individual layers is of the order of 0·03 mm or less. As there are between one and two hundred layers in a fine carved piece of this period, it can be seen that the labour involved in its construction, even before it was passed to the carver, was very great.

The difficulties in getting the lacquer to set can be overcome by the addition to the lacquer of large amounts of ash and the Chinese seem to have been familiar with this technique at least as far back as the third century B.C. From then onwards a few examples of this lacquer composition, generally moulded to shape, have survived, but it was not until the fourteenth century that it was recorded as a well-known type of lacquer. It is described in the *Ko-ku yao-lun* of 1388 by the term *tui-hung*, 'piled-up red' and scorned as a cheap substitute for carved red lacquer.[20] A large number of pieces must have been made at this time, but none of them have so far come to light.[21] Doubtless they were not sufficiently robust to withstand the wear and tear to which they were subjected. There are however a number of pieces known today which belong to the Ch'ing dynasty.

The development of the moulded lacquerwares is described fully in Chapter 5. All we need to consider here is why this type of lacquer sets in thick layers while pure lacquer with relatively little pigment does not. No experimental work has been done on this subject, but it is probable that the ash added to the former acts as a catalyst to provide free radical polymerization of the lacquer. This raises the question as to how far the type of ash affects the setting and whether the setting qualities vary for lacquer trees of different species. It may be significant that the best examples of moulded decoration appear to have come from Burma, where a type of moulded black lacquer, afterwards gilt, is made from the lacquer derived from *Melanorrhoea usitata* and a vegetable ash from paddy husk. The lacquer is said to resemble ebony, but to be superior to wood in that it has no grain.[22]

But even the best moulded lacquer falls far short in quality of the material needed for carving to the standards laid down by Chinese craftsmen. The gritty ash

[19] D'Incarville gives a clear account of the difficulties experienced by the eighteenth-century lacquerers when the layers of lacquer did not set (note 10 above).

[20] Ref. E32, p. 147.

[21] *Tui-hung* is also described in the *Hsiu shih lu*, Ref. C7, Section 125.

[22] A. P. Morris, 'Lacquer ware industry of Burma', *Journal of the Burma Research Society*, Vol. IX, 1919, p. 10. It should be noted that the lacquer tree in Burma has different properties from that used in Chinese lacquer and its qualities may have had something to do with the hardness of the resulting material.

embedded in the *tui-hung* lacquer would clearly render it unsuitable for precision carving. To the Chinese and later the Japanese craftsmen the idea of dispensing with the laborious process of building up, layer by layer, the lacquer to be used for carving must have been ever present and many attempts must have been made to produce a suitable material which could be applied in a single coat. In spite of these attempts no substitute has ever been found and the laborious method first brought to perfection in the fourteenth century has continued to be used down to modern times.[23]

The widespread distribution of lacquer trees in East Asia has already been stressed. In China *Rhus verniciflua* grew over almost the whole of the country south of the Yellow River, extending from the east coast to Kansu, Szechwan and Yunnan in the west. The last province in particular had a traditional reputation for its fine lacquerwares. There is evidence from the Chinese literature that the lacquer tree grew in almost every province in China except for a few northerly ones, and that lacquerwares were made in many widely scattered districts. But the identification of lacquerwares made in particular districts is at present very difficult. In the course of this book however attempts will be made to identify some of the wares.

The possibility that lacquerwares made from *Rhus succedanea* may have been produced in South China on the borders with Annam has already been mentioned. Indeed, it is likely that the wares were introduced to other countries of South-East Asia from the neighbouring provinces of China, such as Yunnan, Kuangsi and Kuangtung. There is a tradition in Burma that lacquer manufacture was introduced from Yunnan. Thus we should regard the manufacture of lacquerware in the mainland of East Asia as taking place not in a few main centres, but in widely scattered districts over the whole of China and South-East Asia.

[23] In the National Palace Museum, Taiwan, copies of Ming carved lacquerwares are being made today in moulded plastic. They are very inferior, and readily distinguished from the genuine wares.

CHAPTER 3

The Early Lacquerwares of China

The probability that lacquer was used as an adhesive covering to artifacts of wood and basketry in prehistoric times in the countries of East Asia has already been suggested in Chapter 1. It will be difficult however to find excavated material to establish this. Even in historic times, as in China during the Shang dynasty, when the orderly burial of ritual objects became the practice, giving greater protection than could have come from casual burying, the wooden bases of most of the decorated objects are found to have become completely disintegrated, leaving nothing but earth impressions. But these impressions, of consolidated earth, can sometimes be found to reveal detailed information on the original structure. The technique for doing this was first developed by European archaeologists in the excavation of ships, particularly in Scandinavia and Great Britain, and can be seen developed to a high degree in the Sutton Hoo excavations made in East Anglia in 1939. In China similar techniques were used from 1951 to 1957 by the Institute of Archaeology of the Academy of Sciences in a tomb at Hui-hsien, Honan Province, containing nineteen chariots, datable from the fifth to fourth century B.C. The excavations revealed clearly the construction of the chariots, even to such details as the spokes of the wheels.[1] The chariots were originally covered with a protective paint, but only traces round the driver's box of one chariot remained. The paint, which was identified as lacquer by the excavators, might well have been overlooked in a less skilful excavation.

Recent excavations in China at T'ai-hsi-ts'un, made in 1973, have established that wooden vessels decorated with painted lacquer were made as early as the Shang dynasty, probably in the thirteenth or twelfth century B.C.[2] Fragments of the vessels were excavated in good condition, far better than had been achieved in any earlier excavations, and laboratory examination enabled the material and methods of construction to be determined. Some of the fragments are shown in Plate 1. Further reports are expected on this important excavation, but it is already clear that the decoration was made by the application of painted lacquer to a carved wooden base. Details of further decoration are provided by shaped pieces of inlaid turquoise.

These latest finds call for a re-examination of the many objects excavated in the last forty-five years, datable to the thirteenth century B.C. onwards. There has been a reluctance among Chinese, Japanese and Western experts alike to identify the

[1] William Watson, *China before the Han Dynasty*, 1961, pp. 136–8.
[2] *Wên-wu*, No. 8, 1974, 'The Shang dynasty site at T'ai-hsi-ts'un, Kao-ch'ang County, Hopei Province', by the staff of Hopei Museum and CPAM, Hopei Province.

covering material as lacquer. What now appears to have been excessive caution is understandable. It is becoming clear that a vast amount of lacquer was made, in various forms, during the whole of this period. But generally, because of the fragmentary state of the excavated material, we can only conjecture what the original objects were like, both in form and decoration.

The first suggestions that lacquer was used in the Shang dynasty came from a study of the inlays on bronze ritual vessels. A number of vessels are known, some as early as the twelfth-century B.C., in which sunken designs are filled in with a black material consisting mainly of quartz and carbon fragments held together by an adhesive.[3] The question of whether the inlay was accidental, resulting from the use of the vessel for cooking, or deliberately applied, was one that was much discussed by connoisseurs some forty or fifty years ago. The earliest scientific work was done by Plenderleith,[4] who concluded that the black inlay was not accidental. His cautious summary was that 'such black inlays in Shang bronzes may be the remains of a primitive form of lacquer of organic origin.' Gettens carried the investigation of the problem a stage further by showing that the quartz fragments were uniform in size and similar to those found in the cores of Shang bronzes. This showed conclusively that the filling was not accidental. His meticulous examination of a large number of bronzes, based on a wide variety of experiments, led him to conclude that 'As Plenderleith suggests, the black filling may indeed be the residues of a lacquer filling.'[5]

The caution expressed by Plenderleith and Gettens must be considered to be justified scientifically by the fact that the problem of the identification of lacquer in the solid state has not yet been solved. An allied problem, the identification of different kinds of amber, has been tackled with some success by Rottländer[6] and others, and it is thought that similar analyses based on a combination of spectrographic and other experiments could solve the problem of lacquer identification. The solution could not only distinguish between lacquer and other adhesives, but might well identify lacquer made from different species of lacquer tree, in which the molecular structures are different. This is an important point in relation to the earliest prehistoric wares, particularly for countries outside China. However, the identification of lacquer, particularly in complete pieces, does not generally call for the use of such difficult experimentation.[7]

The use of semi-precious stones such as turquoise and malachite as inlays on ceremonial weapons goes back to the Shang dynasty. Two fine examples in the Freer Gallery of Art are attributed to this period.[8,9] But large areas of the original

[3] Yüan Tê-hsing, 'Conceptions of painting in the Shang and Chou dynasties', *National Palace Museum Bulletin*, Vol. IX, No. 2, 1974, states that some examples of bronzes in the Museum show traces of colour in the inlays.

[4] H. J. Plenderleith, 'Technical note on Chinese bronzes with special reference to patina and incrustations', *Transactions of the Oriental Ceramic Society*, Vol. 14, 1938-9, p. 38.

[5] R. J. Gettens, *The Freer Chinese Bronzes*, Vol. II, 1969, pp. 197-204.

[6] R. C. A. Rottländer, 'On the formation of amber from *Pinus* resin', *Archaeometry*, 12.1, 1970, pp. 25-31.

[7] See Chapter 2 for information on the various species of lacquer tree in East Asia.

[8] *The Freer Gallery of Art. China*, 1972, Plate 16.

[9] William Watson (note 1 above), Plate 22.

inlay in such pieces have often been found detached at the time of excavation and it is difficult to say whether the present adhesives are original or not. As far as these two particular pieces are concerned, Gettens does not go further than saying that some form of cement was used. But it seems likely that the composition of the adhesive was similar to that used in the black inlays of the bronze vessels. Inlays of mother-of-pearl on bronze *t'ao-t'ieh* plaques are known and although the earliest of those recorded seems to be datable from the ninth to the seventh century B.C.,[10] earlier examples of the use of mother-of-pearl have come from excavations of Shang tombs in Anyang. A number of sets of fragments of mother-of-pearl which may have been originally attached to wood or bronze, or possibly leather, have been assembled in *t'ao-t'ieh* form.[11] If the original pieces were attached to wood or bronze, an adhesive would have been needed and this would almost certainly have been lacquer.

In the light of the recent excavations at T'ai-hsi-ts'un we now find no difficulty in accepting the view put forward tentatively years ago by various experts that lacquer was used to enhance the sunken designs on bronze vessels and for the attachment of various materials such as turquoise, mother-of-pearl, bone and ivory for the decoration of bronze weapons, fittings and other artifacts. But the use of lacquer in a more positive sense for decoration, as seen in the lacquer vessels excavated at T'ai-hsi-ts'un, is far more relevant to studies of lacquer, and it is necessary to consider the vast amount of similarly decorated material which began to be excavated at Anyang more than forty years ago.

The early official excavations at Anyang, made by the Academia Sinica, could hardly have been made under more unfavourable conditions. The hostility of the local inhabitants to official work, which robbed them of the private profits that had been obtained in the past on excavated treasures, and the incursions of bandits, greatly hindered systematic work. This was bad enough for the study of the ritual bronzes, which were the most important objects, but it was disastrous for the more fragile lacquerwares, which required not only careful excavation, but also great skill and care in their preservation afterwards. The war with Japan in 1937 stopped official work, which was not resumed until 1950. Nevertheless a great amount of material, much of which is now in the National Palace Museum, Taiwan, has been preserved, although generally in a very poor state.[12]

The early material excavated in the Anyang area before 1937 has been thoroughly discussed by Umehara,[13] who studied the earth impressions formed from the wooden bases of the artifacts. The skilful work done from 1951 to 1957 on earth impressions by the excavators of the chariot-pit at Hui-hsien has already been mentioned. The advanced techniques that had been developed by that time were not available in China before 1937 and the excavation and preservation of the Anyang

[10] William Watson, *Ancient Chinese Bronzes*, 1962, Plate 81a.

[11] Hsio-yen Shih, 'A Chinese shell-inlay motif', *Royal Ontario Museum, Art and Archaeology Division, Annual for 1961*, pp. 43–9.

[12] Some of the material is still in China, and was examined by Mr. Basil Gray at Nanking in 1957.

[13] Umehara Sueji, *Inyo hakkan mokki in-ei zuroku* (Catalogue of the impressions of wooden objects discovered in Yin tombs), Kyoto, 1959.

artifacts suffered from lack of experience as well as the extremely difficult conditions of operation. Nevertheless, the studies of Umehara, in the light of the most recent excavations at T'ai-hsi-ts'un, make it clear that the artifacts from the earlier excavations were made by similar techniques to those used in the T'ai-hsi-ts'un vessels.

Umehara provided an excellent pictorial record of the excavated material, but his text was cautious and it is difficult to find positive assertions about the materials used for the manufacture of the artifacts. He was quite clear, however, in saying that the earth impressions showed that the original wooden cores were carved with recessed designs similar to those found on the ritual bronzes. From the colour illustrations it would seem that the carved designs were covered with black lacquer and that the parts in relief were then painted in red lacquer. The illustration in Plate 2 of a small piece much enlarged from one of Umehara's excellent colour illustrations enables the decoration to be compared on about the same scale with that of the T'ai-hsi-ts'un fragments in Plate 1. The similarity in decoration is very close.

The survival of the decoration in such pieces as that shown in Plate 2 provides convincing evidence that the covering skin, like that of the T'ai-hsi-ts'un fragments, was of lacquer. While, as I have already pointed out, no scientific test has yet been devised for distinguishing lacquer from other vegetable adhesives and paints, it is safe to say that no covering skin except lacquer would have survived burial in a Shang tomb. But there can be no doubt that large quantities of carved wooden objects covered with paint were made in the Shang dynasty, as they were in bone, a much more durable material. Many examples in bone have survived, but it is unlikely that any will be found to have survived in wood, except possibly in the form of earth impressions.

Some important evidence on the decoration of wooden objects has come from the recently excavated tomb of Li Tsang at Ma-wang-tui, datable to c. 150 B.C., which will call for much discussion later in this chapter. A number of lacquer vessels were found to have, in addition to decoration in lacquer, some decoration in oil paint, thought to be derived from *t'ung* oil. The probable reason why this was used on highly sophisticated lacquer objects was that a wider range of colours could be obtained in paint than in lacquer, which has a strong chemical action on many pigments. This is the first time that the association of the two techniques of decoration in one piece has been established, but there is no reason why paint alone or associated with lacquer should not have been used from the beginning.

There are many objects from Anyang described by Umehara that resemble the piece in Plate 2. There still seems to be a little of the original structure left in some of the objects, but there are other objects in which the earth impressions had disappeared and all that was left was the surface decoration. The royal tombs of the Shang rulers at Hsi-pai-kang, datable to the twelfth or eleventh century B.C., were perhaps the most important of those investigated. In nearly all these tombs the burial chamber was covered with a wooden canopy decorated on the lower surface with what has been generally described as 'red paint' but which can now be confidently identified as red lacquer, with inlays of shell and other materials. An illustration of one of these canopies, taken *in situ* where it had fallen into the tomb, is

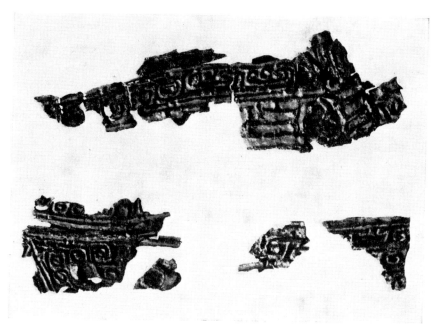

1. FRAGMENT from T'ai-hsi-ts'un
Shang dynasty

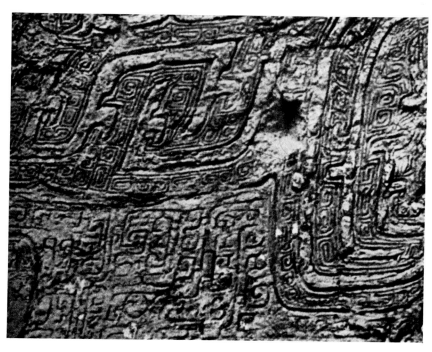

2. FRAGMENT from Anyang
Shang dynasty

shown in Plate 3.[14] This remarkable survival shows part of a dragon outlined in rectangular pieces of shell. In some places there is visible a background decoration of *lei-wen* scrolls in red, but in many places it has disappeared. There can be no doubt that the wooden core was carved in a similar technique to that found in the T'ai-hsi-ts'un fragments. Another piece from the royal tombs and also part of a canopy, illustrated in Plate 4, has circular pieces of shell carved in an overlapping petal design.

All the pieces described by Umehara appear to be of grave furniture. It seems unlikely that lacquer vessels were not buried in the Anyang tombs—indeed the vessels excavated at T'ai-hsi-ts'un provide a strong presumption that they were— but it would not be surprising if fragments of such vessels had been put on one side in favour of the much larger and more impressive pieces of grave furniture. The supreme importance of the T'ai-hsi-ts'un fragments lies in their good state of preservation and the subsequent excellent conservation, which allowed the construction of these thin-walled objects to be studied in detail.

The Shang style of decoration, based on shallowly carved wood designs, continued into the Chou dynasty. The latest objects that have so far been excavated which may have been in this style were those found in the cemetery of Shang-ts'un-ling, which was excavated in 1959. The cemetery contains many tombs, in one of which were found inscribed halberds belonging to the State of Kuo, which was annexed by the State of Ch'u in 655 B.C. A number of vessels, originally of wood, including six goblets (*tou*) and four dishes (*p'ên*), were excavated in the form of earth impressions. One of the goblets had the remains of circular discs of shell. The vessels are reported to have been of lacquer, although no traces of lacquer, nor of carved decoration, seem to have been found.[15] The shell decoration would be meaningless by itself and it seems likely that originally it was associated with a carved and lacquered background similar to that of the canopy in Plate 4. These vessels seem to be the latest examples of lacquerwares decorated in what we may call 'Shang style'. The period from the seventh down to the fourth century B.C. provides little evidence of what was happening in lacquer development. But from the fifth or fourth century onwards there is ample evidence of new decorative styles and new techniques, with improved methods of construction.

These entirely new styles of decoration were the result of the introduction of interlacery and scroll designs which were first used in bronze decoration many centuries earlier. The earliest designs in bronzes go back to the early Chou dynasty, to the tenth and even possibly the eleventh century B.C. and are thought, by some authorities, to have been influenced by the culture of the nomad tribes which invaded China from the north-west. In the later developments the decoration is often described as the 'Huai style', a term coined by Karlgren to describe the decoration of the bronzes made in the fifth century B.C. at Shou-hsien on the River Huai.

In lacquer some of the earliest evidence of interlacery known at present comes

[14] See note 1 above (pp. 69–72).

[15] Institute of Archaeology of the Academy of Sciences, Peking, 'A cemetery of the State of Kuo at Shang-ts'un-ling, Honan Province', *Special Archaeological Series*, 4, No. 10, 1959.

Ch'iang-chin decoration — linear
incised designs filled in with gold, —
first made in China in the early C17th

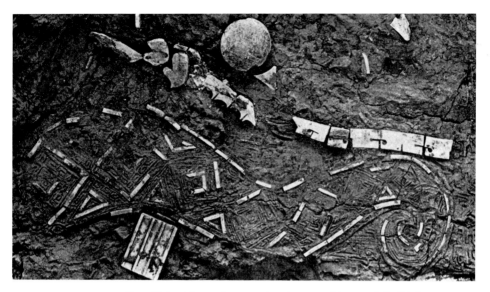

3. FRAGMENTS from Hsi-pai-kang, Anyang, showing carved base and shell inlay
Shang dynasty

4. FRAGMENT from Anyang, showing carved base and shell inlay
Shang dynasty

from perforated panels with painted lacquer decoration. A number of coffin-boards carved in openwork, some with remnants of lacquer decoration, were excavated from tombs in the Ch'ang-sha area from 1930 onwards. The excavations were uncontrolled and there is no reliable evidence on the dates of the tombs. More recently controlled excavations of tombs with coffin-boards have been made. The evidence has been carefully summarized by Fontein and Wu,[16] who date the boards generally to the third century B.C. One of the most important examples of inter-lacery is a panel, finely carved with various animals on a base composed of a large number of interlaced snakes, excavated at Chiang-ling.[17] The panel is best known to Western students from a replica which was included in the exhibition of excavated objects held in Japan and a number of European countries. Some of the colours used in the replica are not possible lacquer colours and moreover are not consistent with the colours described in the original *Wên-wu* report.[18] This makes it difficult to judge one of the most important features of the panel, the lacquer decoration. The date of the panel, while subject to some uncertainty, can be given as not later than 334 B.C. and the panel may claim to be the earliest example of carved interlacery in lacquer so far recorded.

Fine examples of interlacery are to be found in the fittings of the iron sword formerly in the Low-Beer Collection and now in the British Museum. There are four fittings in all and three of them, the sword hilt, the slide and the chape are shown in Plates 5, 6 and 7 respectively. The slide, with its complex design of three intertwined animals, consisting of two snakes and a bear, shows the closest approach to the Chiang-ling panel to be found in a Western collection. It shows traces of painted lacquer decoration in a lozenge border on the foot. The date of the sword is thought to lie between the third and second century B.C.

As well as these pieces, a number of carved wooden figures, many overpainted with lacquer, have been excavated from tombs in Ch'ang-sha, Chiang-ling and other places. In most of the pieces the carving is crude, never approaching the quality of the openwork interlacery designs. Many of the more simple figures were decorated in oil paints and not lacquer, and recent evidence from the Ma-wang-tui tomb has, as I have already mentioned, revealed that lacquer and oil paints can sometimes be found in the same piece. The most important of the wooden sculptures are drum-stands in which pairs of birds standing on tigers and other animals form the support of the drum. A number of drum-stands were excavated under uncontrolled conditions some years ago and were subsequently wrongly assembled. It is only recently that drum-stands have been excavated under controlled conditions, enabling the correct assembly of the stands excavated earlier to be made.[19]

The group of carved wooden objects may be regarded as an interlude between the early Shang-style lacquerwares, based essentially on shallowly carved decora-

[16] Jan Fontein and Tung Wu, *Unearthing China's Past*, 1973, pp. 70–1.

[17] *Wên-wu*, 1966, No. 5. A full account in English of the excavations from three tombs in Chiang-ling is given by Annette L. Juliano, 'Three large Ch'u graves recently excavated in the Chiang-ling district of Hupei Province', *Artibus Asiae*, Vol. XXXVII, 1975.

[18] See note 17 above.

[19] See note 16 above, where the drum-stands and the various methods of assembly are discussed at length (pp. 66–9).

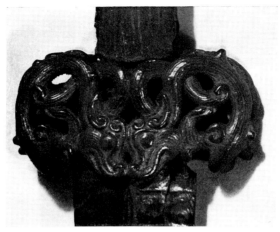

5

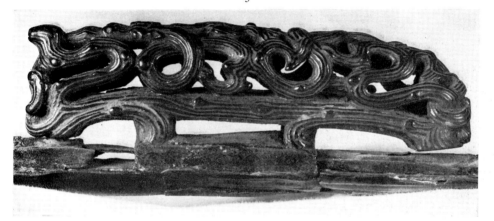

6

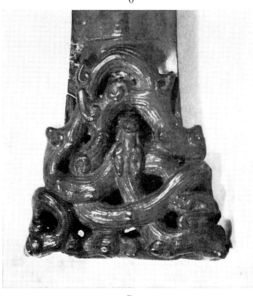

7

5–7. SWORD-FITTINGS
Warring States period. Hilt (Plate 5), slide (Plate 6) and chape (Plate 7)
Length of slide 12·5 cm
British Museum

tion in stylized animal forms, and the introduction of an entirely new style of decoration, of flowing brushwork, based on the interlaced and scroll designs that had first appeared in the bronzes of the tenth century B.C. The decoration was generally applied to a flat surface and is strictly two-dimensional. This astonishing development is the most remarkable one in the history of lacquer development in China and was destined to lead to the introduction of landscape painting.[20, 21] The development was very rapid and, as far as present evidence goes, was started not earlier than the fifth century B.C. Because a good deal of the material excavated so far was obtained under uncontrolled conditions, in spite of the reliable evidence that has come to light recently from controlled excavations, we are still left in some uncertainty on the date of introduction.

At about the same time as the introduction of an entirely new style and technique of lacquer decoration, two new factors which led to more favourable conditions of preservation came into operation. The first was the greatly improved construction of tombs and the second the introduction of better methods of construction of the lacquer objects themselves. These, combined with the carefully controlled excavation of the tombs and the excellent conservation methods applied afterwards, have been responsible for the preservation of one of the greatest cultural achievements of China.

These lacquerwares first began to be excavated in the Ch'ang-sha district some fifty years ago and many of them found their way into Chinese, Japanese and Western collections. Unfortunately none of these pieces can be dated at all closely and the dates given to them at the time of acquisition, ranging from the fifth to the third century B.C., are now thought to have been a century or more too early.

Our knowledge of the methods of construction of these lacquerwares is based on the examination of a large number of pieces in Western and Japanese collections. Such examinations are often very difficult, but the availability of a large number of damaged pieces has enabled much laboratory work to be done. The problem of identifying the various methods of construction has been greatly eased by information coming from a group of imperial lacquerwares belonging mainly to the first century B.C. and the first century A.D. which bear dated inscriptions, many of which give details of the method of construction. We shall refer to these pieces later in this chapter, but the evidence may be summarized here by saying that the surfaces of the wooden vessels were covered with a lacquer composition before the ground colour and then the decoration in lacquer was applied. Sometimes the wood was covered with a layer of fabric, which was embedded in the lacquer composition.[22] In other pieces the so-called 'dry lacquer' technique was used, in which the wooden base was dispensed with and fabric only was used. All these types can be identified, not only in the imperial wares themselves, but also in the pieces excavated in Ch'ang-sha. The result, whichever of the three techniques was adopted, but particularly when fabric was used, was an enormous improvement in durability. The breaking up into small fragments that is a feature of the vessels excavated at

[20] Michael Sullivan, *The Birth of Landscape Painting in China*, 1962.

[21] William Watson, *Style in the Arts of China*, 1973.

[22] The inscriptions invariably refer to the fabric as ramie, and not hemp, the fabric generally mentioned in connection with these wares.

T'ai-hsi-ts'un (Plate 1), for example, would never have occurred if fabric, giving much greater tensile strength, had been used in the construction.

The difference between these later lacquerwares with their greatly superior methods of construction and the earlier ones, in which only a thin layer of lacquer was applied to a wooden core, has been largely responsible for the reluctance of lacquer experts in the past to accept the earlier wares as being lacquer at all. The position is well summed up by the authors of the report on the T'ai-hsi-ts'un excavation. They say 'writers for the most part have been of the opinion that the real stages in the development of Chinese lacquer took place during the Warring States period; that lacquer articles made with a thin wood core, characterised by their lightness, stemmed from that period and that the working of lacquer became an independent craft during that period.'[23] The authors go on to say that the excavations at T'ai-hsi-ts'un show that these ideas were quite wrong and that lacquer-working, as distinct from wood-carving, had become an independent specialist craft in the Shang dynasty. There can be no doubt now that lacquerwares of great artistic distinction were made throughout the Shang and early Chou dynasties, but because of their inferior construction it is unlikely that any of the fine early pieces, and particularly the grave furniture, will ever be revealed in their original splendour.

I have already mentioned the great improvements that took place in the construction of tombs in the Warring States and Han periods. An outstanding example is the tomb of the Marchioness Li Tsang at Ma-wang-tui, near to Ch'ang-sha, which was excavated in 1972,[24] and which was found to contain the most important assembly of lacquerwares of the Han dynasty yet unearthed. In this tomb the coffin, enclosed by three chests in succession, was finally surrounded by a framework of heavy wooden beams carefully jointed together. The framework was packed around with a thick charcoal layer sealed with white clay. Of the three intermediate chests, the two outer ones are decorated with designs of painted lacquer of great distinction. The coffin itself is covered with an unusual fine silk embroidery of a type not previously known and on the coffin was placed a T-shaped silk panel painted with scenes from the nether world of outstanding historical importance. The two outer chests and the many lacquer objects found in the tomb, 184 in all, are still brilliant in their original colours.[25]

The date of the tomb is estimated to lie between the years 174 and 145 B.C. As far as is known, no controlled excavations of lacquer of the types found at Ma-wang-tui earlier than this date have yet been made, except for a few fragmentary pieces, which will be discussed later. However, on a conservative estimate, the lacquer vessels from this tomb are at least a hundred years earlier than the greater part of the imperial lacquerwares of the Han dynasty and they serve therefore as a valuable

[23] Note 2 above (p. 47).

[24] A number of reports on this tomb have already been made. The most important is the two-volumed report published in 1973 entitled *Ch'ang-sha Ma-wang-tui i-hao Han-mu* (Han tomb at Ma-wang-tui, Ch'ang-sha). These volumes, with splendid illustrations, many in colour, and explanatory line drawings, should be consulted by any student who wishes to obtain detailed knowledge of this remarkable tomb.

[25] The third decorated chest, that on the inside, has suffered in burial and much of the original decoration is missing.

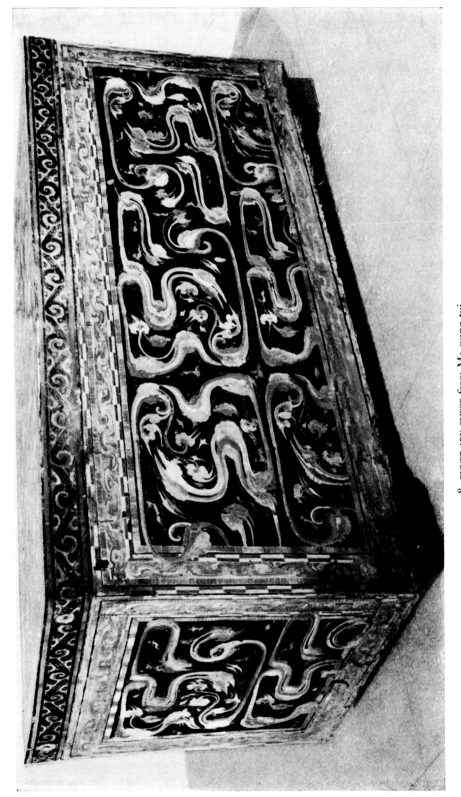

8. FUNERARY CHEST from Ma-wang-tui
Han dynasty

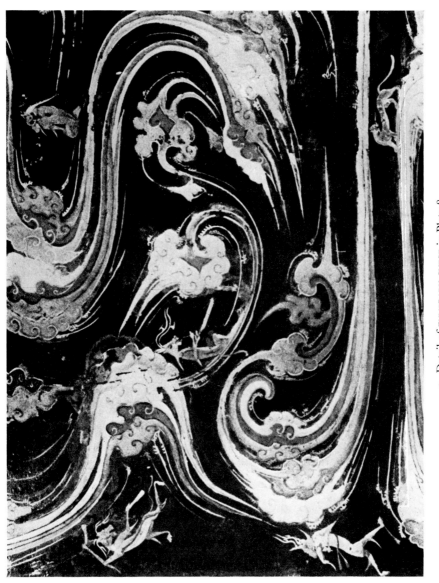

9. Detail of FUNERARY CHEST in Plate 8

background against which the large number of vessels excavated at Ch'ang-sha under uncontrolled conditions may be studied. But before we look at the lacquer vessels, two of the chests surrounding the coffin require special consideration. They are both superbly decorated, the inner one, the middle of the three, on a red ground with interlaced dragons, tigers and other animals and the outside one on a black ground with mythical figures against a background of clouds. It is not possible in this limited survey to illustrate and discuss both chests and the outer one has been selected, firstly because of its human interest and secondly because it can claim to be the finest example of lacquer painting in existence. The chest is shown in Plate 8 and a detail from one of the sides in Plate 9. The swirling clouds, painted in shades of red, yellow, brown and a dull olive green, shading together in broad brush strokes and tapering off in places to the finest of line drawing, show magnificent artistry and craftsmanship, and provide a striking background for numerous mythical animals, some in human form and others in the form of animals and birds.[26] In the detail of Plate 9 there are two dancing figures on the left, one swinging flail-like objects and the other ringing a bell. Another figure, comfortably seated on a cloud, is playing a stringed instrument (*chin*), while his companion, unfortunately just outside the detail illustrated, is playing the pipes (*yü*). The other figures in the illustration are a kneeling bear-like animal, a realistic tiger and a minute bird. There are more than a hundred figures in all represented on the outside of the chest and fifty-seven are described in the report in some detail. The inside of the chest is decorated on a red ground with men and flying horses, but less skilfully than the outside.

The lacquer vessels are in a wide variety of shape, from a large vase of square section (*hu*) down to delicately carved spoons of bamboo. Some of the finest pieces are cylindrical boxes (*lien*), two of which are toilet-boxes with numerous internal fittings, such as cosmetic-boxes and mirrors. A third box was a food container, which when excavated was found to contain biscuits. The two objects illustrated here are a tripod vessel (*ting*) (Plate 10), fitted with a cover and decorated with fine interlacery designs and a small box from the inside of one of the toilet-boxes (Plate 11).

One of the most important features of the very comprehensive report is a detailed discussion of the methods of construction and decoration of the vessels. The three methods of making the body, already mentioned as being used in the Ch'ang-sha lacquerwares excavated earlier and the imperial Han lacquerwares, are all found in the Ma-wang-tui wares. An interesting new point, however, is mentioned in the section of the report dealing with the techniques of decoration. Some of the smaller boxes are partly decorated in oil paint, thought to be derived from *t'ung* oil, and not lacquer. The use of oil paint would enable a greater range of colours to be achieved than would be possible in lacquer and this may explain why it was generally used only for special small objects. This discovery raises the possibility that some of the earlier pieces of the Shang and Chou dynasties may have been decorated, in whole or in part, with oil paints and this may explain why some of these pieces have not

[26] While one cannot be certain that all the colours visible in the excellent colour plates are exact, the variety of colour is very wide and in the descriptions of the animals given in the text there are more than ten different colours mentioned.

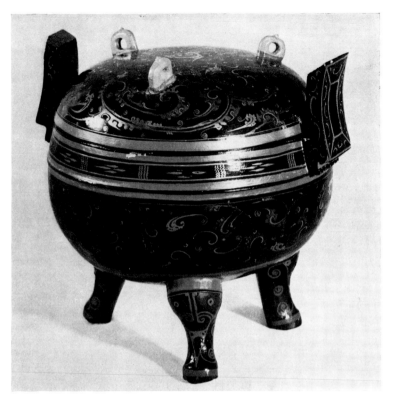

10. COVERED TING from Ma-wang-tui
Han dynasty. Height 28 cm

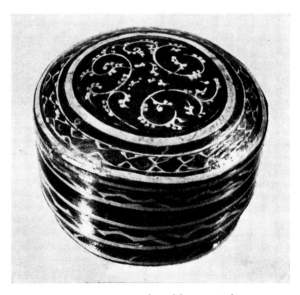

11. COVERED BOX from Ma-wang-tui
Han dynasty. Diameter 9·4 cm

survived. It should be noted that the Ma-wang-tui wares, even when oil paint was used for the decoration, were made with carefully applied lacquer as the base. The report also mentions that incised decoration is used on some of the smaller pieces. The use of incised work is found on other pieces of this period and it is also a feature of the Han imperial wares. I shall return to this type of decoration later.

Mention has been made of the excavation of lacquer fragments that probably belong to an earlier period than that of the Ma-wang-tui tomb. These come from one of a number of tombs in the village of Chu-chin, Anhui Province. A large number of fine bronzes were excavated in the early 1930s from other tombs in this village and one of these is datable to the reign of a Ch'u ruler Yu (237-228 B.C.). A study of the evidence gives strong support to the view that the fragments date from this period. The fragments, probably from the lid of a box, are decorated on both sides with interlaced designs, similar to those on a cylindrical box formerly in the Low-Beer Collection and now in the Museum of Fine Arts, Boston.[27] The top of the box is shown in Plate 12. It has long been described as 'the laughing dragon box'. The main subject of decoration is a complex arrangement of an open-mouthed dragon scratching its neck with its right foot. The box is in poor condition and none of the inside decoration which it almost certainly had originally has survived. But the outside decoration is in good state and reveals a liveliness and skill in design which is unsurpassed in the known vessels of painted lacquer. No pieces from the Ma-wang-tui tomb, except the two superb chests already mentioned, are quite of this quality. While we cannot be sure that the box belongs to the same period as the fragments from Chu-chin, the attribution given by Fontein and Wu to the third century B.C. seems to be reasonable.[28] This would bring it just into the Warring States period.

A still earlier date for painted lacquerwares with interlacery decoration has been established from excavations made in 1972. Particulars of these came to light after the present chapter had been drafted and it must be expected that further evidence will emerge which will call for revision of anything that can be written today on lacquer development between the Shang and Han dynasties. The recent excavations, of two tombs at Fen-shui-ling, Ch'ang-chih, Shansi Province, have brought to light interlacery designs which are described in a recent report.[29] The tombs have been dated to the fifth century B.C. and establish a date for the introduction of these designs on lacquer more than a hundred years earlier than any previously discovered. Moreover, the main contents of the tombs were of bronze vessels with interlacery designs, providing a significant association of design in the two media.

The fact that the location of the site of the Fen-shui-ling tombs is in Shansi, not far from Anyang, raises the question as to whether interlacery designs originated in Shansi and were afterwards transferred to South China. The possibility that the lacquerwares excavated at Fen-shui-ling were actually made in the south cannot be entirely ruled out and indeed some very recent discoveries of inscribed pieces excavated in the Ch'ang-sha and Chiang-ling areas suggest that they were actually made in Szechwan, nearly as far away from Ch'ang-sha as Anyang. On the whole the

[27] See Jan Fontein and Tung Wu, note 16 above, for a full discussion of this box. The excavated fragments are described in *Wên-wu*, 1955, No. 12, pp. 107–14.

[28] Loc. cit.

[29] *K'ao-ku hsüeh-pao*, 1974/2, pp. 63–85.

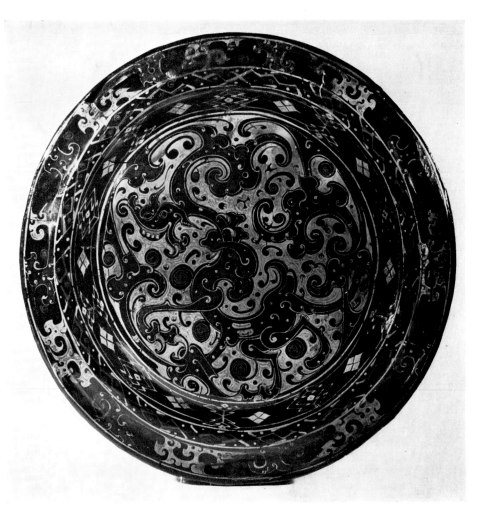

12. COVER of cylindrical box
Warring States period. Diameter 26·5 cm
Museum of Fine Arts, Boston

probability seems to be that the Fen-shui-ling wares were made in the area in which they were found. But it is becoming more and more clear that the manufacture of the painted lacquerwares of the Warring States and Han periods was spread over a wide area of China. Nevertheless, Ch'ang-sha, which has been a name to conjure with ever since the first discoveries of lacquer were made there in the 1930s, will almost certainly remain one of the most important centres of manufacture of these wares. The Ma-wang-tui finds alone, and particularly the mangificent funerary chests, which could hardly have been made far from the site, are sufficient to ensure this.

Lacquerwares in similar style to those found at Ma-wang-tui continued to be made throughout the Han dynasty, during which a number of imperial factories were set up, three of which were devoted to the manufacture of lacquerwares.[30] Two of these, in Szechwan, can be identified by incised inscriptions on the bases. These are not equally comprehensive, but according to a survey made by Umehara thirty-five of them bear, in addition to the date of manufacture, which ranges from 85 B.C. to A.D. 102, the names of the factories where they were made.[31] All but four came from the Western Factory of the Shu Commandery near Cheng-tu or the Kuang-han Factory some thirty miles away. The third factory, at Ho-nei in Honan Province, is only known through the literary sources, but there is no reason to doubt its existence.

The wide range of manufacture of lacquer covered in the Han dynasty, from Cheng-tu in the west to Ho-nei in the north and Ch'ang-sha in the south, shows how important lacquer manufacture was in the Han civilization. The areas over which the lacquerwares were distributed were even more widespread. Lacquer objects, some of them fragmentary, have been excavated at Lolang and other sites in Korea, an important outpost of the Han Empire, Noinula in Northern Mongolia and even as far afield as Begram in Afghanistan. It is impossible at present to identify the places of manufacture of the lacquerwares, except for the pieces from the imperial factories with inscriptions and others closely resembling them. But it may be noted that some of the imperial wares are decorated in a distinctive style not found in the normal wares that we associate with Ch'ang-sha, in which broad brush strokes replace the finer and more fluent strokes as seen, for example, in the vessels from Ma-wang-tui (Plates 10 and 11). An eared cup in the British Museum (Plate 13), decorated in imperial style, is typical of one group made at the Western Factory. It is described in great detail by Watson.[32] It bears an inscription of sixty-seven characters which gives, in addition to the name of the factory and the date of manufacture, corresponding to A.D. 4, a detailed description of the cup, with particulars of the manufacture at each stage and the names of the craftsmen responsible. In addition, the names of the inspector of the piece and of the various officers responsible for the organization of the factory, including even the clerk

[30] See O. Maenchen-Helfen, 'Zur Geschichte der Lackkunst in China', *Wiener Beiträge zur Kunst- und Kulturgeschichte Asiens*, 1937, pp. 62–4, for an account of the early history of lacquer in China.

[31] Umehara, Sueji *Shina Kandai Kinemei Shikki Zusetsu*, 1943.

[32] W. Watson, 'Chinese lacquered wine cups', *British Museum Quarterly*, Vol. XXI, 1957, pp. 21–5.

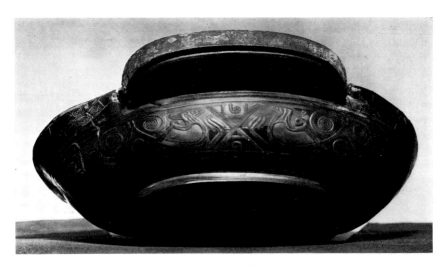

13. OVAL EARED CUP with gilt-bronze mounts
Han dynasty. Length 17·5 cm
British Museum

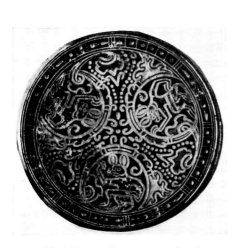

14. Medallion on lacquer DISH showing
incised designs
Han dynasty
*Asian Art Museum, San Francisco,
Brundage Collection*

15. Detail of COVERED BOX showing incised designs
Han dynasty
Formerly in Low-Beer Collection

responsible for recording the manufacture, are recorded. It is doubtful whether this detailed account of mass production methods can be matched in the history of manufacture of artifacts in the ancient world.

There is one unusual point in the inscription to which Watson draws attention. The reference to the incised work on the cup is placed before that of the painting. This may relate to the inscription, but it now seems more likely that it refers to preliminary work intended to assist the painter in his decoration. There is no direct evidence of preliminary incised designs on the cup, but a large dish in the Brundage Collection dated A.D. 1 illustrates it. Incidentally the Brundage dish also has the reference to incised work placed before that to the painting. The central medallion of the dish, shown enlarged in Plate 14, is also, like the cup, painted in broad brush strokes, with three bear-like animals in separate roundels. The style is somewhat different in detail from that of the cup—it may be relevant that the dish was made at the other Szechwan factory, Kuang-han—a feature being the use of a linear arrangement of heavy dots for part of the design. The ring around the central medallion has been incised and clearly was intended to divide the design into six segments, each separated by three radial lines. Three alternate segments of the ring are further subdivided by wavy radial lines into compartments, each enclosing one dot, while the other three have an arrangement of lozenges and dots. The use of incised lines is one more example of advanced production methods. It is possible that other guide lines than those visible were used but are hidden under the heavy brush strokes.

Mention has been made of the use of incised decoration in some of the pieces from the Ma-wang-tui tomb. Some of this is in a more advanced form than that in the Brundage dish, but an example of the use of incised work as part of the decorative design was described by Low-Beer as long ago as 1948. This important account, which appears to have been overlooked by modern writers, describes in some detail incised decoration of birds and animals on a cylindrical box said to have been excavated at Ch'ang-sha.[33] The box, when excavated, was in a wet state and when it reached Low-Beer it had dried out and had disintegrated badly. Fortunately it had been photographed while still in its former state and his very careful account is based on the original photographs and his later observations of the box. The decoration of the inside and sides of the box was of painted lacquer, very much like that on some of the boxes from Ma-wang-tui, but that of the cover, of cloud-scrolls, birds and animals, had a good deal of incised decoration. Some of this is like that on the Brundage dish, in which circular and radial lines provide a framework to the painted designs, but in addition birds and animals, three of each, were also incised. A drawing of one of the birds, based on the original photograph, is reproduced in Plate 15. The thin lines defining the outline of the bird are incised and the dark patches, in slightly raised red lacquer, add the necessary details. The cloud-scroll pattern, indicated within dotted lines, forms the background to the main design of birds and animals which is superposed over them. The cloud-scrolls, now in a faded greyish-blue, were probably originally depicted in yellow. It may be said

[33] Fritz Low-Beer, 'Two lacquered boxes from Ch'ang-sha, II', *Artibus Asiae*, Vol. XI/4, 1948. Another example of the incised techniques is described in *Wên-wu*, 1957, No. 7.

that, even here, the incised decoration plays a subordinate part as a basis for the painted work.

Similar examples of incised work have been discovered much later, in the Ma-wang-tui and other tombs, but it was never developed further than it appears in Plate 15. The incised decoration is discussed here at some length because of its resemblance to the *ch'iang-chin* decoration introduced in the Yüan dynasty, which is however quite different in style and technique, depending entirely upon the gold filling of the incised work for its effect. This is discussed in Chapter 8.

The use of metal inlays, generally in a silver alloy, to supplement painted decoration, seems to have been introduced in the first half of the Han dynasty. A typical example of this decoration is seen in the toilet-box in the British Museum (Plate 16). The painted scrollwork, which can be identified as clouds or mountains, provides the background for mythical animals. Some of these animals, on the cover, were originally inlaid in silver foil, but most are now missing. The linear painting on the box is similar to that on the Ma-wang-tui wares and it is possible that the box was made in Ch'ang-sha. It is said to have come from a tomb in Hai-chou, Kiangsu Province and it is ascribed to the first century B.C. The use of inlays, in a different style, in which gold as well as silver were used, came into vogue in the T'ang dynasty, as we shall see later.

Before we leave the Han wares, we must refer to one of the most famous, the so-called 'painted basket', excavated at Lolang in Korea in 1931. It is decorated in red, black and yellow lacquer applied to a basketry ground with ninety-four figures illustrating the classic Han repertory of paragons of filial piety, ancient worthies and rulers. Many of the figures are identified by the names written beside them. Until recently, this was one of the earliest examples known of figure painting in China, but earlier examples have been found in recent excavations in China.[34]

After the collapse of the Han dynasty there has been, up to the present, little evidence of the manufacture of lacquerwares until we come to the T'ang dynasty. But the small group of panels recently excavated at Ta-t'ung, Shansi Province, datable to the Northern Wei dynasty (386-585), decorated with ladies at various pursuits accompanied by their attendants, is of fine quality and suggests that there was a continuity of manufacture of painted lacquer in the tradition of the 'painted basket' from the end of the Han to at least the Northern Wei dynasty.

There was a great revival in the manufacture of lacquer in China during the T'ang dynasty, when a number of new types were introduced. The most important of these were the inlaid wares, in which designs in mother-of-pearl or gold and silver foil were set in a bed of black lacquer. The number of pieces that have survived is small. Most of them are bronze mirrors and the attachment of the lacquer to the metal base was never very secure, so that most of them have suffered badly through burial. Apart from their intrinsic excellence, these inlaid wares were of supreme importance because the introduction of lacquer to Korea and Japan in the sixth century led to the manufacture in these countries of lacquerwares based on the Chinese. The Japanese soon developed techniques of their own, particularly in

[34] A notable example is the T-shaped silk banner excavated at Ma-wang-tui with scenes from the nether world, which must be more than a hundred years earlier than the 'painted basket'.

the mother-of-pearl wares. They added decoration in painted gold lacquer, which became the basis of the finest Japanese lacquerwares down to the present time.

Many of the early inlaid wares in mother-of-pearl made in Japan used resins and not lacquer as an adhesive and these have survived in good condition, especially in the Shōsō-in. Discussion of these wares, which after the first few years were less and less influenced by China, is outside the field covered by this book. From the point of view of the development of the Chinese and Korean lacquerwares, the T'ang mother-of-pearl wares, as the forerunners of the Korean Koryŏ wares and the Chinese Yüan and Ming wares, are extremely important, although, as we shall see in the chapter dealing with the mother-of-pearl wares (Chapter 11), the lines of development are not easy to follow. The lacquerwares inlaid with gold and silver foil appear to have come to an abrupt end in the T'ang dynasty. In spite of this they are, in view of their superb quality, worthy of a brief description here.

As I have said, most of the artifacts inlaid with metal foil were mirrors. The technique was a Han one (see the toilet-box in Plate 16 as an example), but the T'ang decorative treatment is quite different. The T'ang designs of scrollwork, growing plants and animals closely resemble those of T'ang silverwares, where the designs are generally in *repoussé*. There are fine examples of mirrors in both Japanese and Western collections. The finest piece surviving today is not a mirror, but an eight-lobed mirror-case, in the Shōsō-in, inlaid in silver foil with phoenixes set against a most elaborate background of scrollwork.[35] A fine mirror in the Freer Gallery of Art, inlaid in gold and silver foil with phoenixes and growing plants, is shown in Plate 18. As I have pointed out, many of the inlaid mirrors have disintegrated through burial. This explains why so many excavated pieces of gold and silver foil, delicately incised, as well as scrollwork, are to be found in Western and Japanese collections.[36]

The Chinese term for this type of decoration is *p'ing-t'o* (Japanese *heidatsu*), a term first used in the T'ang dynasty. A begging-bowl in the British Museum is a rare example of *p'ing-t'o* applied to a curved surface.[37] It is decorated in a broader style than that found in the mirrors and most of the T'ang silverwares, with simple lotus motifs, appropriate for a begging-bowl (Plate 17). The survival of this bowl can be ascribed to the lacquered fabric base that supports the silver foil. Another piece inlaid on a curved surface is a ewer in the Shōsō-in, with a body of basketry,

As for the mother-of-pearl lacquerwares, the number of pieces found in China, up to the present, is even smaller than that of pieces decorated in gold and silver foil. Most of them are in poor condition.[38] On the other hand, there is a relatively large number of artifacts in the Shōsō-in and other Japanese temples. Unlike the pieces in Japan inlaid with metal foil, which are nearly all Chinese, it would seem that most of the pieces inlaid with mother-of-pearl are Japanese, although Japanese experts are reluctant to express an opinion on this point. Certainly the use of resin

[35] Beatrix von Ragué, *Geschichte der Japanischen Lackkunst*, 1967, Plate 6.

[36] As, for example, we find in the Kempe Collection. See Bo Gyllensvärd, *Chinese Gold and Silver in the Carl Kempe Collection*, 1953, Nos. 43 and 123.

[37] William Watson, 'Overlay and *p'ing-t'o* in T'ang silverwork', *Journal of the Royal Asiatic Society*, 1970.

[38] Two examples are illustrated by Soame Jenyns, *Chinese Art. The Minor Arts*, II, Nos. 153 and 154.

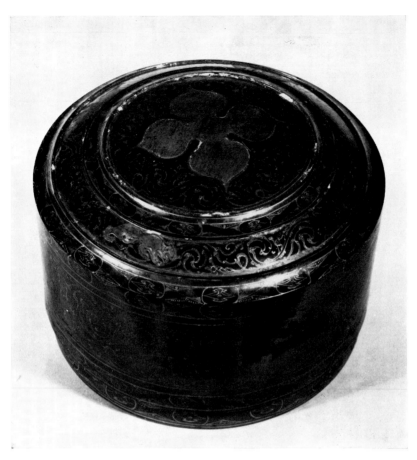

16. TOILET-BOX with inlaid silver
 Han dynasty. Diameter 20·8 cm
 British Museum

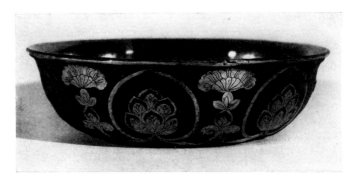

17. BOWL, inlaid silver on lacquer bed
T'ang dynasty. Diameter 10·8 cm
British Museum

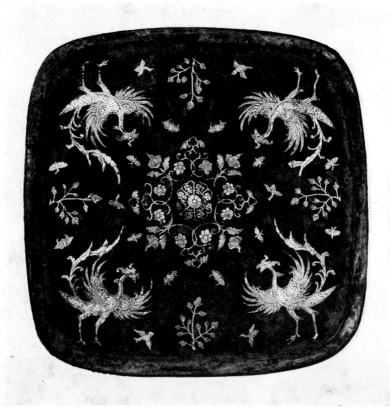

18. BRONZE MIRROR, inlaid gold and silver on lacquer bed
T'ang dynasty. Width 15·9 cm
Freer Gallery of Art

adhesives and the practice of inlaying into the wood itself, found in many of the musical instruments in the Shōsō-in, seems to have had no counterpart in China. Dr. von Ragué points out that the Japanese consider that the technique of mounting the mother-of-pearl in resin was derived from Annam and Thailand during the T'ang dynasty. This possibility seems to me to be remote.

A brief reference should be made to Buddhist figures built up on a fabric base by the 'dry lacquer' process. We have seen that the use of fabric impregnated with lacquer as a base was introduced for vessels round about the third century B.C. Its use for the construction of Buddhist figures, some as large as life size, involving the manufacture of a wooden or clay core round which the fabric was fashioned, was introduced in China as early as the sixth or seventh century A.D. A seated figure in the Metropolitan Museum, New York is thought by Sickman to belong to the late sixth century.[39] Such figures of Chinese manufacture are rare, although they were probably made in some numbers. Japanese figures known today are more numerous. An early eighth-century example, in the Kōfuku Temple, Nara, is illustrated by von Ragué,[40] who mentions that earlier figures, made in the seventh century, are recorded in the Japanese literature. At a much later date, from the tenth to the thirteenth century, a large number of life-size models of Buddhist Lohans were made in China, both in pottery and lacquer. The pottery models are in much better condition than the lacquer ones, but three of the latter, two with the head only preserved, are known.[41]

One other type of lacquer that originated in the T'ang dynasty or earlier should be mentioned. Carved lacquer, in a primitive form, was made as a covering to armour. This lacquer, in which a number of layers of different colours are superposed, was destined to lead the way to true carved lacquer as it is known today, which reached its highest perfection in the early Ming dynasty. The T'ang carved lacquer is best considered as part of the general development of carved lacquer and it is therefore dealt with at length in Chapter 5.

A large amount of lacquer belonging to the Sung dynasty has been excavated in recent years from tombs in China. All the lacquerwares are vessels in simple form, generally in black or dark brown, without surface decoration. They resemble in form the more simple of the Sung ceramic wares and particularly the Ting white wares, which appealed so much to the connoisseurs of the period.

It is unlikely that the types of lacquer that were popular in the T'ang dynasty, such as the pieces inlaid with silver, gold and mother-of-pearl, and even the newly invented carved lacquer, were completely abandoned in the Sung dynasty, but the fact that up to the present no lacquerwares in these techniques have been discovered in Sung tombs, among the hundreds of pieces excavated, seems to show that there was little interest in the decorated wares among connoisseurs and wealthy collectors. A study of the *Ko-ku yao-lun* of 1388 shows that, even at this late date, interest was still in the refined and simple undecorated wares in all types of artifact. For example, Chinese collectors had no interest in the decorative blue and white porcelain that had been made in large numbers for the previous sixty or seventy years. In lacquer,

[39] L. Sickman and A. Soper, *The Art and Architecture of China*, 1956, p. 101.
[40] Note 35 above, p. 6, Plate 3.
[41] Note 39, above, pp. 101–2, Plates 80B, 81A, 82.

we may be sure that some decorative objects were made, but they were not of sufficient importance to be buried in the tombs of the wealthy classes. But a few such objects may be expected to come to light during the extensive excavations taking place in China today.

The Sung and Yüan monochrome lacquerwares that have been excavated in China during the last forty years, and particularly during the last twenty, when the excavations have been carefully controlled, have been fully described by Hin-cheung Lovell.[42] Many of the pieces are inscribed, some with the cyclical date and some with the place of manufacture. The information derived from some 200 pieces gives a comprehensive account of the manufacture of lacquer in the Sung dynasty. The wares are mostly datable to the eleventh and twelfth centuries and they were made in factories situated generally in the lower reaches of the Yangtse River. The places mentioned in the inscriptions include Ch'ang-sha in Hunan Province, Hang-chou and Wen-chou in Chekiang Province, Chiang-ning Fu (the present Nanking) in Kiangsu Province and Hsiang-chou in Hupei Province. There is no reason for accepting the view, based on the similarity of the lacquerwares in form to the Ting white ceramic wares, put forward by some writers, that lacquerwares were made in the neighbourhood of the Ting-chou kiln sites, which was probably too cold for the cultivation of the lacquer tree. Hin-cheung Lovell points out that in a work published by Mêng Yuan-lao in 1147, which gives a street-by-street description of the Northern Sung capital Kai-feng, there is a reference to a shop selling lacquerwares from Wen-chou, some six hundred miles away, so that there is no reason why, in reverse, the lacquerers in the south should not have been familiar with the Northern Sung ceramic wares.

Three examples of Sung lacquer are shown in Plates 19, 20 and 21. The beautiful tiered six-lobed box in Plate 19 is meticulously made, with a closely fitted lobed tray and a lobed box in the interior.[43] The bowl-stand in Plate 20 can be matched in shape by bowl-stands in Ju ware, as well as by southern Chinese and Korean celadons. It bears an inscription attributing the manufacture to Ch'ang-sha and with a cyclical date corresponding to 1094. If this piece was excavated at Chu-lu hsien, as it is said to have been, it had travelled some six hundred miles from its place of origin. The third piece, a seven-lobed black dish with overlapping petals (Plate 21), is thought to be later than the other two, probably belonging to the early Yüan dynasty.[44]

[42] Ref. E40. This work gives full particulars of all the Chinese excavation reports.
[43] A very similar box to that in the interior of the box in Plate 19 was excavated at Shih-li P'u in Hupei Province (see note 42 above, Plate 5).
[44] A seven-lobed dish in the Freer Gallery of Art is also attributed by Hin-cheung Lovell to the Yüan dynasty (note 42 above, Plate 13).

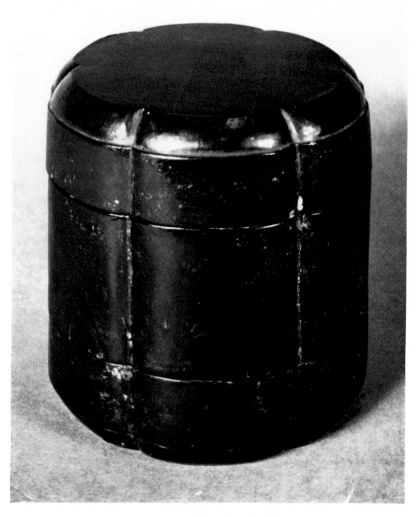

19. TIERED LOBED BOX with interior lobed box and tray
Sung dynasty. Diameter 16·4 cm
Victoria and Albert Museum

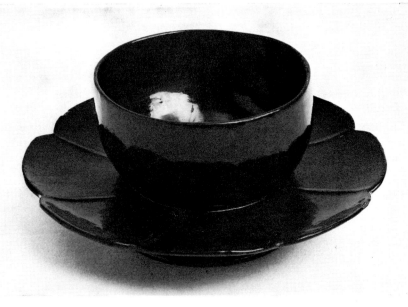

20. BOWL-STAND with foliated flange
Sung dynasty. Diameter 14 cm
Victoria and Albert Museum

21. FOLIATED DISH with overlapping petal design
Yüan dynasty. Diameter 15 cm
Victoria and Albert Museum

CHAPTER 4

The Chinese Literature

The references to lacquer in the Chinese literature are very extensive, comparable in scope with those on ceramics. This book is concerned mainly with lacquer dating from the Yüan to the Ch'ing dynasty, and earlier references than Yüan are not discussed unless they are of special significance in relation to the later lacquerwares.

The literature on the later wares may be divided into four categories:

1. Literature written by connoisseurs or experts on lacquer.
2. Official records of the imperial court.
3. Gazetteers of districts in which lacquer was manufactured.
4. Modern reports of excavations in China.

By far the largest amount of information available at the present time, for the period that concerns us, comes from literature in the first category. This is often unreliable, as we shall see, and it will need very close scrutiny, which it is the main object of this chapter to provide, to sort out the wheat from the chaff. The literature in the other three categories provides factual information which can be accepted as accurate, with some reservations. This kind of information will generally be presented as it becomes relevant during the discussions of various types of lacquer. But a short survey here, before we come to the main discussion of the literature in category 1, is desirable.

The official records of the imperial court, based on day-to-day accounts, provide useful material which relates directly or indirectly to lacquer. The most important account of the records of the Ming dynasty has been given by Wolfgang Franke,[1] who lists more than eight hundred works, quite apart from local histories. Some of the records are of enormous length, the *Ming shih lu*[2] for example covering twenty reigns and consisting of nearly 3,000 *chüan*. The references to lacquer in these records naturally occupy only a minute proportion of the whole and they only occur incidentally, as for example in accounts of gifts to foreign countries, so that a very close scrutiny indeed is needed if they are not to be overlooked.

The day-to-day records, preserved in manuscript, can be divided into various categories, such as biographies, memorials, political institutions and foreign affairs. The official histories are often divided into sections based on these categories. The *Ming-shih*,[3] for example, the most comprehensive of the standard histories, has 200 *chüan* devoted to biographies out of a total of 332 *chüan*.

[1] Wolfgang Franke, *An Introduction to the Sources of Ming History*, 1968.
[2] 明實錄 [3] 明史

53

The *Ming shih lu*, the 'Veritable Records of the Ming dynasty', are the earliest records that have been transmitted as a whole to our times. The day-to-day records were brought together at the end of each reign and two manuscript copies were prepared, of which one was sealed and placed in the Imperial Historical Archives and the other kept for reference by the Grand Secretariat. To ensure secrecy all the drafts and preliminary copies were destroyed in the presence of the compilers. The 'Veritable Records' were kept secret until the late sixteenth century, when duplicate copies began to be made. These formed the basis for the printing of the *Ming-shih kao*,[4] the 'Draft Ming History', compiled in 1679 and the *Ming-shih*,[5] the official history of the Ming dynasty, completed in 1739. The latter is regarded as the most reliable of all the Ming histories by scholars today.

Much useful information on lacquer comes from a study of the biographies of famous men and in this connection the work done by the Ming Biographical History Project at Columbia University, under the editorship of Professor L. Carrington Goodrich, is of great importance. For example, the history of the erection of buildings in Peking during the reigns of Yung-lo and Hsüan-tê, deduced largely from the biographical work, gives valuable, if negative, information on the possibility of manufacture of lacquer in Peking in these two reigns. The long-held view that the so-called Kuo Yüan[6] factory was responsible for the manufacture of imperial lacquer in the early fifteenth century is completely discredited. This is discussed more fully later on in this chapter. Another important piece of evidence that has come from biographical studies relates to Yang Hsüan,[7] who became an important political figure in the reign of T'ien-shun (1457-65). Yang in his younger days was a celebrated lacquerer, but it is doubtful if information on this point would have survived had it not been for the importance of his subsequent career.[8]

But the most important information on Chinese lacquer, particularly in the fifteenth century, has come from Chinese official documents which have been handed down in Japan and have not been found, up to the present, in any of the Chinese official histories. The Japanese records include many of the edicts sent by Chinese emperors to Japan and, more important for our studies, lists of objects, including lacquer, sent as gifts. There are lists for nine years ranging from 1403 to 1464, of which those for five years ranging from 1403 to 1434 contain lacquer objects. They have been fully recorded by Makita[9] and are by far the most important lists. There are shorter lists from Chinese sources, particularly from the *Ming-shih kao*. The reason why many lists have only survived in Japan is not difficult to understand. The Chinese edicts, to which the lists of gifts were attached as appendices, were concerned with matters of prestige, with emphasis on the desire that

[4] 明史稿

[5] Note 3 above.

[6] 果園

[7] 楊塤

[8] For further information on Yang Hsüan, see Chapter 9, where the view that he was responsible for making the earliest 'filled-in' lacquer is put forward.

[9] T. Makita, *Sakugen-nyumin-ki no kenkyu* (A study of Sakugen's visit to Ming China), Kyoto, 1959, Vol. I, pp. 333-50.

Japan should pay tribute to China and acknowledge China as overlord. The edicts proper in the early Ming dynasty were concerned almost entirely with this aspect and the failure of the Japanese to deal sternly with the pirates who continually interfered with Chinese trading ships. The edicts are generally recorded fully in the Chinese histories, the gifts, no doubt regarded by the Chinese as of secondary importance, being omitted. The Japanese, on the other hand, regarded the lists of treasured and decorative objects as of great importance. They have generally been handed down in the form of copies, but at least one of the original documents, that for 1407, has survived.[10]

A comprehensive account of the official relations between China and Japan in the early Ming dynasty is given by Wang Yi-t'ung,[11] with many references to Japanese as well as Chinese sources. Another useful reference for the Western reader is a book by Yoshi S. Kuno, which looks at the relationship from the Japanese point of view.[12]

Very little attention has been given up to the present to the gazetteers which describe the activities of the prefectures in China concerned with the manufacture of lacquer. There is an enormous number of gazetteers, generally issued at irregular intervals, giving information on every aspect of the prefecture, on its history, geography, with long accounts of lakes and waterways, famous buildings and temples, steles and inscriptions, natural products and industries. Generally there seems to be little information on industries, but in the *Fou-liang hsien chih*[13] there are important accounts of the manufacture of porcelain at Ching-tê Chên, including lists of types of porcelain made for the court in the reign of Chia-ching from the eighth year onwards (1529). Bushell gives the full accounts for the years 1546 and 1554,[14] comprising many types, in numbers exceeding 100,000. Nothing of this kind has come to light on lacquer, although it is known that the district of Hsi-t'ang in the prefecture of Chia-hsing was noted for the manufacture of lacquerwares. In the fourteen surviving issues of the gazetteer *Chia-hsing fu chih*[15] ranging from 1492 to 1900, nothing on lacquer has been discovered so far except for some doubtful information which first appears in the issue dated 1610.[16]

The information that has come to light in recent years from controlled excavations in China has transformed our knowledge in many fields of Chinese art. In lacquer, in particular, much information has come on the early wares, as is apparent from the brief discussion of the wares in Chapter 3. On the later wares, the main subject of this book, there is much less information to be derived from tombs. Nevertheless, a few pieces of lacquer belonging to the fourteenth and fifteenth centuries have been excavated which have an important bearing on the development

[10] John Figgess, 'A letter from the court of Yung-lo', *Transactions of the Oriental Ceramic Society*, 1962–3, Vol. 34.

[11] Wang Yi-t'ung, 'Official relations between China and Japan, 1368–1549', *Harvard-Yenching Institute Studies*, IX, 1953 (Ref. E18).

[12] Yoshi S. Kuno, *Japanese Expansion on the Asiatic Continent*, 1937 (Ref. E 13).

[13] 浮梁縣志

[14] *Oriental Ceramic Art*, 1899, pp. 223–6.

[15] 嘉興縣志

[16] Reproduced in *Ch'i-shu* (Ref. C1, p. 62b) and discussed later in this chapter.

of the post-Sung wares. Much of the information is to be found in issues of the two journals, the *Wên-wu*[17] and the *K'ao-ku*,[18] supplemented by special reports on particularly important excavations. These are too numerous to be mentioned in the Chinese Bibliography, but they will be mentioned in the text where relevant to the matter under discussion.

We now come to the literature written by connoisseurs and experts on lacquer, which varies greatly in quality and reliability. The amount produced during the Ming and Ch'ing dynasties is very large and we are fortunate that two surveys have been made of the literature, which makes the task of students today much easier than it would have been without them. The first was produced by Soame Jenyns in 1939[19] and the second was published by Chu Ch'i-ch'ien in 1957.[20] But the first important early Western contribution on the Chinese literature came from Bushell as long ago as 1899. The chapter in his *Oriental Ceramic Art*[21] entitled 'Chinese Bibliography in relation to the Ceramic Art' mentions no less than fifty-five works on art, mostly devoted to ceramics, but including the *Ko-ku yao-lun*,[22] the *Ch'ing pi-ts'ang*[23] and the *Po-wu yao-lan*,[24] all with information on lacquer. His translation of the lacquer section of the first named has had a profound impact on Western students of Chinese lacquer.[25]

Jenyns discusses some thirty Chinese works on lacquer, mostly written in the Ming dynasty, and it is a comprehensive treatment for the time (1939), including notes on almost every important Ming work on lacquer known today. But, as one might expect, the author was not fully conversant with the contents of some of the works and for one of the most important, the *Hsiu shih lu*,[26] only the title is mentioned.

Chu Ch'i-ch'ien's book, the *Ch'i-shu*, consists entirely of extracts without comments from more than a hundred works, mainly belonging to the Ming dynasty. It is an extensive work of more than 80,000 characters and the extracts from some of the works extend to a number of pages. This is an essential work for all students of Chinese lacquer, and it is unfortunate that it is not readily available.[27] It is far more comprehensive than Jenyns' survey, but much of the additional information is not of major importance. Included among the works by connoisseurs are a few extracts from official records and these are of special interest.

The summaries of Chu and Jenyns, valuable as they are, only provide a framework for the next stage, a critical examination of individual works. This is a formid-

[17] 文物

[18] 考古

[19] Soame Jenyns, 'Chinese lacquer' (Ref. E14).

[20] *Ch'i-shu* (Ref. C1).

[21] In his *Description of Chinese Pottery and Porcelain, being a Translation of the T'ao Shuo*, 1910, he gives 103 references, but many of these are historical, with only an incidental association with art.

[22] Ref. C2. [23] Ref. C9. [24] Ref. C14.

[25] S. W. Bushell, *Chinese Art*, I, 1904.

[26] Refs. C6, C7.

[27] See Bibliography, C1. Although actually written in 1925-6, it was not printed until 1957.

able problem, but one made easier by the fact that a large number of the works are of limited value so that they can, after a brief study, be put on one side. The problem is similar to that faced by students of Chinese ceramics in the past and a great deal can be learnt from the earlier studies of the Chinese texts in the ceramic field.

The first important critical studies of the Chinese literature on ceramics was made by Sir Percival David in 1937, in connection with a comprehensive account of the Sung Ju wares.[28] He examined seventy Chinese books containing references to these wares and found that the information in many of them was unreliable. He pointed out that 'there is still an uncritical and almost indiscriminate acceptance of the Chinese texts.' He discussed the various texts in detail, making many caustic comments on the reliability of particular authors. John Pope, in his studies of blue and white porcelain, followed this up in 1956 with severe comments on many of the early Chinese connoisseurs, rightly dismissing many of them as dabblers in a great variety of subjects, with no qualifications for writing on ceramics.[29]

Although John Pope in 1956 was somewhat pessimistic as to whether Sir Percival David's warning on the critical acceptance of the Chinese texts had borne much fruit, there can be no doubt that scholarship in Chinese ceramics today is at a reasonably high level and that the Chinese texts are more critically assessed than they were when Sir Percival David first sounded his note of warning. At any rate, I myself would be well satisfied if the standard of scholarship in Chinese lacquer approached that which has been reached in Chinese ceramics.

The importance of contemporary evidence has been discussed by many writers on Chinese art, but it cannot be stressed too often that the reliability of any evidence is rapidly weakened as the time interval between the event described and the date of the description increases. In this survey I have generally taken the view that evidence more than a hundred years out of date should not be accepted without some confirmation from contemporary accounts.

The difficulties arising from the assessments of evidence from the Chinese literature can best be dealt with in the discussions of particular types of lacquer and they are generally discussed in this book in the appropriate chapters. But it seems worth while to consider here in detail what is probably the most important and at the same time the most controversial problem in Chinese lacquer, the early history of the carved lacquerwares, which reached their greatest heights in the first half of the fifteenth century. They are based in the main on the most important work on lacquer of the early Ming dynasty, the *Ko-ku yao-lun*, published in 1388.

The complete reference in the *Ko-ku yao-lun* to carved red lacquer (*t'i-hung*)[30] is given below. The translation differs in some respects from that given by Sir Percival David[31] but the alterations have been made after discussion with many

[28] Sir Percival David, 'A commentary on Ju wares', *Transactions of the Oriental Ceramic Society*, Vol. 14, 1936–7.

[29] John Pope, *Chinese Porcelains from the Ardebil Shrine*, 1956.

[30] 剔 紅

[31] *Chinese Connoisseurship* (Ref. E33). The most important alteration relates to the interpretation of the term *Yang-hui*. A study of this term both in the *Ko-ku yao-lun* and the *Cho-kêng lu* strongly supports the view that Yang-hui was a place and not a person. It is a coincidence that the character *Yang* in Yang-hui is identical with that in Yang Mao.

Chinese scholars and I think would be generally approved. The passage reads:

> Carved red wares, whether old or new, must be judged according to the thick-ness of the vermilion, the fresh red colour and its strength and weight. Those carved with patterns of sword rings and spiral scrolls are particularly fine. The pieces with a yellow ground on which are carved landscapes with figures, or flowers, birds and animals, although the work is of the finest, are liable to break off. The thin vermilion wares are cheap.
>
> Many of the lacquer pieces of the Sung imperial court were done in unadorned gold or silver.
>
> At the end of the Yüan dynasty Chang Ch'êng and Yang Mao, from Yang-hui in Hsi-t'ang, were famous for their carved red ware. But very often the vermilion lacquering of this ware is thin and not strong, and is apt to flake off. Carved red lacquer is greatly favoured by peoples of Japan and the Liu Ch'iu Islands.

We know from other references in the *Ko-ku yao-lun*, as well as in the *Cho-kêng lu*, published in 1366,[32] that the village of Hsi-t'ang was in the prefecture of Chia-hsing, in the Province of Chekiang. It was situated some sixty miles north-north-east of Hangchow.

The *Ko-ku yao-lun* is the only source of contemporary or near-contemporary information that has come to light from Chinese literary sources on carved lacquer of the fourteenth century. The *Cho-kêng lu* does not refer specifically to carved lacquer, but it provides information on *ch'iang-chin*[33] lacquer which is consistent with that in the *Ko-ku yao-lun*. The latter work has been quoted time and again in later Chinese works with and without acknowledgement, often with the original brief accounts expanded by the addition of new material for which there is no justification.

As we are so dependent on the *Ko-ku yao-lun* for our basic information on four-teenth-century lacquer, it is vital that it should be critically studied. A preliminary assessment of the work, limited to ceramics and lacquer, suggests that the author Ts'ao Chao, when he is dealing with contemporary objects that he had seen and handled, is very reliable.[34] In the field of carved red lacquer, comparisons with contemporary information derived from records preserved in Japan support this view.[35] The remarks on the popularity of Chinese lacquer in Japan are incidentally confirmed. Finally, the excavation in China in 1953 of a carved red lacquer incense-box from a tomb in Kiangsu which, from the archaeological evidence, cannot be later than 1351,[36] provides additional evidence on the reliability of the work. In fact, every piece of evidence that has come forward recently on fourteenth-century carved lacquer is consistent with the account in the *Ko-ku yao-lun*.

The only part of the account of carved red lacquer on which doubts can be cast is the sentence referring to Sung lacquer. This, referring to lacquer that was made

[32] Ref. C4.

[33] 戧金

[34] Harry M. Garner, 'A study of Chinese connoisseurship', *Apollo Magazine*, July 1972.

[35] Harry M. Garner, 'The export of Chinese lacquer to Japan in the Yüan and early Ming dynasties' (Ref. E34).

[36] *Chiang-su shêng ch'u t'u wên-wu hsüan-chi*, Wên-wu Press, 1963.

more than a hundred years before the account was written, differs from the rest of the work in not being contemporary with the pieces described. The translation given here, due to Sir Percival David, and incidentally in agreement with that given by Bushell some seventy years earlier, seems the most sensible. But there is no evidence, literary or factual, of the association of gold decoration with carved lacquer. Another interpretation, that the reference is to carved lacquer on a gold or silver base, was first put forward by Kao Lien in the *Tsun-shêng pa-chien* in 1591.[37] His view has been accepted by a number of Chinese and Japanese writers. But there is no factual evidence to support it, nor does there seem to be any point in using such metals as gold and silver as a base for lacquer.

This view is one of the many flights of imagination put forward by Kao Lien, who must have been one of the most unreliable of all the Ming writers on lacquer. After referring to the gold and silver grounds, he gives a long description of polychrome lacquer of the Sung dynasty with red flowers, green leaves, yellow pistils and black rocks. He describes boxes and dishes of nearly twenty different shapes, some very elaborate. None of this has any justification in fact. He goes on to make two inaccurate statements about the imperial lacquer made in the Yung-lo period, the first that it was made in the Kuo Yüan factory in Peking and the second that there was a rule in the Yung-lo period that not more than thirty-six layers of lacquer should be used.

The first statement, about the Kuo Yüan factory, is one that has been handed down in China and generally accepted, not only in China but also in the West. It is safe to say that it has occurred in every Western description of the so-called 'imperial' lacquer of the fifteenth century. There is in fact no evidence to support the view that there was any lacquer factory in Peking during the reign of Yung-lo. There is a good deal of information available from the official records on the progress made in the erection of buildings in Peking after the decision of Yung-lo to move his capital there from Nanking.[38] It shows that the construction work was very much delayed through the difficulty of obtaining the necessary materials from the various provinces and the shortage of labour generally. Peking was designated the new capital on New Year's Day, 1421 (2 February). At that time only the princes' palaces and altars were complete and work on the gates, walls and turrets was still in progress. There is corroboration, if this were needed, from the account given of the visit of the Persian Embassy in 1420-1.[39] This contemporary account records that when the Embassy reached Peking on 14 December 1420, less than two months before the ceremony of transfer was to take place, 'All around the city wall owing to the fact that it was still under construction there were set up one hundred thousand bamboo poles, each one of which being 50 cubits long, in the form of scaffoldings.' The official records at that time and indeed up to the end of the reign

[37] Ref. C8. It is also mentioned in the *Hsiu shih lu* (Ref. C7) Section 119.

[38] I am indebted to Dr. L. Carrington Goodrich, the Editor of *The Ming Biographical History Project*, Columbia University, for much information on this subject. It has been compiled from biographies submitted to the Project.

[39] *A Persian Embassy to China. An Extract from Zubdatu't Tawarikh of Hafiz Abru*, translated by K. M. Maitra. Published Lahore, 1934. Reprinted under the editorship of L. Carrington Goodrich, 1970 (Ref. E32).

of Hsüan-tê and beyond make no mention of any lacquer factory, nor indeed of factories of any kind, being constructed in Peking.

Even as late as the reign of Chia-ching (1522-66) there is strong evidence that there was no factory in existence with the title Kuo Yüan. In the *Ming kung shih*,[40] 'History of the Ming Palace', it is recorded that lacquering was one of the ten crafts administered by the eunuchs. But it also refers to the Yü-yung-chien[41] as the department responsible for the manufacture of screens and other objects for imperial use. Among the types mentioned, twenty in all, three were of lacquer, the first inlaid with mother-of-pearl, the second carved and the third filled-in.

The Yü-yung-chien is known, from the *Ta Ming hui-tien*,[42] to have been set up by the emperor Hung-wu in 1367, the year before he came to the throne, and it is recorded that it had a staff of nearly three thousand in the tenth year of Chia-ching (1531). It was responsible for the supervision of the manufacture of objects for the court generally and for their subsequent care and maintenance. The manufacture of these objects took place in factories outside the court, in many instances, as for example in porcelain, in districts far distant from Peking. Cloisonné enamel vessels are known with the inscription *Yü-yung-chien tsao* and two lacquer dishes at least are known with the inscription *T'ien-shih-fang*,[43] referring to a sub-department of the Yü-yung-chien.

A stele dated 1553, recording the repairing of the south storage house in the Palace, refers to the Yü-yung-chien as responsible for controlling four storage houses and four workshops, in which objects in lacquer and jade, lamps and Buddhist articles were made and repaired.[44]

All this evidence strongly supports the view that there was not at any time in the fifteenth and sixteenth centuries a factory of any significance engaged on the manufacture of lacquer in Peking. There were workshops responsible for repairs, as there were for repairs of other artifacts, but nothing more extensive than this.

The second statement by Kao Lien, on the number of layers of red lacquer being restricted to thirty-six in the Yung-lo period is demonstrably false, as an examination of any piece belonging to the fifteenth-century group will show at once. Indeed it would be impossible to construct a piece of carved lacquer of even moderate quality with so few layers.

One might be tempted by these glaring errors of Kao Lien to dismiss the whole of the *Tsun-shêng pa-chien* as valueless. But in fact there is some valuable contemporary evidence in the work. A reference to Huang Ch'êng as a famous lacquerer of the Lung-ch'ing period (1567-72), whose work already (in 1591) was being copied by inferior craftsmen, helps to give substance to what would be otherwise a

[40] 明宮史

[41] 御用間

[42] 大明會典

[43] 甘食房 See Chapter 6 for information on this mark.

[44] The accounts of the *Ming kung-shih* and the inscription on the stele dated 1553 are recorded in the *Ch'i-shu* (Ref. C1), f. 20a, columns 4–7 and 8–9 respectively.

mere name. Huang Ch'êng was the author of the *Hsiu shih lu*,[45] by far the most important technical account of lacquer in the Chinese literature, which describes in detail more than a hundred different types of lacquer as well as many technical processes. The work, quite unknown in China, has been handed down in manuscript in Japan. It contains a preface dated 1625 written by Yang Ming, who added numerous commentaries which establish that he was a skilled practical lacquerer. Yang refers to Ch'êng as a renowned craftsman but gives no other details. The combined evidence of Kao Lien and Yang Ming thus establishes the existence of a famous lacquerer of the second half of the sixteenth century who, from all the evidence of the *Hsiu shih lu*, had the techniques of lacquer-making at his finger tips. Particulars of the two published editions of the Japanese manuscripts are given in the Bibliography.

Another useful point established by the *Tsun-shêng pa-chien* is in connection with the marks of Yung-lo and Hsüan-tê found on fifteenth-century lacquer, the former incised with a needle and the latter carved with a knife and filled in with gold. There are a number of reasons why most of these marks cannot be accepted as contemporary with the pieces (see Chapter 6). The methods of inscribing the marks are of course obvious to anyone who cares to examine them, but the observation that they were in existence when the *Tsun-shêng pa-chien* was written suggests that the practice of adding the marks was well established by 1591.

The *Ch'ing pi-ts'ang*, written by Chang Ying-wên,[46] 'to amuse himself after he had failed several times in the public examinations' and published after his death by his son in 1595, is often quoted by modern writers on lacquer. As far as the references to lacquer are concerned, the work is of little value, most of the text apparently having been taken from the inaccurate parts of the *Tsun-shêng pa-chien* published four years earlier. For long the *Ch'ing pi-ts'ang* had been thought to be a primary authority on ceramics, but according to Sir Percival David[47] its reputation in this field is quite undeserved. It has, however, like the *Tsun-shêng pa-chien*, some redeeming features. The account of an exhibition held in Kiangsu in 1570, with all too brief descriptions of objects of art, including bronzes, jades, paintings and ceramics, possibly the first record to be made of an art exhibition, is of great importance and it is surprising that it has not been given intensive study. There were no lacquer items in the exhibition.

Mention has already been made of the gazetteers of the prefecture of Chia-hsing in Chekiang.[48] The references to the manufacture of lacquer at Hsi-t'ang, both in the *Ko-ku yao-lun* and the *Cho-kêng lu*, led to the hope that some useful information might emerge from the gazetteers. All the known gazetteers from 1506 to 1900 have been consulted, but no references to the manufacture of lacquer in Chia-hsing have been found, except for an account in the edition of 1610 of a lacquerer Chang Tê-kang,[49] said to be a son of Chang Ch'êng, one of the two famous lacquerers of

[45] Ref. C6, C7.
[46] Ref. C9.
[47] See note 28 above.
[48] See note 15 above.
[49] 張德剛

the fourteenth century mentioned in the *Ko-ku yao-lun*. The account records that the Emperor Yung-lo ordered Chang Tê-kang to go to Peking, where he was received in audience and appointed a deputy supervisor in the workshops.

The appearance of this apparently factual account in the early seventeenth century, about two hundred years after the events are alleged to have taken place, would have been of outstanding importance if it could be substantiated. But no reference earlier than 1610 can be traced and this is far too late in relation to the event for the evidence to be accepted. The most likely confirmation would be expected to come from earlier versions of the *Chia-hsing fu chih*. The edition of 1549, of which a microfilm exists in the Library of Congress and that of 1506, which exists in manuscript in the Peking National Library, have been examined without any reference to Chang Tê-kang being found.[50]

This long discussion on a single aspect of lacquer, the early development of carved lacquer in the fifteenth century, shows that some views that have been universally accepted, as for example that Peking was an important centre for the manufacture of imperial lacquer in the fifteenth century, must be rejected. The necessity to discard views expressed in the Chinese writings, when there is no contemporary evidence to support them, is found to occur in other fields than carved lacquer. These will be dealt with in the appropriate chapters. In order to assist the reader to see clearly the basis for the conclusions reached, the Bibliography of the Chinese works gives detailed commentaries, showing where the works may be accepted as reliable and where the views are open to question. The Bibliography gives enough information, including the Chinese characters, to enable the student to pursue any controversial points in the original texts. The use of Chinese characters in the rest of the text has been avoided, except in a few places.

[50] I am greatly indebted to Dr. Joseph Needham, who kindly agreed to examine the manuscript in Peking for me.

CHAPTER 5

The Origins of Carved and Marbled Lacquer

From very early times the Chinese showed a genius for the carving of all kinds of material, ranging from some of the hardest materials known, such as jade, to relatively soft materials such as bone, ivory and wood. None of these materials are more suitable for carving than lacquer of fine quality, which can be carved to a high degree of precision. Yet the Chinese were unable, for a very long time, to produce lacquer of sufficient thickness to enable carvings comparable in quality to those achieved in jade, ivory and bone to be produced. The best that could be done, in the earliest artifacts of the Shang dynasty, was to carve a design in wood and cover it with a few layers of black and red lacquer. The development of lacquer of this period has been dealt with in Chapter 3 and need not be recapitulated here. But we may summarize the position by saying that these early lacquerwares, while of considerable distinction as decorative objects, were not sound structurally, so that hardly any have survived in even fair condition. This type of lacquer was abruptly abandoned round about the fifth century B.C. and replaced by the splendid painted lacquerwares of the late Warring States and Han periods. All this lacquer was two-dimensional in its decoration, and although there were attempts to produce three-dimensional objects in a moulded lacquer composition from time to time, two-dimensional techniques remained predominant. It was not until the fourteenth century A.D. that the Chinese craftsmen reached a complete solution to the problem of producing three-dimensional decoration of fine quality.

The reason why the construction of the thick bands necessary for the manufacture of carved lacquer was not achieved earlier lies in the peculiar setting qualities of lacquer, which have been described in Chapter 2. The technical problems are formidable and one may well be amazed that the Chinese craftsmen succeeded in solving them at all. By adding a large proportion of ash to the raw lacquer a composition can be obtained which will set in thick layers. The hardness of the material depends on the type of ash and may also depend to some extent on the type of raw lacquer used, but even at its best the material falls far short in quality of the almost pure lacquer made with a small amount of additive colouring material such as the cinnabar pigment used for red lacquer. The coarser material could be moulded and the details cleaned up if necessary by the use of an abrasive, but the final result could not compare with the carving of the superior lacquer. In the *Ko-ku yao-lun* of 1388 Ts'ao Chao describes the built-up lacquer (*tui-hung*) in these terms:[1]

[1] Sir Percival David, *Chinese Connoisseurship* (Ref. E33), p. 147. Some corrections have been made to the translation.

Imitation carved lacquer is made by building up putty and covering it with a coat of vermilion lacquer. The designs are confined to sword rings and spiral scrolls. They are not worth much. They are also called 'red-coated' (*chao-hung*).

It is necessary, before we go any further, that we should define the precise meaning of the term 'carving' as applied to lacquer. According to the strict definition of the word, carving should only be applied to works of art in such materials as wood and ivory, 'sculpture' being used for stone and 'chasing' for work in metal.[2] However, this strict use of the word 'carving', has long been abandoned and such terms as 'jade carving', in which the shaping is done by abrasive tools, are accepted by writers on the arts and crafts.

In carved lacquer, as in carved wood, the main tool used is the chisel or knife, abrasive tools only being used in a subsidiary manner, as for polishing. This point must be stressed, because the inferior material described by Ts'ao Chao as 'built-up lacquer', which contains a large proportion of ash, could only be shaped by moulding or the use of an abrasive tool and is not therefore carved lacquer as the term is generally understood by connoisseurs.

The Chinese must have made many futile attempts to manufacture true carved lacquer before they finally succeeded in producing the splendid pieces of the four-teenth and fifteenth centuries. But, as I have pointed out in Chapter 3, they were not at a loss in using lacquer on three-dimensional designs of one kind or another. The shallow carvings of the Shang dynasty were followed in the Warring States and Han periods by the modelling of fully three-dimensional objects carved in wood and then painted in lacquer of different colours. Much later, from the sixth century onwards, the use of the process known as 'dry lacquer', in which the base consisted of layers of fabric impregnated with lacquer, was used for Buddhist and other figures. These developments have been discussed in Chapter 3. But the closest approach to the later true lacquerwares was reached in moulded designs with a lacquer composition of the kind referred to by Ts'ao Chao as 'built-up lacquer'. Here, although a wooden base was often used, the composition, generally black, was such that a substantial thickness could be superposed on it and moulded to the required shape, afterwards being finished off with an abrasive tool. Few pieces of this type have survived, and most of them are small figures only a few centimetres across. A number of these have been described and discussed by Dr. Paul Singer.[3] Although scientific tests have not, as far as I am aware, been made of these figures, it seems certain that they were made of a lacquer composition containing a large proportion of ash applied to a wooden base, possibly finished off with a thin layer of lacquer of finer quality. If so, the material was probably moulded and then polished with some abrasive material before being finally coated with a layer of lacquer. There is some evidence that these figures came from Ch'ang-sha and that the date of manufacture was round about 200 B.C.

Only two early pieces showing detailed decoration and therefore approaching more closely the true carved lacquerwares have come to light up to the present.

[2] *Oxford English Dictionary*, 1933, Vol. 3.
[3] Paul Singer, 'Black lacquer', *Archives of Asian Art*, XX, 1966–7, pp. 82–3.

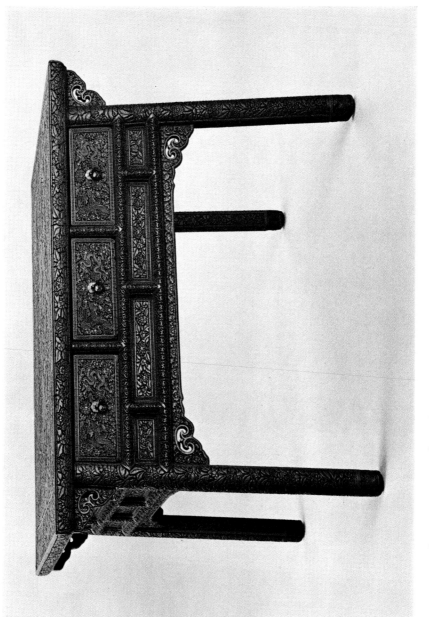

A. IMPERIAL TABLE of carved red lacquer, decorated with dragons and phoenixes, with floral borders
First half of 15th century. Height 79·2 cm. Width 119·5 cm
Victoria and Albert Museum. See page 92

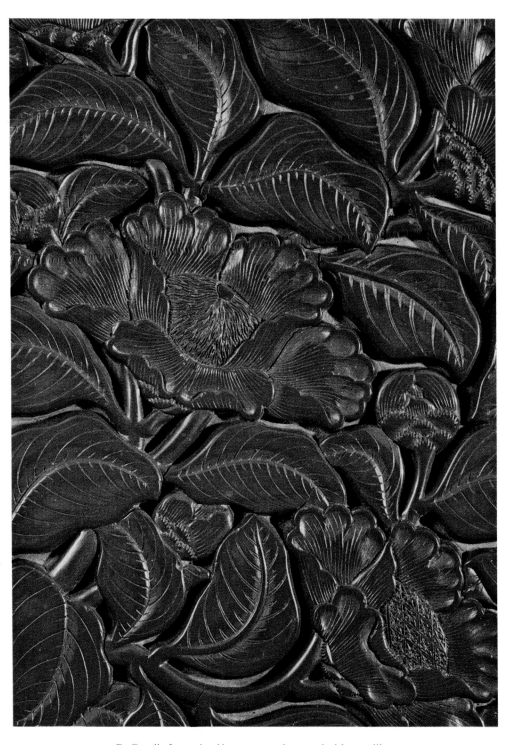

B. Detail of carved red lacquer BOX, decorated with camellias
First half of 15th century
Victoria and Albert Museum. See Plate 32 and pages 86 and 134

Such pieces must have been made as substitutes for the more durable carved wood figures and openwork panels covered with painted designs, but few have survived, no doubt because of their fragility. The first piece, datable to the second century B.C., is a circular disc, probably a sword-pommel, shaped in the form of a dragon mask (Plate 22).[4] Although the material has not up to the present been analysed, here again it is almost certainly of lacquer mixed with a large proportion of ash applied to a wooden base, moulded to shape and finished off with an abrasive tool.[5] The second piece is much later, datable to the seventh century A.D. It consists of a circular panel supported by a rectangular pillar, which has been preserved in the Hōryu-ji Temple, Nara (Plate 23).[6] It is of moulded lacquer composition applied to a wooden base and the moulded design in relief, probably *appliqué*, of a dancing phoenix surrounded by clouds on the circular panel and flower scrolls on the pillar, is entirely Chinese in feeling. It is probably one of the many pieces of T'ang art taken to Japan in the early years of the dynasty.

A third piece should be mentioned here, although it was made some time after the introduction of true carved lacquer in the T'ang dynasty. It is a wooden casket, one of a number of similarly decorated objects, which was recently excavated at Jui-an, Chekiang Province (Plate 24).[7] The wooden base is covered with a thin layer of lacquer and decorated with Buddhist figures in gold lacquer, which are framed in ogival panels of moulded lacquer embellished with pearls. It is clear that the process is one of *appliqué*, in which the decoration is moulded separately and then attached to the casket. There are a number of pieces with similar panels, but with gold decoration of formal diapers. The *appliqué* decoration is reminiscent of that in the Nara panel (Plate 23), but the date is considerably later. The piece illustrated in Plate 24 was excavated from a pagoda and not from a dated tomb and is actually dated 1042, but, like most of the objects in the hoard, the lacquerwares were almost certainly made before this date. Apart from their importance in the history of moulded lacquer, these pieces are of interest in the development of the gold-painted lacquerwares and will be referred to again in Chapter 10.

The earliest true carved lacquer known to us, primitive in form, was used for the proofing of armour. The evidence of this comes, not from China itself, but from Fort Miran in East Turkestan, where Aurel Stein found in 1906 scales of armour belonging to the T'ang dynasty.[8] It is regrettable that, until very recently, the existence of this most important evidence on the early development of carved lacquer has been completely overlooked by Chinese and Japanese authorities in their studies of carved lacquer.

The use of lacquer to give toughness to armour was known to the Chinese long before the T'ang dynasty. There is, for example, in the *Tso Chuan*, written in the fourth century B.C., a reference to the use of cinnabar lacquer for the proofing of

[4] Fritz Low-Beer, 'A carved lacquer plaque of the late Chou period' (Ref. E16).

[5] The possibility that the shaping of this piece was done entirely by abrasion cannot be ruled out.

[6] Beatrix von Ragué, Ref. E30, Plate 4.

[7] *Wên-wu*, 1973, No. 1.

[8] M. Aurel Stein, *Serindia*, Vol. I, 1921, pp. 459–67. The armour is illustrated in Vol. IV, Plate L.

22. Moulded lacquer DISC
2nd century B.C. Max. diameter 4.4 cm
British Museum

23. PILLAR with moulded *appliqué* designs
7th century A.D. Height 72 cm
Hōryu-ji Temple, Nara

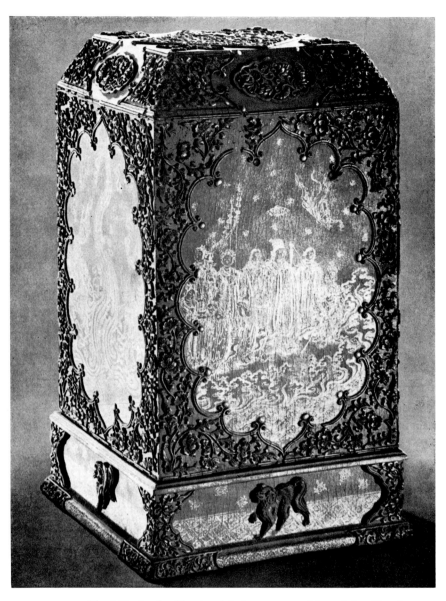

24. BOX, with *appliqué* and gold-painted designs, excavated from Jui-an Pagoda
11th century A.D.

armour made from hides.[9] The armour at Fort Miran consists of small rectangular pieces, about 10 centimetres long, made of untanned leather, probably camel hide, with holes through which thongs were passed to secure one piece to the next. Stein was able, from the remains of thongs still threaded through the holes, to deduce the methods of attachment. Earthenware figures of armed warriors and horses fitted with armour belonging to the period between the Han and T'ang dynasties are known, from which the arrangements of the scales can be seen.[10]

Fort Miran was originally the site of a Buddhist temple, built about the third century A.D., which was occupied as a Tibetan military post in the middle of the eighth century, after Tibetan troops had over-run Kansu. The principal buildings on the site were used as rubbish dumps when the importance of the fort diminished. Among the discarded rubbish in these buildings Stein found a number of sheets of armour together with wooden tablets and paper inscribed in Tibetan which had been perfectly preserved in the dry climate of Turkestan. The inscriptions refer to matters of administration and indicate that there was an effective civil government in the Tarim Basin at the time when Fort Miran was occupied. From the evidence of the inscription Stein deduced that the Tibetan occupation stretched from the last third of the eighth century to about the middle of the ninth. The armour, of Chinese manufacture, was presumably captured in Kansu in the eighth century.

Some of the pieces of armour are preserved in the British Museum. A part of one of the pieces is shown enlarged in Plate 25. The complete piece, about 10 by 5 centimetres, is rectangular with rounded corners and slightly convex. The leather base is covered with lacquer on both sides. On the front, the convex side, there are seven bands of brownish-red and black in alternation. The lacquer has been carved at sloping angles, which can be clearly seen in the illustration. Close examination has revealed that each band of decoration consists of two or more layers of lacquer and it is estimated that this particular piece has had between twenty and thirty layers applied to it. Other pieces are carved with simple designs such as crescents, commas, and S-shapes. In some of them the carved designs are supplemented by the building up of ridges.[11]

Here then we have the first authenticated simple examples of true carved lacquer. The total thickness of the lacquer in the piece illustrated in Plate 25, less than one millimetre, is one quarter of that needed to produce the kind of design, whether of flowers, landscapes, dragons or formal scrollwork that formed the normal decoration of the lacquerwares of the Yüan and early Ming dynasties. But it was undoubtedly from such simple beginnings that the later carved lacquerwares were developed.

There is no evidence of earlier true carved lacquer than is found in the Fort Miran armour. There is some literary evidence of carved lacquer being made as early as the fourth century A.D., but this is based on a Sung work which misquoted

[9] For more information on the proofing of armour, see O. Maenchen-Helfen, 'Zur Geschichte der Lackkunst in China', *Wiener Beiträge zur Kunst- und Kulturgeschichte Asiens*, XI, 1937.

[10] H. Russell Robinson, *Oriental Armour*, 1967, illustrates a number of these arrangements.

[11] See the author's 'Guri lacquer of the Ming dynasty', *Transactions of the Oriental Ceramic Society*, Vol. 31, 1957–9, for more details of the armour and its decoration.

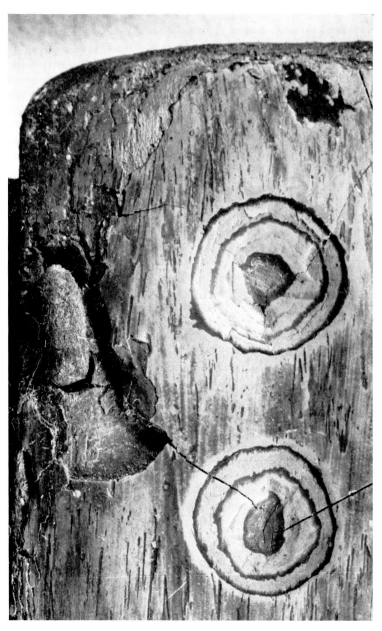

25. Lacquered ARMOUR from Fort Miran
8th–9th century A.D. Length approx. 7 cm
British Museum

the original fourth-century account and so is untenable. One tentative suggestion may be made. If there is any earlier carved lacquer than that on the armour from Fort Miran it is more likely to have been applied to armour than to vessels or furniture. There was clearly a need for a good thickness of lacquer in armour to give it resistance to weapon attack, whereas for other artifacts simple well-developed techniques, such as wood-carvings covered with lacquer or 'dry lacquer', could be used to achieve the decorative or functional features desired.

The decoration on the armour relies as much on the variation of colour as on the pattern of the carving. The variation gives a marbled effect[12] and much confusion has arisen in the attempt to interpret what the early writers meant when they talked about marbled surfaces. There are two types of marbled lacquer. In one the decoration is obtained on a flat surface and is analogous to that of a polished piece of variegated marble with stripes and other markings of different colour. In the other the lacquer is applied to a smooth surface in bands of different colour which are exposed by carving at an angle to the surface. The decoration on T'ang armour belongs to the second class.

The term *hsi-p'i*, in various forms, has been associated with a type of marbled lacquer as far back as the T'ang dynasty. It would be safe to say that few terms in the Chinese decorative arts have led to more confusion than *hsi-p'i*. In the form 犀毗, 'rhinoceros connection' it was used in the Han dynasty to describe a belt-hook. Even at this time there were many alternative forms of the characters, described by Pelliot as 'phonetic misunderstandings'.[13]

The first use of *hsi-p'i* to describe a type of lacquer occurs in the *Yin-hua-lu*, written by Chao Lin in the ninth century. The earliest version known of the description occurs in a quotation in the *Cho-kêng lu*, printed in 1366.[14] Chao Lin states that the characters generally used were 犀皮, literally 'rhinoceros skin', but maintains that the first character is incorrect and that the characters should read 西皮, literally 'western skin'. He gives as his reasons the similarity of the lacquer to the worn surface of western harness. Sir Percival David's translation of the relevant passage reads:

> In the western regions a rider's saddle changes its colour through wear from black to red and then to brown. Finally it becomes a combination of all three colours. Furthermore stirrups constantly rubbing against it make a clear pattern in it. *Hsi-p'i* is an imitation of the worn leather of such a saddle.[15]

The second reference to *hsi-p'i* occurs in a Sung work by Ch'êng Ta-ch'ang, the *Yên-fan-lu*,[16] which has a preface dated 1181. The earliest surviving publication of this work belongs to the Ming dynasty. The relevant passage reads:

> Nowadays the three colours of red, yellow and black are arranged repeatedly

[12] The term 'marbled', first used to describe imitations of marble in 1671, is preferred to the later term 'marbleized', which first appears, in the United States, in 1875.
[13] Paul Pelliot, 'Review of *Chinese Lacquer* by E. F. Strange, 1926', *T'oung Pao*, Vol. XXV, 1928, pp. 124–7.
[14] Ref. C4.
[15] Ref. E33, p. 145.
[16] Ref. C11.

and carved, so that their layers are exposed one after the other. This is called *hsi-p'i*, 犀 皮 , which looks like tiger-skin.

In another passage the *Yên-fan-lu* describes the lacquer as resembling the pattern created by wear on a leather saddle. This is similar to the account given in the *Yin-hua-lu*.

The third use of the term *hsi-p'i* occurs in the *Ko-ku yao-lun*, written by Ts'ao Chao and published in 1388.[17] The passage, headed 'Ancient *hsi-p'i*, 古 犀 毗', reads:

> Among ancient carved wares, *t'i-hsi*, 剔 犀 (literally carved rhinoceros), is burnished purple; the more valuable pieces have a burnished ground and show a reddish-black colour. The bottom is like an inverted roof-tile.

It seems to be quite fortuitous that the term first used by Chao Lin and afterwards by Ch'êng Ta-ch'ang to describe a type of lacquer is phonetically similar to that used in the Han dynasty to describe a belt-hook. Yet we find, only twenty-two years after Chao Lin's views had been introduced in the *Cho-kêng lu*, that Ts'ao Chao went back to the belt-hook form of *hsi-p'i*.[18]

A further misunderstanding was introduced by the late fifteenth-century writer Tu Mu in the *T'ing-yü chi-t'an*,[19] in which the fantastic suggestion was put forward that the character for *p'i*, 毗 should be interpreted as 'navel' and that the characters *hsi-p'i* refer to the pattern round the navel of a rhinoceros, which takes the form of two facing *t'ao-t'ieh* masks, a pattern that is claimed to occur in the lacquer decoration.

A further reference to the *Yên-fan-lu* must be made to correct a mistaken impression by some writers today that the *Yeh-chung chi*, a fourth-century work (Ref. C12), refers to *hsi-p'i* lacquer. Ch'êng Ta-ch'ang, in the *Yên-fan-lu*, quoting from the *Yeh-chung chi*, says: 'Imperial seats and table were made of carved lacquer all decorated in five colours.' But in fact the character *hua* (painted), is omitted in the quotation, so that the original meaning has been completely altered.[20] The original text in fact reads: 'Imperial seats and tables were carved and decorated with lacquer in five colours.' Thus the reference is not to carved lacquer but to a type of lacquer that is well known to have been made during the Warring States and Han periods, of which some exceptionally fine pieces have recently been excavated in Ch'ang-sha.[21]

Discussions on the semantics of the term *hsi-p'i* have continued down to the present day. Entertaining as these discussions must have been to the Chinese scholars, a far more important point to the student of lacquer is the identification of the type of lacquer to which the term *hsi-p'i* should be applied, irrespective of the form of the characters and the interpretations placed on them. Here the evidence shows that we are on much firmer ground.

[17] note 15 above, p. 144.
[18] note 15 above, pp. 41b and 144–6.
[19] Ref. C13.
[20] A reference to a thorough study of the texts by Cheng Kuo-hsün is given in the Bibliography in Ref. C12.
[21] See Chapter 3.

The Origins of Carved and Marbled Lacquer

The three earliest references to the term *hsi-p'i* as a description of a type of lacquer, in the *Yin-hua-lu* of the ninth century, the *Yên-fan-lu* of the twelfth and the *Ko-ku yao-lun* of the fourteenth are remarkably consistent. All three clearly refer to carved lacquer and indeed the term 'carved' specifically occurs in the second and third. The first two refer to three distinct colours, while the *Ko-ku yao-lun* refers to reddish-black and a yellow base. It also refers to the bottom of the lacquer being like an inverted roof-tile.

When the descriptions of the three works are compared with the carved decoration of the lacquer on the Fort Miran armour no doubt can remain that the three earliest references clearly describe this decoration. And yet Chinese writers from the sixteenth century onwards have interpreted *hsi-p'i* as describing a type of lacquer in which the decoration is shown on a flat surface and not a carved type. The confusion may have arisen from the use in the *Ko-ku yao-lun* of the term *t'i-hsi* as synonymous with *hsi-p'i*. Certainly Huang Ch'êng, the author of the *Hsiu shih lu*[22] and an eminent lacquerer of the late sixteenth century, includes *hsi-p'i* not in the group of carved lacquer but in the filled-in and inlaid group. His description of *hsi-p'i* is:

> Lacquer with layers of different colours. The motives are clouds, medallions, pine tree marks and so on. Recently there have been specimens with a red surface. The smooth ones are good.

Yang Ming in his commentary says:

> There are many varieties, but the original design is black on the surface, red in the middle and yellow on the base. Some are red on the surface, black in the middle and yellow on the base. Some are yellow on the surface, red in the middle and black on the base.

Yang Ming thus, in conflict with Huang Ch'êng, clearly described a type of carved lacquer, in which the differently coloured layers are identifiable. In fact, in a flat type of marbled lacquer, it is almost impossible to determine the order in which the layers are applied.

Huang Ch'êng includes *t'i-hsi* among the carved lacquers and describes it as follows:

> *T'i-hsi* (carved marbled lacquer). The surface layer can be black, red or transparent brown. Sometimes a thick black layer alternates with a thin red layer or *vice versa*. Sometimes the red and black are of equal thickness. Sometimes instead of these two colours alternating, there are three. The motives are sword guards, lattice-work, double circles, square spirals, cloud scrolls and so on.

This is clearly a description of the carved type of lacquer.

Modern Chinese writers have accepted Huang Ch'êng's use of the term *hsi-p'i* to describe a flat type of lacquer and Yüan Ch'üan-yü has described the method of construction of the type and illustrates a number of examples.[23] But we cannot escape the conclusion that had the Chinese connoisseurs over the centuries down

[22] Ref. C7, Section 106.
[23] Yüan Ch'üan-yü, 'On the *hsi-p'i* lacquer wares', *Wên-wu*, 1957, No. 7, pp. 1–7.

to the present day been familiar with the carved lacquer on the T'ang armour, agreeing so closely with the contemporary account of Chao Lin and the later ones of the twelfth and fourteenth centuries, misunderstanding in the identification of the types of lacquer described by the term *hsi-p'i* would never have arisen. As it has, it seems most undesirable that Western writers should use the term *hsi-p'i* to describe marbled lacquer of any kind. I propose to use the terms 'carved marbled lacquer' and 'flat marbled lacquer' which, although clumsy, are precise, to describe the two types. It will be noted that the former agrees exactly with that described as *t'i-hsi* by Huang Ch'êng. Carved marbled lacquer is by far the more important of the two types. Flat marbled lacquer, was not made, as far as our present evidence goes, until much later than the carved type.

The Japanese term *guri* for carved marbled lacquer has become well established. One meaning of the term is 'spiral' and this no doubt has led to its application to a type of lacquer that makes use of spiral designs of one kind or another. But the term has been extended to apply to other designs in which bands of different colour are used. It has also been used in recent years to apply to scroll, cloud-collar and *ju-i* head patterns in a single colour and even to the spiral scroll borders to be found on the undersides of dishes decorated with floral or landscape designs on the front. The term *guri* is not very appropriate for a type of lacquer that originated in China, but if it is to be used it should be confined to lacquer in which bands of different colour provide an important feature of the design. Flat marbled lacquer is described in Japan by the term *tsugaru-nuri*.

The Chinese had exploited, by the end of the T'ang dynasty, the use of clays in two or three colours to give a marbled effect to pottery. Sometimes the effect seems to be almost uncontrived, but at others patterns of considerable complexity were achieved. It is not known exactly what processes were adopted in mixing the clays, but we may note that basically the problem of decoration in marbled clays and flat marbled lacquer are analogous, although in the former the operation must be effected while all the materials are in a plastic state, while in the latter the lacquers of different colours must be applied in a number of successive stages. There is no evidence to support the view that there is any connection between the ceramic and marbled lacquerwares.

It is disappointing that up to the present no links connecting the T'ang carved lacquer with that of the Yüan dynasty have yet been found. In Chapter 3 reasons have been given why such links, if they exist, have not been found in excavations of Sung tombs. However, similar motifs to those that appear later, in Yüan and early Ming carved marbled lacquer, are to be found in silverware datable to the Sung dynasty. A silver box excavated at Lao-ho-shan, near Hangchou,[24] datable from an inscribed black lacquer piece in the same tomb to 1162, has designs very similar to those found on lacquer of the fourteenth and early fifteenth centuries. This raises the possibility that similar designs to those on silver may some day be found in twelfth-century lacquer. But there are many examples in Chinese art in which there was a considerable delay in designs in one medium being adopted in another. Here we may turn to porcelain and stoneware, in which it is easier to find authenticated examples than in lacquer. There is a good deal of evidence to support the

[24] *Wên-wu*, 1957, No. 7, pp. 28–30.

view that the designs of cloud-collar and *ju-i* head motifs were not transmitted to ceramics before the Yüan dynasty. In porcelain we find the evidence in the *ch'ing-pai* and the blue and white porcelain wares, and in the brown-decorated stonewares of South China. The evidence from the latter is especially convincing.

The Chi-chou stonewares with painted designs in buff-white slip on a brown ground have long been familiar to collectors. They were formerly attributed to the Sung dynasty and it was not until the exhibition of ceramics of the Yüan dynasty was held in the British Museum in 1955 that these wares, decorated with trefoil elements derived from the West, were established as belonging to the Yüan dynasty.[25] A typical jar of this group is shown in Plate 26. The similarity in design to that of the lacquer bowl-stand in Plate 27 is evident. This important piece will be discussed in the next chapter.

During the last ten years evidence has come from excavations in the Philippines of stonewares of a type previously unknown, with somewhat similar decoration to that of the Chi-chou painted wares, but using an entirely different technique.[26, 27] A typical incense-burner is shown in Plate 28. The grey body was deeply carved with spiral trefoil and other formal designs, before being fired, and the raised parts only covered with a dark brown glaze. The designs include key-fret and scroll borders that are more often found in blue and white porcelain than in the Chi-chou wares. There can be no doubt that these brown wares were imitations of lacquer and if they could be dated they would provide valuable information on the dating of the lacquerwares. But although some of the stonewares are said to have come from tombs attributed to the Yüan dynasty, the evidence is not very solid and there is as yet no information from China on the provenance or date of manufacture of these wares. The first half of the fourteenth century seems to be a probable date.[28]

The foregoing discussion on the carved marbled lacquerwares, with its complex semantic arguments on *hsi-p'i* may seem confusing and perhaps unnecessarily long to most readers, whose main interest is in the pictorial lacquerwares, with their floral, landscape and dragon designs, which provide by far the greater and more important part of the carved wares. But it has been necessary to clear away, it is hoped once and for all, the misunderstandings largely based on Chinese writings of the sixteenth and later centuries, that have arisen. With the origins of carved lacquer established by the Fort Miran finds, much of the verbiage that had become almost sacrosanct can now be ignored. In the next chapter the development of the carved marbled lacquerwares will be discussed. But, far more important, the development of the carved pictorial lacquerwares will be traced from their origins in the first half of the fourteenth century down to the fifteenth, when the finest of all the carved lacquerwares were made. All the evidence available supports the view that carved

[25] John Ayers, 'Some characteristic wares of the Yüan dynasty', *Transactions of the Oriental Ceramic Society*, Vol. 29, 1954–5, pp. 85–6.

[26] John Addis, 'Chinese porcelain found in the Philippines', *Transactions of the Oriental Ceramic Society*, Vol. 37, 1967–9, Pl. 38.

[27] Cecilia F. Locsin, 'A group of painted wares from Chi-chou and some related wares excavated in the Philippines', *Manila Trade Pottery Seminar*, 1969, No. 5.

[28] Margaret Medley, *Yüan Porcelain and Stoneware*, 1974, has suggested that these stonewares may have been made, not at Chi-chou, but in kilns placed nearer to the lacquer factories of Kiangsi.

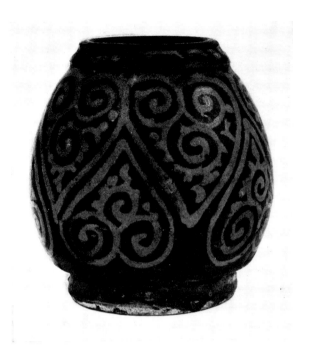

26. Kian stoneware JAR
Yüan dynasty. Height 8·9 cm
British Museum

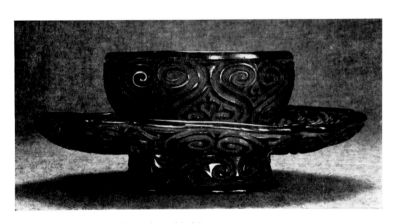

27. Carved marbled lacquer BOWL-STAND
15th century. Diameter 16 cm
British Museum

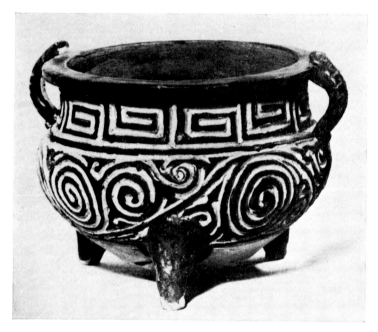

28. Carved stoneware INCENSE-BURNER
14th century. Height 13·2 cm
Elizalde Collection, The Philippines

lacquer, as we understand it today, started in earnest in the Yüan dynasty. The outburst of creative energy with which we are familiar in other branches of the creative arts, and particularly porcelain, undoubtedly had a similar impact on lacquer. It may seem strange that the Mongol influence should have spread to lacquer, a material alien to the west, but the facts are inescapable. The Yüan dynasty saw the blossoming of new types of lacquer, of which carved lacquer was only one example, which laid the foundation for the superb lacquerwares belonging to the fourteenth and the early part of the fifteenth century.

Carved Lacquer of the Yüan and Early Ming Dynasties

We have seen in Chapter 5 that the origins of carved lacquer go back to some time before the Christian era and that carved lacquerwares in a form not basically different in technique from those of the Yüan and Ming dynasties were made as early as the eighth century A.D. Nevertheless Chinese carved lacquer, in the form we are familiar with today, cannot be considered to have started before the Yüan dynasty. The earliest carved lacquerwares that have been preserved in any quantity, belonging to the fifteenth century, must have been developed from the fourteenth-century wares, themselves derived in some way from the rudimentary lacquer found on the Fort Miran armour. The problem of tracing the connections between the fifteenth-century lacquerwares and their forerunners is one of the most difficult and controversial in the whole study of Chinese lacquer.

We have seen that there is good evidence of the development of carved marbled lacquer from the *Yin-hua-lu* of the ninth century and the *Yên-fan-lu* of the twelfth, which form the links that connect the Fort Miran armour of the eighth century with the carved marbled wares described in the *Ko-ku yao-lun* of the fourteenth. It is extremely likely that carved marbled wares were made throughout the whole of this period, although no established examples have yet come to light. Reasons have been given why any such wares are not likely to have appealed to the connoisseurs of the Sung dynasty, so that their absence from Sung tombs is not surprising. Nevertheless, it is probable that examples of simple carved marbled lacquerwares firmly dated by evidence from excavations—and nothing less than this should be accepted—will some day emerge.

Even when we come to the fourteenth century there is great difficulty in finding pieces of carved marbled lacquer that can be firmly attributed to it. As this type of lacquer was never included in the official wares of the fifteenth and sixteenth centuries, it is also difficult to date the later wares. They had little impact on the bulk of the carved lacquerwares of the Ming dynasty, and I propose to defer discussion of them to the end of this chapter and deal first with the normal carved lacquerwares.

It is not sufficiently appreciated, even among those who have devoted some time to the study of carved lacquerwares, that there are no contemporary references to the carved wares, other than those of the marbled type, earlier than the publication of the *Ko-ku yao-lun* of 1388. The marbled wares are all carved in formal designs, such as those found on the Fort Miran armour and those clearly described in the

Yin-hua-lu and the *Yên-fan-lu*. The 'pictorial' lacquerwares, if I may use this term to describe the wares decorated with flowers, landscape and similar subjects that comprise almost all the early fifteenth-century wares, are clearly described in the *Ko-ku yao-lun*, but until the recent excavation was made of a small landscape box in China datable to the Yüan dynasty there was no factual evidence to support the literary account. The *Ko-ku yao-lun* is thus seen to be of great importance in the study of the early carved wares and a critical assessment of its reliability is needed.

The *Ko-ku yao-lun* has always had a high reputation in China. Many editions were printed and it has been referred to extensively by later Chinese writers from the sixteenth century onwards. Western students owe a great debt to Sir Percival David, whose *Chinese Connoisseurship*,[1] published in 1971, is by far the most important study of the Chinese work. He has identified what appears to be the only surviving copy of the first edition of 1388, which is reproduced in facsimile and fully translated. A full account of the later editions is given, including the second edition, edited and enlarged by Wang Tso in 1459. The value of Wang's additional material is not high, as far as lacquer is concerned, although a few useful minor points are raised.

The greater part of the *Ko-ku yao-lun* consists of discussions of paintings, calligraphy and bronzes. These are not of great value and there are far more important works on these subjects dating from the Sung and Yüan dynasties. But the work is unique for its period in its detailed accounts of objects which the author Ts'ao Chao had himself handled and studied. These accounts, mainly confined to porcelain and lacquer, have provided convincing evidence of the accuracy and acuteness of Ts'ao's observations.[2] In many of the types observed by him, in which contemporary or factual information is available from other sources, confirmation of his comments has been found. Much of this evidence has come forward during the last twenty years. This has led me to the conclusion that, even when no corroboration from other sources is available, his accounts of pieces that he himself had handled, as distinct from hearsay evidence, can be relied upon. In the account of carved lacquer only one statement, relating to the Sung imperial wares, has to be rejected. I have dealt with this point in Chapter 4.

The whole account in the *Ko-ku yao-lun* of carved lacquer consists of some two hundred and fifty Chinese characters only. The first section, on *hsi-p'i* lacquer, and the third, on the imitation carved lacquerwares, have already been discussed in Chapter 5. The remaining section, the most important of the three, dealing with carved red lacquer and containing a mere hundred characters, was discussed in Chapter 4.

Some of the details of this short account of carved red lacquer are difficult to interpret, even by expert Chinese linguists. It is not surprising that later Chinese writers have expanded Ts'ao's account, often with unjustifiable additions, which have unfortunately been accepted as original by modern writers.[3]

[1] Ref. E33.

[2] See the author's 'A study of Chinese connoisseurship', *Apollo Magazine*, July 1972, for a discussion of this aspect.

[3] For example, some modern writers have built up a distinction between the lacquer-wares made by Chang Ch'êng and Yang Mao, which is quite unjustified. All that is known of these two lacquerers from fourteenth-century evidence is contained in the *Ko-ku yao-lun*, which simply records their existence.

Carved Lacquer of the Yüan and Early Ming Dynasties

Until comparatively recently the evidence from the *Ko-ku yao-lun* was all that was known about carved lacquer of the fourteenth century, but now a good deal of further evidence has come to light. Before looking at this I should refer to the *Cho-kêng lu*,[4] published in 1366, which, although it does not refer specifically to carved lacquer, has an important passage which describes the method of applying one thin layer of lacquer after another, an essential feature of carved lacquer. The *Cho-kêng lu* also has an important account of the *ch'iang-chin* lacquerwares, which is not only consistent with the account of these wares in the *Ko-ku yao-lun*, adding further to its credibility, but also gives evidence on the subjects of decoration on *ch'iang chin* wares, which agrees closely with those on the carved wares. Further information on the *ch'iang-chin* wares is given in Chapter 8.

The first new evidence comes from lists of lacquer sent from China to Japan in the early fifteenth century and preserved in Japan, although apparently not in China, their country of origin. These were first published in 1955. The objects described are consistent with those referred to in an account of Chinese lacquer in a Japanese collection in 1363.[5] The third important piece of information comes from the excavation of a carved lacquer box datable to 1351 or earlier, already mentioned, which was first reported in 1963. These three additional pieces of evidence are all of supreme importance and enable a much more reliable assessment to be made of the early carved lacquerwares. Before we go into this new evidence in detail it is desirable to study the knowledge already gained on fifteenth-century lacquer, because the connection between the fourteenth- and fifteenth-century wares is a vital part of the early developments.

THE OFFICIAL FIFTEENTH-CENTURY WARES

The carved wares of the fifteenth century are, without question, the finest of all carved lacquerwares. They have always been highly appreciated by the Chinese, and particularly by the members of the court, and a large number of pieces were stored in the Palace and used for the serving of food and other purposes. In the Ch'ing dynasty no less than thirty-six pieces, twenty-four attributed to the Yung-lo period and twelve to that of Hsüan-tê, were recorded among the Emperor Ch'ien-lung's poems.[6] The characteristics of this group have always been well understood by Chinese connoisseurs and four pieces correctly ascribed to the fifteenth century were shown in the International Exhibition of Chinese Art in London in 1935-6.

A large number of these wares had found their way to Europe in the late nineteenth and twentieth centuries and they have been thoroughly studied by a number of Western connoisseurs. The most important of the studies was made by Low-Beer in 1950.[7] His thorough account, based on a careful examination of a number of fine examples, is of outstanding importance, although the attribution to a Peking

[4] Ref. C4.

[5] Ref. E31.

[6] Hsü Shih-chang, *Hao-yüan-pi-chi* (Jottings of Hao-yüan). See Ref. C1, f. 40b.

[7] Fritz Low-Beer, 'Chinese lacquer of the early fifteenth century', *Museum of Far Eastern Art Bulletin*, No. 22, 1950.

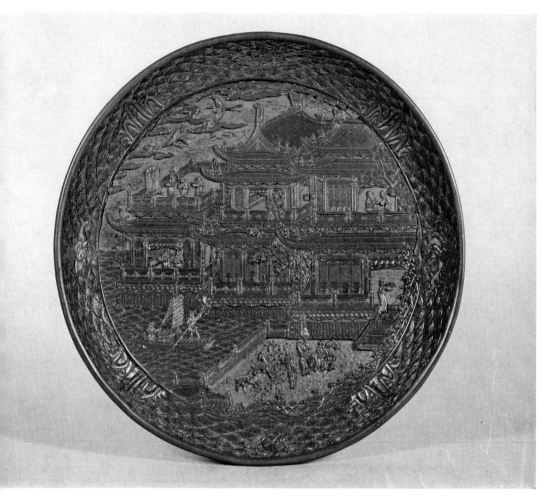

C. DISH of carved polychrome lacquer, decorated with the Orchid Pavilion with numerous figures
Dated 1489. Kansu ware. Diameter 18·8 cm
Lady Garner. See pages 116, 123–6

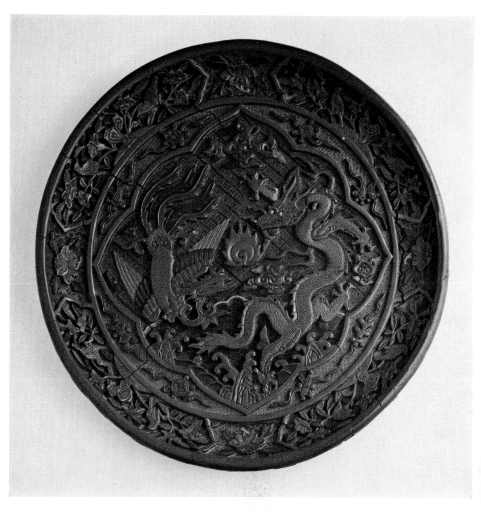

D. DISH of carved polychrome lacquer, decorated with a dragon and phoenix in
the centre, and panels of birds on flowering sprays around
Dated 1593. Diameter 22·4 cm
British Museum. See page 144

workshop can no longer be accepted. Nor can the importance attributed to the Yung-lo and Hsüan-tê marks be justified. But these minor faults, based on erroneous statements by Chinese connoisseurs of the sixteenth century and later, hardly detract from the general assessment, which remains one of the most important studies on Chinese lacquer ever made in a Western language. Since this critical study was made a large number of additional lacquerwares belonging to the fifteenth century have come to light. More than a hundred have been recorded and the total in existence must exceed a hundred and fifty. A large proportion bear the Yung-lo or Hsüan-tê mark. These pieces enable an even more complete assessment of the group to be made.

One of the finest of these wares is a box in the Freer Gallery of Art, carved on the top with a landscape with pavilions and figures and with floral borders round the edges (Plate 29). Although of exceptionally high quality, it may be regarded as typical of landscape pieces in the group, which probably number some forty pieces in all. The box is described in detail and the general characteristics of the group are fully discussed in a paper devoted to two fifteenth-century boxes in the Freer Gallery of Art.[8] It is not necessary to repeat the lengthy discussion here, but mention of the salient points is made below.

In the first place the extremely fine craftsmanship must be stressed. The wooden base is carefully constructed and strengthened by the addition of a fabric covering impregnated with lacquer. This is covered with a thick layer of a black lacquered composition containing a large amount of ash, which gives a smooth solid surface to which the layers of decoration are applied. The lowest layers, few in number, are yellow and above them are the red layers, only interrupted by a narrow black band consisting of three or four layers. Each layer, less than 0·05 millimetres in thickness, was allowed to set and then polished before the next layer was applied. There are well over a hundred layers in each piece, and as each layer must have taken four or five days to complete, something like two years must have elapsed before the piece was ready for the carver. The reason why this lengthy technique was necessary has been fully discussed in Chapter 2.

The details of technique have been largely established by scientific studies of sections of fifteenth-century lacquerwares. An exhaustive study was made by the author in 1963 of the remains of a box which may, originally, have closely resembled that in Plate 29.[9] There is literary evidence that the technique was well established before the end of the Yüan dynasty. The *Cho-kêng lu* gives a graphic description of the details of manufacture of lacquerwares made with a number of successive layers, referring to the meticulous care with which the ground work was done and each layer polished before the next was applied. It mentions that several months elapsed between the preparation of the base and the application of the first coloured layer.[10]

The quality of the carving of the fifteenth-century wares can be judged by a study

[8] Ref. E39. For information on the diapers Ref. E28 should be consulted. The second box is later than the official group and is discussed in Chapter 7.

[9] Harry M. Garner, 'Technical studies of oriental lacquer', *Studies in Conservation*, Vol. 8, No. 3, August 1963, pp. 84–97.

[10] Otto Maenchen-Helfen, Ref. E11, gives a full translation of the passage.

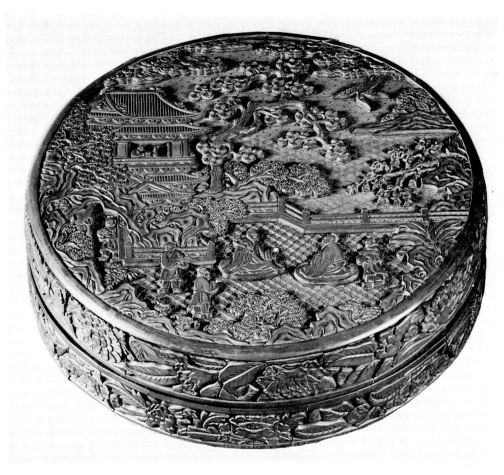

29. CYLINDRICAL BOX with carved landscape
15th century. Diameter 26·7 cm
Freer Gallery of Art

of the boxes such as that in Plate 29. While the boxes with landscapes are no finer, basically, than those with dragon or floral decoration, they well illustrate the fineness of the fifteenth-century wares generally. The three background diapers, representing land, water and air, are not only meticulously carved, but the surfaces have first to be carved to a level base, no mean task, after which the diapers have to be carved in detail to the depth of less than a millimetre. In this carving the use of so-called 'guide-line', a black band of some three or four layers only, must have been invaluable to the craftsman, enabling him to work more speedily. There is evidence to suggest that the band was arranged to provide a weak link, so that the lacquer would readily break away at the bottom of the black band. The floral borders are, like all the floral designs, carved down to the yellow base.

The large number of surviving fifteenth-century pieces suggests that manufacture was on an enormous scale. The qualities of construction, design and decoration are consistent with a strictly controlled routine of manufacture. The method of constructing the base is similar in all the pieces and the use of the black guide-line, a highly sophisticated device, is universal, showing little variation in thickness and position. Low-Beer has pointed out the similarity in the design of dragons in the carved lacquer group, which even extends to the filled-in group. This makes it certain that cartoons were used for these designs. In landscape pieces there are many examples in which large parts of the design are repeated from one piece to another. One example has been given in the paper already mentioned.[11] Further evidence of repetition occurs in the floral borders which are found on the sides of the boxes and round the edges of dishes. The flowers of the four seasons, when only four species are shown, are invariably the same and presented in the same order, peony for Spring, pomegranate for Summer, chrysanthemum for Autumn and camellia for Winter.[12] When the number exceeds four, there is some elasticity, but there is generally an orderly arrangement. In the fine dish illustrated in Plate 30 the arrangement of the flowers, eight pairs in all, on the front of the dish is exactly repeated underneath, but in the reverse order, suggesting that an inverted template was used.[13]

We have already seen in Chapter 4 that no manufacture of lacquer took place in Peking before the end of the reign of Hsüan-tê (1435) and there is evidence to support the view that none was made there before the reign of Chia-ching (1522–1566). The fifteenth-century lacquerwares were almost certainly made in factories situated in the lower reaches of the Yangtse River. From the *Ko-ku yao-lun* we know that carved wares were made in the late Yüan dynasty at Hsi-t'ang in the Province of Chekiang and this is a likely area for the manufacture of the Ming wares. The close supervision of manufacture evident from a study of the wares suggests that, as far as the pieces made for the court are concerned, supervision was provided by some department of the Nei-fu (the Imperial Household). In porcelain, vessels were made under the supervision of the Kung-yung K'u (Treasury for Tribute), while bricks and tiles were made under that of the Kung-pu (Board of

[11] Ref. E39.

[12] The four species are clearly seen, for example, in the dish in Plate 31.

[13] A similar dish, in the Peking Palace Collection, appears to have exactly the same borders (Ref. E27, p. 91).

Public Works).[14] There is evidence of the manufacture of cloisonné vessels made under another department of the Nei-fu, the Yü-yung Chien (Office for Imperial Use).[15] In lacquer, as we shall see later, pieces are known with the mark *T'ien shih-fang* (Department of Sweetmeats), a sub-department of the Yü-yung Chien.[16]

None of the departments, in porcelain, lacquer or any other material, were however entirely under the control of the court. The workmen were bound under a feudal system, similar to that which was in operation in contemporary Europe, by which they were compelled to work for the court, or for a feudal overlord, after which they could obtain payment for work done for private customers. Without doubt the standard of craftsmanship maintained for private customers was lower than that for the court. But while there are differences in quality the standard, even among the less good pieces, is still very high. It is clear that the term 'imperial' that has been used to describe these pieces is inappropriate. Strictly speaking, it could only be applied to those decorated with imperial dragons, which were undoubtedly made for the emperor. Even the term 'official' is not entirely appropriate, but it is a useful label to attach to a group of pieces made under strict control, many indeed under the direct control of the Yü-yung Chien, and it is therefore proposed to use it to describe the wares generally.

Important as the official fifteenth-century lacquerwares are, it is not possible to describe more than a limited number of them in this book. The reader is referred to the catalogues of the numerous exhibitions of carved lacquer that have been held both in the West and Japan during the last thirty years for supplementary information. Two landscape pieces have already been mentioned. The first (Plate 29) is fully described elsewhere, where the landscape design is compared with that of a dish formerly in the Low-Beer Collection.[17] The second, the foliated dish in Plate 30, is of special interest, not only for the superb craftsmanship of the landscape and floral border carvings, but for the fact that it bears on the back, in addition to the six-character Yung-lo mark, the mark *Nei-fu tien-shih fang*.[18] The Tien-shih Fang, already mentioned, was a sub-department of the Yü-yung Chien, which was responsible to the Nei-fu for the ordering of decorative objects and their subsequent care and maintenance. The only other piece of lacquer recorded with the mark *Tien-shih fang*, in this instance without the accompanying *Nei-fu* mark, is a floral dish in Copenhagen which will be described later (Plate 34). Another fine landscape piece is the square dish in the Figgess Collection (Plate 31), which bears the Hsüan-tê mark. Other pieces with landscape decoration are described in the British Museum Catalogue of 1973 and in other Western and Japanese exhibitions.

[14] Margaret Medley, *Porcelain Decorated in Underglaze Blue and Copper Red in the Percival David Foundation*, 1963.

[15] See the author's *Chinese and Japanese Cloisonné Enamels*, second edition 1970, p. 8.

[16] For information on the organization of craftsmen in the Ming dynasty the following works should be consulted: (a) Ting I, *Ming tai tê-wu chêng ch'i* (Government by secret police methods in the Ming dynasty), Peking, 1951; (b) Ch'ên Shih-ch'i, *Ming t'ai kuan-shou-kung-yeh ti yên-chu* (The official handicraft industries of the Ming dynasty), Peking, 1958; (c) Hans Frieze, *Des Dienstleistungs-System der Ming Zeit*, Wiesbaden, 1959.

[17] Ref. E39.

[18] It is not known whether the similar dish to that of Plate 30 in the Peking Palace Collection (see note 13 above), bears this mark.

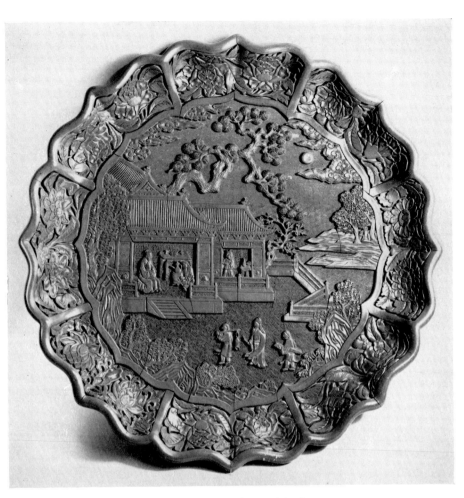

30. FOLIATED DISH with carved landscape
 15th century. Diameter 35·2 cm
 British Museum

The largest group of fifteenth-century official wares consists of pieces with floral decoration. The boxes, with sprays generally of a single species on the top, are invariably decorated on the sides with the flowers of the four seasons, generally in pairs, but sometimes singly. The upper and lower borders were always arranged to match exactly, but a number of examples exist in which the borders do not match, a sure indication that they came originally from different boxes. The existence of many non-matching boxes is not surprising when one realizes that the boxes were made in a number of standard sizes, so that the interchange of parts could have easily occurred when the boxes were in the same store, as for example in the imperial storeroom. Interchange could even have taken place in the factory where the pieces were made. The parts have generally every indication of being contemporary. Examples are known in which the top of a floral box has been fitted to the bottom of a box decorated on the sides with clouds, which must originally have had a dragon decoration on the cover. The fit on one such combination is perfect and a study of the technique of manufacture of the two parts suggests that the parts were contemporary.[19]

One of the finest floral pieces is the box decorated with camellias shown in Plate 32. Formerly in the Chester Beatty and Garner Collections, it is now in the Victoria and Albert Museum. It bears the Yung-lo mark, probably added in the sixteenth century. The illustration of a detail of the box in Colour Plate B gives some idea of the skill and artistry with which floral subjects were depicted. The carved design in red stands out clearly against the ground, originally yellow but now faded to buff, and suggests a close affinity to silk brocade decoration. It may indeed be argued that the floral designs, among all the official fifteenth-century lacquerwares, are the most appropriate to the material. The bowl-stand, with the flowers of the four seasons on the outside of the bowl and on both sides of the flange, in the Victoria and Albert Museum (Plate 33) and the dish decorated with hibiscus sprays in the National Museum of Denmark, Copenhagen (Plate 34) are two typical examples of fine floral design. The dish, as I have mentioned, has the rare inventory mark *T'ien-shih fang*. It was acquired by the Museum as early as 1882. The beautiful box decorated with the 'three friends', the pine, bamboo and plum, in the Philadelphia Museum of Art (Plate 35), is unusual in being carved at several levels, with the bamboos at the top, then the pine, and finally, at the lowest level, the plum. A dish, decorated with hibiscus in the Palace Museum, Peking, carved on similar lines, was exhibited at the International Exhibition of Chinese Art in London in 1935-6.[20]

The last floral piece to be illustrated here is the foliated oval dish in the British Museum (Plate 36). Boldly carved with a central spray of herbaceous peonies and with borders of the flowers of the four seasons, it is included as probably belonging to the late fourteenth rather than the fifteenth century. Of all the pieces in the official group known to me this is the only one that has no guide-line and there are other technical features that support an early date. As we shall see later, dishes with this kind of decoration were included in the 1403 Yung-lo list, and so must go back to the fourteenth century.

A third group of official wares is that in which the main feature of the design is

[19] Ref. E41, No. 35.
[20] No. 1420. It is illustrated in Refs. E14 and E16.

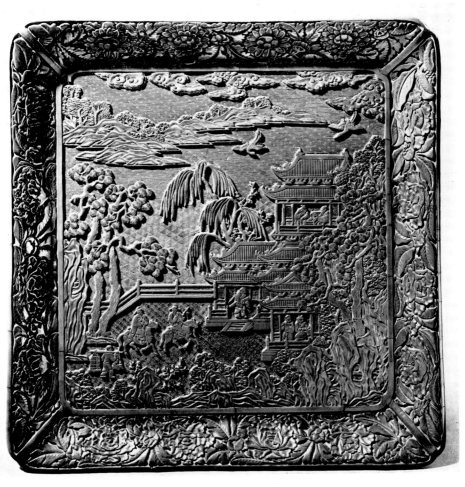

31. SQUARE DISH with carved landscape
15th century. Width 39·5 cm
Figgess Collection

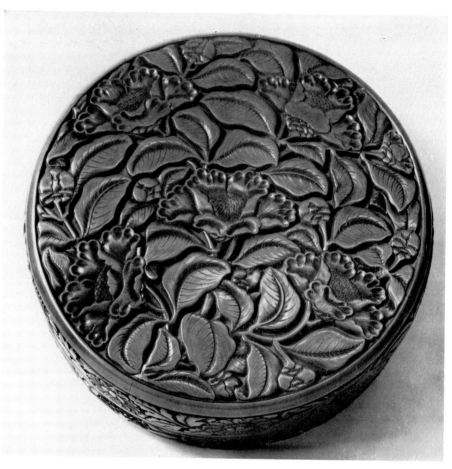

32. CYLINDRICAL BOX carved with camellia sprays
15th century. Diameter 22·2 cm
Victoria and Albert Museum

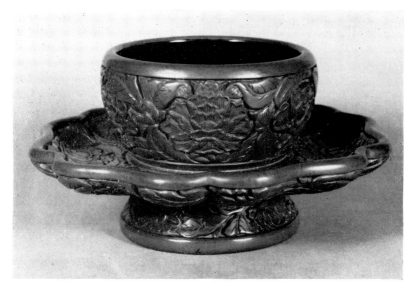

33. BOWL-STAND carved with the flowers of the four seasons
15th century. Diameter 16·5 cm
Victoria and Albert Museum

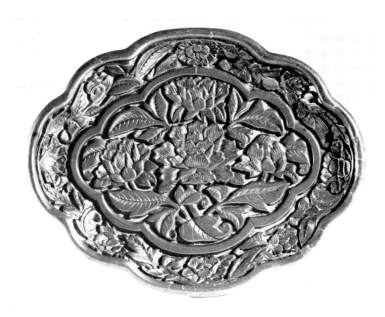

36. FOLIATED OVAL DISH carved with peonies
14th–15th century. Length 19·6 cm
British Museum

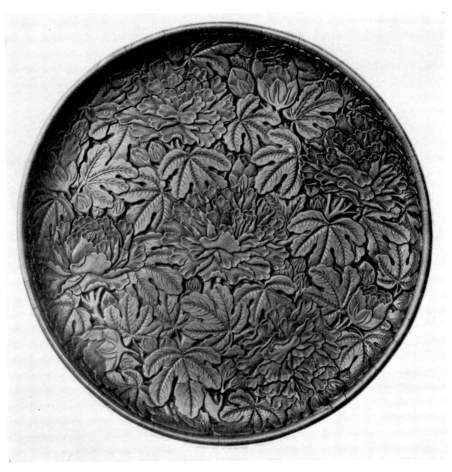

34. CIRCULAR DISH carved with hibiscus sprays
15th century. Diameter 31·2 cm
National Museum of Denmark, Copenhagen

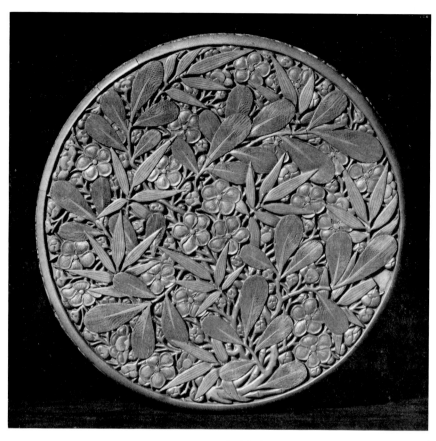

35. CYLINDRICAL BOX carved with the 'three friends'
15th century. Diameter 27·3 cm
Philadelphia Museum of Art

of imperial dragons or pheonixes, or with both in combination. This group may be truly described by the term 'imperial'. The most important piece in this group, and indeed the most important piece of carved lacquer in existence today, is the magnificent table formerly in the Low-Beer Collection and now in the Victoria and Albert Museum. This is so well known and has been so well illustrated, with many details, that I must content myself here with a single illustration showing the whole table (Colour Plate A).[21] Such large pieces as this are best seen in detail, but in place of a detail of the table top, a similarly decorated panel, also with dragons and phoenixes, once the side of a cabinet, is shown in Plate 37. The main theme is of two facing dragons against a background of peonies, set in an ogival panel and filled in at the corners with phoenixes against backgrounds of the flowers of the four seasons. An interesting feature is the subsequent treatment of the five-clawed dragons, in which one claw has been partially removed on each foot, leaving a small circular boss. The practice of downgrading the status of pieces with dragon decoration by defacing one claw was widespread in the Ming dynasty. Possibly this was done occasionally with imperial permission when a piece was presented by the emperor to a member of the court for distinguished services, but it is likely that most of the pieces with defaced claws were stolen from the Palace and downgraded with a view to avoiding discovery. There are many examples of this kind of deface-ment, particularly in the imperial wares of the Chia-ching and Wan-li periods, but quite a number can be found in the official fifteenth-century wares as well. For example the Low-Beer table has had all the fifth claws removed from the dragons, although the missing claws of the main dragon have been subsequently restored.

Historical evidence that pieces were stolen from the Palace comes from an account in the *Yeh-huo-pien*,[22] dating from the Wan-li period, which states that pieces of lacquer, both of the carved and filled-in types, were stolen from the Palace and sold in the market of the City God's Temple held on the third day of each month. No doubt the pieces with dragon decoration were suitably defaced before being offered for sale. Examples of filled-in lacquer, similarly defaced, will be discussed in Chapter 9.

A similar panel, once probably the top of a box, decorated with a single dragon against a background of clouds and waves, in the Victoria and Albert Museum, has suffered no such disfiguration. A detail of this panel, shown enlarged in Plate 38, illustrates a feature which is found on a number of dragon and other pieces, although generally it has largely disappeared through wear. The head and claws of the dragon are delicately incised. Even in this piece, which is remarkably well pre-served, some of the details have become faint.[23] Similar details can be seen in a box decorated with Buddhist lions (Plate 40), which will be discussed below.

Other pieces belonging to the imperial group are two formerly in the David Collection. The first is a large box decorated with phoenixes against a background of the flowers of the four seasons, which was presented by Sir Percival and Lady David to His Majesty King Gustav VI of Sweden. This is now in the Museum of

[21] It is shown, with some excellent enlargements, in Ref. E14.

[22] Ref. C10.

[23] The panel is illustrated in colour in Ref. E24 and in black and white in Ref. E39 (No. 40).

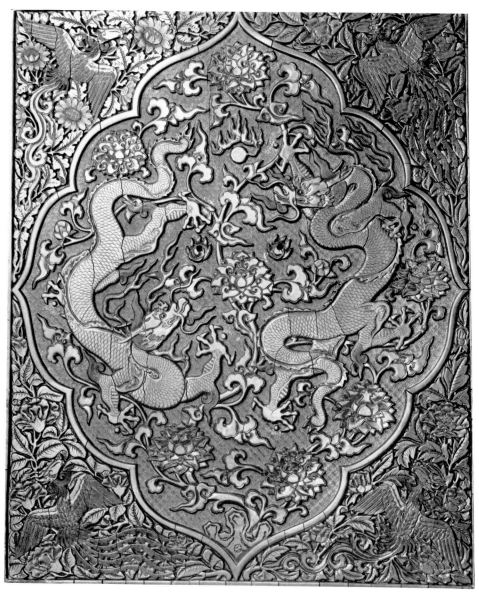

37. RECTANGULAR PANEL carved with dragons against a ground of peonies, and with
phoenix corner-pieces
15th century. 44·2 by 36·1 cm
British Museum

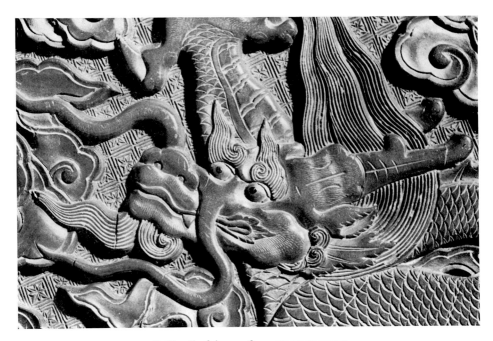

38. Detail of dragon from CIRCULAR PANEL
15th century
Victoria and Albert Museum

Far Eastern Antiquities, Stockholm.[24] The second piece is a bowl-stand decorated with phoenixes against a background of lotus scrolls. This was formerly in the Peking Palace Collection and it bears an inscription by the Emperor Ch'ien-lung, dated 1781, incised and filled in with gold inside the bowl. Both pieces were exhibited in the Oriental Ceramic Society's *Arts of the Ming Dynasty* in 1957.[25]

Two boxes with decoration of Buddhist significance must be mentioned. The first, in the Seattle Art Museum, is decorated on the top with the eight Buddhist emblems and on the sides with lotus scrolls (Plate 39). The second box, in the British Museum, belongs to a rare group of fifteenth-century boxes in which the cylindrical shape is replaced by a round one (Plate 40). It seems likely that this shape is an indication of a somewhat later date, and this box is ascribed to the second half of the fifteenth century. The decoration of two Buddhist lions sporting with a brocade ball against a background of clouds shows delicate incised details, very much worn, but still visible in the illustration. A pair to this box, from the Palace Collection, is in the National Palace Museum, Taiwan. Another beautiful box of this shape is decorated with narcissus sprays. It was formerly in the Sedgwick Collection and is now in the British Museum.[26]

The marks on the official fifteenth-century wares have been subject to much discussion since the sixteenth century. A large proportion of the pieces bear either the Yung-lo or Hsüan-tê mark, in six characters, nearly always placed on the left-hand edge of the base. The Yung-lo mark is invariably incised with a needle, while the Hsüan-tê mark is cut with a knife and filled in with gold.

A very close study of these marks has convinced me that none of the Yung-lo marks and very few of the Hsüan-tê ones are contemporary with the piece. They were, however, almost certainly in existence in the second half of the sixteenth century, as we know from contemporary references in the Chinese literature. An interesting feature of the marks, one that very rarely occurs in other artifacts, is the inscription of both the Yung-lo and Hsüan-tê marks on the same piece, generally but not always with the latter superposed on the former, which is sometimes partially erased. I have examined in detail seven pieces with the two marks, in several of which the Yung-lo mark is almost indecipherable. There must be a few other pieces with the two marks that are not recorded, which may well come to light when the bases have been critically examined.

Many conjectures on the reason for these marks have been put forward. The most reasonable explanation is that the marks were inscribed in the Palace storeroom to indicate the reign to which the court officials thought they belonged. The superscription of the Hsüan-tê mark over the Yung-lo one would thus indicate a change of opinion on the part of the officials. Most of the marks were added in the sixteenth century, in my opinion, often over a relacquered base, but there are some Hsüan-tê marks, very few in number, applied to the original base, which could possibly belong to the fifteenth century, if not to the actual period.

[24] The box is fully described by Jan Wirgin, 'An early fifteenth-century lacquer box', *Bulletin of the Museum of Far Eastern Antiquities*, Vol. 38, 1966.

[25] Nos. 236 and 234 respectively.

[26] Illustrated in *The Arts of the Ming Dynasty*, No. 229.

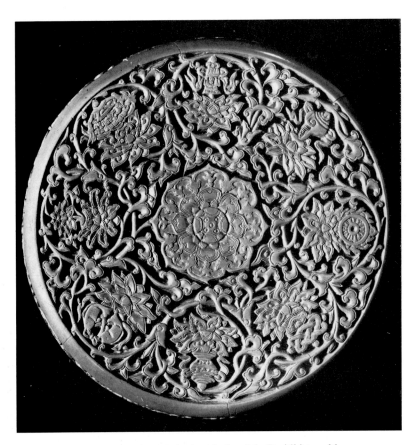

39. CYLINDRICAL BOX carved with the eight Buddhist emblems
15th century. Diameter 13·3 cm
Seattle Art Museum

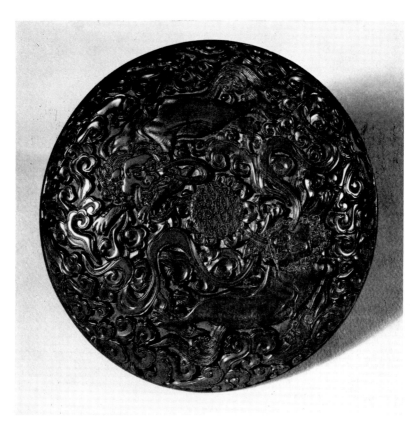

40. ROUND BOX carved with Buddhist lions among clouds
 Second half, 15th century. Diameter 13 cm
 British Museum

The presence of Yung-lo and Hsüan-tê marks thus by no means indicates any attempt at deception. Very few marks of this kind are found on pieces not genuinely belonging to the fifteenth century. This combination is an unusual feature in objects of Chinese art, in which the addition of fictitious marks has long been a widespread practice. Thus the marks on the lacquerwares may be regarded as supporting a fifteenth-century origin, although many of those with the Yung-lo mark are certainly later than the mark indicates. Moreover, as we shall see, there is a strong presumption that some of the pieces with this mark may belong to the end of the fourteenth century, some years before Yung-lo came to the throne.

The view formerly held by Chinese, Japanese and Western authorities alike, that all the fifteenth-century official lacquerwares were made either in the reign of Yung-lo or Hsüan-tê and that no official wares were made after these two reigns until manufacture commenced of the imperial wares of the Chia-ching period (1522-66), left a gap of nearly ninety years during which no carved lacquerwares were made for the court. This view is no longer tenable. The fact that none of the Yung-lo and very few of the Hsüan-tê marks are contemporary with the piece is now inescapable, but we are left with the more difficult problem of determining the period during which the official wares were made. I think it is quite possible that manufacture extended throughout almost the whole of the fifteenth century. Two of the boxes already described, that decorated with Buddhist lions (Plate 40) and the narcissus box formerly in the Sedgwick Collection, have already been attributed to the second half of the fifteenth century. It must be admitted that the uniformity of style and technique of the official wares makes it difficult to determine which pieces in the groups belong to the first and which to the second half of the century. But this should not blind us to the fact that it is completely unreasonable to accept a complete gap in the production of lacquerwares for the court over a period of more than fifty years.

A somewhat similar gap in the dating of blue and white porcelain existed some thirty or forty years ago. The general view then held was that no official wares were made after the end of the reign of Hsüan-tê in 1435 up to the beginning of the reign of Ch'êng-hua in 1465. These thirty years were called the 'interregnum'. We now know that there is no evidence to support the idea of a cessation in the manufacture of blue and white porcelain during the interregnum and that indeed many pieces were made during this period bearing the Hsüan-tê mark, which has now lost the importance once attributed to it, although there are probably a small number of marked pieces actually belonging to the period. In lacquer, of course, the situation is far more difficult and it will take longer to arrive at the truth than it has done in the blue and white porcelain wares. Thus, while the group of official fifteenth-century wares is well defined, the relative dating remains obscure. The attempt is here made to place a few pieces tentatively in the second half of the fifteenth century (Plate 40) and one indeed to a date before the beginning of the Yung-lo reign (Plate 36), but this is a mere shadow of what needs to be done in the more precise dating of what is one of the most important groups of lacquer ever made.

There are a number of pieces allied to the official wares which are however of lower quality and differ from the official wares in essential details. Most of them are datable to the sixteenth century, but there are a few that have claims to belong to the

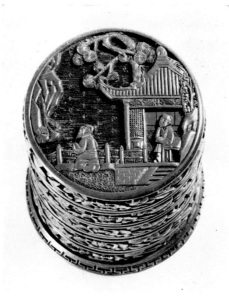

42. CYLINDRICAL TIERED BOX carved with land-
scape on the top and with floral borders
Late 15th century. Height 7·6 cm
Victoria and Albert Museum

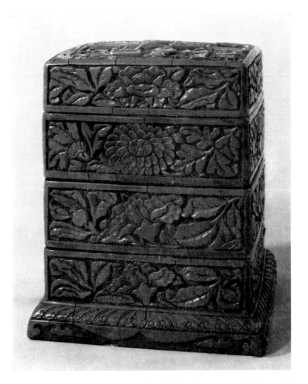

41. SQUARE TIERED BOX carved with landscape on the top and
with floral borders
Late 15th century. Height 14·5 cm
British Museum

late fifteenth century. The two tiered boxes in Plates 41 and 42 are two such pieces. They follow the official wares fairly closely in design. Indeed the floral borders of the former are close to the borders of the official group, but there are differences in design and construction in such details as the position of the guide-line. It is an interesting fact that no tiered boxes are known belonging to the official group although, as we shall see later, such boxes were officially sent from China to Japan as early as the first year of Yung-lo (1403).

FOURTEENTH-CENTURY AND ALLIED WARES

While knowledge of the official fifteenth-century carved lacquerwares among connoisseurs was well established in China from the time of manufacture onwards, and in Europe for the last hundred years or so, no pieces now attributed to the fourteenth century appear to have been accepted as such until comparatively recently. Nor do there seem to have been any pieces in the Chinese Imperial Collection or other early Chinese collections, although the account of Yüan lacquer-wares made by Chang Ch'êng and Yang Mao given in the *Ko-ku yao-lun* was accepted as genuine by Chinese connoisseurs. The evidence that has enabled specific pieces to be ascribed to the fourteenth century has come entirely from Japan, except for the most recent evidence of an incense-box from a tomb of the Yüan dynasty, excavated in 1953. A great interest in Chinese lacquer by British collectors in the early 1950s led to many fine pieces being sent from Japan to Great Britain at this time. This interest owed a good deal to Sir Percival David, who had in fact collected important pieces of lacquer much earlier, some of which were included in the International Exhibition of Chinese Art in London in 1935-6. He continued his interest after the Second World War. The pieces sent from Japan included a number that began to be ascribed to the fourteenth century. In addition, documentary evidence of the export of early carved lacquerwares from China to Japan in the fourteenth and early fifteenth centuries helped to confirm this early date. The presentation of the documentary evidence to Western students was largely due to Sir John Figgess, who indeed has acted as a general interpreter on the Chinese lacquerwares in Japan to the Western world. His papers on the subject are mentioned and summarized below.

We have already seen in Chapter 3 that from the time of the introduction of Buddhism from China to Japan round about the seventh century there were close contacts between the two countries which led to a rapidly expanding lacquer industry in Japan. But by the time of the Yüan dynasty the relations between the two countries had become less cordial. Two unsuccessful attempts to invade Japan were made by the Mongols in the Yüan dynasty, first in 1274 and then in 1281, and these stimulated an intense nationalistic feeling in Japan, which persisted even when the Ming dynasty was established in 1368. This prevented the Chinese from re-introducing the tributory system that had existed in the T'ang dynasty and was still in operation in almost every other country in East Asia. But in spite of the official unfriendly relationship, there was a close and almost continuous interchange of religious ideas between the Buddhist priests of the two countries, associated with which was the import into Japan of Chinese religious books, many of which were

printed in Korea. Associated works of art, such as religious paintings, were also sent. The objects included lacquer sutra boxes, made for the storage of Buddhist sutras. We shall see in Chapter 8 that a number of Chinese sutra boxes in the *ch'iang-chin* technique inscribed and dated to 1315 are preserved in Japanese temples today, although no box of this type has been found in China. The sending of these boxes at a time when official communications can hardly have existed is evidence of close, though surreptitious, contacts.

In carved lacquer, there are a number of vessels listed in a catalogue of works of art in the collection of the Hōjō regents of Kamakura dated 1363, at the end of the Yüan dynasty. The catalogue, the *Butsu-nichi-an kōmotsu mokuroku*, describes vessels, some in red and some in black, in the form of round and square trays, bowls, incense-boxes, tea-caddies and tiered food-boxes which were in the Butsu-nichi-an, a sub-temple of the Engaku-ji Temple, Kamakura, where the list is preserved today.[27] The list shows that there must have been an extensive manufacture of carved lacquerwares before the end of the Yüan dynasty. None of these objects can be identified today, although there are vessels answering these broad descriptions to be found in Japan and elsewhere.

We now come to what is by far the most important detailed information on early carved lacquerwares that has been brought to light. It consists of lists of objects, including lacquerwares, sent from China to Japan in the early fifteenth century. The lists, for the years 1403, 1406, 1407, 1433 and 1434, are preserved in the Myōchi-in Temple, a sub-temple of the Tenryū-ji Temple, Saga. They were first published, as far as can be ascertained, by Makita in 1955.[28] The lists are copies of original Chinese documents, considered by Japanese literary experts to be nearly contemporary with the originals. Fortunately one of the original lists, that for 1407, has been preserved in the Reimei-kai Museum in Nagoya.[29] It is an imposing document, written on paper decorated with imperial dragons and clouds in gold. Except for one small detail, the items agree exactly with those in the Tenryū-ji copy. This inspires confidence in the authenticity and accuracy of the rest of the lists.

None of these lists, as far as is known, are preserved in China, although a large number of Chinese edicts sent to Japan in the late Yüan and early Ming dynasties are recorded. These have been dealt with at length by Wang Yi-t'ung.[30] The edicts for the years in question are nearly all referred to by Wang, but they do not include the supplementary lists of gifts. The reasons why the Chinese have not preserved the lists must be that they were considered to be of little importance as compared with the edicts themselves, which dealt with matters of protocol and were very much concerned with criticisms of the Japanese, who would not, or could not,

[27] See John Figgess, 'Ming and pre-Ming lacquer in the Japanese tea ceremony', Ref. E31, for this and further information on the early wares preserved in Japan.

[28] T. Makita, *Sakugen-nyūmin-ki no-kenkū* (A study of Sakugen's visit to Ming China), Kyoto, 1955-9. This work is based on the writings of the Buddhist monk Sakugen, about his two visits to China in the mid-sixteenth century. The original documents, like the lists, are in the Myōchi-in and the lists are clearly included in the book as relevant to Sakugen's account. See also Ref. E34 for a full study of the lists.

[29] John Figgess, 'A letter from the court of Yung-lo', Ref. E23.

[30] Wang Yi-t'ung, 'Official relations between China and Japan, 1368-1549', Ref. E18.

prevent Japanese pirates from interfering with Chinese trade. On the other hand, the Japanese have not preserved the Chinese critical edicts, but have preserved the lists of Chinese objects of art, which have been treasured and handed down in temples and by the tea masters.

Of the five lists mentioned, only the first three, for 1403, 1406 and 1407 include carved lacquerwares. The numbers of pieces in these lists are fifty-eight, ninety-five and fifty respectively. By far the most important list is that for 1403, because in this list nearly all the objects are described in some detail, generally sufficient for us to be able to identify the decoration and compare it with that of pieces existing today. The list of 1406 gives no details, except to tell us that there were forty dishes of eight different kinds, while the 1407 list gives the diameter of twenty apparently identical dishes, and includes twenty incense-boxes, without any further details.

The 1403 list gives not only details of decoration, but in many of the items gives the three dimensions, something that is rarely found in the descriptions of exhibition catalogues even today. In the dishes, fourteen in number, the main description on the front, the floral border round the edge and the decoration round the edge beneath are all described. Before studying these, we should examine the significance of the date 1403. This was the year in which Yung-lo came to the throne. It has already been pointed out that the time taken to manufacture a piece of carved lacquer was two years or more, so that it appears likely that work on the pieces sent to Japan in 1403 must have started some three years before they were made, inspected and assembled for despatch. Moreover, the designs on which the pieces were based must have been laid down some time before manufacture started. We can say therefore that the lacquerwares in the 1403 list were typical of carved lacquer of the late fourteenth century. We may note that some of the designs are similar to those given in the *Ko-ku yao-lun* twelve years before the end of the century.

The designs have been discussed at length in the paper already mentioned and the reader who wishes to go into the subject in detail should study this.[31] The Japanese copy of the original Chinese text is reproduced in facsimile and a complete translation is given. A brief survey of the designs reveals the surprising fact that few of them are to be found in the official wares of the fifteenth century, in which there are only landscape and floral dishes similar to those in the list. On the other hand, the large cylindrical boxes in the official group with floral and landscape decoration, which form by far the largest proportion of the official wares, are not found at all in the list. A particularly interesting group in the list comprises four small boxes decorated on the top with a landscape and on the sides with key-fret or Buddhist lotus borders. Two of these boxes have a single compartment and are described as 'incense-boxes' and two have a number of compartments and are described as 'incense-containers'. This type of box is not included in the official wares although we know, as we shall see later, that such boxes were made as early as 1351. A number of similar boxes with this decoration, of undoubted Chinese provenance, were made in the sixteenth and seventeenth centuries. There are also late Japanese copies.

Perhaps the most surprising feature of the 1403 list is the inclusion of six large

[31] Ref. E34.

dishes, all of the same size, but differently decorated with a variety of birds against floral grounds. There is also a single dish with a landscape without figures or buildings. These designs do not appear on any pieces in the official group.

It is generally agreed by students of carved lacquer today that there are a number of pieces with designs similar to those found in the 1403 list that undoubtedly belong to the fourteenth century. But there are considerable disagreements in the attribution of dates to individual pieces. The differences of opinion seem to be due to the fact that over-optimistic collectors are inclined to attribute any piece with fourteenth-century designs to that century, so that more conservative collectors tend to react to these opinions by discarding some pieces that have good claims to be early.

I suggest that manufacture of the fourteenth-century types continued in China throughout the fifteenth century and beyond, although many of the types never found favour in the official factories. We have seen that the official wares, splendid as they are, were strictly controlled in their designs and this may explain why many of the fourteenth-century types never gained a foothold in the official factories. A number of controversial pieces, wrongly attributed today to the fourteenth century, may well belong to the fifteenth or even the sixteenth century.

At some stage the manufacture of carved lacquer was introduced to Japan and it is necessary to consider the evidence on the date of introduction. This is a difficult problem and it is not made easier by the Japanese themselves, who are reluctant to attribute pieces of carved lacquer which appear to be of any considerable age to any country but China. The earliest tradition of carved lacquerwares in Japan is that they were made by a Japanese lacquerer Monnyu in the second half of the fifteenth century, but no pieces attributed to him are known. A later tradition, that the Tsuishu School made carved lacquerwares based on Yüan originals at the beginning of the seventeenth century is also unsupported by any attributions.[32] The earliest piece of lacquer carved in this style, illustrated by von Ragué, is a black box carved with two birds against a background of peonies. It is attributed to the seventeenth century, but von Ragué admits that there is no factual evidence to support this date.[33] She appears to be the only writer who has given any serious consideration to the possibility of early manufacture in Japan. She has pointed out that failure to study this vital question by the Japanese is surprising in a country so interested in lacquer art and goes on to say that this is a subject in which all the evidence is in Japan and that it cannot be adequately dealt with by Western scholars. There is much to support this view, but it must be pointed out that the study will need a critical assessment of the traditional evidence on dating, which has not always been present in past studies.[34]

We may summarize the above analysis of pieces made in what we may describe as in fourteenth-century style by postulating three groups:

[32] Dr. von Ragué's views are given in her remarks at the Yüan Art Symposium, Cleveland in 1968. See Ref. E30.

[33] Ref. E30, Plate 135.

[34] We may note, for example, that in the Exhibition of Chinese Ming and Ch'ing Art held in Tokyo in 1963 a number of pieces of Japanese lacquer of the eighteenth century were described as Ming.

1. Chinese fourteenth-century wares.
2. Chinese later wares stretching from the fifteenth century onwards.
3. Japanese wares. On present evidence none of these are earlier than the seventeenth century.

A number of pieces belonging to the first two groups will now be described and illustrated. I have deliberately confined the pieces to those I have had an opportunity of seeing and handling because the method of construction and other technical features provide valuable evidence which can only be assessed properly at first hand. This explains why many important pieces which have very strong claims to a fourteenth-century date, as well as pieces belonging to the fifteenth century in Japanese collections, are not discussed here. The separation of pieces belonging to these two centuries presents a particularly formidable problem.

One feature of the fourteenth-century wares is a weakness in construction which is described in the *Ko-ku yao-lun* as particularly noticeable in the carved red lacquerwares. The description of carved red lacquer says that 'the pieces with landscapes and human figures and with flowers, trees, birds and animals, although the workmanship is of the finest, are liable to break off.' The structural weakness of pieces made in the late Yüan dynasty by Chang Ch'êng and Yang Mao is also mentioned in the *Ko-ku yao-lun* under the heading *hsi-p'i*.

We have already seen that the official wares of the fifteenth century were exceptionally well made. The attachment of the lacquer layers to the base is very firm and there is no tendency for the lacquer to break away. Moreover there is little distortion to be found in the bodies of the vessels after some five hundred years of wear and tear. The structural weakness of the fourteenth-century wares, it must be noted, is associated in the description in the *Ko-ku yao-lun* with the finest of workmanship in other respects and these two contrasting qualities must be looked for in the search for genuine fourteenth-century carved wares.

There is one group of pieces, the dishes decorated with birds in flight against a floral background, of which there are six examples in the 1403 list, that seem to have very good claims to belong to the fourteenth century, although there are many late copies. It is convenient to describe these as 'two-bird dishes'. There are probably in existence today some twenty pieces with 'two-bird' decoration, nearly all dishes, belonging to the fourteenth or fifteenth centuries. A typical fourteenth-century dish, of black lacquer, in the Honolulu Academy of Arts, is illustrated in Plate 43. The decoration of two pheasants in flight against a background of hibiscus or mallow is very similar to that in one of the dishes in the 1403 list, except that it has a spiral scroll border underneath instead of a hibiscus scroll. The spiral scroll border, however, occurs in five of the dishes in the list, and is mentioned twice as a feature of decoration in the *Ko-ku yao-lun*. The term used for it, *hsiang ts'ao*, literally 'fragrant grass', occurs frequently in the Chinese literature. In spite of the common use of the spiral scroll in the fourteenth century, it is only known to occur on one piece in the official fifteenth-century group, an oval dish decorated with a landscape surrounded by a floral border.[35]

[35] The dish is described and illustrated in Ref. E34. One oval dish with similar decoration is included in the 1403 list. It may be argued that the dish in question is likely to

The quality of the lacquer in the 'two-bird' dishes seems to be exceptionally high and the careful method of construction, with fabric all over the base, should have combined to make a structurally sound vessel. It is difficult to understand why the final results turned out to be unsatisfactory. The breaking away of the whole of the lacquer band from the base suggests that the lacquer was extremely hard and not sufficiently flexible to accommodate the strains that have inevitably taken place as the wooden base contracted in drying over the years. Another feature of the lacquer is that the surfaces tend to become concave, in contrast with the flat surfaces of the fifteenth-century wares. This may imply some fault in the application of the separate layers of lacquer.

Criticisms of the designs of many of the fourteenth-century lacquerwares have been made, and particularly of the 'two-bird' dishes. These criticisms have been based on a comparison of the designs with those of the official fifteenth-century wares. The differences have seemed to me for many years to be similar to those found between the fourteenth-century blue and white wares, with their wayward patterns, and the Ming imperial wares of the fifteenth century, with their closely controlled balance of design. It may be recalled that the fourteenth-century blue and white wares were not recognized as such, either in China or the West, until some fifty years ago. There were plenty of the fourteenth-century wares in the West, but they were attributed to the sixteenth century. In China, no fourteenth-century wares were to be found in the imperial collections and there seems to be no mention of individual pieces in official records or the many accounts of porcelain written by connoisseurs from the sixteenth century onwards.

The argument that the 'two-bird' dishes are much later than the fifteenth century and that they are Japanese in provenance was strongly put forward by Fritz Low-Beer on stylistic grounds and his views are given in a posthumous paper prepared by Beatrix von Ragué.[36] While I have a great admiration for Low-Beer's work on Chinese lacquer of all types and periods, as will be seen from the many tributes paid to him throughout this book, I cannot agree with his arguments on this point. I think his views are too strongly influenced by his concentration on the fifteenth-century official wares, on which he was an outstanding authority. The stylistic differences between these and such pieces as the 'two-bird' dishes must be evident to anyone who has studied them but, as I have said, they are closely paralleled by similar differences in blue and white porcelain. The position on lacquer is more complicated than it is on porcelain, in that copies of the early wares were made in the sixteenth and seventeenth centuries, not only in China but also in Japan.

Low-Beer's arguments are based largely on the arrangement of the floral backgrounds, particularly round the edges of the dishes. I propose, in the first place, to discuss three of the 'two-bird' dishes which I consider to belong to the fourteenth century and then to pass on to a few pieces which are much later. Two of the earlier dishes are in black lacquer and the third is in red. The first dish, already described in the Honolulu Academy of Art, is illustrated in Plate 43. The carving of the two

belong to the fourteenth century, but its qualities suggest an early fifteenth-century date rather than a fourteenth-century one.

[36] *Oriental Art*, N.S., XXII (2), 1976.

pheasants against the background of hibiscus is very competent, almost entirely done with the knife, and the design is free and vigorous. These qualities seem to most connoisseurs to support a late Yüan or early Ming date. The back of the dish, like a number of those in the 1403 list, is decorated with a spiral scroll. The second black dish, in the British Museum, is illustrated in Plate 44. The decoration is of two water-fowl against a background of lotus and other water-plants, and it also has a spiral scroll border beneath.

There are a number of dishes similar in design to these in red lacquer, including the famous dish decorated with a peacock and peahen against a mixed floral ground in the Daitoku-ji, Kyoto, which is said to have been presented to the Temple in 1509.[37] I am inclined to the view that this dish belongs to the fifteenth rather than the fourteenth century, but this is based only on photographic evidence. A second red dish, also decorated with peacocks, in the British Museum, is illustrated in Plate 45. This I think has good claims to belong to the fourteenth century. All the three dishes illustrated here are badly distorted, with the lacquer in places almost broken away from the base. The structural defects, hardly noticeable in the illustrations, appear to be very close to those described in the *Ko-ku yao-lun* as a feature of the early carved wares.

The stylistic arguments put forward by Low-Beer[38] suggest that the arrangements of the flower sprays illustrated in Plates 43 and 44 lack co-ordination and that the dishes are late copies probably made in Japan. On the other hand, he accepts the dish illustrated in Plate 45 as one of the few early pieces. A study of the background designs shows that this dish has undoubtedly a more orderly arrangement of the floral pattern than that of the other two. My interpretation of the differences is that the dish in Plate 45 is later than the other two, showing the introduction of the Ming influence that led to the qualities of the official wares of the fifteenth century. It may well be that this dish belongs to the end of the fourteenth century. The two black dishes are thought to be earlier, possibly as early as the Yüan dynasty.

Two later copies of the fourteenth-century designs are illustrated in Plates 46 and 47. The box in Plate 46, formerly in the David Collection, is decorated with two birds on the top set against a background of prunus and other flower sprays and with floral borders on the sides. The flower-pot or leys-jar (*ch'u-tu*) in Plate 47, with similar floral decoration but without the birds, in the Peking Palace Museum, has remarkably similar qualities to those of the box in Plate 46.[39] Both are carved in a bright red lacquer down to a buff ground. The thickness of the lacquer is much less than in the fourteenth-century dishes or the official fifteenth-century wares, although the quality of the carving is high. The flower-pot has been ascribed in China to the Yüan dynasty and the box, which was purchased by Sir Percival David in Japan, was given a Yüan attribution there. To complete the close similarity of the two pieces, it should be added that they both have the mark *Yang Mao tsao*.

[37] Published in many Japanese works. Perhaps the most convenient illustration for Western readers is that given in Ref. E31.

[38] F. Low-Beer, 'Carved lacquer of the Yüan dynasty: a Reassessment', *Oriental Art*, N.S., XXIII (3), 1977.

[39] The flower-pot is described and illustrated in *Wên-wu*, 1956, No. 10, pp. 57–8.

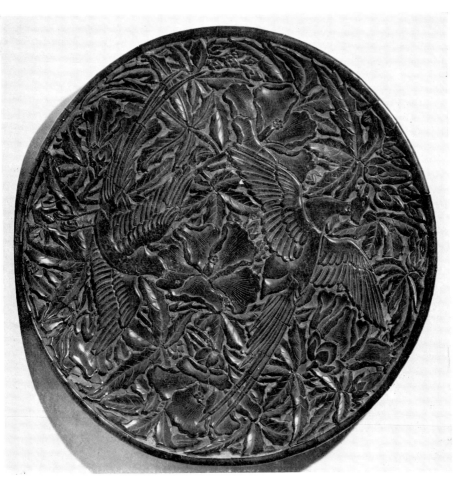

43. Black lacquer DISH carved with two pheasants against a ground of hibiscus
14th century. Diameter 31·7 cm
Honolulu Academy of Arts

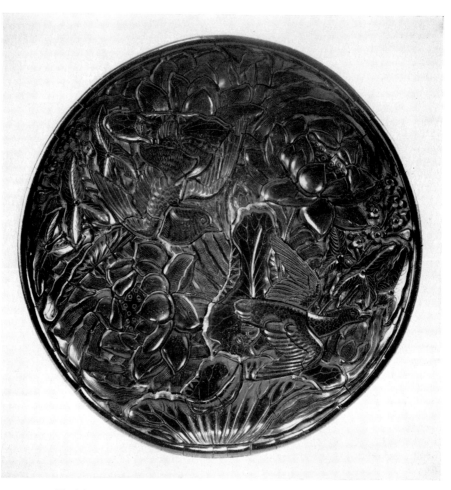

44. Black lacquer DISH carved with two water-fowl against a ground of lotus and
other water-plants
14th century. Diameter 30 cm
British Museum

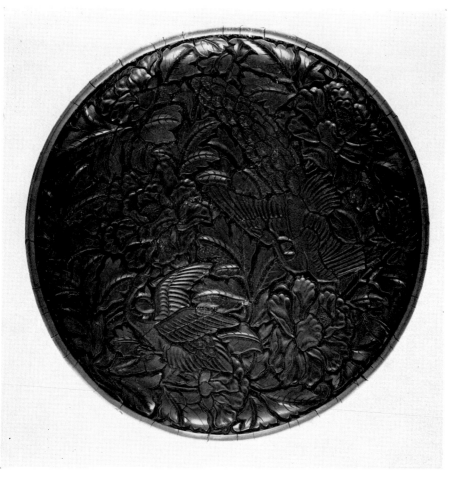

45. Red lacquer DISH carved with two peacocks against a ground of tree peonies
14th century. Diameter 32·6 cm
British Museum

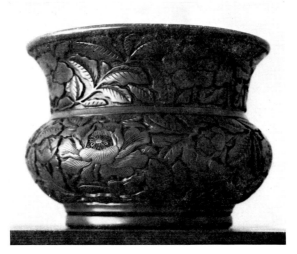

47. FLOWER-POT carved with floral designs
16th–17th century. Height 9·5 cm
Palace Museum, Peking

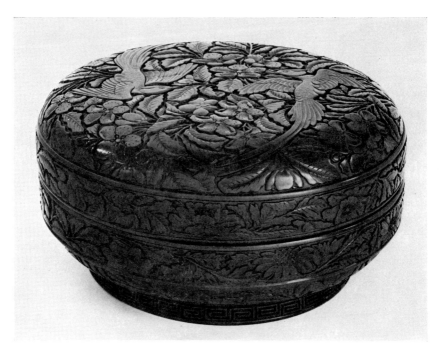

46. BOX of red lacquer carved with two birds on a floral ground on the top and
with floral borders on the sides
16th–17th century. Diameter 24·2 cm
Victoria and Albert Museum

In spite of the attributions mentioned, I do not think that these two pieces are earlier than the second half of the sixteenth century.

After the 'two-bird' decoration, the most frequent subject found in the 1403 list is that of landscapes with figures. This subject, as we have seen, was very common among the official wares of the fifteenth century and examples of dishes and boxes with landscapes bordered by the flowers of the four seasons have been discussed and illustrated (Plates 29, 30 and 31). But there are, in the 1403 list, as I have already pointed out, small incense-boxes with landscapes on the top and with key-fret or Buddhist lotus borders on the sides, which are unknown among the official wares, although they are common enough among the non-official lacquerwares of the sixteenth century and later. The excavation in 1953 at Ch'ing-p'u hsien in Kiangsu Province, of an incense-box, datable to not later than 1351, similar to one in the 1403 list, thus becomes of extreme importance in establishing that a type of box described in the list was being made more than fifty years earlier.[40] The excavated box is illustrated in Plate 48. Unfortunately the illustration is not clear enough to give more than a general idea of its decoration. The box however was exhibited in the Chinese Exhibition of excavated objects in 1973 which was held in Paris and London, and so is familiar to many Western students.[41]

It cannot be claimed that the box is comparable in quality with the official fifteenth-century wares. It is indeed what we should expect in an early example of carved landscape decoration. Nor is the stylistic treatment very close to that of the official fifteenth-century wares. But we see in this early box the beginning of the carved diaper grounds, later to become standardized with the use of three diapers representing land, water and air, which started in the late fourteenth century and was still in use in the eighteenth. The two diapers in the box represent land and water. The latter is of special interest, being in the eddying form, quite different from the humped form that was standard in the fifteenth-century official wares and the later imperial wares. The eddying form however did persist in the later pieces that followed the fourteenth-century traditions.[42]

In both the *Ko-ku yao-lun* and the *Cho-kêng lu* there are several distinct groups of landscape decoration. One, generally described by the term *Jên wu ku shih*, describes a type of landscape which has human figures depicting a story. All the landscapes in the official group are of this type. But there are several other types, which mention trees, birds, animals and rocks, without human figures.[43] Such dishes are included in the 1403 list. Although no landscapes of this type are to be found in the official wares, some fine pieces are known which have been attributed to the fourteenth or fifteenth century. The lobed dish in the British Museum, formerly in the David Collection, illustrated in Plate 49, is one of these. It is carved in black lacquer on a red ground and it has the eddying form of the wave diaper. It has been given a fourteenth-century date, but at this stage a fifteenth-century date cannot be ruled out.

[40] *Kiangsu shêng ch'u-t'u wên-wu hsüan-chi*, Wên-wu Publications, 1963, No. 304.
[41] *The Genius of China*, 1973, No. 373.
[42] See Ref. E28 for a full discussion of the diaper grounds. The only example of the eddying type of diaper in the official wares is on a box in the Nezu Art Gallery (illustrated in Ref. E31, Plate 51b), where it appears in addition to the humped wave form.
[43] Ref. E34.

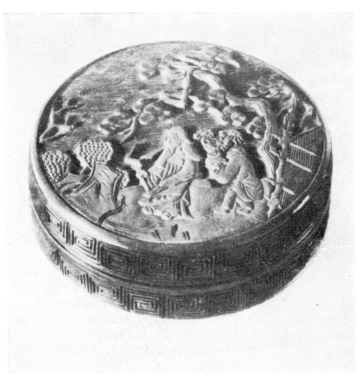

48. INCENSE-BOX carved with landscape. Excavated at Ch'ing-p'u hsien
A.D. 1351 or earlier. Diameter 11·7 cm

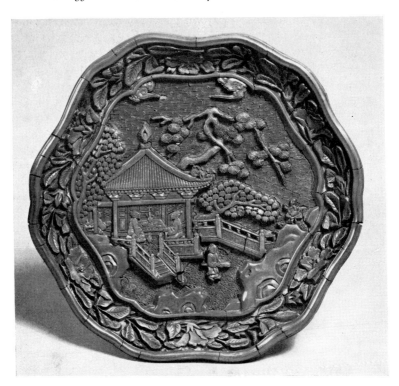

50. LOBED DISH carved with landscape
Late 14th century. Diameter 18 cm
Victoria and Albert Museum

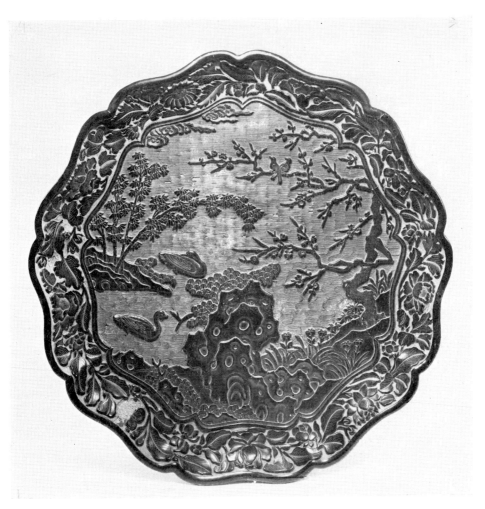

49. LOBED DISH carved in black on a red ground with landscape
14th or 15th century. Diameter 38·2 cm
British Museum

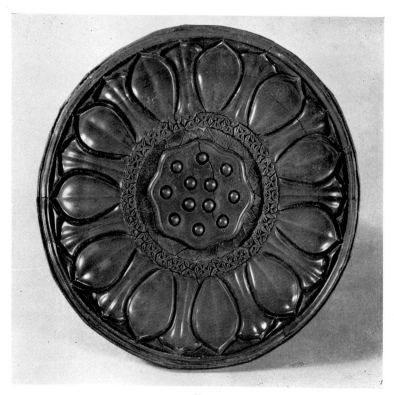

51

52

51, 52. DISH carved with lotus flower above (Plate 51) and spiral scroll border
beneath (Plate 52)
14th century. Diameter 18·3 cm
British Museum

Another dish, which has similar diapers to those of the fifteenth-century official wares, in the Victoria and Albert Museum, is illustrated in Plate 50. It has a floral border of a single species, probably belonging to the mallow family, and a spiral scroll border underneath. This is attributed to the late fourteenth century.

Another group of dishes, some of which have claims to belong to the fourteenth century, are carved in red or black lacquer, with a single stylized lotus flower on the front. One of the earliest of these, in red lacquer, is shown in Plate 51. It has a spiral scroll border beneath (Plate 52) and the general appearance of the base, both in the design of the border and the techniques of construction, is very similar to that of the 'two-bird' dishes in Plate 43, 44 and 45. The lotus dish has a marked distortion and breaking away of the lacquer. The design on the front of the dish, with a ring of eleven petals round the rim and a seed pod in the centre, separated by a ring of waves and another of petals, is highly stylized. The choice of such an odd number as eleven for the petals seems to be a feature of the experimental period between the Sung and Ming dynasties, which is manifested in porcelain as well as lacquer. In porcelain some of the large blue and white dishes are made with thirteen foliations, which must have posed difficulties in design and construction.[44] In lacquer, the usual five, six or eight lobes of the Sung dynasty were sometimes replaced by seven lobes, as instanced by the dish with overlapping petals (Plate 21) and a foliated dish in the Freer Gallery of Art.[45]

The dish in Plate 51 bears on the black lacquered base the incised mark *Chang Ch'êng tsao*. The mark is of some age but, as I have already said, there is no justification for attributing this or any other of the pieces bearing the Chang Ch'êng or Yang Mao mark to either of these two lacquerers. Nevertheless, I think that the dish has good claims to belong to the fourteenth century and possibly the Yüan dynasty.[46]

THE CARVED AND FLAT MARBLED WARES

To complete the account of the carved lacquerwares of the Yüan and early Ming dynasties it is necessary to discuss the carved marbled wares and with them the flat marbled wares, although there is no present evidence of the latter being made before the sixteenth century, in spite of the Chinese association of these wares with the type known as *hsi-p'i*.[47]

As I pointed out at the beginning of this chapter, there is no evidence of the manufacture of the carved marbled wares between the Fort Miran armour of the T'ang dynasty and the late fourteenth-century wares, although it is extremely likely that some were made in this period. The decoration of nearly all the carved marbled wares is confined to *ju-i* head and spiral scroll designs, generally arranged in annular groups placed horizontally round the vessels. The bands of colour are nearly always red, black and yellow, the colours mentioned in the *Yin-hua-lu* and the *Yên-fan-lu*,

[44] Margaret Medley, *Yüan Porcelain and Stoneware*, p. 40.

[45] See footnote 44, p. 50.

[46] Jean-Pierre Dubosc, in his paper 'Pre-Ming lacquer', *The Connoisseur*, August 1967, describes a number of dishes with lotus flower decoration. Some of these, in my opinion, are much later than the dish described here.

[47] See Chapter 5.

and also found in the Fort Miran armour. At some stage other colours were intro-
duced, including green and various distinct shades of red. As far as green lacquer is
concerned, its earliest known use in the pictorial lacquerwares occurs in the late
fifteenth century, in the famous dish dated 1489.[48] This by no means rules out an
earlier use of green in the carved marbled wares, but it would be rash at this stage
to say when this colour was introduced.

In Chapter 5 the decoration of the bowl-stand in Plate 27 has been compared
with that of a typical Chi-chou stoneware vase datable to the Yüan dynasty. The
bowl-stand is undoubtedly fairly early, but the use of green lacquer makes it
doubtful whether it can be ascribed to the Yüan dynasty. The colour scheme of the
bands of decoration is similar to that of the unusual lobed box illustrated in Plate 57,
also in the British Museum. This has generally been given an early sixteenth-
century date, but it may well belong to the previous century. Tentative dates for
the bowl-stand and lobed box of early fifteenth and late fifteenth century respec-
tively are suggested.

There has been a general tendency to give the earliest dates to the more simple
vessels, with relatively few bands of colour, such as the bowls illustrated in Plates
53 and 54. The former is carved in V-shaped grooves with alternate bands of red
and black down to a yellow base. The latter, also with red and black bands, has
rounded grooves with a black base. These are dated with some hesitation to the
fourteenth or the first half of the fifteenth century.[49] Both types continued to be
made throughout the sixteenth and seventeenth centuries, but the type with
V-shaped grooves became dominant at the end of the sixteenth century.

Two later pieces, which can be confidently attributed to the sixteenth century,
are the box in Plate 55 and the libation-cup in Plate 56. The box, with three
annular bands of ten, fourteen and eight *ju-i* motifs in succession, the numbers
being adjusted so as to give a uniform size to the individual elements, has a central
medallion with the characters *T'ien-hsia t'ai-p'ing*, 'May peace prevail throughout
the world', enclosing a *shou* character. The box seems to be the only recorded piece
of carved lacquer with an inscription incorporated in the design. The libation-cup,
in a shape that can be matched in sixteenth-century porcelain, is of interest in
showing the ingenuity of the craftsman in fitting the carved spiral elements to an
irregular shape of vessel.

In the late sixteenth and early seventeenth centuries carved marbled lacquerwares
were given added decoration in mother-of-pearl and gold painting. A square box in
the Royal Scottish Museum, Edinburgh is decorated with a landscape in mother-
of-pearl on the top, with borders of carved marbled lacquer,[50] and a pair of dishes
with landscapes in gold on the front and carved *ju-i* heads on the back were
exhibited in the British Museum Exhibition in 1973.[51]

Many carved marbled wares, based on the Chinese, were made in Japan from the
eighteenth century onwards, where they are known by the term *guri* (see Chapter 5).

[48] See Chapter 7, Colour Plate C.
[49] Similar examples are illustrated by Jan Wirgin, Ref. E37 and Yu-kuan Lee, Ref. E25,
where they are given Yüan and even Sung attributions.
[50] Ref. E30. Plate 21C.
[51] Ref. E41, No. 18. The gold decoration on one of the dishes is shown in Plate 149.

53. CUP, carved marbled lacquer
14th–15th century. Diameter 6·4 cm
British Museum

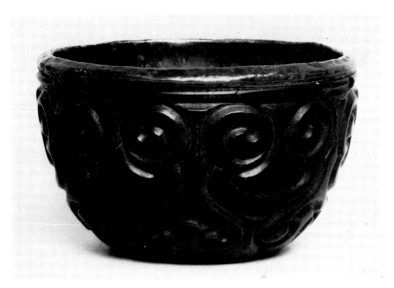

54. HEMISPHERICAL BOWL, carved marbled lacquer
14th–15th century. Diameter 9·4 cm
Victoria and Albert Museum

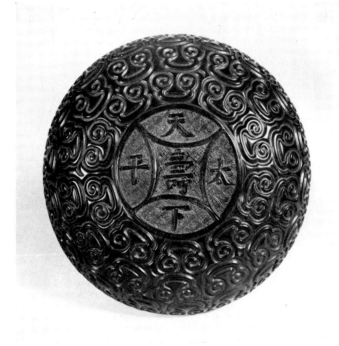

55. ROUND BOX, carved marbled lacquer
16th century. Diameter 16·6 cm
Victoria and Albert Museum

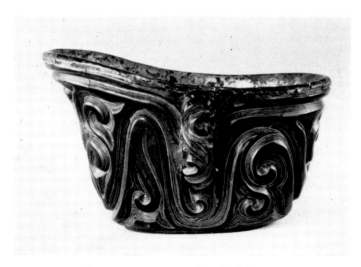

56. LIBATION-CUP, carved marbled lacquer
16th century. Length 9·2 cm
Victoria and Albert Museum

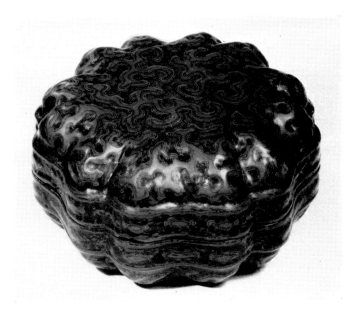

57. LOBED BOX, carved marbled lacquer
15th–16th century. Diameter 15·5 cm
British Museum. See page 116

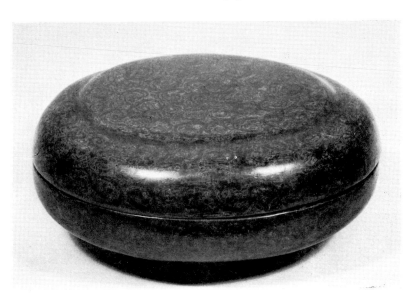

58. ROUND BOX, flat marbled lacquer
16th century. Diameter 18·5 cm
Victoria and Albert Museum

These are outside the scope of this book, but it is desirable to say something about them, because there is still some confusion in the minds of collectors between the Chinese and Japanese wares. For example, a number of Japanese pieces were exhibited as examples of Ming lacquer in the exhibition of Chinese wares of the Ming and Ch'ing periods in Tokyo in 1963.[51] An earlier paper by the author in 1958, made some attempt to distinguish between the Chinese and Japanese wares in this technique[52] and the exhibition in the British Museum in 1973 showed Japanese examples of *guri* lacquer side by side with the Chinese carved marbled wares.[53] The distinguishing features are generally quite clear but further work, with Chinese and Japanese examples side by side, is badly needed.

The flat marbled lacquerwares are relatively uncommon. They were made by building a pattern in a raised moulded lacquer composition and then applying to it successive layers of different colours in the same way as in the carved marbled wares. Finally the whole surface was ground level, leaving a pattern similar to that of the original built-up pattern. A typical example of the flat technique is the round box, in the Victoria and Albert Museum, shown in Plate 58. The design, of spiral scrolls, is the most common of those found in the flat marbled wares of the Ming dynasty. A similar box to this, in the Peking Palace Museum, is illustrated by Yüan Ch'üan-yü in a paper discussed in Chapter 5.[54] It is given a Ming date by the Chinese. The box in Plate 58 may be dated a little more precisely as belonging to the sixteenth century. The designs in the flat marbled wares are not confined to simple formal subjects, although pictorial designs are scarce. Pieces are known decorated with peony sprays, or even with phoenixes against a background of peonies, which can be reliably dated to the late Ming dynasty, but these are not very effective.

Flat marbled wares continued to be made in the Ch'ing dynasty. A box of this period is illustrated by Yüan Ch'üan-yü,[55] but the most notable examples seem to be in furniture. Some fine pieces are in the William Rockhill Nelson Gallery of Art, Kansas City. The decoration, in many colours, is generally of an irregular pattern, as seen in the enlargement in Plate 59, taken from a chair attributed to the seventeenth century. The pattern is often described by the term 'rhinoceros skin'. Similar designs are to be found, finely executed, in Japanese lacquerwares of the nineteenth century.

[51] Among the carved marbled wares, Nos. 239 and 240 are Japanese.
[52] Ref. E20.
[53] Ref. E41.
[54] Yüan Ch'üan-yü, 'On the *hsi-p'i* lacquer wares', *Wên-wu*, 1957, No. 7, pp. 1–7.
[55] Loc. cit.

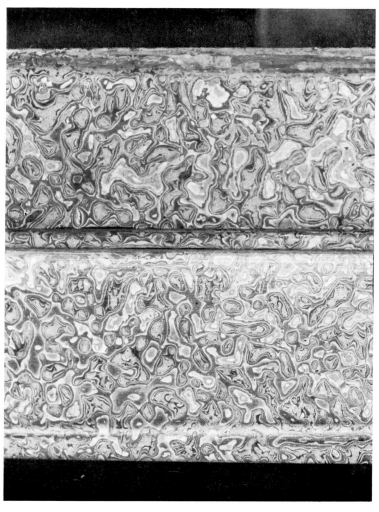

59. Detail of front of CHAIR showing 'rhinoceros skin' pattern
17th century
William Rockhill Nelson Gallery of Art, Kansas City

CHAPTER 7

The Later Carved Lacquerwares

The earlier carved lacquerwares, treated in Chapter 6, were dominated by the official fifteenth-century wares. Their superb quality, which appealed to the wealthy connoisseurs and the court, has ensured that a large number have survived. The more ordinary wares have survived in relatively small number. The two tiered boxes in Plates 41 and 42, may be two of these, although probably made late in the fifteenth century. But in addition to the pieces that followed the style of the official wares there was, I have suggested, a continuation of manufacture of pieces in the fourteenth-century tradition throughout the fifteenth century and later. It will be some time before these wares can be arranged chronologically, but when this has been done it should bring to light a number of pieces in the early style and so give us a more balanced picture of the fifteenth-century wares than we have at present.

In the sixteenth century the picture presented is quite different. There are a large number of pieces outside the imperial wares of the Chia-ching (1522-66), Lung-ch'ing (1567-72) and Wan-li (1573-1619) periods, many of which are of high quality. Some indeed are superior to many of the imperial wares. A number of the imperial wares, decorated with five-clawed dragons and bearing the mark of Chia-ching, which must have been made for the court, are of poor quality. The difference between the best of the Chia-ching wares and these inferior wares is surprisingly great.

Another important point to bear in mind is that the imperial lacquerwares of the Chia-ching, Lung-ch'ing and Wan-li periods are very restricted in their decorative schemes. The wide scope of the official fifteenth-century wares, covering floral and landscape designs as well as designs with dragons and phoenixes, was replaced in the sixteenth century by one dominated by dragon and phoenix decoration. In the comprehensive survey of the Chia-ching wares made by Low-Beer in 1952[1] all the thirteen pieces described and illustrated are decorated with dragons in a major or minor role. The few floral borders that appear, perfunctory in execution, are a poor substitute for the magnificent floral designs of the fifteenth century. As for landscapes, there are very few with this decoration. For this reason, it seems desirable to start with the non-imperial wares, with their much wider pictorial range, and deal with the imperial wares later. This approach is all the more desirable because the first pieces of importance made after the official fifteenth-century wares were not made for the court. Moreover, there are good grounds for thinking that they were made in the western province of Kansu, nearly a thousand miles from the lower

[1] Ref. E17.

122

reaches of the Yangtse River, the main centre of manufacture of lacquer in the Ming dynasty.

The distribution of lacquer trees and the centres of lacquer manufacture have been touched upon in Chapters 2 and 3. We have seen that in the Han dynasty lacquer factories in Szechwan, Shansi and Honan, many hundreds of miles apart, were making lacquer of high quality. In the T'ang dynasty the armour decorated with carved lacquer found at Fort Miran was almost certainly made in Kansu. There is literary evidence that lacquer workers were sent from Szechwan to Yunnan in the T'ang dynasty to set up a new lacquer industry. Much of this is circumstantial, but we shall see later that carved lacquer of a distinctive type has been given, with some justification, a Yunnan attribution.

The manufacture of lacquerwares in China could have taken place in any area where the lacquer tree *Rhus verniciflua* flourished. This covered the whole of China except for a few areas in the extreme north and there can be no doubt that lacquerwares of one kind or another were made over a wide area during the whole of the Chinese civilization from the Shang dynasty onwards. Most of the wares would be simple artifacts needed for daily use. The vital question is whether wares of sufficient distinction were made which would be regarded as suitable objects to be treasured by wealthy connoisseurs. The evidence from Szechwan, Kansu and Yunnan suggests that important wares of this calibre were made in all three provinces, as well as the main centre in the Yangtse Valley. But the fact that some of these centres were far from the main centres of government must have reduced the chances of survival and increased the difficulty of determining their provenance today. A close study of the local gazetteers might reveal important information on lacquer manufacture in the different regions.

The group of pieces mentioned, which may have been made in Kansu, are of outstanding importance in the history of carved lacquer in the Ming dynasty. Four pieces are known in all. The most important is a dish formerly in the collection of Sir Percival David, who exhibited it in the Chinese International Exhibition in 1935-6,[2] and now deposited in the British Museum. It bears an inscription dated 1489 and there can be no doubt that it was made at that date. The dish differs from the official fifteenth-century wares in almost every respect. In the first place it is very fragile and the thickness of the lacquer is not much more than half that of the official wares. Another feature is that the decoration is in polychrome. The dish is carved on the front with a landscape showing a palatial pavilion by the side of a lake, on which is a boat, and with a terrace in the foreground on which are numerous figures (Colour Plate C). The scene is identified, by an inscription in raised characters on the back, as the Orchid Pavilion of Prince T'ang (Plate 60). The carving is exceptionally fine and delicate. At the same time it shows none of the careful control of the official wares. The diapers of land, water and air are carved in an irregular manner and the surfaces, instead of being level, are undulating. It is clear that the dish, and all the other pieces in the group, were carved by artist craftsmen not restricted by factory regulations.[3]

The use of polychrome decoration occurs in this dish for the first time in the

[2] No. 1405.
[3] See Ref. E39 for a full description of these details.

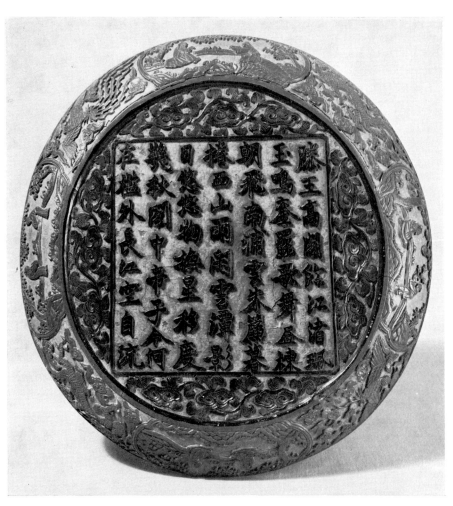

60. Rear view of DISH dated 1489, with inscription describing the Orchid Pavilion depicted on the front
Diameter 18·8 cm
British Museum. See Colour Plate C

Chinese carved pictorial lacquerwares. The front is decorated in brownish-red, dark green and yellow. The border on the back of the dish is in similar colours but the central base bears the raised inscription in black, which stands out against the yellow ground. The introduction of a new colour over only part of the piece seems to be unknown elsewhere and it provides another instance of the freedom accorded to the craftsmen, one that would not be allowed in a production factory, such as those that made the official fifteenth-century wares.

The dish bears three marks, inscribed on the front (Plate 61). The first, on the horizontal beam over the doorway of the pavilion, reads *Hung-chih erh nien*, 'Made in the first year of Hung-chih' (1489). The other two, on the vertical posts to the left of the doorway, read *Wang Ming tsao*, 'Made by Wang Ming', on the left, and *Ping-liang*, the name of a town in Kansu province, on the right. This is presumed to be the birthplace of Wang Ming.[4]

The question as to whether the dish was actually made in Kansu needs serious consideration. The alternative possibility is that Wang Ming moved hundreds of miles from his birthplace to the main centre of lacquer manufacture in the lower reaches of the Yangtse River, there to set up a factory making lacquerware in a style entirely different in its intrinsic qualities from the local lacquerwares. I was inclined to accept this view some years ago, but I now think it is extremely likely that the dish was made in Kansu. Some writers have suggested that the group of wares typified by this dish form a connecting link between the fifteenth- and sixteenth-century wares, but there is nothing to support this view. The group seems to be quite independent of any other wares of the fifteenth and sixteenth centuries.

The second piece in the group is a large round box in the Freer Gallery of Art decorated in black over a ground of red lacquer. The diapers are actually just carved through to the yellow base, so that the general appearance of the ground is orange. The box is inscribed with the name of the maker Wang Ming and his birthplace, but bears no date. It has been fully discussed by the author elsewhere and does not need any detailed discussion here.[5] The third piece, a box which bears no inscription, is close in the treatment, particularly in the diapers, to that of the dish.[6] The fourth piece of the group is a box in the British Museum, illustrated in Plate 62. It differs from the other three in having only two colours, brownish-red and yellow, but it adopts the same technique as that found in the Freer box in having the lowest diaper, representing water, carved through to the yellow base, so producing an orange effect. The top of the box is delicately carved with a group of horsemen approaching an inn. A detail of the scene is shown in Plate 63. The poise of the horsemen is superbly rendered and the carving of cloud scrolls whirling through the pine clusters is most attractive. The gently undulating surface of the land diaper is in marked contrast with the flat surfaces of the typical fifteenth-century wares. Around the main scene are four separate scenes, each of which is described by a classical poem of the T'ang or Sung dynasty. The lower part of the box has four other scenes, each with an associated poem.

[4] Loc. cit.

[5] Loc. cit. See also Jean-Pierre Dubosc, 'A rare example of the late fifteenth century lacquer in an English private collection', *The Connoisseur*, June 1966, pp. 78–81.

[6] Ref. E17, No. 110.

61. Detail of front of DISH dated 1489, showing entrance to Pavilion, with incised date *See Colour Plate C*

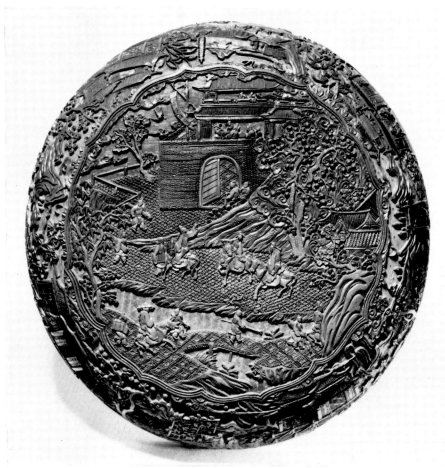

62. BOX, carved lacquer with landscape
15th–16th century. Diameter 27·4 cm
British Museum

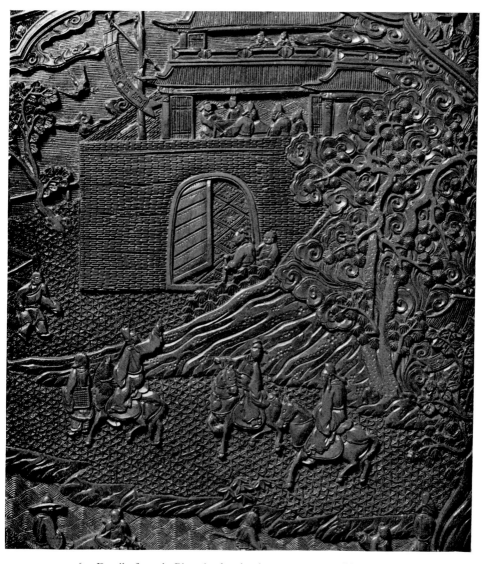

63. Detail of BOX in Plate 62 showing horsemen approaching an inn

The fact that four pieces have survived in this group, which comprises the most fragile of all known carved lacquerwares, supports the view that the manufacture was on a substantial scale. It seems likely that Wang Ming, far from being an individual craftsman, was an artist responsible for the organization of a number of expert lacquerers and that manufacture continued over a long period.

In the sixteenth century, one of the largest groups of carved lacquerwares consisted of small boxes decorated over the whole of the outside, generally in red, although a few are known with designs in black over a red ground. The subjects are generally floral, although a number are decorated with landscapes and figures. Sometimes there is a landscape on the upper part and a floral design on the lower. The floral designs are much more open than those of the fifteenth century and they are always set against a single diaper ground and not, as in the fifteenth-century floral pieces, against a plain yellow ground.[7] The diapers may represent land, water or, more rarely, air. One of the most common and attractive designs is of fruiting sprays, with the fruits carved with various diapers. The box shown in Plate 64, in the Museum of Far Eastern Antiquities, Stockholm, is decorated with lichees, the most usual subject, but there are a few pieces in which the fruits can be identified as pomegranates or peaches. But the lacquerers were not very particular in defining the fruits or flowers depicted. There is none of the careful delineation such as we find in the official fifteenth-century wares, where we can distinguish between every species, depicted in groups of four, eight or twelve, even though we cannot identify each species positively. The box in Plate 65, decorated with birds on a prunus tree above and prunus sprays beneath, set against a wave diaper ground, and the rather unusual arrangement of landscapes on both halves of the box in Plate 66, in the Victoria and Albert Museum, give some idea of the variety that can be found in the group.

Associated with these cylindrical or round boxes is a series of boxes of rectangular shape, in which the upper and lower parts are secured by means of an inner tray, an uncertain arrangement which must have been responsible for many casualties. The box in Plate 67, in the Museum of Far Eastern Antiquities, Stockholm, is typical of this group. The sides are decorated with camellia sprays and the top with pomegranate sprays on which are perched two parrots.[8] These boxes are not carved overall, but generally have a flat base of black lacquer, with no foot-rim.

These boxes must have been made over a long period. At one time some of them were attributed to the late fifteenth century, but now it seems certain that the earliest belong to the early sixteenth century and that they continued to be made up to the end of the century and possibly into the seventeenth. No boxes carved overall seem to have been made for imperial use in the Ming dynasty, although there are some imperial wares of the Ch'ien-lung period carved in this way.

Other types of vessel are known with similar decoration to that on the boxes.

[7] The only fifteenth-century pieces known in which a red diaper is used for a floral subject are a large box with phoenixes and flowers in Stockholm (Ref. E37, Plate 12) and the foliated dish, now in the British Museum, exhibited in the *Arts of the Ming Dynasty*, 1957, No. 239.
[8] Unfortunately not visible in the illustration.

64. BOX carved overall with lichee sprays
16th century. Diameter 7·6 cm
Museum of Far Eastern Antiquities, Stockholm

65. BOX carved overall with birds and prunus sprays
16th century. Diameter 7·9 cm
British Museum

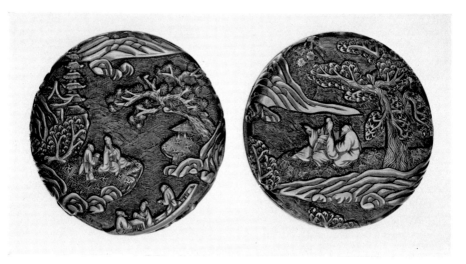

66. BOX carved overall with landscapes
16th century. Diameter 7·9 cm
Victoria and Albert Museum

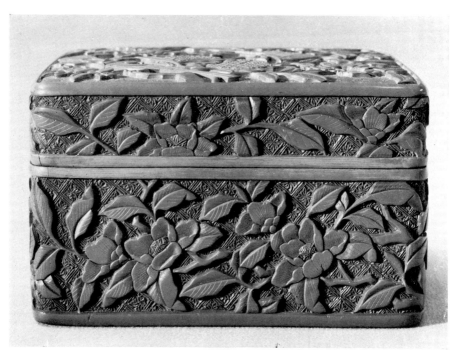

67. RECTANGULAR BOX carved with camellias
16th century. Length 13.7 cm
Museum of Far Eastern Antiquities, Stockholm

Among these were bowls and stem-cups fitted with grooved rims made to take metal linings. The large bowl decorated with phoenixes among peonies in Plate 70 and the small bowl in Plate 68, with the unusual decoration of separate flower sprays of peach, camellia, orchid and lily, and a carved whorl on the base, are fitted with grooves, as is the stem-cup decorated with fruiting sprays (Plate 69).

The carving of the seventeenth-century wares was generally softer and somewhat shallower than that of the sixteenth. The brush-pot in Plate 71 is a typical example. It bears the Wan-li mark, but this is not contemporary. The brush-pot is, however, almost certainly an early seventeenth-century piece.

As I have said, the question of the manufacture of lacquerwares in other areas of China than the Yangtse valley is one about which little is known. There is one group of wares that can be reasonably established as having been made in Yunnan. The earliest reference to Yunnan carved lacquer is found in the second edition of the *Ko-ku yao-lun*, published in 1462. In an addition to the original section 'Carved red' we read:

> At the present time craftsmen of Ta-li-fu in Yunnan are skilled in making this kind of lacquer, but many of their products are imitated by others. Their objects are often found in noble houses in Nanking. There are two kinds, vermilion and darker red. Fine specimens are very expensive. But there are many imitations that call for careful study.

A much more informative account comes from a later work, the *Yeh-huo-pien*, written by Shên Tê-fu and published in the Wan-li period (1573–1619).[9] He refers to the manufacture of lacquer in the T'ang dynasty, when the Yunnanese invaded the Province of Szechwan and took back with them a number of lacquerers who then set up an important industry in Yunnan. Later, master craftsmen were sent from Yunnan to the capital by the Mongols in the thirteenth century and further craftsmen continued to be sent there down to the Chia-ching period. None of this seems to be substantiated by contemporary historical records, but Shên Tê-fu's account of the lacquer carries some conviction. He was a great admirer of Yunnan lacquer and suggested that it was undervalued by his fellow collectors. He says, comparing it with the lacquer made in the Kuo Yüan factory,[10] 'there is another kind, dull and dark and badly engraved, known as the old Yunnan lacquer. The price is only one or two tenths of the other kinds.' He goes on to praise the merits of the Yunnan wares and concludes by saying that 'if my thesis is correct, then an old Yunnan piece should be several times dearer than the Kuo Yüan wares. My antiquarian friends could not dispute this.'

This is all very circumstantial, but the description given by Shên fits very well a group of pieces which are quite distinct from any other carved lacquerwares. Their colour is a dull reddish-brown and they are generally carved down to a plain buff ground. While the carving is far better than is implied by the term 'badly engraved' used by Shên, the edges are left unpolished and, as compared with the polished edges of the official fifteenth-century wares and even with the more simple boxes of the sixteenth, look somewhat unfinished. Indeed, there is a roughness in the edges

[9] Ref. C10.
[10] Shên is clearly referring here to the official fifteenth-century wares.

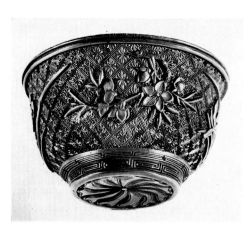

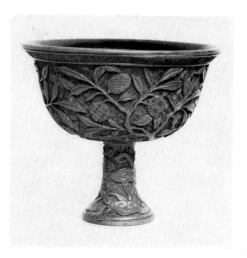

68. BOWL carved with sprays of peach, camellia, orchid and lily
16th century. Diameter 10·2 cm
Victoria and Albert Museum

69. STEM-CUP carved with lichee and pomegranate sprays
16th century. Height 10·2 cm
British Museum

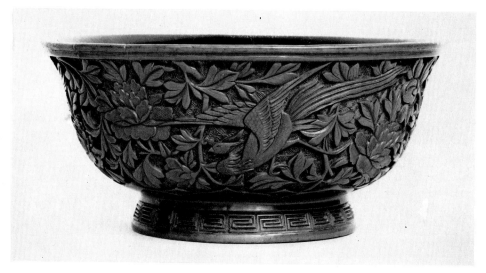

70. BOWL carved with phoenixes and peonies
16th century. Diameter 20·4 cm
Victoria and Albert Museum

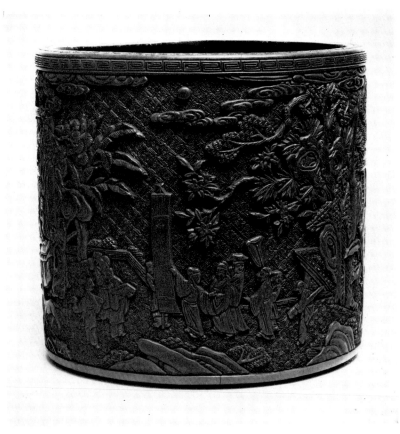

71. BRUSH-POT carved with figures in a landscape
 Early 17th century. Height 16·3 cm
 Victoria and Albert Museum

which suggests that the carving was done before the lacquer was set really hard, so that there was a tendency for the lacquer to be pulled away during the carving.

One feature of the decoration of all the pieces is that the design fills up almost the whole of the space, so that very little indeed of the buff ground is visible. This feature is even more evident than it is in the official fifteenth-century wares and it contrasts greatly with the decoration of the sixteenth-century wares, in which the grounds, almost always of diapers, are very open. The dish in Plate 72, with its beautiful carved peony flowers and its overlapping stems and leaves, forms a perfectly balanced floral design which, in spite of its rough edges, could hardly have been improved upon, even when compared with the early floral pieces. A second dish, of square foliated shape (Plate 73), is decorated with the 'three friends', the pine, bamboo and plum, surrounded by a floral border and an unusual rim of bamboo segments. A third dish is also decorated with the 'three friends', which provide a setting for various animals and insects, the latter including a dramatic praying mantis (Plate 74). Such subjects are not to be found elsewhere in Chinese carved lacquer.

A second feature of these wares is a sense of movement which distinguishes them from all the other Ming carved lacquerwares. Low-Beer, who discusses and illustrates four pieces at some length describes the decoration as 'almost tortuous'.[11] This restlessness is particularly noticeable in the box illustrated in Plate 75, decorated on the top with a landscape surrounded by floral and diaper borders. This box differs from the rest in having diaper grounds in green and buff for the landscape, very crudely rendered. Indeed the carving of the whole piece shows a rough technique, but the resulting decoration is full of movement, both in the landscape and the floral borders.

The Yunnan pieces described and illustrated here have been dated to the sixteenth century, but the evidence summarized above suggests that carved lacquerwares were made in Yunnan much earlier than this. The reference in the second edition of the *Ko-ku yao-lun* to the manufacture taking place in 1462 suggests that wares attributed to Yunnan were being made in the mid-fifteenth century, and it should be noted that all the references to the Yunnan wares in the *Yeh-huo-pien* refer to Yunnanese lacquer by the term 'old Yunnan'. It seems likely therefore that some pieces discussed here may be as early as the fifteenth century.

Finally, to complete the discussion of the non-imperial sixteenth-century wares, the box illustrated in Plate 76 seems to be worth while including as a piece in an individual style which may have been made in another district far from the general centres of manufacture. There are other pieces of this kind that are difficult to place and a further study of these is desirable.

A feature of the sixteenth-century wares generally is the use of labour-saving devices in the carving. The official fifteenth-century wares made great use of the knife in the carving of details, such as the veins of leaves, in which two knife strokes for each vein were invariably used, as can be seen in the detail of Colour Plate B. In the sixteenth century the knife was replaced by the gouge, in which only one stroke was needed, requiring far less skill. The use of the gouge is particularly noticeable in the imperial wares of the sixteenth century.

[11] Ref. E17, Plates 113–16.

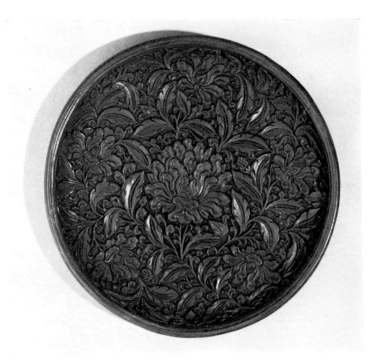

72. DISH carved with peonies
16th century. Yunnan ware. Diameter 14·5 cm
British Museum

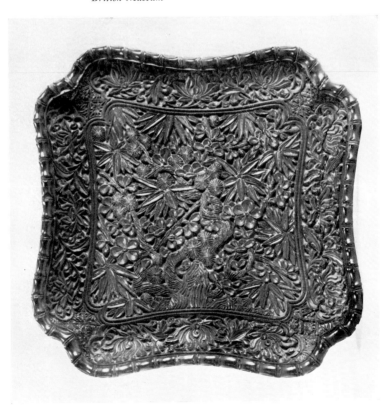

73. SQUARE FOLIATED DISH carved with the 'three friends'
16th century. Yunnan ware. Width 15·9 cm
Seattle Art Museum

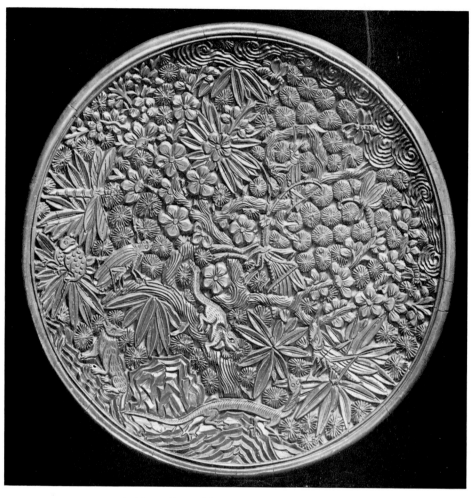

74. DISH carved with reptiles and insects against a ground of the 'three friends'
16th century. Yunnan ware. Diameter 25·4 cm
Formerly Dreyfus Collection

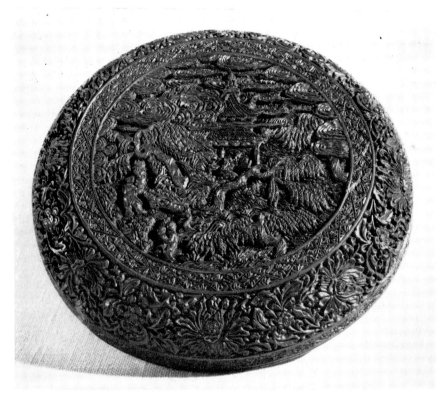

75. BOX carved with landscape on the top and with floral borders
16th century. Yunnan ware. Diameter 24 cm
Victoria and Albert Museum

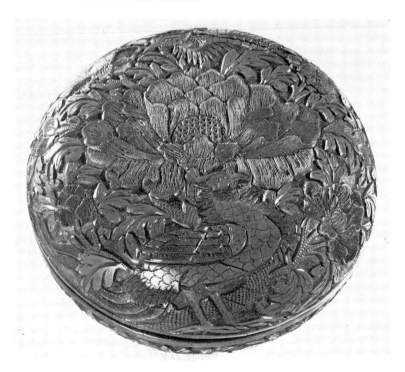

76. BOX carved with phoenixes and peonies
16th century. Diameter 17·6 cm
British Museum

Two typical imperial pieces of the Chia-ching period are the leys-jar (*ch'u-tu*) in Plate 77 in the Hosokawa Collection, and the dish in Plate 78, formerly in the Sedgwick Collection. The former, carved with dragons and phoenixes in red, green, yellow and black lacquer against a red diaper ground, is of fine quality. The dish, coarser in the carving, shows clearly the use of the gouge in the depiction of the details. The three peaches, inscribed with the three characters *fu*, *lu*, and *shou* (happiness, riches and long life) are in red on a green ground with a border of dragons on a buff ground. A piece of exceptionally fine quality is the ingot-shaped dish formerly in the Hakutsuru Collection and now in the British Museum (Plates 79 and 80). It is carved in red with the unusual subject of the Eighteen Lohans, set in dragon borders.

There is a small group of Chia-ching wares decorated, not with five-clawed but with four-clawed dragons. The square lobed dish in the Museum of Fine Arts, Boston, illustrated in Plate 81, is a typical example. The decoration is unusual, with four interlaced ogival panels containing a snake, umbrella, lute and sword, surrounding a central four-clawed dragon, with further dragons round the rim. An octagonal dish belonging to this group was shown in the British Museum Exhibition in 1973,[12] and there are several others. The high quality suggests that some influential members of the court were able to arrange surreptitiously for pieces to be made for them which were superior to those made for the emperor.

A number of cabinets, chairs and other pieces of furniture of fine quality attributable to the sixteenth century are known. Few have contemporary marks, but the imperial status of some of them can hardly be questioned. The chair in Plate 82, formerly in the Low-Beer Collection and now in the Victoria and Albert Museum, is one of the finest of these. It is particularly important because there are strong grounds for attributing it to an earlier date than Chia-ching, although Low-Beer gave it this date. Some details of the chair in Plates 83, 84, and 86 illustrate the fineness of the carving, which is more compact than in the imperial Chia-ching group, with none of the usual diapers to form the background. The carving of the cloud scrolls and particularly the peony scrolls on the top of the foot-stool (Plate 86) approaches closely in technique that of the fifteenth-century official wares.

The chair bears, on the back of the splat, the six-character mark of Hsüan-tê. The smoothness of the carving of the edges of the characters (Plate 85) makes it almost certain that the mark is contemporary with the chair. The calligraphy is close to that of some of the official fifteenth-century wares and is entirely different from that of the imperial Chia-ching wares.

To sum up, the examination of all the features of the chair leads to the conclusion that it is earlier than the Chia-ching reign but, from the style of the dragons, considerably later than the reign of Hsüan-tê. This would place it in the difficult 'interregnum' period on which, at present, there is so little evidence.

The carved lacquerwares of the Lung-ch'ing reign are, as one might expect from such a short span, few in number and they follow the general pattern of the Chia-ching wares. The deep dish in the British Museum (Plate 87) is decorated with an imperial dragon at the centre, with two other dragons in the well of the dish

[12] Ref. E41, No. 68, plate 31.

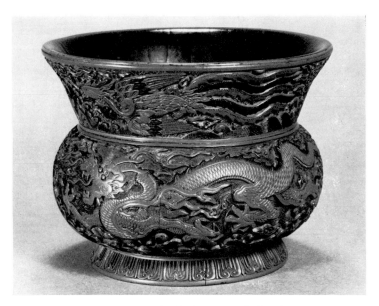

77. LEYS-JAR carved with dragons and phoenixes
Chia-ching mark and period. Height 13·9 cm
Hosokawa Collection

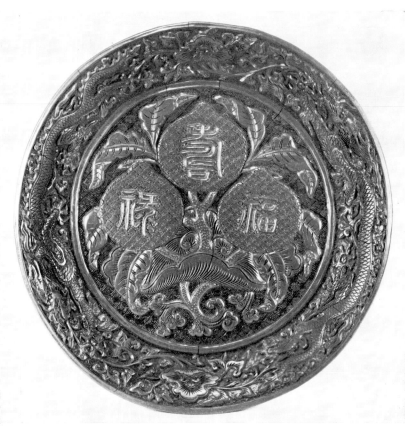

78. DISH carved with three peaches and characters
Chia-ching mark and period. Diameter 19·2 cm
Formerly Sedgwick Collection

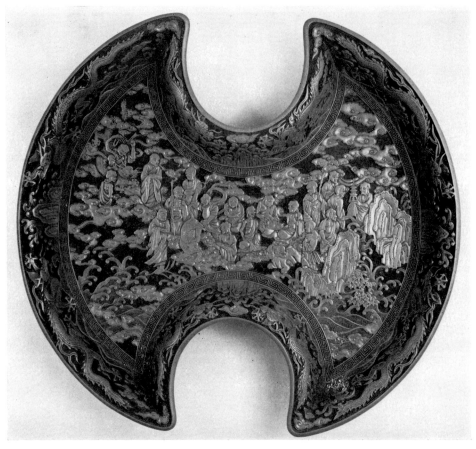

79. INGOT-SHAPED DISH, carved with the Eighteen Lohans, with dragon borders
Chia-ching mark and period. Length 32·8 cm
British Museum

80. Detail of INGOT-SHAPED DISH showing dragon borders

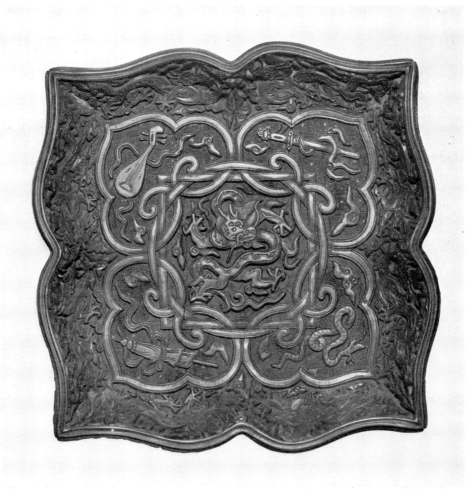

81. SQUARE FOLIATED DISH carved with four-clawed dragons and emblems
Chia-ching mark and period. Width 17·5 cm
Museum of Fine Arts, Boston

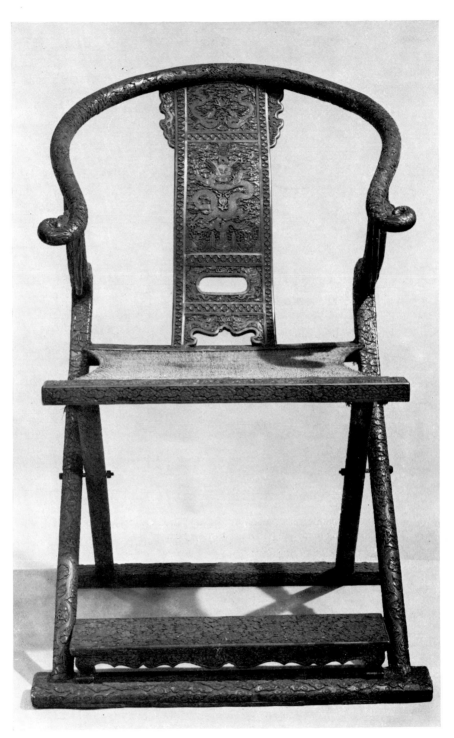

82. CHAIR, carved with dragon motifs on splat, arms and legs, and fitted with a
footstool carved with floral scrolls
Early 16th century. Height 114·5 cm
Victoria and Albert Museum

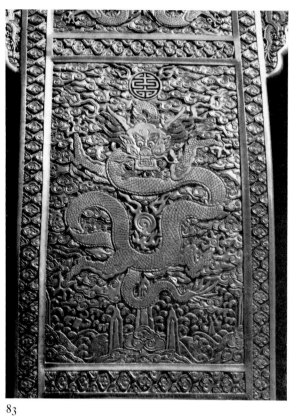

83

84

85

86

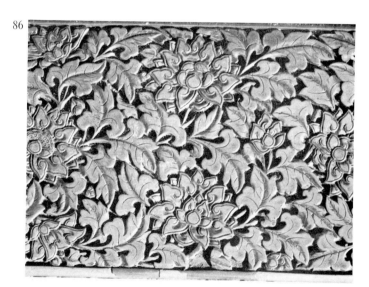

83–86. Details of CHAIR in Plate 82, showing dragon decoration on splat (Plate 83) and arm (Plate 84), Hsüan-tê mark on back of splat (Plate 85) and floral decoration on foot-stool (Plate 86)

and a floral border round the flange. An unusual feature is the head of the *shih* dragon just outside the jaws of the main dragon. The significance of this is not known.

The imperial carved wares of the Wan-li period, on the whole, are of more uniform quality than the Chia-ching wares, and they show even less variety in design. An innovation of this reign was the replacement of the six-character mark by one of eight characters including the cyclical date, thus giving the exact year of manufacture. The mark is generally placed horizontally on the edge of the base. The earliest Wan-li date recorded on a carved piece is 1585 and there are many pieces with dates in the last decade of the sixteenth century, the most common date being 1595. The dish in Colour Plate D, in the British Museum, is typical of the polychrome decoration at its best, with a dragon and phoenix facing each other, with a flaming pearl between. It is dated 1593, the original incised inscription being just visible under the black relacquered base. Another polychrome piece, a box in the Freer Gallery of Art (Plate 89), is decorated with two facing dragons with a large medallion between enclosing complex flame designs, clearly an elaboration of the flaming pearl seen in Colour Plate D. Another box, rectangular in shape, in the Royal Scottish Museum, with a single dragon on a floral ground, which is dated 1595, is shown in Plate 88.

The practice of removing the fifth claw from imperial dragons was discussed at some length in Chapter 6, where it was pointed out that the practice was widespread as early as the sixteenth century. Many imperial pieces of the Chia-ching and Wan-li periods were so mutilated, and many of them have had the fifth claw restored at a later date.

The last two reigns of the Ming dynasty T'ien-ch'i (1621-7) and Ch'ung-chên (1628-43), produced little carved lacquer. Indeed there was a falling off in manufacture in the Wan-li period, if we may judge by the few dated pieces made after 1595. The few marked pieces known of the T'ien-ch'i and Ch'ung-chên periods are of poor quality and there appear to be none in the latter part of the seventeenth century, comprising the reign of Shun-chih (1644-61) and much of the reign of K'ang-hsi (1662-1722). It is not until we come to the reign of Ch'ien-lung (1736-1795) that carved lacquer of fine quality flourished once again.

The absence of carved lacquer made in the first half of the K'ang-hsi period is one of the mysteries of this reign. The historic records of the activities of the imperial factories conflict with the factual evidence of pieces made for imperial use, not only for carved lacquer, but also in a much wider group of artifacts. We are informed that some thirty factories were set up in the Forbidden City in Peking by the Kung Pu, 'The Board of Public Works', before 1680 and that in these factories metalwork and carvings in jade, lacquer, ivory and other materials were made.[13] But it is difficult to find artifacts made in any of these materials that could be given an imperial attribution. Even in porcelain, which of course was made in Ching-tê Chên and not even decorated in Peking before the eighteenth century, there is little that can be regarded as made especially for the emperor. The latter part of the reign saw new and important developments in porcelain decorated in enamels with imperial dragons and new types of monochromes such as the peach-bloom wares, all bearing

[13] Stephen W. Bushell, *Chinese Art*, Vol. I, 1904, p. 108.

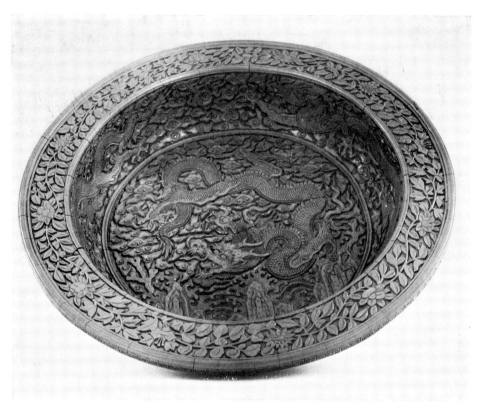

87. DEEP DISH carved with dragons and floral border
Lung-ch'ing mark and period. Diameter 59·1 cm
British Museum. See page 138

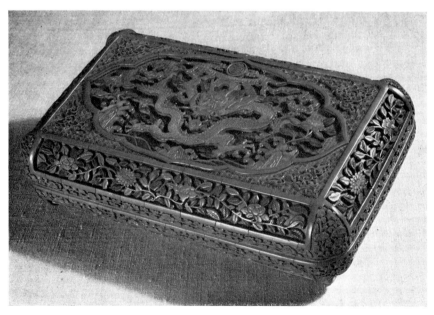

88. BOX carved with dragon on top and with floral borders
Wan-li mark and period, dated 1595. Length 50 cm
Royal Scottish Museum, Edinburgh

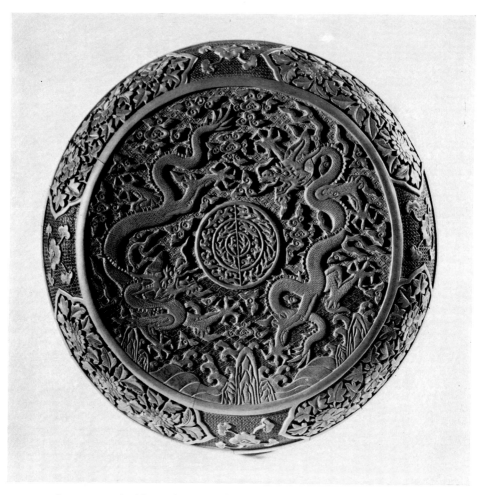

89. BOX carved with two dragons with an elaborate medallion of flames between
Wan-li mark and period. Diameter 31·2 cm
Freer Gallery of Art

the K'ang-hsi mark, but there is no evidence of imperial carved lacquerwares being made in this period.

Quite apart from the imperial lacquerwares, we must reluctantly come to the conclusion that we cannot, at present, identify any carved lacquer that was made in the K'ang-hsi period. Nor is there any that can be attributed to the Yung-chêng period (1723-35). There are apparently no marked pieces in the Palace Collections, which are rich in pieces belonging to the Ch'ien-lung period. The Ch'ien-lung wares are also very strongly represented in Western collections, as for example in the Victoria and Albert Museum, where the famous Ch'ien-lung throne, by far the finest surviving piece of Ch'ing carved lacquer, is to be seen.

The Ch'ien-lung carved lacquerwares were at one time regarded as the summit of achievement in carved lacquer by Western countries and it was not until the International Chinese Exhibition in 1935-6 that the superior qualities of the early Ming wares were revealed to Western connoisseurs. Li Hung-ch'ing distinguishes the qualities of Ch'ien-lung lacquer from that of Ming lacquer.[14] One of the main distinctions he makes is that the Ch'ien-lung wares were not polished but were left with sharp edges. Thus, he says, the later pieces have a sharpness in appearance and a lack of mellowness, which exists even after the piece is polished with wax. The colour of the early Ming wares is described as red with a slightly purple tinge, while the red in the Ch'ing wares is 'vivid but dull'.

Some of the finest of the Ch'ien-lung wares are furniture, like the throne already mentioned. They include large twelve-fold screens, couches fitted with small tables, larger tables, chairs and framed panels. It is not possible to illustrate these large pieces adequately here and the reader is referred to such catalogues as that of the Chinese lacquer in the Victoria and Albert Museum produced by E. F. Strange in 1925 for illustrations of furniture and large imposing vases, including excellent details of the throne.[15] However, the qualities of Ch'ien-lung lacquer can be well studied in the smaller pieces illustrated here. The box in Plate 90, in the Brundage Collection, belongs to a well-known group, made in various sizes. It is decorated in red, dark green and buff with a basket carrying emblems and supporting a large character *ch'un*, 'spring', which has an inset circular panel with Shou Lao and his attendant. These boxes are rarely marked and the special interest of this box is that it not only has the Ch'ien-lung mark but also four additional characters *Shou-ch'ou pao-p'an*, 'Eternal youth treasure vessel'. The use of additional characters describing the piece is a feature of some of the finest of the Ch'ien-lung wares. A similar use on a dish with filled-in decoration will be seen later (Plate 140). Another fine carved piece, also in the Brundage Collection, brings together the carved and filled-in techniques. The elaborate stand, ingot-shaped in section, with perforated sides is of carved red lacquer, with the top carved down to a green diaper ground. This encloses a nest of boxes decorated with filled-in lacquer in red, yellow, green and black (Plate 91). The bowl and cover (Plate 92) in the Victoria and Albert Museum was made as a birthday gift. It bears a medallion on each part with the greeting *Wan-shou wu-chiang*, 'a thousand years without end'.

[14] Li Hung-ch'ing, 'The lacquer of the Ming and the Ch'ing, and the carved lacquer of the Yüan', *Wên-wu*, 1957, No. 7.

[15] Ref. E9. A splendid colour illustration of the throne is given in Ref. E24, No. 178.

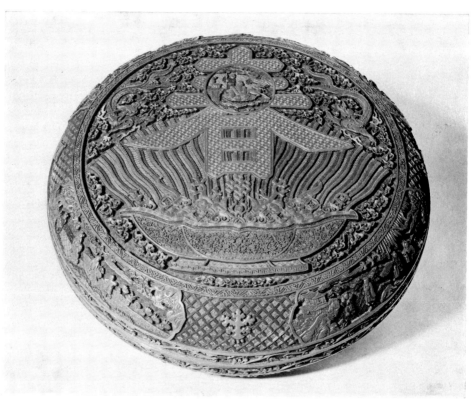

90. BOX carved with *ch'un* character and emblems
Ch'ien-lung mark and period. Diameter 52·5 cm
Asian Art Museum of San Francisco, Brundage Collection

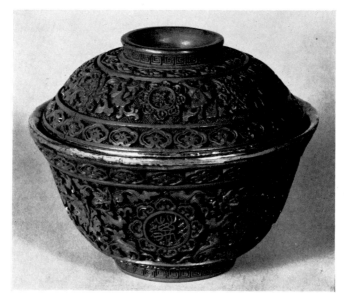

92. BOWL AND COVER carved with formal borders enclosing medallion
with birthday greetings
Ch'ien-lung mark and period. Diameter 11·9 cm
Victoria and Albert Museum

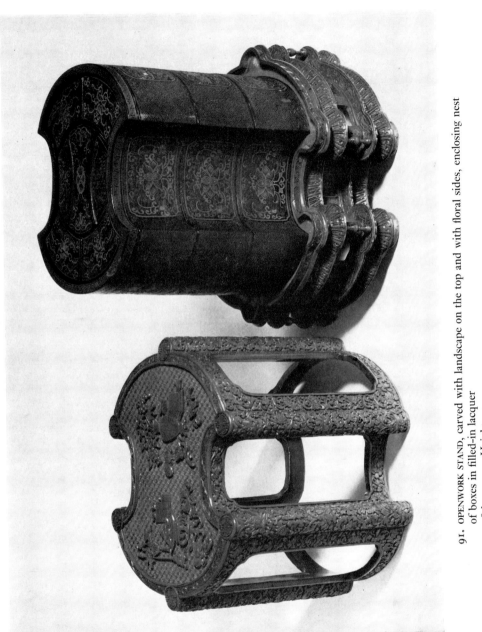

91. OPENWORK STAND, carved with landscape on the top and with floral sides, enclosing nest of boxes in filled-in lacquer
18th century. Height 25·9 cm
Asian Art Museum of San Francisco, Brundage Collection

Two pieces dated to a specific year throw some light on the decline in quality that took place in the later years of the reign. The first (Plate 93) is a bowl with a long inscription containing a poem written by the emperor and ending with a date corresponding to 1746. The second (Plate 94), made more than forty years later, is an eight-lobed dish carved with a landscape with an inscription on the base bearing a date corresponding to 1787. The lacquer is dark reddish-brown and the carving, although deep, is perfunctory. The decline in quality seen in this dish steadily continued through the nineteenth century.

References have been made in earlier chapters to imitations of carved lacquer. Although described in the *Ko-ku yao-lun* and *Hsiu shih lu*, no Ming examples have come to light. No doubt they were of little account, and being fragile in construction have not survived. There are a few Ch'ing examples that may be as early as the eighteenth century, of which the box in Plate 95 is an example. It has a moulded diaper ground, on which is superimposed in *appliqué* a landscape on the top and flower scrolls on the sides. The moulded material is a black lacquer composition which is covered with a layer of red lacquer. A detail of a large dish in the National Museum of Denmark is shown in Plate 96. The decoration is close to that of some carved wares of Ch'ien-lung lacquer and it is reasonable to date it to the eighteenth century.

A number of late imitations of carved wares are known with various Ming reign marks. I have myself seen pieces bearing the marks of Hsüan-tê, Ch'êng-hua, Chêng-tê and Wan-li, and one bearing the mark of Ch'ung-chên is known. A vase in the British Museum bears the mark of Wan-li, set in a 'cracked-ice' ground. The quality of the vase is poor and it seems likely that it is a very late piece, probably belonging to the late nineteenth or early twentieth century. The selection of such marks as Ch'êng-hua and Chêng-tê, otherwise unknown in lacquer, suggests that they were made for very unsophisticated collectors. They can hardly have deceived anyone familiar with genuine Ming or Ch'ing carved lacquerwares.

Some interesting and attractive lacquerwares, which are not strictly in the carved technique, are mentioned here for convenience. They consist of bowls, dishes and boxes very lightly constructed, moulded in foliated form to represent chrysanthemum flowers. They are all covered with red lacquer and they all bear poems composed by the emperor Ch'ien-lung ending with a precise date. They are described by Li Hung-ch'ing as 'painted with glossy vermilion lacquer. The best are made with a silk groundwork, rather similar to the light wares of Foochow. They are, however, easily breakable. Many of this kind were made in the Ch'ien-lung period, with marks and inscribed poems, used for tea service and decorated with chrysanthemums.' Two pieces are illustrated here. The first is a bowl and cover (Plate 97), which is incised inside on both parts with a poem and a date corresponding to 1776, and the second is a box (Plates 98 and 99) with an inscription on the black base dated to 1777. The bowl was formerly in the David Collection and was exhibited in the International Chinese Exhibition in 1935-6. There are bowls similar to that in Plate 97, some lacquered red inside and some black, but all with the same inscription, and there is also a porcelain copy of the bowl, with the same inscription, in the Percival David Foundation.[16]

[16] It was exhibited in the *Arts of the Ch'ing Dynasty*, 1964, No. 289.

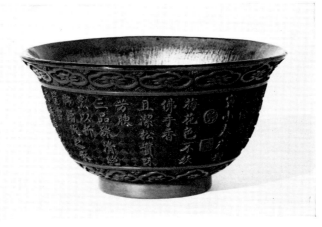

93. BOWL carved with inscription dated 1746
Ch'ien-lung mark and period. Diameter 11·2 cm
Victoria and Albert Museum

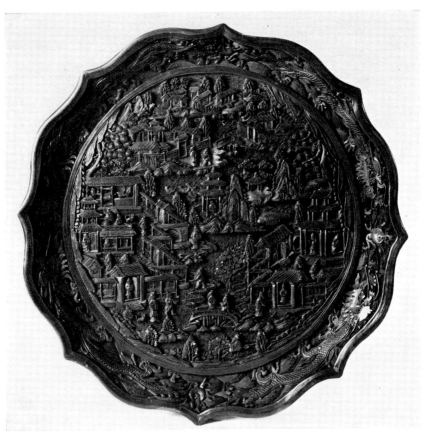

94. DISH carved with landscape. Inscription on back dated 1787
Ch'ien-lung period. Diameter 35·8 cm
Victoria and Albert Museum

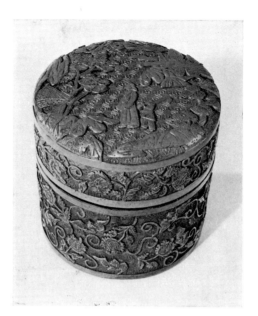

95. BOX with *appliqué* moulded designs, with landscape on the top and floral borders on sides
18th century. Diameter 9·9 cm
British Museum

96. Detail of DISH with *appliqué* moulded decoration of flowers, with a border of bats and waves
18th century
National Museum of Denmark, Copenhagen

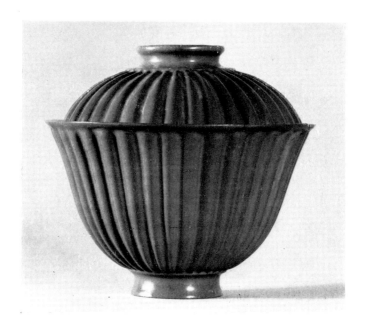

97. FLUTED BOX AND COVER in red lacquer, each part with an inscribed poem dated to 1776
Diameter 11·2 cm
Victoria and Albert Museum

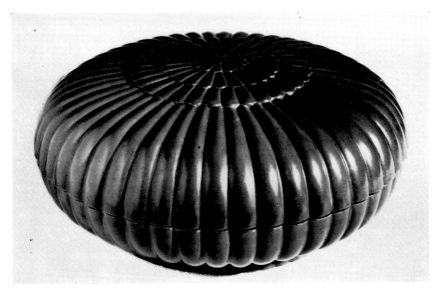

98

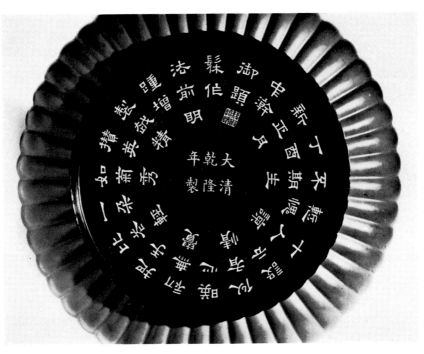

99

98, 99. FLUTED BOX AND COVER of red lacquer, with inscribed poem dated 1777
on black base
Diameter 24·4 cm
British Museum

CHAPTER 8

Ch'iang-chin Lacquer

The manufacture of gold-decorated lacquerwares was always less developed in China than it was in Japan, where superb decoration in gold employing many different techniques provided the dominant type of lacquer from the T'ang dynasty onwards. Nevertheless, the Chinese developed a number of methods of decoration in gold, one of which, known in China by the term *ch'iang-chin*, 'etched gold',[1] with designs etched into a plain black or red ground and filled in with gold, was not only of great beauty and importance itself, but led to the introduction of 'filled-in' lacquer, which became one of the most important of the Chinese imperial wares, particularly in the sixteenth century. The *ch'iang-chin* technique was also introduced into Okinawa in the fifteenth century, where it produced the finest of all the Ryukyuan lacquerwares. It continued to be made there after it had become of little interest in China.

Ch'iang-chin lacquer and its derivative, filled-in lacquer, were the most important of the gold-decorated techniques in China. It may be a new idea to Western students that these two groups are strongly associated, but the Chinese, and particularly the Japanese, have always recognized the connection. Indeed the Japanese have generally exhibited the two types in conjunction. The important fact to bear in mind is that the filled-in technique is imprecise and that the design is basically determined by the gilt outlines, which are almost as important as they are in the more simple *ch'iang-chin* wares. The association of the two techniques in the filled-in wares provides a brilliance which, as Chinese writers have repeatedly pointed out, is maintained even when the lacquerwares have been subjected to considerable wear.

Although incised decoration takes pride of place in Chinese lacquer, lacquer decorated with gold applied with the brush was made in much greater quantities, as we shall see later. The gold was often applied over a linear design, generally in red if the ground colour is black, or in black if the ground is in red, so as to give a slightly raised effect. Another technique was like that used in *kinrande* porcelain, in which gold leaf is applied by means of lacquer and then cut away to give a precise design.

Gold decoration is often used, in a subsidiary way, to finish off a painted design in colour, as it is for example in *famille verte* and *famille rose* porcelain. This type of decoration is discussed in the general account of painted lacquer (Chapter 12).

Although the gold-painted lacquerwares were made in China before the *ch'iang-*

[1] The Chinese term *ch'iang-chin* is precise, and it seems preferable to use it exclusively to describe these wares.

chin wares there is, apart from a group of recently excavated wares datable to before 1043, little of importance known before the second half of the sixteenth century. By contrast, there is a good deal of factual and literary evidence on the *ch'iang-chin* and filled-in lacquerwares from the early fourteenth century onwards. Moreover, these two types are of far greater importance than the surface-decorated wares, as far as Chinese lacquer is concerned. It has seemed desirable therefore to discuss the *ch'iang-chin* lacquerwares first, in this Chapter, then the filled-in wares, in Chapter 9, and finally the gold-painted and other surface-decorated wares, in Chapter 10.

The *ch'iang-chin* wares, from all the evidence available at present, were first made in China in the early fourteenth century. Although, as we saw in Chapter 3, the Chinese used etched designs in association with painted decoration in the Warring States and Han periods (see page 44 and Plate 15), these are a far cry from the gold decoration of the *ch'iang-chin* wares of the Yüan dynasty. Although large amounts of *ch'iang-chin* lacquer were sent to Japan in the fourteenth and fifteenth centuries, some by imperial gifts in the Yung-lo and Hsüan-tê periods, the *ch'iang-chin* wares were never very much appreciated by the Chinese themselves. According to Li Hung-ch'ing, who made a survey of the lacquerwares in the Palace Museum, Peking in 1957, there were no pieces of *ch'iang-chin* lacquer in the Museum, although gold-painted wares formed the greater part of the whole lacquer collection.[2] He speaks of *ch'iang-chin* lacquer as belonging to the mythical past and says that its main merit was that it led to the development of the gold-painted wares.

The lack of interest by the Chinese in the *ch'iang-chin* lacquerwares is in marked contrast with the enthusiasm shown by the Japanese, who imported a large number of *ch'iang-chin* sutra boxes from the early fourteenth century onwards. We know from records preserved in Japan that the Japanese were presented with imperial gifts of furniture in red lacquer decorated in this technique, in 1406 in the reign of Yung-lo and in 1433 in the reign of Hsüan-tê. In the latter year the furniture was supplemented by bowls in red and black lacquer. The fact that no example of *ch'iang-chin* lacquer has been recorded in China until recently has led to a misunderstanding of the importance of these wares, except possibly in Japan itself. The recent excavation of two *ch'iang-chin* lacquer boxes in China has proved of great value in throwing further light on the wares, but it must be clearly understood that even now the earliest *ch'iang-chin* wares preserved in Japan are some sixty years earlier than anything that has been found in China.

A further complication, which has added to the difficulty of the study of the *ch'iang-chin* wares, arises from the fact that the *ch'iang-chin* technique was introduced by the Chinese into the Ryukyu Islands in the first half of the fifteenth century. The early Ryukyuan wares are of a very high quality and this has led to a reluctance, particularly by the Japanese, to ascribe them to a small and otherwise undistinguished group of islands. As a result, they have been given a Chinese attribution and it is only recently that the differences between the wares of the two countries are beginning to be understood.

[2] Li Hung-ch'ing, 'The lacquer of the Ming and the Ch'ing, and the carved lacquer of the Yüan', *Wên-wu*, 1957, No. 7.

Ch'iang-chin Lacquer

The development of the *ch'iang-chin* lacquerwares can be divided into two main periods. In the first the wares were entirely Chinese. In the second, the technique was introduced to the Ryukyu Islands in the fifteenth century, where it continued to be used down to the nineteenth. During this period there seems to have been little made in China, except for a burst of activity towards the end of the sixteenth century, when an entirely new style was introduced. It does not seem to have lasted very long.

The earliest reference to *ch'iang-chin* in the Chinese literature is to be found in the *Cho-kêng lu*,[3] written by T'ao Tsung-i and published in 1366. T'ao describes the process in great detail. The etched design is covered with lacquer mixed with orpiment, the yellow arsenic trisulphide, and gold leaf is then pressed into the incisions, the surplus being removed by cotton wool. T'ao describes how the surplus gold is collected for future use, a procedure known to have been adopted all over the world from early times by goldsmiths to save the precious metal. *Ch'iang-yin*, 'incised silver', is also described, the silver being attached by lacquer mixed with *shao-fên*, lead carbonate powder.[4] It seems never to have been satisfactory, because of the rapid tarnishing of the silver. Very few examples of decoration in *ch'iang-yin* seem to have survived.[5]

T'ao's very practical account is supplemented by Ts'ao Chao in the *Ko-ku yao-lun*, published in 1388.[6] Ts'ao states that the manufacture of *ch'iang-chin* started in the early Yüan dynasty and that it was made by P'êng Chün-pao, who worked in the district of Hsi-t'ang in the prefecture of Chia-hsing, in the Province of Chekiang, a known centre of manufacture for carved lacquer at this time.[7]

These accounts of the manufacture of *ch'iang-chin* lacquer in China in the fourteenth century are consistent with the evidence provided by a number of large sutra boxes which have been preserved in various temples in Japan. No boxes of this kind have been found in China and their importance in the study of lacquer can hardly be over-estimated. Full particulars of the boxes do not seem ever to have been given, even in Japan. By far the most complete account that has been given in a Western language is that of Figgess, written in 1964.[8] Since then further information on the sutra boxes, including the discovery of another box, bringing the total to nine, has become available. A brief summary of our present state of knowledge is given below, but the reader who wishes to be fully informed on the details must refer to Figgess's paper of 1964.

All the boxes are similar in shape and decoration and all of them except one are still to be found in Japan. The exception is a box that was acquired from Japan in

[3] Ref. C4. A translation of the section on *ch'iang-chin* lacquer is given in Ref. E33, *Chinese Connoisseurship*. There are some errors in the translation, which have been corrected here.

[4] I am indebted to Dr. Joseph Needham for an authoritative identification of the chemical materials used in the process.

[5] An example, with *ch'iang-yin* associated with mother-of-pearl, in the Victoria and Albert Museum, was exhibited in the British Museum Exhibition in 1973 (Ref. E41, No. 125).

[6] Ref. C2. See also Ref. E33, p. 147.

[7] See Chapters 5 and 6.

[8] Ref. E26.

the 1930s by the Ostasiatische Kunstabteilung, Berlin. This fine box disappeared, with many other oriental treasures, during the Russian occupation of East Berlin during 1946. Its present whereabouts are unknown, but a photograph of the box has fortunately survived.[9]

All the boxes, with one exception, are the same size. The exception is one of two boxes in the Jōdo-ji Temple, Hiroshima prefecture, which is larger than the rest. The decoration is generally of two birds, which may be phoenixes, pheasants or parrots, against a background of clouds, set in an ogival panel surrounded by peony scrolls. Three views of one of the finest of the boxes, in the Daitoku-ji Temple, Kyoto, show the front of the box with male and female phoenixes (Plate 100), one of the shorter sides with parrots (Plate 101) and the other short side with Buddhist figures (Plate 102). Buddhist figures only occur in one other box, in the Yamamoto Collection, Hyogo. The Daitoku-ji box has another unusual feature, which, strangely enough, has apparently come to light only recently. On the top of the lid the ogival panel encloses a single five-clawed dragon in place of the usual pairs of birds. The Berlin box differs from the rest in having peonies instead of clouds as a background inside the ogival panels.

Most of the boxes bear, near their lips, at one end of the lid and one end of the container, characters from the *Chien-tzu-wên*, 'Thousand characters classic', possibly as an aid to keeping the right lid on each container and maintaining the boxes in a certain order. However, the lids do not now match the containers to which they are at present fitted nor can they be matched up themselves. This implies that the surviving boxes are only a small proportion of those that were made.

Four of the boxes have inscriptions on the insides of the lids, printed in black lacquer from a wooden stamp. Two of them, one in the Kōmyō-bō Temple, Hiroshima prefecture and the other, in the Seigan-ji Temple, Fukuoka prefecture, have identical inscriptions of sixteen characters, the first group of eight bearing a date corresponding to 1315 and the second reading 'made by the Chin family of Yu-chu chiao, Hangchou'. A third box, the smaller of the two in the Jōdo-ji, has the same first group of characters with the date 1315 with the addition of seven characters reading 'made by the Sung family in front of the Ming-ching Temple'.[10] A fourth box, in the Myōren Temple, Kyoto has these seven characters, but the group of eight characters giving the date is missing.

The Jōdo-ji box has, in addition to the Chinese inscription, a Japanese one applied with the brush in red lacquer stating that the box belonged to the Temple in 1358. The Seigan-ji box has a few indecipherable characters applied with the brush also.

We could hardly expect to find better documentation for early groups of lacquer than this. But if we look at the evidence critically, we must conclude that it is most unlikely that all the boxes were made in or about the year 1315 and it may also be questioned as to whether the wood-stamped marks are contemporary with the boxes, or whether they were added later in Japan. The arrangement of the Chinese

[9] Illustrated in Ref. E14, as well as E26.
[10] The larger box in the Jōdo-ji Temple has, exceptionally, four characters at one end of the container.

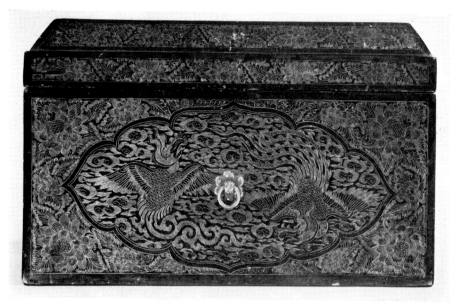

100

101

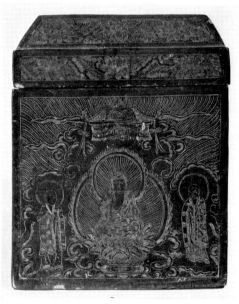

102

100–102. SUTRA BOX, Daitoku-ji Temple, 14th century
Plate 100. Front view, showing male and female phoenixes among clouds,
with peony scrolls around. Width 36·5 cm
Plate 101. Side view, showing parrots among clouds, with peony scrolls
around. Width 18·3 cm
Plate 102. Side view, showing Buddhist figures

and Japanese inscriptions, dated 1315 and 1358 respectively, on the Jōdo-ji box shows that the former was applied before the latter, so that it is not unreasonable to conclude that not only was the box in the Temple before 1358 but also that it had the Chinese inscription dated 1315 on it at that time.

The evidence provided by the top panel of the box in the Daitoku-ji might have been expected to throw some light on its date from the stylistic features on the dragon and particularly from the five-clawed feet, but unfortunately there are indications of restoration. In the absence of scientific examination it is doubtful whether any useful deduction can be made at present. We may feel however that the presence of a dragon on one of the sutra boxes suggests that some of the boxes were made under imperial supervision and were sent as gifts from the court to Japan.

To sum up all the evidence from the sutra boxes, it can be said that there are strong grounds for assuming that they were made over a large part of the first half of the fourteenth century and that the earliest of them go back to the year 1315, or possibly a little earlier. There are no grounds at present for suggesting that they were made before the fourteenth century.

There is no further evidence on the early manufacture of *ch'iang-chin* lacquer until we come to the large robe-box excavated from the tomb of Chu T'an at Chiu-hsien, Shantung Province, in 1970-1 (Plate 103). Chu T'an, the tenth son of the emperor Hung Wu, was born in 1370 and died in 1389, so that the box can be dated to 1389 or a little earlier. The box, of wood covered with red lacquer, is decorated in the *ch'iang-chin* technique with roundels, one on each face of the box, containing a five-clawed dragon among clouds. Various scroll borders round the edges complete the design. The box, which is 61·5 centimetres high, is fitted with a drawer and divided into a number of compartments. The objects found inside it include another box, rectangular in shape, nearly 50 centimetres long, also decorated with five-clawed dragons in the *ch'iang-chin* technique.

The style of decoration of the robe-box is quite different from that of the sutra box bearing the date 1315 and suggests that a change of technique took place at some time between the dates 1315 and 1389. The new style of decoration, instead of relying on long flowing lines, uses short heavy lines massed together so as to give the effect of solid gold. This difference was pointed out, in connection with the Ryukyuan lacquerwares, in a paper by the author in 1972.[11] It is not possible to see the technique in the illustration of Plate 103, because of the small scale of the large robe-box, but the two details of Plates 104 and 105, taken from the early Komyō-bō sutra box and the Ryukyuan box in the Todai-ji Temple respectively show the earlier and later techniques clearly. Some other examples of the new techniques and styles in the Ryukyuan *ch'iang-chin* wares will be discussed later in this chapter.

References already made to the furniture with *ch'iang-chin* decoration sent by the court to Japan in 1406 and 1433 show that *ch'iang-chin* lacquerwares were being made in China in the fifteenth century. The small six-lobed box recently excavated at Kiang-yang and now in the Soochow Museum, provides more solid evidence. The box is described as being etched on a deep purple ground. Two illustrations of

[11] Ref. E.35.

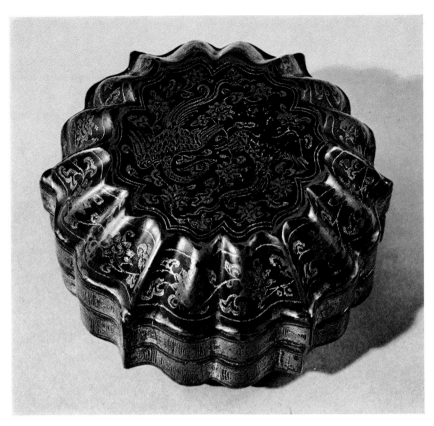

E. FOLIATED BOX of *ch'iang-chin* lacquer, decorated on the top with two phoenixes amid
lotus scrolls and on the sides with lotus scroll and key-fret borders
Early 15th century. Diameter 12·5 cm
British Museum. See page 164

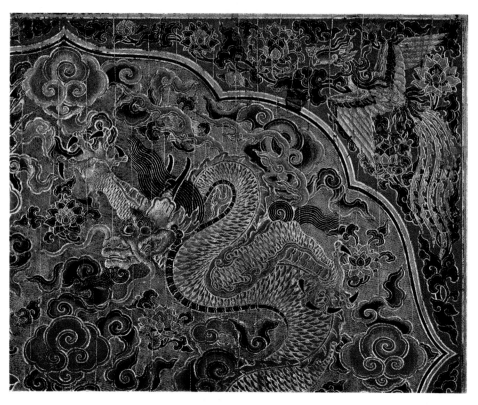

F. Detail of dragon from CABINET of filled-in lacquer in polychrome
First half of 15th century
Victoria and Albert Museum. See pages 181–4

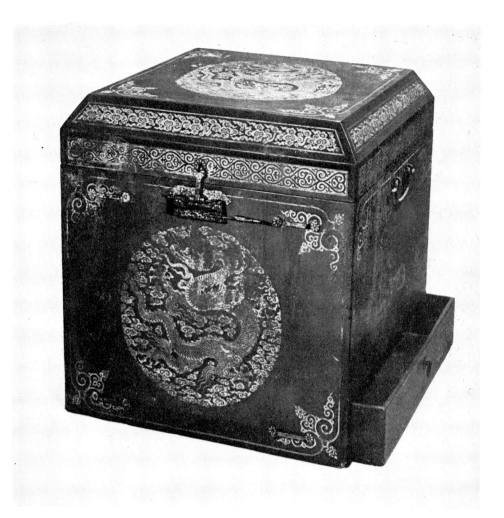

103. ROBE-BOX from Chu T'an tomb, decorated with dragon roundels and formal borders
Dated to c. 1389. Height 61·5 cm

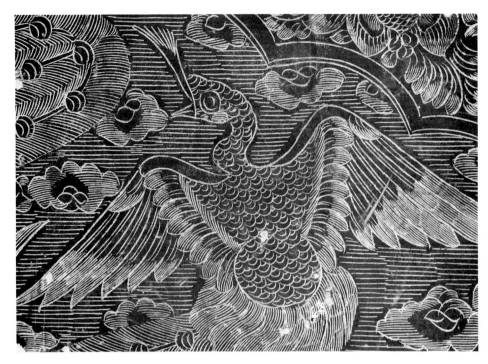

104. Detail from SUTRA BOX, Komyō-bō Temple, showing earlier type of *ch'iang-chin*
First half of 14th century

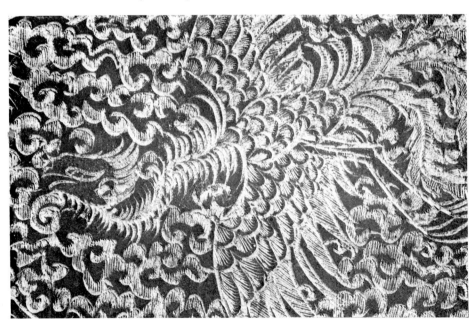

105. Detail from SUTRA BOX, Todai-ji Temple, showing later type of *ch'iang-chin*
15th century, Ryukyuan

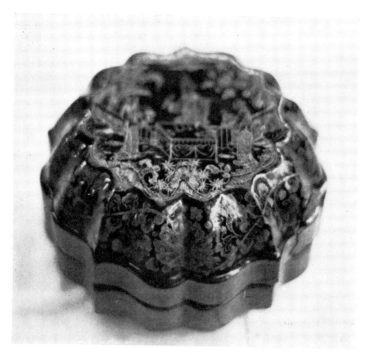

106

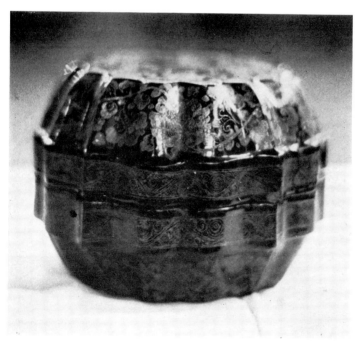

107

106, 107. FOLIATED BOX, excavated at Kiang-yang, decorated with an
audience scene on the top and formal borders on the sides
Early 15th century
Soochow Museum

the box are shown in Plates 106 and 107. There is an audience scene on the top, while the sloping sides are decorated with lotus scrolls and the vertical sides with spiral scrolls. On the base is a cyclical mark with a date corresponding to the series ... 1345, 1405, 1465. ... The most likely date of manufacture is 1405 and the comparison of the shape and decoration with that of a pair of boxes brought from China by Hochstadter in the 1940s makes this date almost certain. One of the boxes, formerly in the Low-Beer Collection and now in the British Museum, is illustrated in Colour Plate E. The pair to it is in the Yamato Bunkakan, Nara.[12]

The shape of the boxes, with their sharply lobed edges, which can be closely matched by metalwork of the Yüan and Ming dynasties, and the lotus scrolls on the sloping sides are very close. The *ch'iang-chin* technique is barely visible in the illustration of the excavated box, but it is clear on the box shown in the Colour Plate. The rest of the decoration is different, with a pair of phoenixes on the British Museum box and a key-fret border on the sides. Low-Beer, discussing the date of the box in a paper written in 1950,[13] showed that the design is close to that of the phoenixes in the interior of a porcelain stem-cup decorated in blue and white, which he attributed to the early fifteenth century. This attribution has stood the test of time. An early fifteenth-century date would be given to the stem-cup by authorities on blue and white porcelain today. The Chinese excavators themselves have given an early fifteenth-century date to the Kiang-yang box.

An unusual feature of the phoenix boxes is the use of a red lacquer layer underneath the final black layer. As a result of wear, the surface of both boxes now reveals an alternation of red and black, as can be clearly seen in Colour Plate E. It was once thought that the use of a red layer was to provide an imitation of the Japanese *negoro-nuri* and therefore to imply a Ryukyuan rather than a Chinese provenance. This explanation, in the light of the recent evidence, is now seen to be untenable. We now know from recent excavations that it was a practice at some centres of manufacture of Sung lacquer to apply a black layer over a red ground.[14] A group of nineteen pieces excavated from a Sung tomb at Shih-li-p'u in Hupei Province were lacquered in this way, giving a reddish-black surface. It may be recalled that the Kiang-yang box is described as being purple in colour, possibly the result of one colour being applied over another.

There is a possible practical reason for the use of a red undercoating. The incisions, being cut into a red ground, would make the decoration more brilliant than on a black ground. It is worth noting that all the earliest *ch'iang-chin* wares were on a black ground, while the later ones were generally red.

This brings us to the end of the first phase of the development of *ch'iang-chin* lacquer and to the beginning of the second, when manufacture of the *ch'iang-chin* wares began in the Ryukyu Islands. The quality of the best of these wares was so high that the Japanese, who have by far the largest number of pieces in any country

[12] Yasuhiko Mayuyama, *Chugoku Bunbutsu Kembun* (Observations of the Chinese Cultural Civilization), 1973, plate 172.
[13] Ref. E16.
[14] The results of the excavations of the Sung lacquerwares have been fully summarized by Hin-cheung Lovell, Ref. E40.

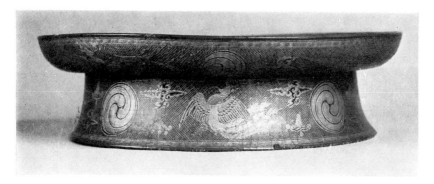

108

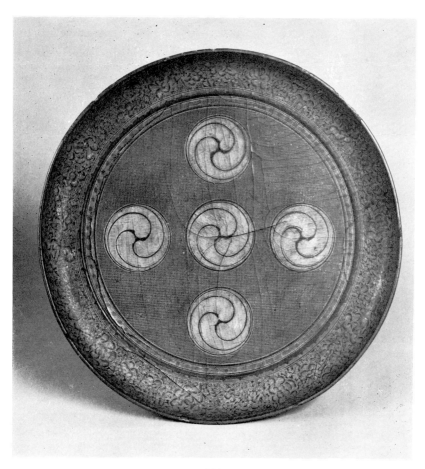

109

108, 109. OFFERING-DISH decorated with phoenixes and Shō *mon* among clouds
outside and Shō *mon* with floral borders inside
Ryukyuan, 15th century. Diameter 38 cm
Tokugawa Foundation

today, have given them a Chinese attribution. There is one piece, however, an offering-dish with a deep foot in the Tokugawa Collection, which is universally accepted as Ryukyuan, and it is appropriate therefore that it should be studied in detail (Plates 108 and 109). It has almost every characteristic that we associate with a Ryukyuan attribution. In the first place, the shape of the vessel is suitable for people who normally sit on the floor, as do the Ryukyu Islanders and the Japanese, unlike the Chinese, who make use of chairs and high tables. Among the sixty designs of Ryukyuan lacquer objects illustrated by Ishizawa[15] the most common type of vessel is the offering-dish on a pedestal stand, either by itself or associated with a tiered food-box, a combination never found in Chinese lacquer. The decoration of the Tokugawa dish, while it follows the 'massed gold' technique of the Chinese pieces bearing the dates 1389 and 1405 (Plates 103 and 106), includes a number of new stylistic features. Some of these are shown in Plates 110 to 113 on an enlarged scale. The introduction of a square diaper as a background to the main decoration is one of the most important new features. The more simple form is shown in Plate 112. A more elaborate form, in which intersecting circles are added, is seen in Plate 113. Two narrow borders are shown in Plates 110 and 111. The former, clearly derived from the Chinese key-fret, but showing no continuity of line, which I have described by the term 'debased key-fret', and the latter, a simple humped wave border, are commonly used. These borders and the more simple form of the square diaper are all used in the Tokugawa dish. It should be noted, however, that the plain backgrounds were never entirely abandoned. This feature, for example, is to be seen in the peony scroll on the inside of the Tokugawa dish (Plate 109) and we shall see other examples later.

But the feature that makes the Tokugawa dish of supreme importance is the use of the *mon* of the royal Shō family in Okinawa, which is seen both on the outside and inside of the dish. A large number of later Ryukyuan lacquerwares, many in *ch'iang-chin* technique, are known with this device, but this is the only piece known with any claims to be really early. The family name was conferred on the Okinawan ruler by the Chinese emperor Hsüan-tê in 1427,[16] so that the dish cannot be earlier than that date, but it is reasonable to attribute it to the second half of the fifteenth century.

Also of great importance are two cylindrical boxes which have been handed down in Kume Island, some sixty miles west of Okinawa. Very little lacquer survived the devastation that took place when Okinawa was invaded by American troops in 1945, when all the historic records and most of the cultural objects were destroyed. The small island of Kume was spared this destruction, so that these two important boxes have been preserved. They are said to have belonged to a prince of Shuri, the capital of Okinawa, who was exiled from Okinawa in 1470, and to have been handed down as heirlooms to the present members of the Yamazoto family. One of the boxes is illustrated in Plate 114. Such boxes, from the number that have survived, must have been common in the fifteenth century. They were fitted with an internal tray which served to secure the lid, and were used as containers of symbolic ornaments, necklaces and hairpins. The decoration of the box

[15] Ishizawa Hyogo, *Ryūkyū shikki kō*, 1889. See also Ref. E35.
[16] Ref. E21.

110

111

112

113

110–113. Details of decoration in *ch'iang-chin* lacquer: Plate 110. Debased key-fret border. Plate 111. Wave border. Plate 112. Simple square diaper ground. Plate 113. Square diaper ground with circular arcs

114. BOX from Kume Island, decorated with phoenixes among clouds
Ryukyuan, 15th century. Height 20·1 cm
Shuri Museum

116. COSMETIC-BOX decorated with birds on peony branches and insects
Ryukyuan, 15th century. Length 38·2 cm
Tokyo National Museum

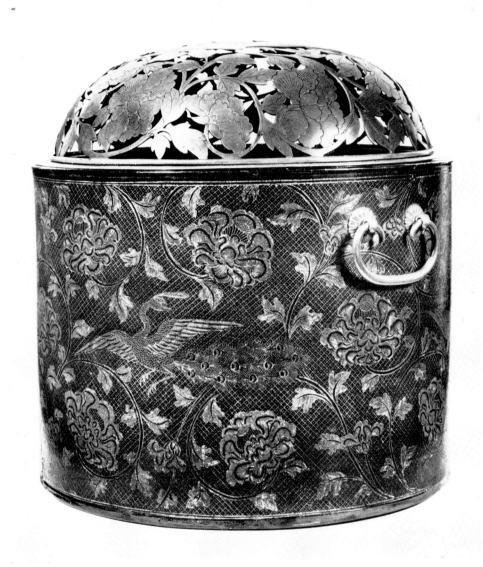

115. CYLINDRICAL BOX decorated with peacocks set in peony scrolls
Ryukyuan, 15th century. Diameter 24·9 cm
British Museum

in Plate 114, showing phoenixes and clouds against a square diaper ground, resembles closely, except for the absence of the Shō *mon*, that on the exterior of the Tokugawa dish (Plate 108). The second box is decorated with short-tailed birds and chrysanthemums against a square diaper ground of the more complex form, with circular arcs, which is shown in Plate 113.[17]

A number of other cylindrical boxes are known, some of which have lost their internal trays and lids. The finest of these is the box in the British Museum illustrated in Plate 115, which has been converted into an incense-burner by the addition of a metal liner and a perforated cover, almost certainly made in Japan. The decoration of flying peacocks and peony scrolls is very fine.

Another exceptionally fine piece of *ch'iang-chin* lacquer, perhaps the finest of all the Ryukyuan wares, is the cosmetic-box (*tebako*) in the Tokyo National Museum (Plate 116). This box has for a long time been given by the Museum a Chinese attribution and dated to the fifteenth century. I think that there can be no doubt as to the fifteenth-century date but that the box is of Ryukyuan provenance. The use of a plain background is not common, although there are a number of other examples known, such as the border of peonies inside the Tokugawa dish, already mentioned. The lack of any narrow borders is also unusual although not unknown among the Ryukyuan wares. But the important feature that places the box firmly among the Ryukyuan wares is the *ch'iang-chin* style, which closely resembles that of all the accepted Ryukyuan wares, including the Tokugawa dish. In Plate 117 an enlargement of a detail of the Tokyo box is shown side by side with one of the British Museum box (Plate 118) to about the same scale. The resemblance in decoration is very close, particularly in the depiction of the peony flowers, in which the undecorated parts stand out against the massed goldwork, giving a three-dimensional effect. The precision with which the parts in reserve are depicted is remarkable. Very few of the other pieces come up to this standard, but the same principles of decoration apply. It would be difficult to find a group of artifacts that are more consistent in decoration than these Ryukyuan *ch'iang-chin* wares.

The interesting feature in the Tokyo box is the shape of the edges of the cover. The curved rounded edge, with a narrow horizontal ledge is very common on Japanese lacquer. It is known by the term *chiri-i*, 'dust piece', and it was first introduced in the early Heian period (tenth century) and has continued to be very popular down to the present time. I know of no authenticated Chinese lacquer box of this shape.

I have stressed the reluctance of Japanese experts to accept as Ryukyuan the group of *ch'iang-chin* lacquerwares discussed above, with the single exception of the Tokugawa dish (Plates 108 and 109). This reluctance is based on the view that the Islanders were incapable of making lacquer of such distinction. But in fact the Tokugawa dish itself, although not quite up to the standard of the two finest pieces, the Tokyo box (Plate 116) and that in the British Museum (Plate 115), is itself a piece of great distinction, requiring for its manufacture a well-organized lacquer industry and highly skilled craftsmen. Moreover, all the individual features of the dish, such as the treatment of the diaper grounds, the narrow borders and, above

[17] Both boxes are illustrated in Ref. E35, Plates 16 and 17.

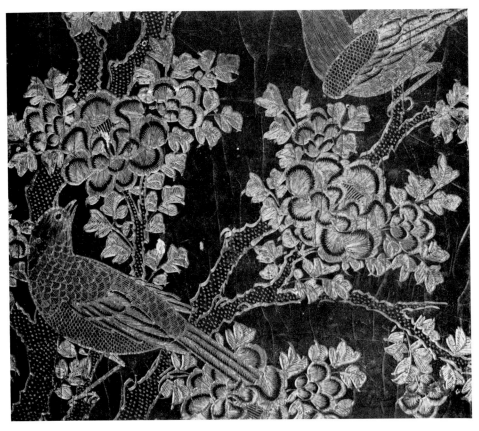

117. Detail of *ch'iang-chin* decoration on COSMETIC-BOX (Plate 116)
Tokyo National Museum

118. Detail of *ch'iang-chin* decoration on CYLINDRICAL BOX (Plate 115)
British Museum

all, the techniques of decoration are repeated, in one form or another, in every one of the pieces that have been attributed by the Japanese to China.

It seems that the Japanese, in reaching their conclusions, have taken insufficient account of the history of the Ryukyu Islands in the fourteenth and fifteenth centuries when, under the guidance of the Chinese and to a less extent the Koreans, the Islanders built up a number of industries, of which lacquer manufacture was the most important. As early as 1393 a Chinese settlement was installed at the village of Kume, situated near to Shuri, the capital of Okinawa. The records, now unfortunately destroyed, referred to specialist craftsmen in ship building, and the manufacture of paper, ink and writing-brushes. Numbers of craftsmen from the Islands were sent to the great Chinese seaport of Ch'uan-chou in Fukien to learn the arts and crafts. Indeed, it would not be far from the truth to regard the Ryukyu Islands as a minor province of China up to the time of the Japanese occupation in the early seventeenth century.[18] It is possible that the Chinese craftsmen at Kume took a prominent part in the manufacture of the earliest pieces to be made in Okinawa, but the introduction of non-Chinese features, such as the debased key-fret borders, suggests that this earliest phase of Chinese domination was of short duration. Even after the Japanese occupation in the early seventeenth century the Chinese community at Kume continued to be active, down to the nineteenth century.

The Ryukyuan *ch'iang-chin* wares that have been discussed (Plates 108 to 116) include some of the finest known. A number of others, of less fine quality, nevertheless have claims to belong to the late fifteenth or sixteenth century. At some stage, probably in the seventeenth century, there was a great deterioration in the quality of the *ch'iang-chin* decoration, which is seen even in the pieces made for the court and bearing the Shō *mon* in the decoration. It is difficult to say when this change took place. If there were ever any records to throw light on this point they were almost certainly destroyed in the U.S. attack on Okinawa in 1945. The only indication we have that *ch'iang-chin* decoration continued in the sixteenth century comes from an unexpected source. There are a number of Namban screens of the Momoyama period which depict the off-loading of artifacts from ships. Details from one of these screens in the Freer Gallery of Art[19] show objects being landed on the quayside (Plates 119 and 120). The tiered box on a pedestal-dish in Plate 119 is a typical Ryukyuan combination and establishes without doubt that *ch'iang-chin* lacquer-wares were being sent to Japan in the late sixteenth or early seventeenth century.

One of the earliest of the Ryukyuan lacquerwares in the new style may well be the toilet-box fitted with drawers, whose cover is missing, illustrated in Plate 121, in the Shuri Museum. The decoration, which includes the Shō *mon*, set in peony scrolls against a square diaper ground, has lost the three-dimensional quality of the earlier wares, as a comparison with the pieces in Plates 108 to 116 shows at a glance.

[18] A fairly full account of the history of the Islands is given in the author's 'Ryukyu lacquer' (Ref. E35). For more extensive information reference should be made to George H. Kerr, *Okinawa. The History of an Island People* (Ref. E21) and the *Ryukyu Cultural Survey* made in 1960.

[19] For an illustration of the complete pair of screens, see *Masterpieces of Chinese and Japanese Art: Freer Gallery of Art Handbooks*, 1976, p. 123.

119

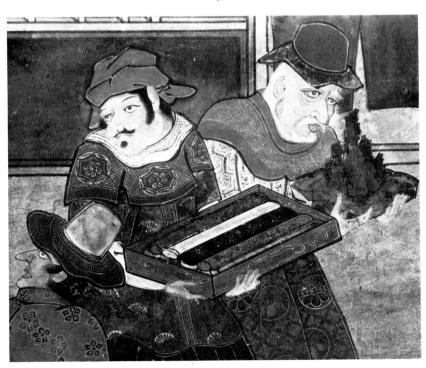

120

119, 120. Details from NAMBAN SCREENS showing *ch'iang-chin* lacquer vessels
Freer Gallery of Art

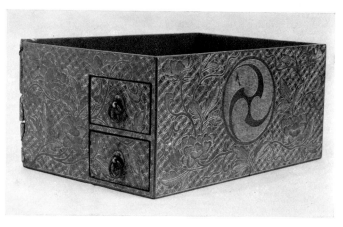

121. TOILET-BOX decorated with Shō *mon* and peony scrolls
Ryukyuan, 18th century. Length 22·9 cm
Shuri Museum

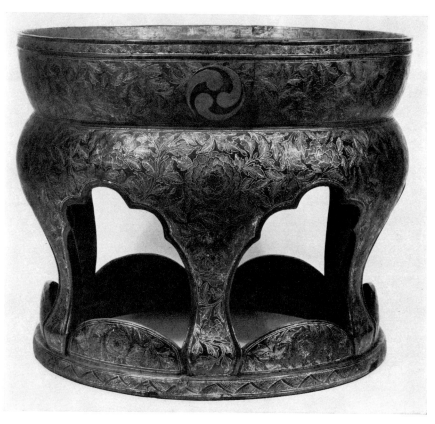

122. OFFERING-DISH decorated with Shō *mon* and peony scrolls
Ryukyuan, 18th century. Diameter 54·3 cm
Honolulu Academy of Art

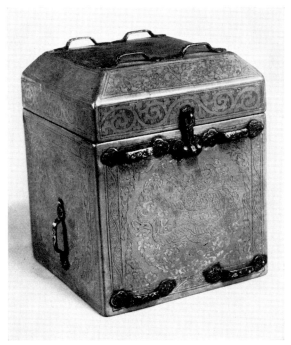

123

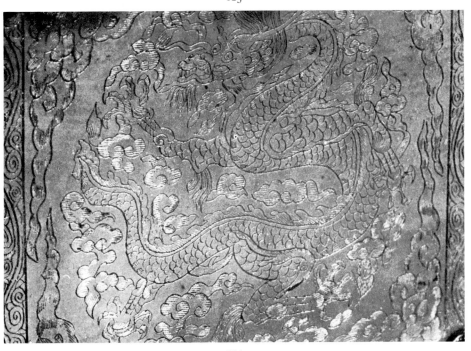

124

123, 124. SEAL-BOX decorated with dragon roundels (detail in Plate 124) and formal
borders.
16th century. Height 17·7 cm
Eisei Bunko, Tokyo

I do not think this box can be earlier than the middle of the seventeenth century. It defines a style of decoration which continues down to the nineteenth century. The large offering-dish, also with the royal *mon*, in Plate 122, in the Honolulu Academy of Art, is a fine eighteenth-century example, and there are a number of designs belonging to the eighteenth and nineteenth centuries illustrated in the dated patterns described by Ishizawa. They include a pattern for a small table dated 1775, in which the *ch'iang-chin* design is only partially completed.[20] The latest pattern given by Ishizawa is dated 1860, but there can be no doubt that the style continued into the twentieth century. In the eighteenth and nineteenth centuries painted lacquer was used in association with *ch'iang-chin* lacquer.

To complete this chapter, we must now return to the Chinese wares and find out what happened in China after the manufacture of the lobed boxes of Plate 106 and Colour Plate E. The sending of furniture and bowls with *ch'iang-chin* decoration in 1433 has already been mentioned. There is no further information, factual or literary, of manufacture of *ch'iang-chin* lacquer until we come to the middle of the sixteenth century. There can be no doubt that the introduction of the filled-in wares in the fifteenth century caused a loss of interest in the less colourful *ch'iang-chin* wares, although the latter must still have been made in small quantities. Indeed, as we shall see in the next chapter, imperial dishes bearing the Chia-ching mark are known with a combination of filled-in and *ch'iang-chin* techniques in the decoration.

The only piece of Chinese *ch'iang-chin* lacquer belonging to the sixteenth century that has yet come to light is a seal-box in the Eisei Bunko, Tokyo, which is illustrated in Plate 123. The panel of a five-clawed dragon on the front of the box of which a detail is shown in Plate 124, may be compared with that on the Chu T'an robe-box illustrated in Plate 103. Although there is a marked difference in the technique of decoration, the resemblance in shape, the bronze fittings and the general decorative treatment, all suggest that the Eisei Bunko box was derived from the Chu T'an robe-box and inspire the hope that some day other similar boxes will come to light. It must be admitted that the standard of the decoration of the seal-box is not high when compared with that of the Chu T'an robe-box and the best of the Ryukyuan wares, but it seems certain that it was made for the Chinese court. It bears the mark of Wan-li on the base, but the mark is not contemporary with the piece. In fact, the style of the dragon suggests that the box may have been made in an earlier part of the sixteenth century than that indicated by the mark.

Towards the end of the sixteenth century an entirely new group of *ch'iang-chin* wares appeared in China, some with a black and some with a red ground. We know from the *Hsiu shih lu* that the manufacture of both types was familiar to lacquerers during the second half of the sixteenth century.[21] They are mentioned both by the author Huang Ch'êng and Yang Ming, whose preface is dated 1625. The author points out that 'the areas bordered by the outlines should be closely incised, so that the design will stand out more vividly from the ground.' This, as we have seen, is a feature of the early *ch'iang-chin* wares, both in China and the Ryukyu Islands,

[20] Ref. E35, Plate 3b.
[21] Ref. C7, Section 131.

125

126

125, 126. OCTAGONAL TIERED BOX decorated with figures in a landscape on the top and with borders of landscape panels on the sides (detail in Plate 126) Late 16th century. Diameter 29·7 cm
Victoria and Albert Museum

which to some extent was lost in the later wares. Its revival in the late sixteenth century is a tribute to the resilience of the Chinese lacquerers in this period.

One of the finest examples in this new group is the tiered octagonal box of black lacquer, formerly in the Figgess Collection and now in the Victoria and Albert Museum, illustrated in Plates 125 and 126. For the first time we see the application of the *ch'iang-chin* technique to landscape.[22] It can be seen to be very effective. The landscape on the top of the box, with a splendid pine tree in the background and a group of horsemen approaching a pavilion in the foreground compares with the landscapes found in lacquerwares in other techniques belonging to the late sixteenth and early seventeenth centuries. This period in China was responsible for the development of landscape decoration of great distinction in many media. In blue and white porcelain it reached its zenith in the transitional wares of the third and fourth decades of the seventeenth century. In lacquer it is found in painted lacquer, sometimes associated with gold-painting, and in mother-of-pearl lacquer, as well as in this revival of *ch'iang-chin* lacquer. The dating of these groups largely relies on the many painted lacquerwares bearing precise dates, generally with basketry panels—few of the other wares seem to be dated—and it was therefore decided to deal with the landscape wares more fully in the chapter on the painted wares (Chapter 12). Largely on the stylistic evidence of the painted wares, the *ch'iang-chin* wares can be dated to the late sixteenth and seventeenth centuries.

Far more common than the pieces with landscape decoration are those with floral designs, sometimes in association with birds.[23] All the pieces unfortunately suffer from a technical weakness, the use of a thin lacquer base, which has resulted in badly cracked surfaces, which are often found to have broken right away. It would seem that only the careful preservation methods adopted in Japan have ensured their survival. Up to the present no examples of this type of lacquer seem to have been recorded in China.

Mention should be made of the Japanese *ch'iang-chin* wares (Japanese *Chinkin*), although these are outside the field covered by this book. A number of pieces datable to the sixteenth and seventeenth centuries are known, but apart from the similarity of technique they have little in common with the Chinese and Ryukyuan wares.

[22] Although the Kiang-yang box shows a primitive example.
[23] A number of examples are illustrated by Arakawa Hirokazu, *Ch'iang-chin Chinkin and Zonsei*, 1974, Nos. 17–27.

CHAPTER 9

Filled-In Lacquer

The *Hsiu shih lu*,[1] the most authoritative Chinese work on lacquer techniques, gives, among the hundred or so techniques described altogether, a number which involve the inlaying of lacquer into an already made lacquer bed. The main type of this filled-in lacquer, described by the term *t'ien-ch'i*, is divided into two kinds, 'wet' and 'dry', the former being laid into the final layer of lacquer while it is still fluid and the latter cut into the fully set lacquer. According to Yang Ming, who wrote the preface dated 1625 to the *Hsiu shih lu*, the former was not polished.[2] From a study of the available pieces of filled-in lacquer it is clear that the dry process was that generally used, the depth of inlay being considerably greater than could be obtained in a single layer of lacquer. The best known of the filled-in lacquerwares, the imperial wares of the Chia-ching, Wan-li and Ch'ien-lung periods, all seem to have a depth of lacquer of the order of half a millimetre and all have been polished to a fine even surface.

It has already been pointed out that the filled-in lacquerwares are a development of the *ch'iang-chin* wares and depend just as much on the incised gold decoration of the outlines for the precision of design. The term 'filled-in lacquer', while it takes no account of the incised outlines, is thought to be sufficiently clear to distinguish the wares from other types. It is almost an exact equivalent of the Chinese term *t'ien-ch'i*. The Japanese term *zonsei*, said to be the brush-name of a Chinese painter, seems to have become established in the seventeenth century and it is used universally in Japan today. But it includes a large group of pieces in which the design is overpainted and not inlaid.[3] It is desirable therefore that the term *zonsei* should not be used to describe the Chinese wares, but that the original Chinese term *t'ien-ch'i* or its Western equivalent 'filled-in' lacquer should be retained.

The first specific references to filled-in lacquer found in the Chinese literature occur in works published in the late sixteenth and early seventeenth centuries, although one of these works, the *Tsun-shêng pa-chien*,[4] published in 1591, describes somewhat vaguely what must be filled-in lacquer as having been made in the Hsüan-tê period. But this work, while of some value in describing the contemporary lacquerwares of the late sixteenth century, is generally unreliable in its

[1] Refs. C6 and C7.
[2] Ref. C7, Section 100.
[3] The reader is referred to Herberts's account in E22 for the intricacies of the Japanese use of the term *zonsei*.
[4] Ref. C8.

comments on the early wares, and the references to lacquer made some hundred and fifty years previously would be of little value without further support.

There is, however, a near-contemporary reference to the manufacture of poly-chrome lacquer in the reign of Hsüan-tê, which can be dated to 1435. This refer-ence, the only one to polychrome lacquer in the fifteenth century, is so important that it must be discussed in detail. It occurs in the *Ying-tsung shih-lu*, a section of the voluminous *Ming shih-lu*.[5] Ying-tsung was the dynastic title of the emperor Chêng-t'ung (1436-49), who was deposed and succeeded by Ching-t'ai (1450-6) and then reascended the throne as T'ien-shun (1457-64). The records for the periods 1436 to 1449 and 1457 to 1464 are collected in the dynastic records *Ying-tsung shih-lu*. The manufacture of polychrome lacquer in 1435 is attributed to Yang Hsüan, a skilled lacquerer from a family of lacquerers. Yang Hsüan achieved some fame, in a matter not connected with his skill as a lacquerer, due to his support for a colleague who was wrongfully accused by a powerful official in the reign of Ching-t'ai. He was exiled but was subsequently pardoned by the Emperor T'ien-shun and reinstated in office. The reference to his work on lacquer appears as part of his biography in the *Ying-tsung shih-lu*, and this explains why the reference to Yang's lacquer-making in the reign of Hsüan-tê was not published until the early years of Ch'êng-hua (1465-1487). However, as these records are based on contemporary accounts it is reason-able to describe the reference to Yang Hsüan's work as near-contemporary.

A literal translation of the passage referring to Yang Hsüan's activities as a lacquerer in the *Ying-tsung shih-lu* is given below:

Yang Hsüan, *tzu* Ching-ho, was a righteous man. His ancestors were natives of a certain place. His father was a lacquerer. In the reign of Hsüan-tê for the first time men were sent to Japan and to them was transmitted the *ni-chin hua-ch'i* method to bring back to China. Hsüan then learnt it and moreover made his own contribution by combining five colours, inlaid mother-of-pearl and gold, unlike the old method which used only gold. The pieces and their colours were appro-priate and naturally resplendent. The Japanese when they saw them rubbed their hands in admiration and wonder, conceding that they could not match them.

The passage is obscure in certain places, particularly in the reference to Yang Hsüan's ancestry. His father's full name is not given. It is only a conjecture, but a feasible one, that Yang Hsüan was a descendant of Yang Mao, the famous Yüan lacquerer whose name is mentioned in the *Ko-ku yao-lun*. Yang Mao was a native of Hsi-t'ang and it may be significant that another lacquerer, Yang Ming, already mentioned, who wrote the preface dated 1625 to the *Hsiu shih lu*, was also a native of Hsi-t'ang. The possibility of a family of lacquerers stretching over nearly two hundred years is perhaps not entirely ruled out.

But the most important obscurity in the passage in the *Ying-tsung shih-lu* lies in the interpretation of the type of lacquer made by Yang Hsüan. A number of writers have interpreted the passage as meaning that he was attempting to copy the Japan-ese gold-decorated lacquer. I think in fact that it implies just the opposite and that he was producing a different type of lacquer with polychrome decoration that had no resemblance to the Japanese wares.

[5] *Ming shih-lu*, Vol. 328, Chüan 328, pp. 7142-4.

There is plenty of evidence to show how greatly the Chinese admired the Japanese gold-decorated lacquerwares at this time. Quite apart from the reference already mentioned in the *Ming shih-lu* there are records of three ship-loads of goods being sent to China from Japan in 1433 and of a further nine in 1435. In the former there were a number of cases and boxes decorated in gold wash, sprinkled gold and mother-of-pearl, and in the latter unspecified lacquerwares.[6] But in spite of the admiration of the Chinese for the varied methods of gold decoration used by the Japanese, there is no factual evidence that they did, at any time, make any serious attempt to copy them. *Ni-chin hua-ch'i*, literally 'lacquer painted with gold dust', is a type of decoration that hardly ever appeared in the Chinese repertoire. Moreover, this type of decoration would be incongruous in association with polychrome decoration. The Chinese text stresses the point that the new method of decoration was 'unlike the old method which used only gold'. The account does, it is true, refer to the use of mother-of-pearl decoration in addition to polychrome, an association that hardly occurs at all in Chinese lacquer. It seems likely that some official in recording the astonishment of the Japanese in seeing Yang Hsüan's work has been guilty of gilding the lily.

If we leave out the reference to mother-of-pearl decoration we have a description which fits very well the filled-in technique and there is a strong presumption that this first reference to polychrome lacquer in China was to a filled-in type. It is a natural development from *ch'iang-chin* and we know that examples of the latter appear in the list of objects sent to Japan in 1433. The presumption becomes a near certainty when we take into account the fact that there are a few pieces with filled-in decoration in existence today which can be attributed to the fifteenth century and one, in particular, whose claims to belong to the first half of the century are unassailable. This is the cabinet, inlaid in a wide variety of colours and incised in gold, decorated with imperial dragons and phoenixes, which is illustrated in Plates 127 and 128, with a detail of one of the dragons in Colour Plate F. This superb piece, formerly in the Low-Beer Collection and now in the Victoria and Albert Museum, was fully described by the former owner in a paper written in 1950. His close comparison of the designs of the dragons and phoenixes in the cabinet with those of the equally famous carved red lacquer table (see Chapter 6 and the Frontispiece) shows that there can be no doubt whatever that the cabinet belongs to the first half of the fifteenth century.[7]

Low-Beer not only studied closely the stylistic features of the cabinet, but also with commendable boldness took minute sections of the inlays and established in detail the method of construction. This is the first explanation in a Western language of the technique of filled-in lacquer, but of course it was well understood by Chinese connoisseurs. The writers of the sixteenth century were never tired of describing how the brilliance of the filled-in lacquerwares was maintained after a good deal of wear. Filled-in lacquer at this time was even more widely esteemed

[6] *Ming shih-lu*, Vol. 34, Chüan 236, p. 5139. A translation of the list of objects, which unfortunately omits the reference to mother-of-pearl lacquer, is given by Wang Yi-t'ung, 'Official relations between China and Japan, 1368–1549', *Harvard-Yenching Institute Studies*, IX, 1953, pp. 104–5 (Ref. E18).

[7] Ref. E16, pp. 152–6.

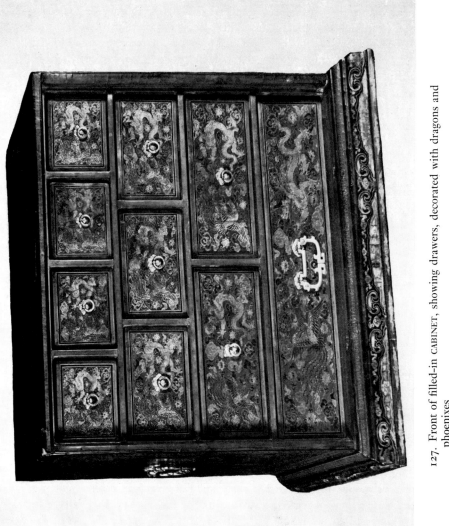

127. Front of filled-in CABINET, showing drawers, decorated with dragons and
phoenixes
First half of 15th century. Width 42 cm
Victoria and Albert Museum

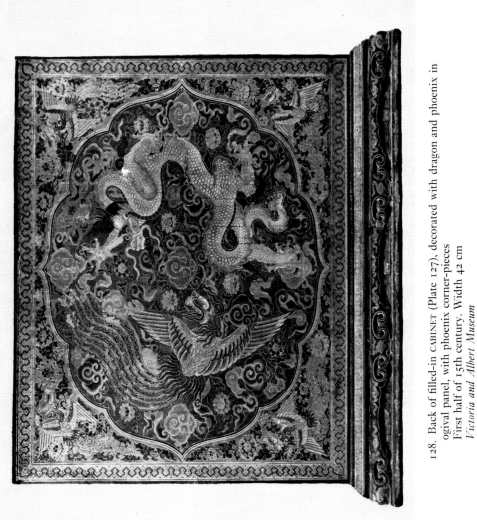

128. Back of filled-in CABINET (Plate 127), decorated with dragon and phoenix in ogival panel, with phoenix corner-pieces
First half of 15th century. Width 42 cm
Victoria and Albert Museum

than the carved lacquer. The popularity of both types was extremely high and the Wan-li writer Shên Tê-fu in the *Yeh-huo-pien* describes how carved and filled-in lacquerwares were smuggled out of the Palace in Peking and sold in the market which was held once a month near the City God's Temple.[8]

The range of colours in the cabinet is astonishingly wide and it is almost impossible to produce them in a single colour illustration. The detail in Colour Plate F, however, gives a good idea of the range. There are at least three shades of red and a number of brown, yellow and orange shades. There appear to be two shades of green, as well as an intense black. It seems likely that some variation of colour has been caused by fading and by the effect of uneven polishing over many years, but even on a conservative basis it is clear that the variety of colour in the cabinet is far greater than is found in any other piece made over the whole period of manufacture of the filled-in wares, from the fifteenth to the eighteenth century. The appearance of this cabinet in the fifteenth century, with a range of colour never seen before in any type of lacquer, may well have astonished the Japanese lacquerers when it, or a similar piece, was shown to them by Yang Hsüan.

One other cabinet, of similar shape is known, now in the Kaisendo Museum, Yamagata, decorated on the front with a landscape of Taoist temples set among mountains and pine trees, and on the drawers inside with growing plants and rocks.[9] This cabinet, which has had considerable restoration on the inside, a number of the drawer-fronts being complete replacements, seems on grounds of style to be later than the imperial cabinet, although possibly belonging to the late fifteenth or early sixteenth century.[10] Of the smaller pieces discussed by Low-Beer and attributed to the fifteenth century,[11] I think there is only one that has strong claims to belong to that century, a cylindrical box decorated with lotus sprays on the top (Plate 129). This box, formerly in Berlin, is now lost and an up to date assessment of it cannot be made. But the design is remarkably close to that of a similarly shaped box of cloisonné enamel, now in the Uldry Collection, which belongs to the second half of the fifteenth century.[12]

Reference has already been made to the so-called wet process of inlay. The term 'filled-in' in this connection is somewhat of a misnomer and it must be pointed out that there are a number of techniques more suitably described as painted rather than filled-in lacquer. Two attractive little boxes, one decorated with clouds and the other with a peony spray, both on a red ground, were exhibited in the Arts of the Ming Dynasty Exhibition in London in 1957 as examples of filled-in lacquer and tentatively ascribed to the fifteenth century.[13] There has been an opportunity

[8] Ref. C10.

[9] It was shown in the Exhibition of Chinese Arts of the Ming and Ch'ing Periods, Tokyo National Museum, 1963, and is illustrated in the Catalogue (No. 269).

[10] The cabinet is similar in shape to the imperial cabinet, but it has a feature not known to occur in any other piece of filled-in lacquer made before the Wan-li period, i.e. a filled-in diaper ground. For the present the date of manufacture is best left open.

[11] Note 7 above, Nos. 21, 22, 27, 28 and 30.

[12] The box is illustrated in the author's *Chinese and Japanese Cloisonné Enamels*, Plate 26A.

[13] Catalogue of the Arts of the Ming Dynasty Nos. 267, 268, Plate 73. Low-Beer previously (note 7 above) had ascribed the former to the fifteenth century.

129. CYLINDRICAL BOX decorated with lotus scrolls
15th century. Diameter c. 18 cm
Formerly in the German State Museums, Berlin

130. CYLINDRICAL BOX decorated with a lotus spray
16th century. Diameter 6·6 cm
Victoria and Albert Museum

recently to examine closely the second of these two boxes, which is now in the Victoria and Albert Museum (Plate 130) and it is clear that the technique is closer to a painted rather than a filled-in one. It may, however, come under the description of 'wet inlay'. The date of manufacture now seems likely to be in the sixteenth rather than the fifteenth century. The second box, in the Royal Scottish Museum, may well belong to a similar period, but there are signs of redecoration which make the dating even more difficult.

Apart from the few pieces mentioned above, of which three pieces at the most can fairly claim to belong to the fifteenth century, no other lacquerwares in the filled-in technique earlier than the Chia-ching period (1522-66) have so far been recorded. The manufacture in this later period must have been very extensive, for at least thirty pieces bearing this reign mark have survived. A typical example is the large dish illustrated in Plate 131, with a winged dragon in the centre surrounded by the unusual border of the eight musical instruments. The cabinet in Plate 132 has the mark of the Hsüan-tê period, but it is clear that it belongs to that of Chia-ching because, although the two middle characters indicating the reign have been replaced, the outside characters *Ta Ming* and *nien chih*, which are original, are in typical Chia-ching calligraphy. The five-lobed box in Plate 133, formerly in the Figgess Collection, is a third fine example of the Chia-ching filled-in lacquerwares. The dragons in this piece have had the fifth claw overpainted with small clouds, no doubt added when the piece was removed from the imperial collection, either as a gift from the emperor, or more surreptitiously as described in the *Yeh-huo-pien*. An ingot-shaped dish in a private Japanese collection has been mutilated in the same way. A detail of this dish, showing clearly the overpainting, is depicted in Plate 134.[14] The dish in Plate 135, in the Yamato Bunkakan, is of special interest in showing in the same piece both the *ch'iang-chin* and filled-in techniques, the dragon in the former and the hibiscus spray in the latter, a practical demonstration of the close association of the two techniques. A pair to this dish was formerly in the Sedgwick Collection.

Only one example of filled-in lacquer with the reign mark of Lung-ch'ing (1567-1572) has yet come to light. This, a box in the Barber Institute, Birmingham, with the unusual shape of two intersecting lozenges, is decorated with two dragons on the top and lotus and scroll borders on the sides (Plate 136). From the subsequent reign of Wan-li (1573-1619) there are many surviving pieces, even more than there are with the Chia-ching mark. These include sets of five small dishes which have been built up in Japan, no doubt for use in the tea ceremony. The marks on Wan-li pieces, with few exceptions, run horizontally along the edge of the base and contain two additional characters giving the cyclical date. The known dates in the filled-in lacquerwares stretch from 1585 to 1619, covering the greater part of the reign. One of the finest pieces is a brush-holder in the Royal Scottish Museum, Edinburgh which bears the date corresponding to 1601 (Plate 137). It is decorated on a red ground with four ogival panels, each containing two finely etched dragons rampant, facing each other, among clouds and over rocks and waves, the space between being filled in with a square diaper ground with each square enclosing a *wan* character.

[14] Other illustrations of this dish are given by Arakawa Hirokazu, *Ch'iang-chin, Chinkin and Zonsei Lacquerwares*, 1974, No. 42 (in Japanese).

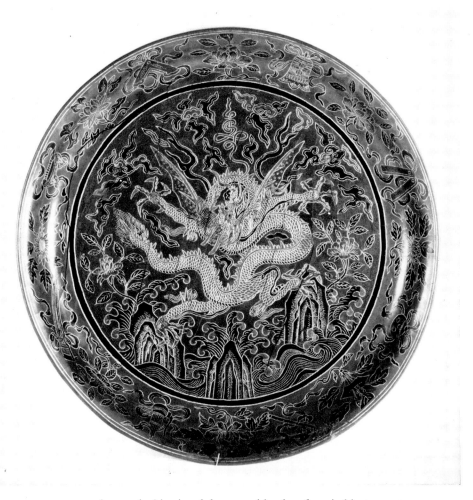

131. DISH decorated with winged dragon and border of musical instruments
Chia-ching mark and period. Diameter 38·1 cm
Victoria and Albert Museum

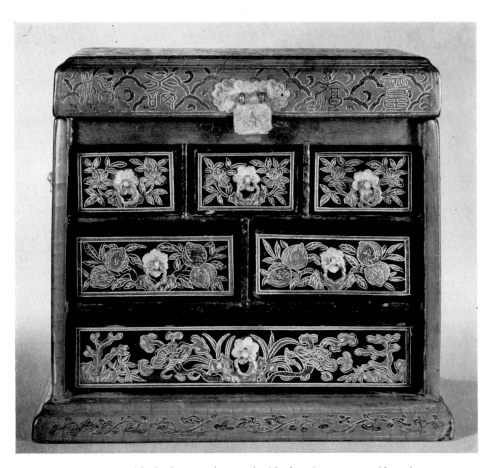

132. CABINET with six drawers, decorated with *shou* characters outside and
the drawers with floral and fruiting sprays
Chia-ching period. Height 25·4 cm
Victoria and Albert Museum

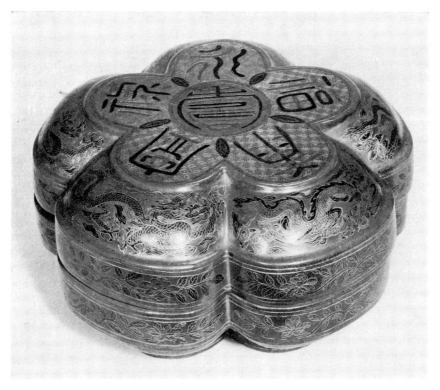

133. FIVE-LOBED BOX decorated with dragons and characters on the top and with floral borders
Chia-ching mark and period. Diameter 25·6 cm
Victoria and Albert Museum

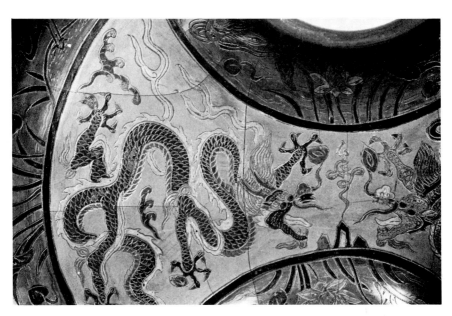

134. Detail of INGOT-SHAPED DISH showing dragon with defaced claws
Chia-ching mark and period
Private Japanese Collection

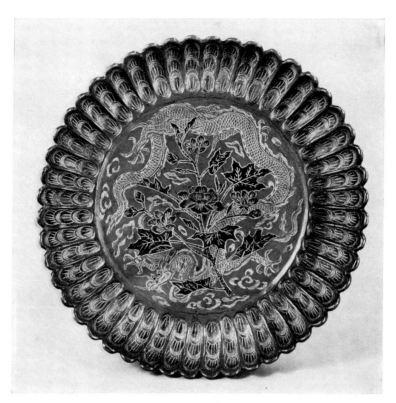

135. LOBED DISH decorated with dragons in *ch'iang-chin* and hibiscus spray in filled-in lacquer
Chia-ching mark and period. Diameter 17·7 cm
Museum Yamato Bunkakan, Nara

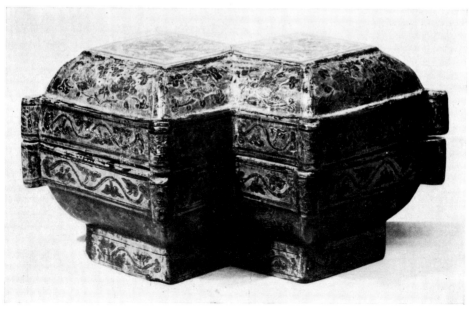

136. LOZENGE-SHAPED BOX decorated with dragons on the top and with floral borders
Lung-ch'ing mark and period. Length 25·9 cm
Barber Institute, Birmingham

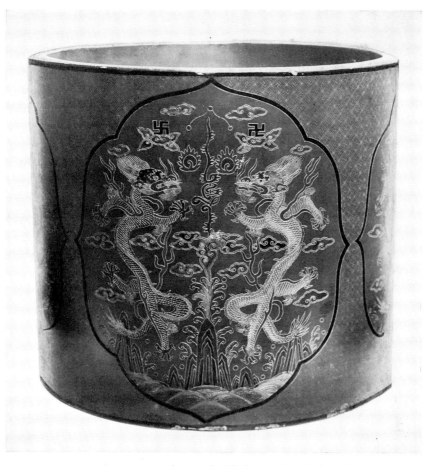

137. BRUSH-HOLDER decorated with dragons in ogival panels
Wan-li mark, dated 1601. Height 22·9 cm
Royal Scottish Museum, Edinburgh

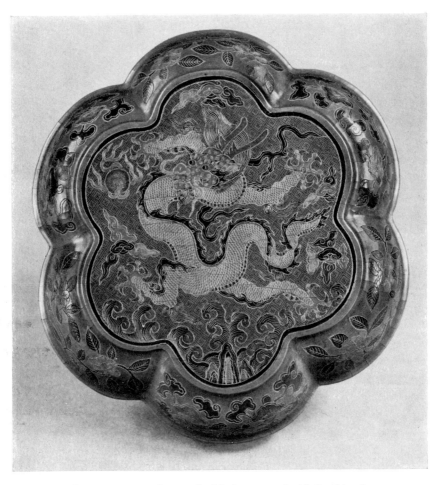

138. SIX-LOBED BOX decorated with dragons and with floral borders
Wan-li mark, dated 1586. Diameter 25·3 cm
Okayama Art Museum

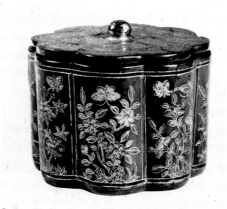

139. EIGHT-LOBED BOX with flat cover, decorated with
flowering plants and butterflies
16th century. Height 9·2 cm
Victoria and Albert Museum

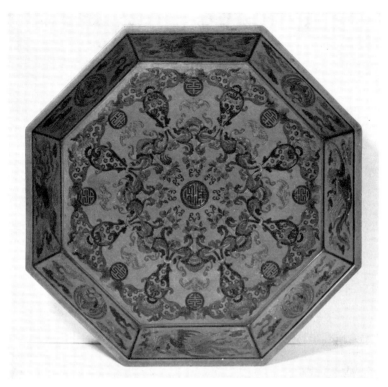

140. OCTAGONAL TRAY decorated with formal designs, the rim with panels of dragons and phoenixes
Ch'ien-lung mark and period. Diameter 41·1 cm
Museum of Far Eastern Antiquities, Stockholm

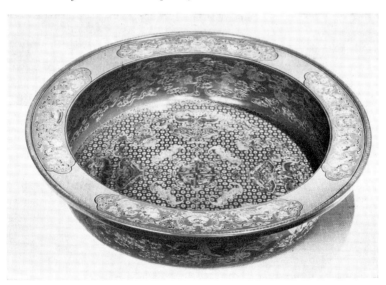

141. DEEP DISH decorated with bats and emblems, with formal borders
Ch'ien-lung mark and period. Diameter 44·2 cm
Victoria and Albert Museum

The use of a decorative ground such as this is a feature of the Wan-li lacquerwares, every piece that has come to light being decorated on the ground for at least a part of the piece. This is in contrast with the Chia-ching wares which never, as far as present evidence goes, have inlaid diaper grounds.[15] Another fine dragon piece, made earlier in the reign, in 1586, is the five-lobed box in the Okayama Art Museum shown in Plate 138. The charming lobed box with flat cover, formerly in the Sedgwick Collection and now in the Victoria and Albert Museum (Plate 139) although unmarked, can be attributed to the Wan-li period from its resemblance to porcelain boxes of this period. The decoration of flowering plants and butterflies makes a welcome change from the imperial dragons that provide the decoration of nearly all the pieces with the Wan-li mark. It should be mentioned, as the decoration of the cover is only just visible in the illustration, that it has the square diaper ground and so conforms to the general rule for Wan-li pieces already mentioned.

Filled-in lacquerwares continued to be made in the Ming dynasty after the reign of Wan-li and a few are known with the marks of T'ien-ch'i, (1621-7) and Ch'ung-chên (1628-43). The quality shows a marked deterioration as compared with the Wan-li wares and in some of them the filled-in technique has been replaced, in whole or in part, by an overpainted one, although the gilt outlines are still retained. This cheaper technique is also to be found among a large number of the later Ryukyuan wares.

There was apparently a cessation of manufacture of filled-in lacquer in the early part of the Ch'ing dynasty. But the absence of pieces attributable to the K'ang-hsi and Yung-chêng periods is consistent with the absence of lacquerwares of all kinds with the marks of these two periods, and indeed other artifacts. There is no shortage of pieces with the Ch'ien-lung mark and some of these are of very high quality. The octagonal tray in the Museum of Far Eastern Antiquities, Stockholm, formerly in the King of Sweden's Collection (Plate 140), is a fine and typical example of imperial lacquer of the Ch'ien-lung period. It bears in addition to the six-character mark of the period, the four characters *pa-fang jui-p'an*, 'lucky octagonal tray'. Fine as this piece is, it resorts to a little overpainting for some of the finest details. This feature is never found in the imperial filled-in lacquerwares of the Ming dynasty. Another fine piece is the deep circular dish shown in Plate 141. This has an unusual mark, the six-character mark of Ch'ien-lung being set in an elaborate cartouche flanked by two dragons among lotus scrolls. A number of nests of boxes in filled-in lacquer fitted with stands of carved lacquer were also made in this period. An example of this combination is discussed in the chapter on the later carved wares (Chapter 7) and is illustrated in Plate 91.

[15] The backgrounds of the Chia-ching lacquerwares, with very few exceptions, are plain. The exceptions have a ground drilled with small holes and filled in with black lacquer, similar to those of the fifteenth century (see Colour Plate F). One of these in the Peking Palace Collection, is illustrated by Speiser (Ref. E27, pp. 122-3). This background may be an indication of earliness in the Chia-ching reign.

CHAPTER 10

Surface Gold-Decorated Lacquer

The complex relationship between the various techniques of gold-decorated lacquer has already been apparent from the two previous chapters. Although in China the lacquerwares with the more simple type of decoration, those painted in gold with the brush on a smooth red or black ground were far more numerous than the incised gilt wares, the latter were more important artistically and did in fact lead, in the filled-in technique, to some of the finest of the Chinese decorative lacquerwares. This explains why it seemed to be preferable to treat the wares with incised decoration first and leave the flat painted wares to this later chapter.

We have seen that surface gold-decorated lacquer was generally, in China, far less important than the superb Japanese work with its great variety of techniques, including the preparation of many kinds of sprinkled gold and other metals, and the elaborate building up of surfaces, followed by meticulous grinding processes. The Chinese were certainly familiar with the Japanese gold lacquerwares long before the fifteenth century and greatly admired them, but there is no evidence of any great desire to copy them. Most of the Chinese gold lacquerwork is relatively simple, the brushwork being applied to the flat surface or, in the later developments, to a slightly raised linear design. On red lacquer the raised decoration is in black and on black lacquer it is generally red. There are a few exceptions, in which the building up of the designs by the technique known to the Japanese by the terms *hiramakie* and *takamakie* was adopted. An example of this rare type will be discussed later (Plate 151).

The earliest examples of painting in gold lacquer that have come to light are to be found in a group of boxes excavated from the Pagoda at Jui-an, Chekiang Province during late 1966 and early 1967.[1] Although this is not a dated tomb, but a hoard, most of the objects are datable to before 1043 and the boxes can be accepted as earlier than this date. They have already been discussed in the chapter on the early carved lacquer (Chapter 5) because they have a moulded *appliqué* decoration which was a forerunner to the true carved lacquer of the fourteenth and fifteenth centuries. The elaborate *appliqué* work in fact formed the panels that served as the framework for the designs in gold. These designs are mainly of formal scrolls and diapers, but the most interesting and that chosen for illustration in this book is of Buddhist figures in Sung style (Plate 24).

It is remarkable that no other early example of gold-painted lacquer except the group of boxes from Jui-an have come to light and still more remarkable that even in the Ming dynasty there seem to be no examples earlier than the sixteenth century.

[1] *Wên-wu*, 1973, No. 1.

195

Certainly Li Hung-ch'ing does not mention any earlier pieces in the Palace Collection than a pair of drug-cabinets of the Wan-li period.[2] It would seem that gold-painted lacquer was of little account before the Wan-li period, either at the court or among connoisseurs, for although *ch'iang-chin* lacquer is described in the literature of the fourteenth century and pieces were sent by the court to Japan in the fifteenth, no references in the Chinese literature to gold-painted lacquer can be traced. The earliest references are to be found in the *Hsiu shih lu*, dated to the late sixteenth century. Various types of gold painting, as well as raised designs imitating Japanese lacquer and decoration with gold foil are described.[3]

The drug-cabinets described and illustrated by Li Hung-ch'ing are imposing objects. One of them is illustrated in Plates 142 and 143. It is of black lacquer decorated on the front and sides with imperial dragons; the fronts of the numerous boxes inside are similarly decorated. The doors inside are decorated with flowering plants growing from rocks, birds and butterflies, and the back of the cabinet, which bears the six-character Wan-li mark, is similarly decorated.

A fine wardrobe with good claims to belong to the same group as the drug-cabinets, formerly in the Wannieck Collection and now in the Musée Guimet, is illustrated in Plate 144.[4] All the wardrobes of this type were originally fitted with cupboards above, provided for the accommodation of hats. This particular wardrobe, when in the Wannieck Collection, had two cubical boxes above, but these have disappeared since 1924. It is decorated with imperial dragons on the front and with landscapes on the sides and back. Like the drug-cabinets, it has the Wan-li mark on the back. A detail of the dragon decoration, against a background of lotus scrolls, shown in Plate 145, gives some idea of the quality of the painting and throws some light on the technique of decoration. The gold decoration was applied over a linear design in red and this is exposed where the surface has been rubbed. While the decoration has lost some brilliance, there has been a compensating gain in that the method of painting with its skilful brushwork is revealed.

Another painted wardrobe with gold dragon decoration is illustrated by Low-Beer.[5] It was formerly in a French private collection, but its present whereabouts are unknown. A third wardrobe, not with painted dragons, but with dragons in filled-in lacquer, should be mentioned here. This is in the Herbig-Haarhaus Lackmuseum, Cologne.[6] None of the wardrobes just mentioned have retained the containers for hats which were fitted originally, but a later wardrobe of painted gold lacquer in its original form will be discussed later (Plate 153). It may be noted that similar wardrobes in complete form are known in other lacquer techniques and that complete plain wooden wardrobes belonging to the Ming and Ch'ing dynasties are relatively common.

There are no other painted lacquerwares known belonging to the sixteenth or

[2] Li Hung-ch'ing, 'The lacquer of the Ming and the Ch'ing, and the carved lacquer of the Yüan', *Wên-wu*, 1957, No. 7.

[3] Ref. C7, Sections 82, 93–8, 108.

[4] See Daisy Lion-Goldschmidt, 'Nouveaux laques Chinois, Musée Guimet', *La Revue du Louvre et des Musées de France*, 1973, No. 2, for a full account of this wardrobe, with illustrations, one in colour.

[5] Fritz Low-Beer, Ref. E17, Plates 105 and 106.

[6] Werner Speiser, Ref. E27, pp. 144–9.

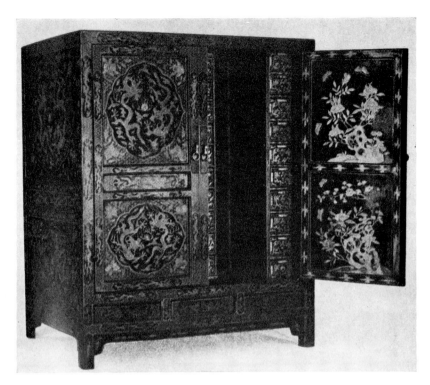

142. DRUG-CABINET
Wan-li mark and period
Palace Museum, Peking

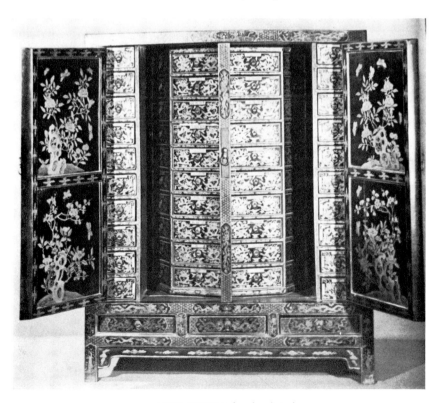

143. DRUG-CABINET showing interior

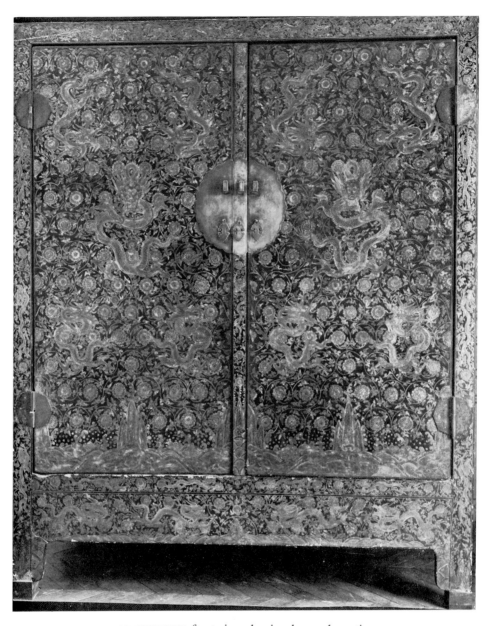

144. WARDROBE, front view, showing dragon decoration
Wan-li mark and period. Height 222 cm
Musée Guimet, Paris

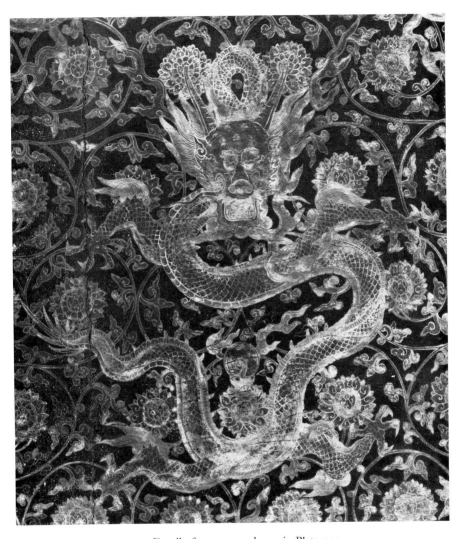

145. Detail of WARDROBE shown in Plate 144

146. BOWL, black lacquer inside with painted decoration in gold and red.
Basketry outside
16th century. Diameter 13 cm
Schloss Ambras, Innsbruck

149. Front view of black lacquer DISH with landscape in gold. Carved
marbled lacquer beneath
17th century. Diameter 14·3 cm
Victoria and Albert Museum

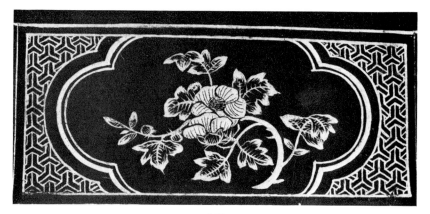

147

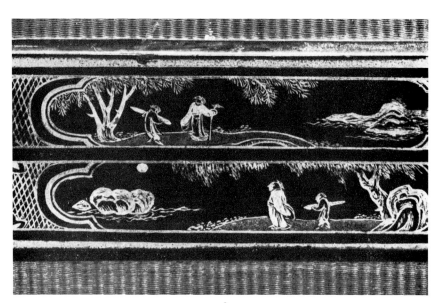

148

147, 148. Details of floral and landscape decoration in gold on BOX dated 1614
Honolulu Academy of Art

early seventeenth century as important as these pieces of imperial furniture, but there is no doubt that a large number of less important pieces with designs in gold were made for ordinary use. An example that has recently come to light is a small bowl that has been preserved at Schloss Ambras, Innsbruck, Austria since the sixteenth century (Plate 146). The bowl is covered outside with basketry and lacquered black inside. The inside is decorated mainly in gold, with touches of red lacquer, with fishes and water-weeds in the centre and floral panels round the rim. This simple piece is no doubt the kind of bowl that was made in large numbers for domestic use in China, where it would have been discarded after a few years of wear. It owes its survival through being preserved as a curiosity in Europe and not used as a food vessel.

Basketry was used a great deal in China for vessels decorated with lacquer. We saw an early example of this in the 'painted basket' made in the Han dynasty (Chapter 3). Basketry vessels played a prominent part in the late sixteenth and seventeenth centuries. The decoration of these was mainly in polychrome-painted lacquer, although a number of pieces were decorated in mother-of-pearl. The painted lacquerwares will be dealt with in Chapter 12 and would not call for reference here were it not for the fact that some of them are decorated in parts solely in gold, particularly on the sides of boxes whose main decoration on the top is in poly-chrome. The brushwork of these gold-painted panels is often of very high quality. Two examples from an octagonal box dated to 1614 in the Honolulu Academy of Art are shown in Plates 147 and 148. The close resemblance in style between the landscape decoration in Plate 148 and that in the *ch'iang-chin* box in Plate 126 is striking.

Gold-painted lacquer belonging to the late Ming and early Ch'ing dynasties is found in association with carved marbled lacquer. A small circular dish, one of a pair, painted with a landscape in gold on the front is shown in Plate 149. The back of the dish has carved marbled *ju-i* heads. In this piece the painted decoration is built up in black before the gilding is applied and details of the black ground are left exposed in places. There are some simple Japanese dishes of black lacquer in the National Museum of Denmark, Copenhagen, datable to the early seventeenth century, with similar decoration in *hiramakie* painted in gold with details in brownish-red.[7] The small dish of red lacquer (Plate 150), painted in gold in a similar technique to that of Plate 149 belongs to the first half of the seventeenth century. It is probably Chinese, although a Ryukyuan provenance cannot entirely be ruled out.

The Japanese dishes in Copenhagen provide the closest parallel to the Chinese gold-painted wares. No Chinese wares closely resembling the typical Japanese gold-decorated wares with different shades of gold, including 'sprinkled gold' in relief (the Japanese *hiramakie* or *takamakie*) have been found in China nor, as I have already suggested, is it likely that such close imitations ever existed. The nearest approach to a close imitation that has come to light is the small stem-cup illustrated in Plate 151. The design is entirely Chinese in feeling, with flowering plants, butterflies and emblems slightly moulded in relief in different shades of

[7] Martha Boyer, *Japanese Export Lacquer of the Seventeenth Century in the National Museum of Denmark*, 1959, Plate I, Nos. 5 and 6.

gold on a mottled ground, which may be a crude attempt to reproduce the Japanese sprinkled technique. The stem-cup belongs to the first half of the seventeenth century.

We have seen that the more simple gold-decorated objects made in China from the seventeenth century onwards are often difficult to distinguish from those made in the Ryukyu Islands. The square box illustrated in Plate 152, with the characters *Shuang-hsi* (Wedded bliss), which is often found in Chinese vessels made as wedding presents, is however undoubtedly of Ryukyuan manufacture.

Li Hung-ch'ing in his survey refers to a number of pieces of gold-painted lacquer in the Palace Museum, Peking bearing K'ang-hsi marks with precise dates, which he conjectures were made by the lacquerer Liu Yüan. As far as is known, none of these pieces has been published in detail, and in the absence of full information about them we can only conjecture which pieces in Western collections are likely to resemble the imperial wares in China. The fine wardrobe in the Musée Guimet, illustrated in Plate 153, may be one of these. It still retains the upper cupboards intended to contain hats. The decoration on the front of five-clawed dragons and on the sides with landscapes is of high quality. The wardrobe is unmarked, but it has good claims to belong to the K'ang-hsi period.

The last group of gold-decorated lacquer to be dealt with here is that in which the decoration is in gold foil, attached to a red lacquer base by means of a lacquer adhesive. The technique was first developed in China for porcelain round about the middle of the sixteenth century. In porcelain the piece, which had previously been decorated in underglaze blue or enamels, or both, was further decorated by the attachment of pieces of gold foil by an adhesive such as white of egg, which were then carefully trimmed to shape and incised to give the necessary details. Pieces of this kind, known to the Japanese by the term *kinrande*, literally 'gold brocade', were made in large numbers in the Chia-ching period, some of them bearing the mark of the period. One piece is known with the Lung-ch'ing mark (1567-72) but there is none that can be dated later than this. Thus the dating of the *kinrande* porcelains can be closely defined, probably stretching over a period of not more than forty years. The wares were, and are, greatly admired in Japan and many pieces were preserved there. They were also exported to Western countries in some numbers. There are still some thirty pieces in the Topkapu Serayi, Instanbul today. Very few pieces of *kinrande* have survived in China.

In lacquer a similar technique was used, although the number of surviving pieces seems to be very small. The technique is mentioned in the *Hsiu shih lu*,[8] but no details are given. The large red dish attractively decorated with trees, shrubs, birds and animals in the Yamato Bunkakan, illustrated in Plate 154, is the best known and finest of the pieces in existence today. The dish is generally described in Japan by the same term as is applied to the similarly decorated porcelain, i.e. *kinrande*.

Another piece in Japan decorated in this technique is an unusual twelve-sided dish standing on a separate pedestal, in the Tokugawa Collection, Kyoto, illustrated in Plate 155. The decoration on the outside of both the pedestal and the dish is of panels of birds or animals among foliage. The detail of Plate 156, of three panels on the pedestal, shows the *kinrande* technique very clearly. The inside of the dish is

[8] Ref. C7, Section 91.

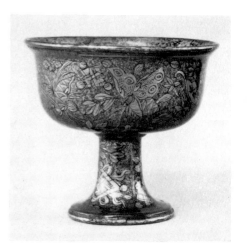

150. Red lacquer DISH with gold-painted
landscape
Possibly Ryukyuan. Diameter 11·5 cm
Victoria and Albert Museum

151. STEM-CUP with raised gold decoration on
sprinkled ground
17th century. Height 7·4 cm
British Museum

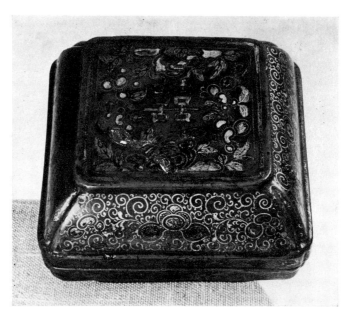

152. SQUARE BOX with painted gold decoration on red ground
Ryukyuan, 18th century. Width 15·3 cm
Victoria and Albert Museum

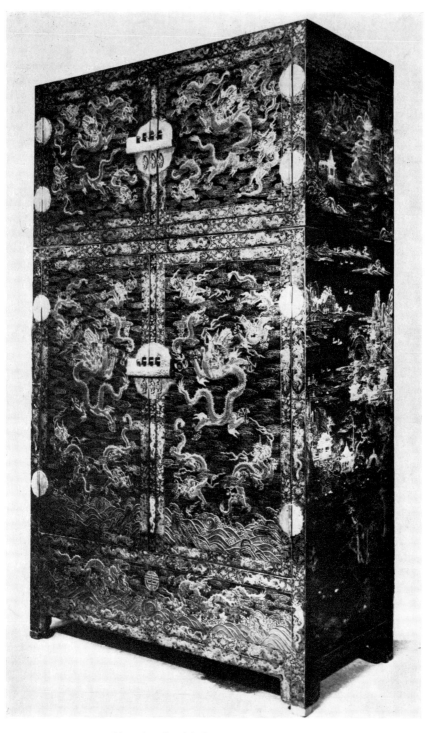

153. WARDROBE with painted gold decoration of dragons on the front and landscapes on the sides
K'ang-hsi period. Height 288 cm
Musée Guimet, Paris

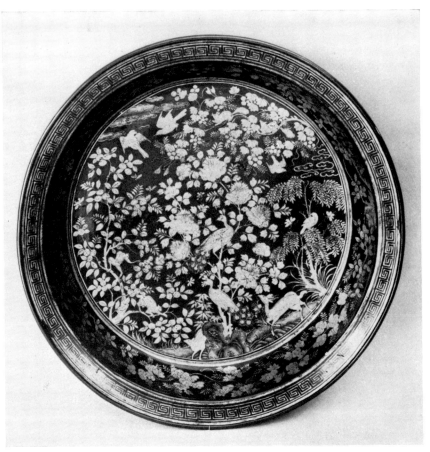

154. Red lacquer DISH with *kinrande* decoration of a woody landscape with animals and birds
Mid-16th century. Diameter 37·1 cm
Yamato Bunkakan, Nara

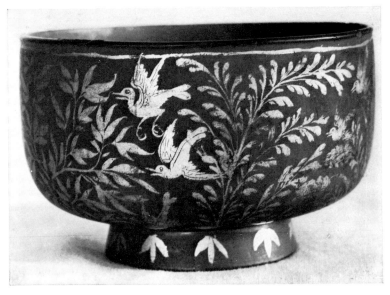

157. Red lacquer BOWL with *kinrande* decoration of birds and growing plants
Mid-16th century. Diameter 15 cm
Schloss Ambras, Innsbruck

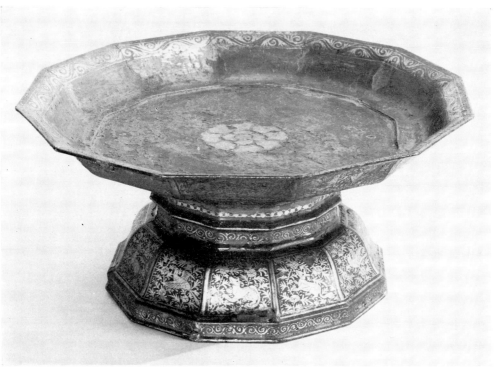

155. TWELVE-SIDED DISH on separate stand, red lacquer with *kinrande* decoration
of panels of birds and animals on a leafy ground
Mid-16th century. Diameter 40·2 cm
Tokugawa Foundation, Japan

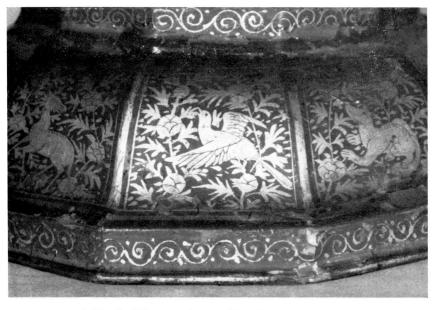

156. Detail of Plate 155 showing *kinrande* decoration on stand

very much worn. The piece has always been given a Ryukyuan attribution in Japan, and although the technique undoubtedly originated in China, this attribution cannot be entirely ruled out, in view of the close contacts between China and the Ryukyu Islands in the fifteenth and sixteenth centuries. The shape of the piece, which makes it functionally suitable for people who sit on the floor, like the Ryukyu Islanders, and do not make use of chairs and tables, like the Chinese, also favours a Ryukyuan origin, but in spite of this I think it is unlikely that the expensive foil process was introduced to the Islands. It should be added that nothing approaching the shape of the pedestal dish is known among Chinese or Ryukyuan lacquerwares.

A third piece of *kinrande* lacquer has come to light within the last few years at Schloss Ambras, Innsbruck. This is a deep bowl of red lacquer decorated on the outside with birds in flight among foliage (Plate 157). The style of decoration, although more simple than that of the Yamato Bunkakan dish and that in the Tokugawa Collection, is similar in style to both. A comparison of the decoration with the detail of the panels of the Tokugawa pedestal in Plate 156 indeed shows a remarkable similarity. The bowl was undoubtedly in the Collection of the Archduke Ferdinand II in the late sixteenth century, as were four porcelain *kinrande* bowls which are referred to in the inventory of the collection compiled in 1596. The manufacture of this type of lacquer can hardly have continued when the manufacture of *kinrande* porcelain ended after the reign of Lung-ch'ing, and the lacquer bowl can thus be dated to a period not later than the third quarter of the sixteenth century.

CHAPTER 11

Mother-of-Pearl Lacquer

The term mother-of-pearl has been in use in English from the early sixteenth century[1] to describe the iridescent layers of material found in the shells of many marine and freshwater molluscs. Similar terms have been in use in French, German and other European languages from early times. It is unfortunate that the term *laque burgauté*, invented by Jacquemart and le Blant as recently as 1862 to describe porcelain covered with mother-of-pearl lacquer[2] has been almost universally used by writers in English to describe all pieces of lacquer decorated with mother-of-pearl and still more lamentable that the term has been invariably misspelt. I think it is highly desirable that the term should be avoided in an English context.

The use of mother-of-pearl dates back almost to the very beginning of lacquer manufacture in China. Two examples belonging to the Shang dynasty have been illustrated in Plates 3 and 4. After the Chou dynasty no examples of mother-of-pearl inlay have been recorded until we come to the T'ang dynasty, but inlays in other materials, and particularly silver and gold, were made, as we have seen in Chapter 3. The re-introduction of mother-of-pearl inlay in the T'ang dynasty marks a new era in lacquer development. The Chinese monopoly in the manufacture of lacquer, which had lasted for more than 1,500 years, was at last broken when the introduction into Japan of fine lacquer objects decorated with mother-of-pearl inspired the Japanese to manufacture lacquer themselves. Before long the Japanese had not only mastered the manufacture of mother-of-pearl lacquer but had introduced entirely new techniques, particularly in raised gold decoration (*makie*). The gold decoration, sometimes by itself and sometimes in association with mother-of-pearl decoration, was destined to dominate Japanese lacquer down to modern times and formed the basis of Japan's superb and unique contribution to lacquer development.

There is a strong tradition in Japan that lacquer manufacture, associated with the introduction of the Chinese lacquer tree, *Rhus verniciflua*, was brought first to Korea and then to Japan at the time of the introduction of Buddhism in the sixth century. Although there is no direct evidence to support this tradition, all the facts at our disposal lead to the view that it may not be far from the truth. But however indeterminate the origins of lacquer in Japan may be, there is ample evidence that from the eleventh century onwards there were close contacts in the development of

[1] The earliest reference in the *Oxford English Dictionary* is taken from an inventory of York Minster dated 1510, where one object is described as 'Unum pace de moder perl'.

[2] A. Jacquemart and E. le Blant, *Histoire de la Porcelaine*, 1862.

lacquer between Japan on the one hand and China and Korea on the other. It is clear that study of the lacquerwares of all three countries is often necessary if we are to determine the provenance of the wares of even one of them. We can, however, ease the problem a little by leaving out of account the large amount of Japanese lacquer that pursued its independent way, uninfluenced by current developments in China and Korea.

This book is mainly confined to lacquer made in the period from the Yüan dynasty onwards which started, in mother-of-pearl, with the introduction of an entirely new style of decoration in China. Pictorial designs, based on Sung and Yüan paintings, replaced the formal designs of the T'ang dynasty and called for a different type of material in the mother-of-pearl. To understand this new development we must look at the types of shell used in the manufacture of the wares.

References to the different types of shell used in East Asia are numerous. A cursory study of the literature reveals some forty different descriptions in Chinese, Japanese, Korean and Ryukyuan lacquer. The terms are often difficult to interpret and only occasionally can they be identified as belonging to a particular species of shell. Sometimes the place where the shell was collected is given, such as the Yaku shell, used in a modern publication[3] to describe shell from the Yaku Island, lying to the south of Kyushu. From the context it seems likely that the shell is *haliotis* or sea-ear.

The Japanese have two basic terms to describe mother-of-pearl lacquer, *raden* and *aogai*. The former, derived from the Chinese term *lo-t'ien*, introduced in the T'ang dynasty, was first associated with the *sazake* shell (*turbo cornutus*) and *yakōgai* (*turbo marmoratus*). The term *yakōgai* is often used in Japan to describe the thick layers of shell used in Chinese lacquer down to the T'ang dynasty. *Aogai* is the Japanese term used for the lacquer made from the iridescent shell that forms the inner layer of the *haliotis*. The Japanese name for this shell is *awabi*.[4, 5] Herberts, whose account of lacquer techniques is by far the most comprehensive in a European language, has pointed out however that even in Japan, with its many descriptive terms, the distinction between the terms *raden* and *aogai* are often not carefully made.[6] In China there does not seem to have been any established distinction of terminology, although of course the Chinese were well aware of the differences.

While the earlier shell, such as that used for example in the Chinese lacquerwares of the T'ang dynasty, show some iridescence, it is too thick to give the brilliance that is found in the later shell. The very thin layers that are taken from the inner layer of the *haliotis* show a brilliant iridescence in shades of green, blue and pink, particularly when mounted on a white ground. This later shell had ideal qualities for pictorial decoration, but the small size and fragility of the pieces made it difficult to use the incised technique associated with the earlier shell, and so a different

[3] Tomio Yoshino, *Japanese Lacquer Ware*, 1959. This popular account gives much information on the various techniques.

[4] E. F. Strange, *Catalogue of Japanese Lacquer in the Victoria and Albert Museum*, 1925, p. 15.

[5] E. Herberts, *Oriental Lacquer*, 1962, pp. 267, 345-7.

[6] Note 5 above, p. 346.

technique was needed. The fragment of a box recently excavated at Tatu, the Yüan capital to the north of the present city of Peking, shows how brilliantly the problem was solved (Plate 161). The landscape of pavilions, trees and clouds representing the Kuang-han Kung (the Moon Palace), is depicted almost entirely with minute pieces of shell.[7, 8, 9] On this small fragment there are more than a thousand individual pieces. Incised decoration is used to a small extent, almost certainly applied with the shell *in situ*. But in many places where the incised technique would have been needed for the earlier type of shell, as for example in the roofs of the buildings, small pieces of shell are massed together and some advantage taken, even in this early piece, of the variety of colour to give a realistic effect that could never be achieved by incised designs.[10] In later pieces contrasts in colour were obtained by tinting each piece of shell. This technique was brought to a fine art in the Ch'ing dynasty, as we shall see later, when green, blue, pink and purple shades were often used in a single piece. The colour scheme was further extended by the addition of gold and silver foil inlays.

There are a number of references in the Chinese literature to the need for a new type of shell to give the required pictorial qualities. The author of the *Hsiu shih lu*, Huang Ch'êng, is clearly referring to this shell when he says:

> The greater the care taken over the details to achieve a resemblance to painting the better. The fact that there are differences in colour in different shells is sometimes exploited by using them in different parts of the design.

Yang Ming, another practical lacquerer, in his preface dated 1625, adds further details. He says:

> On old specimens the shell inlay is thick but on recent specimens the shell is thinner. There are as many as fifty-five varieties of details in the form of dots, curves, lines and so on, a repertoire sufficient to meet any requirements.[11]

Wang Shih-hsiang, in his recent commentary dated 1959, sums up the subject by saying that

> Peking lacquerers today call the thick kind 'hard mother-of-pearl' and the thin kind 'soft mother-of-pearl'. It is generally true to say that the hard was used in ancient times and the soft became fashionable in the Ming and Ch'ing dynasties. T'ang mirrors invariably have the hard type. What Huang describes as 'to achieve a resemblance to painting' is a reference to the soft kind. The hard kind cannot be made to resemble a painting.[12]

The question of the date when this new type of mother-of-pearl decoration was introduced in China now has to be critically examined. The earliest reference to

[7] *Wên-hua ta-kê-ming Ch'i chien ch'u-t'u wên-wu* (Cultural objects excavated during the Great Cultural Revolution), Peking, 1972.

[8] *Wên-wu*, 1972, No. 1.

[9] *K'ao-ku*, 1972, No. 1.

[10] This is shown in the excellent colour illustration in note 7 above.

[11] Ref. C7, Section 103.

[12] Ref. C7.

mother-of-pearl lacquer that has come to light so far is that in the *Ko-ku yao-lun* of 1388. The short reference reads:

> Mother-of-pearl inlay. Those made in the past for the Sung Imperial Court were in solid lacquer. Some of them have copper-thread inlays. Those made recently at Chi-chou in Kiangsi are mostly of putty, pig's blood and *t'ung* oil. They are not solid wares, being easy to make and liable to damage.[13]

The reference to the Sung imperial wares, like the similar reference to the carved Sung lacquerwares, can be regarded as mere hearsay. There is no contemporary evidence to support the view that imperial wares of this kind were manufactured in the Sung dynasty and, as I pointed out in Chapter 3, the absence of any mother-of-pearl lacquerwares among the large number of pieces excavated from tombs suggests that no mother-of-pearl wares of quality were made in the Sung dynasty. However, the account in the *Ko-ku yao-lun*, if regarded as one of contemporary events, makes it certain that the manufacture of mother-of-pearl wares was well established by 1388 and gives the additional information that the pieces were inlaid with copper-thread inlays.[14] It is not unreasonable to interpret this evidence as establishing that mother-of-pearl lacquerwares were being made in the Yüan dynasty, which ended twenty years before the publication of the *Ko-ku yao-lun*.

The Tatu fragment cannot be dated positively before the fifteenth century. It did not come from a tomb, but from a building that was demolished to enable the new city to be built. Much information on the building of the city is available from contemporary accounts and this has been fully discussed in Chapter 4. Nevertheless the fragment seems to be the earliest piece known of this type and it undoubtedly belongs to the group discussed in the *Ko-ku yao-lun*, which went back to the middle of the fourteenth century and possibly a little earlier.

THE EARLY KOREAN MOTHER-OF-PEARL WARES

We are concerned in this chapter mainly with the lacquerwares that started with the Yüan dynasty and, as far as the Chinese wares are concerned, we can start with the Tatu fragment (Plate 161). But the Korean mother-of-pearl wares were earlier and it is therefore necessary to say something about the earlier wares that started in the T'ang dynasty and led to the introduction of lacquer manufacture in Korea and Japan. In China itself, as we have seen in Chapter 3, the manufacture of decorative lacquerwares of all kinds virtually ceased in the Sung dynasty. The evidence of many excavations establishes this point and we can justifiably ignore the attempts of enthusiastic connoisseurs in the Ming dynasty and later to attribute to the Sung dynasty pieces which have no claims to belong to it and are quite out of keeping with Sung traditions.

The evidence from Japan and Korea is of a quite different kind. In Japan the evidence comes mainly from pieces that have been handed down in temples, where

[13] Ref. E33. There is a considerable addition to the account on mother-of-pearl lacquer in the second edition of 1462, but it does not add anything of value to this aspect of the subject.

[14] It seems certain that this refers to stranded wires. Bushell (Ref. E8) translates the term as a 'network of copper wire'.

they have been carefully preserved almost since the time when they were made. While there is literary evidence for the manufacture of mother-of-pearl lacquer from the ninth century onwards, the earliest pieces preserved in Japan date from the early twelfth century.[15] From then onwards there is almost continuous evidence of the manufacture of mother-of-pearl lacquerwares in Japan. The wares generally show little evidence of either Chinese or Korean influence, except for a group made in the late sixteenth and early seventeenth centuries. This latter group is the only one that comes within the scope of this book and is discussed later in this chapter.

In Korea the evidence generally has none of the certainty that comes from the Chinese excavation of dated tombs, nor from the Japanese records of pieces carefully preserved in temples. The Korean evidence is entirely literary. There are a number of references in the *Koryŏ-sa* (History of Korea) to mother-of-pearl lacquerwares that go back to the eleventh century. None of these records are contemporary with the events described and it is difficult for anyone not fully conversant with the Korean literature to express an opinion on their reliability. But fortunately there is one piece of reliable contemporary evidence which can be accepted without question. This comes from the *Hsüan-ho fêng-shih Kao-li t'u ching*, a comprehensive account of Hsü Ching's visit from China to Korea in 1123.[16] Hsü Ching's account has long been familiar to students of Korean ceramics, with its references to the resemblance of the Korean celadon wares to the Chinese Yüeh wares and the 'new kiln wares of Ju-chou'. It was first brought to the attention of Western students by Bushell as long ago as 1899.[17] More information was given by Sir Percival David in his important paper on the Ju wares,[18] but by far the most informative account in a European language is that given by Gompertz.[19] The references to lacquer, two in number, are not so well known as those on ceramics, but they are equally important. The first states that the Koreans 'were not very good at lacquer but their mother-of-pearl inlay is minutely executed and worthy of esteem'. The second refers to saddles elaborately inlaid with mother-of-pearl.

It is clear from Hsü Ching's account that mother-of-pearl lacquerwares were made in Korea long before the new style was started in China. It is difficult to trace the influences that led to their manufacture. There is no doubt that they stemmed originally from China in the T'ang dynasty, although there is little resemblance between the early Korean sutra boxes, the best known of the Korean wares with their 'minutely executed' designs as described by Hsü Ching, and the boldly executed Chinese T'ang wares. Moreover the style of decoration has no affinity with the Japanese wares and no suggestion has been made that the Korean wares at this time owed anything to Japanese influence.

The surviving pieces of Korean lacquer belonging to the Koryŏ dynasty form a

[15] The question has been fully dealt with by Beatrix von Ragué, Ref. E30. Earlier lacquer objects decorated in gold are known that go back to the ninth century.

[16] Ref. C16.

[17] S. W. Bushell, *Oriental Ceramic Art*, 1899, p. 679.

[18] Sir Percival David, 'A commentary on Ju ware', *Transactions of the Oriental Ceramic Society*, Vol. 14, 1935-7.

[19] G. St. G. M. Gompertz, 'Hsü Ching's visit to Korea in 1123', *Transactions of the Oriental Ceramic Society*, Vol. 33, 1960-2.

remarkably consistent group. All are large sutra boxes or small circular and lobed boxes probably intended as containers of incense and all, with one exception, are decorated in similar style. One of the sutra boxes, in the British Museum, is illustrated in Plate 158. It has been described at length by Basil Gray.[20] There are a number of boxes similar to this in Japanese and Western collections, as well as the small boxes, but unfortunately there seem to be no well preserved pieces remaining in Korea today. The decoration of the British Museum box is of tight floral scrolls, with flowers and leaves in thin iridescent mother-of-pearl and the spiral stems in inlaid silver wire. Inlays of silver wire in lacquer form a new feature in lacquer decoration and have an important bearing on the history of the development of Korean lacquer. In addition to the single-stranded wires of the stems, there are double-stranded wires, used to strengthen the edges of the boxes and also to separate the main panels of decoration from the narrow borders surrounding them. The double-stranded wires in both these functions can be seen in the detail of Plate 159. We have already seen that stranded wires were described in the *Ko-ku yao-lun*, but there is no evidence that wires of this kind were used in Chinese lacquer before the end of the Yüan dynasty. If, as seems certain, the technique of inlaid wires was already in use in the mother-of-pearl lacquerwares described by Hsü Ching, it was established in Korea more than two centuries before it was used in China.[21]

The dating of the surviving mother-of-pearl lacquerwares of the Koryŏ dynasty is difficult to determine with any precision. There has been, in general, a tendency to ascribe them all to the thirteenth, or even the fourteenth, century.[22] The main reason for this seems to be based on an account in the *Koryŏ-sa* of the setting up in the thirteenth year of the King Wŏnjong (1272) of an office for the production of lacquerwares inlaid with mother-of-pearl for the Queen, who wished to have lacquer boxes to contain Buddhist sutras. But the account of Hsü Ching and the evidence from other inlaid materials, in ceramics and metalwork, would support a much earlier date of manufacture than 1272. It would seem preferable to date the group broadly as twelfth to thirteenth century, keeping the dates of individual pieces open for the present.

The lack of any close similarity between the Korean mother-of-pearl lacquerwares, both in technique and decorative motifs, and those of China and Japan

[20] Basil Gray, 'Korean inlaid lacquer of the thirteenth century', *British Museum Quarterly*, Vol. XXXII, Nos. 3–4, 1967.

[21] There has been much discussion on the composition of the wires in Korean lacquer. The only analysis I have seen is one made by Dr. W. J. Young of a single-stranded wire from a sutra box in the Museum of Fine Art, Boston, which was composed of silver with 3% copper and 1% zinc. The twisted wires of a small box in the Metropolitan Museum of Art, on the other hand, are said to be composed mainly of copper with the addition of some white metal such as silver, zinc or tin. It is likely that the twisted wires, in Chinese as well as Korean lacquer, were made of a copper alloy, whitish in colour. The single-stranded wires, at any rate in the early Korean wares, intended for decoration, are likely to have been made of a silver alloy of high quality, such as that in the Boston sutra box.

[22] Jan Fontein, for example, gives a fourteenth-century date. But his pioneer paper in the *Bulletin van Vereeniging van Vrienden der Aziatische Kunst*, September 1956, was written before later important information had become available. See also John Figgess, 'Mother of pearl inlaid lacquer of the Koryŏ dynasty', *Oriental Art*, N.S. XXIII (1), 1977. (Ed.).

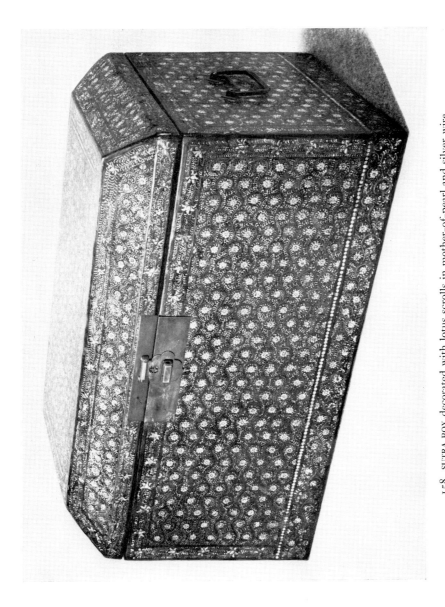

158. SUTRA BOX decorated with lotus scrolls in mother-of-pearl and silver wire
Koryŏ dynasty. 12th–13th century. Length 45·7 cm
British Museum

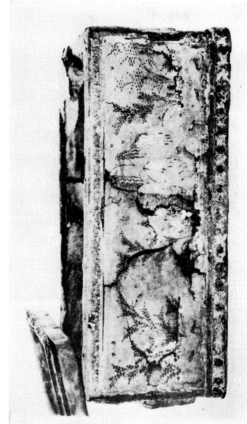

160. BOX decorated with landscapes in mother-of-pearl and wire, with lotus
scroll borders
Koryŏ dynasty
Formerly in the Ducksoo Museum, Korea

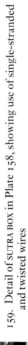

159. Detail of SUTRA BOX in Plate 158, showing use of single-stranded
and twisted wires

poses some difficult problems. In ceramics, we know that the Chinese influence was enormous, so much so that it would often be difficult to distinguish between the Korean and Chinese undecorated celadon wares were it not for certain differences of construction, of which the use of white spurs during the firing is one of the more obvious ones. But in the decorative treatment and technique of the inlaid ceramic wares there appears to be no direct influence.

It is well known that the Khitan state of Liao had close associations with Korea in the early twelfth century and the Japanese writer Manzō Nakao has suggested that these brought about a strong influence on the manufacture of artifacts.[23] In the early twelfth century, before the date of Hsü Ching's visit, the Khitans were attacked by the Jurchen Tartars and were finally overthrown by 1125. As a result a large number of Khitan refugees fled to Korea. Many of these were highly skilled craftsmen and Hsü Ching's paper records that the best of these were selected to work at the royal palace. Gompertz has pointed out that Liao designs had a strong influence on Korean ceramics and other wares.[24] The most remarkable influence from Liao is to be seen in the decoration of the inlaid celadon wares, in which the delicately depicted landscapes of willow trees, reeds and ducks resemble closely the 'Spring landscape' painted on the walls of the mausoleum at Ch'ing-ling of the sixth emperor of Liao, who died in 1031. One piece of lacquer decorated in this style, a box with a landscape of trees, ducks and other water-fowl, was once in the Ducksoo Palace of Fine Arts. It has now disintegrated, but fortunately photographs of the box have survived, one of which is reproduced in Plate 160. Of all the known pieces of Korean lacquer this, to those familiar with the beautiful inlaid ceramic wares, provides the most typical example of Koryŏ decoration. But the box clearly has close associations with the sutra boxes of more formal design, with its scroll borders, and it is clear from the photographs that wire was used in the scroll decoration, both to strengthen the edges and to define the borders of decoration.

Bronzes are also known with similar landscape decoration inlaid with silver wire. Indeed the use of silver wire inlay is a feature of a number of bronze vessels made in Korea from the twelfth century onwards. Basil Gray, who made a special study of the bronzes, concluded that the technique was brought from China to Korea through Liao.[25] The technique had originated in China during the Warring States or Han period, but it is difficult to find examples that can be securely dated to the T'ang or Sung dynasty. The earliest of the Korean bronzes, bearing the date corresponding to 1178 and now in the Hōryū-ji Temple, Nara, has an inscription with a Chin and not a Chinese reign mark, but while this emphasizes the close relationship with the Khitans it does not imply that there was a Khitan origin to the technique. We are left with the uncertainty as to how the technique actually reached Korea, but it is clear that inlaid decoration had a fascination for the Koreans which continued long after the Koryŏ dynasty. We find it in the later stonewares and it was a prominent feature in the later mother-of-pearl lacquer-

[23] Manzō Nakao, *Chōsen Kōrai Tōji Kō* (Essays on the Koryŏ pottery of Korea), Tokyo, 1935.

[24] See note 19 above, p. 7.

[25] Basil Gray, 'The inlaid metalware of Korea', *British Museum Quarterly*, Vol. XX, No. 4, 1956.

wares. While the Chinese and Ryukyuan lacquerers used wires for structural reasons, the Korean craftsmen were the only ones to make regular use of wires for decorative purposes. As we shall see later, this continued down to the nineteenth century.

Before passing to the main subject of this chapter, I should like to make a few general remarks about the early Korean wares. The conditions for preservation in Korea were worse than they were in China and far worse than they were in Japan. As a result the evidence from Korea, particularly of the early wares, is extremely scanty and there may well be a tendency to give too late a date to them. Recent excavations in Korea have brought to light painted lacquerwares attributed to the fifth century, which would be earlier than any sophisticated lacquerwares known to have been made in Japan. The earliest piece of lacquer made in Japan is generally accepted to be the Tamamushi Shrine in Nara, the decoration of which is attributed to Korean craftsmen and given a mid-seventh century date. If the earlier fifth-century date is accepted for the recently excavated Korean wares new possibilities are opened up. The treatment of the early wares is outside the scope of this book, but one cannot ignore the possibility that they have a bearing on the dating of the Koryŏ and later mother-of-pearl wares, which may require some reassessment in the future.

THE CHINESE PICTORIAL MOTHER-OF-PEARL WARES

We now come to the main objective of this chapter, the study of the development of the mother-of-pearl lacquerwares made in China from the fourteenth century onwards and the associated wares, which include the later Korean wares, those of the Ryukyu Islands and, to a limited extent, those of Japan. As we have seen, these wares were preceded by the Korean wares of the Koryŏ dynasty, with their delicate mother-of-pearl scrollwork and landscape decoration. An important feature of the Koryŏ wares, which were made some two centuries before the earliest of the Chinese pictorial wares that have so far been recorded, is the use of twisted wires for the protection of the edges of the pieces and also in the decoration. This technique, mentioned in the *Ko-ku yao-lun* of 1388, plays an important part in the Chinese post-Sung lacquerwares, but there can be no doubt that it originated in Korea in the twelfth century and that it was introduced to China much later. It is likely that the earliest post-Sung lacquerwares used this technique, but so far nothing earlier than the second half of the fourteenth century has been recorded. The excavated Tatu fragment (Plate 161) does not use this technique but, as we have seen, there is no firm evidence that it was made before the fifteenth century. Nevertheless, it provides a good starting point in that it closely conforms to the pictorial style which became fully established in the sixteenth century and which indeed is to be found in a few pieces attributable to the fifteenth. One early piece, an octagonal box in the Figgess Collection, probably belonging to the latter part of the fifteenth century, is illustrated side by side with the Tatu fragment in Plates 162, 163 and 164. This box illustrates the complexity and variety of techniques in the new style. The side view (Plate 162), with its diaper panels following closely those of the Tatu fragment and the flower scrolls, with the leaves built up of a

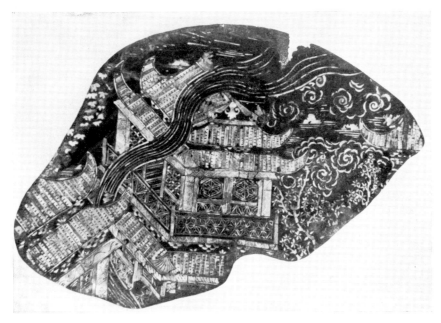

161. Fragment of mother-of-pearl BOX excavated at Tatu
Early 15th century
See pages 59, 211–12, 218 *and* 220

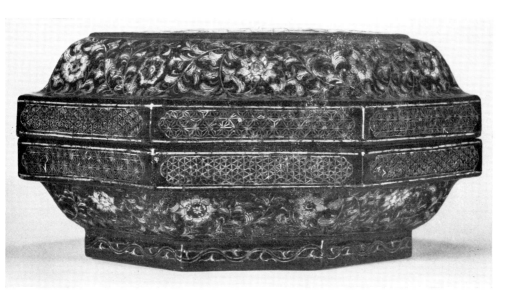

162. Side view of OCTAGONAL BOX showing diaper borders
Late 15th century. Width 24·6 cm
Figgess Collection

number of small pieces, is typical. The complexity of the new style is even more evident in the landscape on the top of the box (Plate 163), as is seen in the detail illustrated in Plate 164. The massing together of groups of small pieces is supplemented with incised work of great delicacy. It seems likely that the incised work was done *in situ*. It would have been almost impossible for it to have been done before the mother-of-pearl was mounted.

The foliated round box (Plate 165) in the Victoria and Albert Museum, decorated with an audience scene surrounded by floral scroll borders, is thought to be the earliest of the known mother-of-pearl pictorial wares. Twisted wires are used in this box not only for strengthening the edges but also, as is seen in the detail of Plate 166, to separate the landscape from the surrounding border. The box may be tentatively ascribed to the late fourteenth or early fifteenth century.

A third box is of special interest because it depicts an audience scene that is undoubtedly the subject illustrated in the box from which only the small Tatu fragment remains. The fragment was identified as representing the Moon Palace (*Kuang-han Kung*), literally 'The wide halls of clear cold'. Dr. von Ragué has brought to light two mother-of-pearl boxes which enable the subject to be identified in detail.[26] The finer of the two, an octagonal box in the Okayama Collection, is illustrated in Plate 169. The scene represents the Moon Palace, depicting the old Taoist story of the Moon Fairy, Hêng O. She was the wife of the archer Yi, who had built a jade palace for the Queen of the Western Heaven and had been rewarded by the gift of a pill of immortality. His wife stole the pill, swallowed it and fled to the moon. Arriving there out of breath, she coughed out part of the pill, which was transformed into the moon hare. Hêng O was changed into the immortal three-legged toad, Ch'an.

The story in this form goes back to the Han dynasty, but it was embellished later, at the time of the T'ang dynasty. The T'ang emperor Ming Huang was drinking wine with two of his magicians, when one of them threw a bamboo stick into the air and converted it into a bridge to the moon. They walked along the bridge to the Moon Palace, where they paid their respects to Hêng O, magically transformed to her original form. All the items of the story are reproduced in the landscape of Plate 169 including, as well as the audience scene, the toad emitting the stream of immortality, the moon hare pounding the elixir of life and the fragrant cassia tree in bloom. Only the stream of immortality and the cassia tree have survived in the fragment, but there can be no doubt that the Tatu box had originally a picture resembling that in Plate 169. In further confirmation of this it should be pointed out that a very small separate fragment from Tatu has a woman's head and part of a square tablet with the character *kuang* (wide) on it.

The four pieces in Plates 161 to 166 and 169 display exceptionally high craftsmanship, hardly surpassed in any of the decorative arts of China. The subjects, generally depicting Taoist legendary, often cannot be identified, as has been possible in the Tatu fragment and the complete box in Plate 169. The absence of inscribed pieces makes accurate dating of the mother-of-pearl wares difficult and a general attribution covering the second half of the fifteenth and the whole of the

[26] Beatrix von Ragué, 'The Moon Palace, Some iconographical remarks', *Oriental Art*, Vol. XXII, No. 2, gives a full account of the decoration.

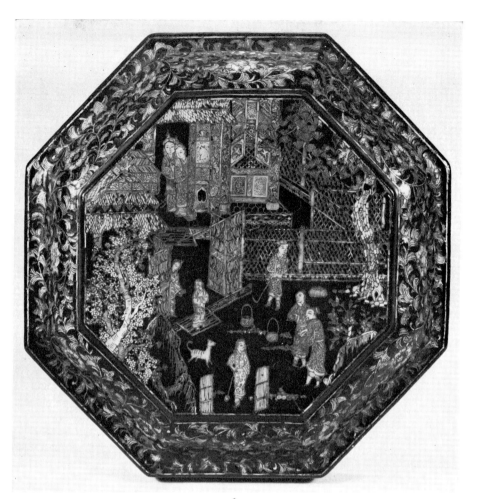

163

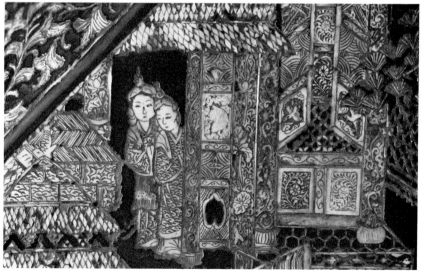

164

163, 164. Top view of OCTAGONAL BOX with figures and pavilion (detail in Plate 164)
Late 15th century. Width 24·6 cm
Figgess Collection

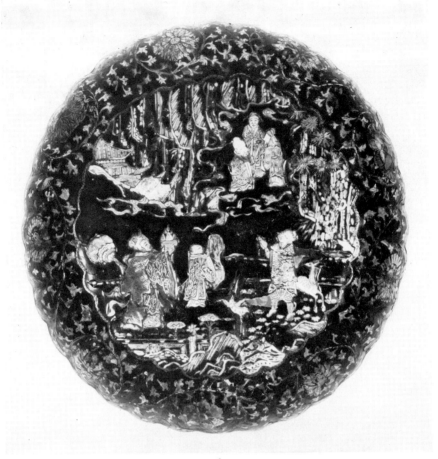

165

166

165, 166. ROUND FOLIATED BOX with audience scene and floral scroll borders
(detail showing twisted wire borders, Plate 166)
15th century. Diameter 18·3 cm
Victoria and Albert Museum

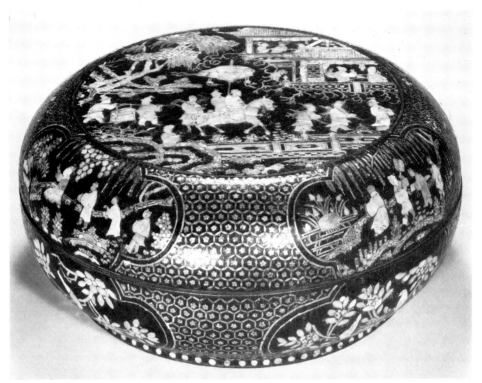

167

168

167, 168. ROUND BOX with figures in landscape on the top and similar panels on
the sides (detail with inscription dated 1537, Plate 168)
16th century. Diameter 27·9 cm
Victoria and Albert Museum

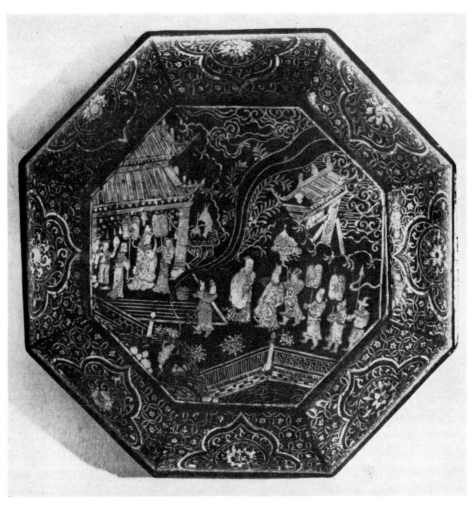

169. OCTAGONAL DISH with landscape representing the Moon Palace, with floral
borders
16th century. Width 22·2 cm
Okayama Collection

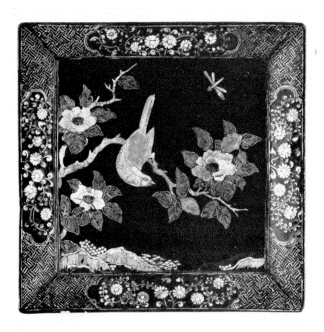

170. SQUARE DISH with bird on a camellia spray and borders of
floral panels and diapers
16th century. Width 19·5 cm
Victoria and Albert Museum

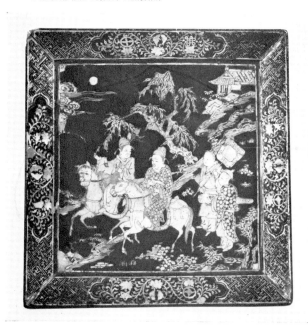

171. SQUARE DISH with landscape and horsemen and borders of
floral panels and diapers
16th century. Width 18·6 cm
British Museum

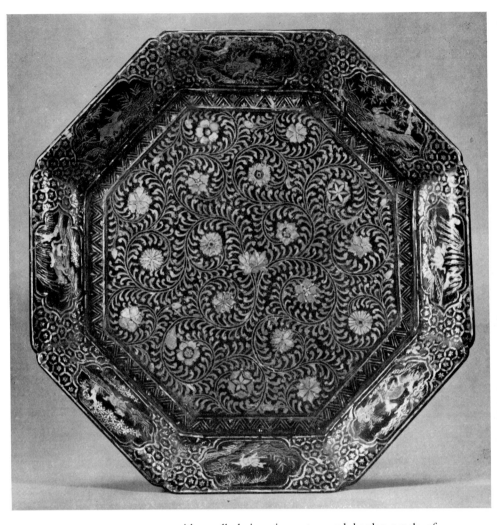

172. OCTAGONAL DISH with scroll designs in centre, and border panels of
landscapes on diaper grounds
16th century. Width 31·2 cm
Victoria and Albert Museum

sixteenth century is often the best that can be made. One piece, however, the round box illustrated in Plates 167 and 168, bears the date corresponding to 1537, inscribed on the extreme left pillar of the pavilion, and there are good reasons for accepting the inscription as contemporary with the box itself.

While landscapes dominate the decoration of the Ming mother-of-pearl lacquer-wares, floral subjects were treated with the same masterly skill. The two square trays in Plates 170 and 171 show the skilful use of floral borders. The main subject of decoration of the former is a bird perched on a camellia branch, in which the delicate method of building up the decoration of the leaves by linear strips is a prominent feature. We are frequently reminded by the Chinese writers of the sixteenth century of the close resemblance of the decoration in the mother-of-pearl wares to Sung painting. We could not find a better example than this.

The octagonal dish of Plate 172 is of particular interest as being one of the rather rare pieces of Chinese mother-of-pearl lacquer showing Korean influence. The central floral scroll is based on Koryŏ designs, as a comparison with the sutra box in Plate 159 clearly shows. The landscape panels on the border of the dish are typical of the style found in basketry lacquerwares dated to the second half of the sixteenth century, and this dish cannot be much earlier than this.

The almost complete absence of mother-of-pearl lacquerwares among those made for the court is very difficult to explain. We have seen that carved lacquer dominated the scene in the fifteenth century. In the sixteenth, the filled-in wares became very popular with the court and, as far as one can tell from surviving pieces, these two types comprise almost all the imperial pieces known with Chia-ching, Lung-ch'ing and Wan-li marks. Only two pieces are known of mother-of-pearl lacquer with sixteenth-century marks that can claim to be contemporary. The first, a round box decorated with floral scrolls against a diaper ground and with the Wan-li mark in mother-of-pearl, in the Low-Beer Collection,[27] is much inferior in craftsmanship to the landscape pieces already described. The second, formerly in the David Collection and afterwards in that of the King of Sweden, an octagonal box decorated with a five-clawed dragon on the top and with floral borders on the sides, has the Lung-ch'ing mark incised and filled in with gold on the base (Plate 173). In addition to the reign mark the inscription includes the characters *Yü-yung chien*, the name of a department of the *Nei-fu*, the Imperial Household, responsible for the ordering, manufacture and maintenance of objects made for the court. As we saw in the chapter on the carved lacquerwares (Chapter 6), this department played an important part in the organization of imperial wares of all kinds from the reign of Hung-wu onwards. There can be no doubt that the box was made in the reign of Lung-ch'ing and as such is an important documentary piece. But the quality of the mother-of-pearl inlay shows a much lower skill in execution than that found in the landscape pieces. The shell used is of thick, relatively large pieces, more like the earlier shell used in the T'ang dynasty. It would seem that there was a deliberate abandonment of the technique adopted for the pieces with landscape decoration in this imperial box.

There are several distinct groups in which thick shell was used. One of the most interesting is an easily recognizable group, in which the subject is of simple sprays

[27] The box is illustrated in Refs. E17 and E24.

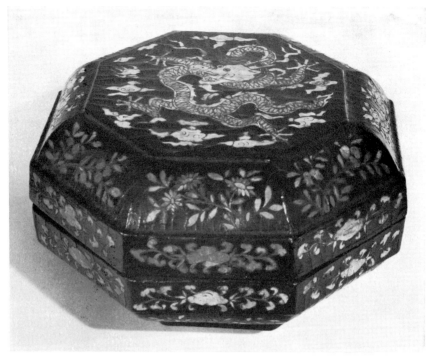

173. OCTAGONAL BOX decorated with dragon on top and floral borders
Lung-ch'ing mark and period. Diameter 22·6 cm
Museum of Far Eastern Antiquities, Stockholm

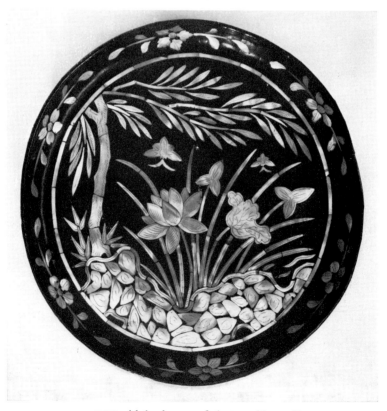

174. DISH with landscapes of plants and butterflies
17th–18th century. Diameter 22 cm
Formerly Sedgwick Collection

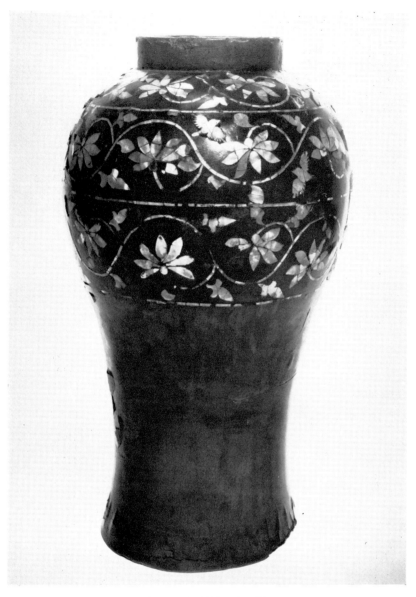

175. VASE decorated with bands of lotus scrolls
Korean, 15th century. Height 34·8 cm
Fitzwilliam Museum, Cambridge

or landscapes. These pieces have roughly finished red bases, still showing the lacquer brushwork. A typical piece is the dish shown in Plate 174. The broad treatment of a bamboo and lotus plant is planned with great skill. It is possible that the group is of Korean origin. In date the pieces are attributed to the late seventeenth century.

THE LATER KOREAN WARES AND THE DERIVED JAPANESE WARES

The Korean wares, which in the Koryŏ dynasty had a delicacy of treatment not found in the T'ang wares from which they must have been derived, in the Yi dynasty (1392-1910) show a much coarser treatment, in which large thick pieces of shell were generally used. The reason for a general deterioration in quality, which is found in Korean ceramics and other artifacts as well as lacquer, can be ascribed to the extreme poverty of the country, which started with the Mongol invasion of the thirteenth century. After a short renaissance in the late fifteenth and sixteenth centuries the disastrous invasion by the Japanese in the late sixteenth century led to a deliberately imposed isolation from the outside world. In spite of the poverty of the country the Yi lacquerwares have a distinct attractive style which owes little to either China or Japan. Indeed, and this is remarkable, the mother-of-pearl lacquerwares of this small and impoverished country had a strong influence on the Japanese wares of the Momoyama period (1573-1615).

There is a lack of information on the dating of the Yi lacquerwares and we have to rely on style and techniques in an attempt to place the pieces in some sort of chronological order. On this basis, one of the earliest pieces is the vase illustrated in Plate 175. Of splendidly robust form, reminiscent of some of the ceramic wares of the Koryŏ dynasty, it is decorated with three bands of lotus scrolls on the upper half, with the lower half undecorated. There are birds in flight interspersed among the lotus scrolls. The vase is in a bad state of preservation, but careful restoration has revealed evidence of insects being incorporated in the original design. The vase is attributed to the fifteenth century. No similar piece seems to have been recorded. The small hinged box in the Figgess Collection (Plate 176) is an early example of a type not uncommon among the wares of the Yi dynasty. The bold decoration of lotus scrolls which, like that of the vase, includes a number of birds in flight, is very similar to that of the vase, which suggests that it is early, probably belonging to the fifteenth century. The metal fittings, with strengthening corner-pieces terminating in rosettes, are of a type commonly found in Korean boxes.

Another box, in the Gompertz Collection (Plate 177), similar in shape to the Figgess box, but more refined and with thinner and more iridescent shell, is similarly decorated. The metal fittings, however, are quite different and of a type that it has not been possible to match in either Korean or Japanese lacquerwares. But far too little attention has been devoted to the study of the metal fittings of the Korean wares. This beautiful box is either a Korean piece nearly contemporary with the Figgess box, or a later copy made in Japan. But if the latter, it does not seem to be later than the early seventeenth century, when Japanese copies in this style were made under strong Korean influence.

The scroll decoration typified in Plates 175, 176 and 177 was thought at one

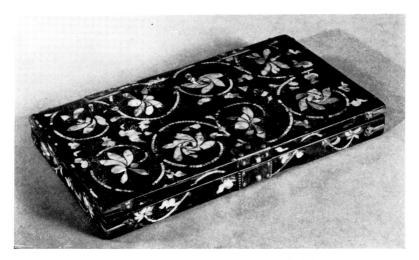

176. BOX decorated with lotus scrolls and birds
Korean, 15th–16th century. Length 25·2 cm
Figgess Collection

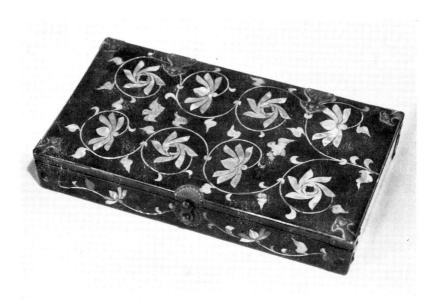

177. BOX decorated with lotus scrolls and birds
Probably Korean, 16th century. Length 25·8 cm
Gompertz Collection

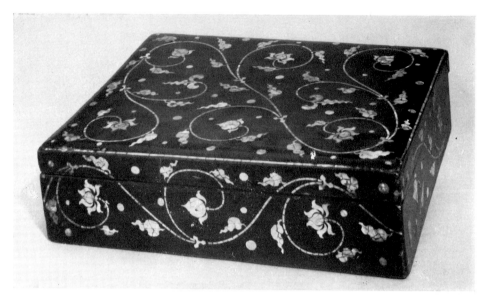

178. BOX decorated with lotus scrolls
Korean, 16th century. Length 39·3 cm
British Museum

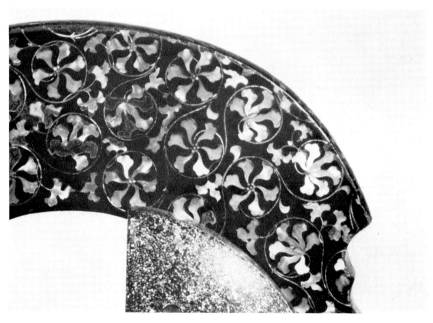

179. Detail of SADDLE decorated with lotus scrolls
Japanese, c. 1600
British Museum

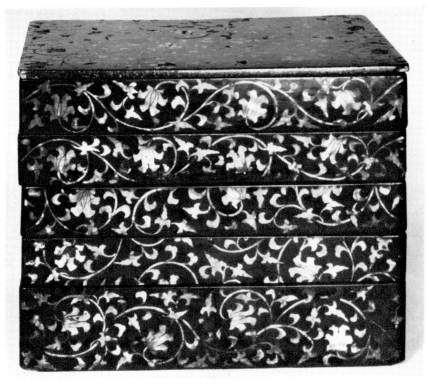

180

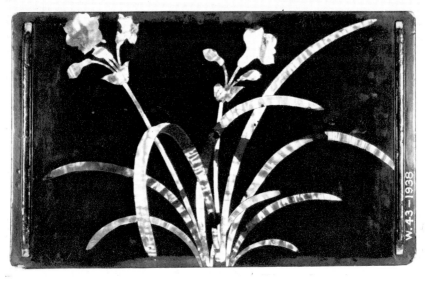

181

180, 181. TIERED BOX decorated on the outside with lotus scrolls (Plate 180)
and inside the lid with narcissus (Plate 181)
Japanese or Korean, early 17th century. Height 21 cm
Victoria and Albert Museum

time to have had some influence on the Chinese wares and many pieces so decorated have been given an attribution 'Korean or Chinese'. There now seems to be no justification for suggesting that any of these pieces are Chinese. The box in Plate 178, made somewhat later than that in Plate 176, is undoubtedly Korean. However, as I have already mentioned, there was a strong influence on Japanese lacquer during the Momoyama period. Three fully authenticated Japanese pieces are described and illustrated by von Ragué.[28] They differ in that the shell used is thinner and more iridescent than that used in the Korean wares and the designs are less strong and more refined.[29] There is evidence that one of them, a rectangular box, was presented to the Hōmpō-ji Temple, Kyoto, not later than 1605. Another box, in the Atami Museum, has details showing European influence, which would support a date of manufacture not later than the third decade of the seventeenth century.

One of the finest Japanese pieces is a saddle in the British Museum, of which a detail is shown in Plate 179. The inscription which the saddle once bore under one of the side bars is now indecipherable, but there can be little doubt that the saddle was made round about 1600. The side bars are decorated with coarsely sprinkled mother-of-pearl fragments, a Japanese technique not found in Korean decoration. Nevertheless, it is possible that decoration of the saddle was done by Korean craftsmen who were taken to Japan after the conquest of Korea in the late sixteenth century.

A particularly interesting piece in early Yi style is the tiered box in the Victoria and Albert Museum shown in Plates 180 and 181. Here the scrollwork is in a style that has generally been dated to the seventeenth century, very similar to that of a number of boxes generally attributed to Korea. But there are features in the decoration that suggest a Japanese origin. The cover has an edge of sprinkled pearl and the design of narcissus plants inside the cover suggests a Japanese rather than a Korean provenance. The shell is rather thin as compared with contemporary Korean wares. The piece is attributed to the early seventeenth century.

It should be mentioned that all the Yi pieces discussed here are decorated entirely with mother-of-pearl, the use of wire inlay, both for strengthening the edges and as part of the decoration, so prominent a feature in the Koryŏ wares, being abandoned. The use of wire inlay does not seem to have been reintroduced much before the eighteenth century in Korea. An example of this will be mentioned later (Plate 183).

As far as we know, all the earliest mother-of-pearl Yi lacquerwares seem to have been decorated with formal lotus scrolls, but there are many pieces in pictorial style, decorated with landscapes, prunus sprays and similar subjects. A detail of the top of a low table in the Honolulu Academy of Art is illustrated in Plate 182. The lively landscape of a peach tree, with cranes and turtles, is in typical Korean style. There is a tendency in Korea to give such pieces as this a later date than would generally be given by Western authorities. It may be that this table is as late as the eighteenth century.

The use of inlaid metal wires, abandoned during the earlier part of the Yi

[28] Ref. E30, pp. 229–31.

[29] The shell in the box of Plate 178 is a little thinner than that in Plate 176, but it is thicker than that of the Japanese pieces.

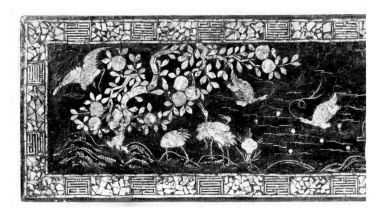

182. Detail of TABLE TOP, decorated with landscape
Korean, 18th century
Honolulu Academy of Art

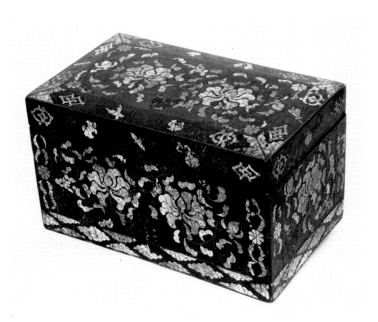

183. BOX decorated with lotus scrolls and emblems in mother-of-pearl,
tortoise-shell and twisted wire
Korean, 18th century. Length 41·9 cm
British Museum

dynasty, seems to have been re-introduced in the second half of the eighteenth century and it was very popular in Korea in the nineteenth century. Wires were not only used for strengthening the edges of the pieces, but also for a considerable part of the decoration. Cabinets and screens of the nineteenth century are known with a good deal of the decoration of the phoenixes, dragons and peony sprays done in twisted wire. The box in Plate 183 belonging to the eighteenth rather than the nineteenth century, has the decoration mainly in mother-of-pearl, but the flower stems are in twisted wire and the stems terminate in shields of tortoise-shell.

THE LATER CHINESE WARES

Let us now return to the Chinese mother-of-pearl lacquerwares and follow their development after the end of the Ming dynasty. There does not seem to have been any sudden change of style during the seventeenth century, but there was a gradual introduction of refinements, such as the use of finely sprinkled mother-of-pearl fragments to simulate the ground in landscapes, the closer control of colour by selection of the mother-of-pearl pieces and the introduction of inlay in gold and silver, both in foil and sprinkled. In the seventeenth century the finest pieces seem to have been in furniture, such as screens, cabinets, thrones and chairs. Some of these found their way to Europe, like the so-called Coromandel screens.

Undoubtedly two of the most important surviving pieces of mother-of-pearl furniture known today are the throne and screen formerly in the Low-Beer Collection and now in the Museum für Ostasiatische Kunst, Berlin.[30] It is not possible to give more than a brief account of these here and we must await the result of the extensive studies being made by the Director of the Museum, Dr. Beatrix von Ragué, who is supervising the restoration of the pieces, for a full account. Quite apart from their imposing intrinsic qualities, they are important in showing the technical refinements already mentioned, which were destined to become standard in the vessels, generally small in size, characteristic of the best of the Ch'ing wares.

The three-fold screen, illustrated in Plate 184 has, as its main features, three panels of landscapes surrounded by narrow floral borders. The panels are mounted on elaborate plinths and surmounted by stepped rectangular head-pieces with geometric designs. A detail of a landscape, taken from the right-hand screen, illustrated in Plate 185, shows the decoration on a larger scale. Here we see the use of finely sprinkled fragments to depict the ground and clouds. The other refinements are not visible and indeed silver foil is only used in the geometric borders. There does not appear to have been any colour applied to the backs of the mother-of-pearl, variations of colour being provided by a careful selection of the pieces, all of which are mounted on a brownish-red lacquer ground which has been over-painted with gold. This gold ground gives increased brilliance to the decoration, but it is not in lacquer as is shown by the fact that it is soluble in water. It seems almost certain, however, that it was part of the original design.

Dr. von Ragué is of the opinion that the screen and throne can be attributed to

[30] Mention should be made, however, of a fine large twelve-fold screen in the City Art Gallery, Bristol. This also may belong to the seventeenth century.

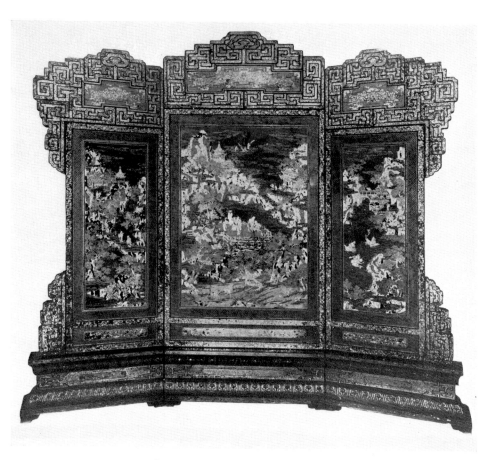

184. SCREEN with three landscape panels
K'ang-hsi period. Height 286 cm
Museum für Ostasiatische Kunst, Berlin

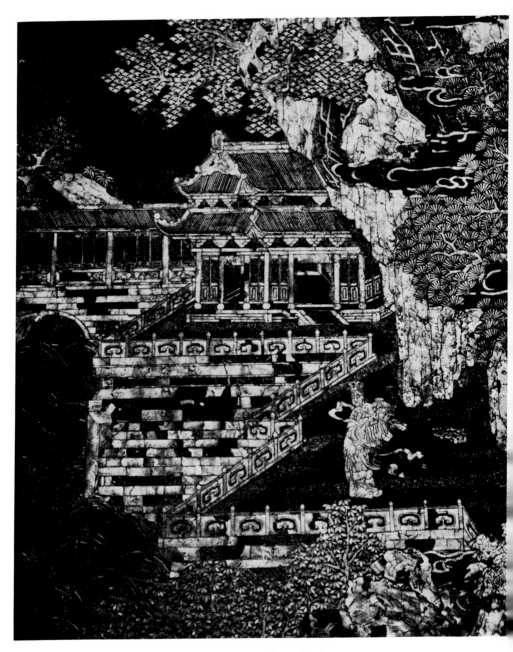

185. Detail of SCREEN shown in Plate 184

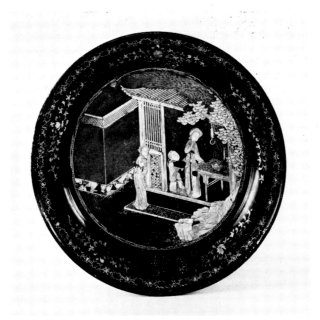

186

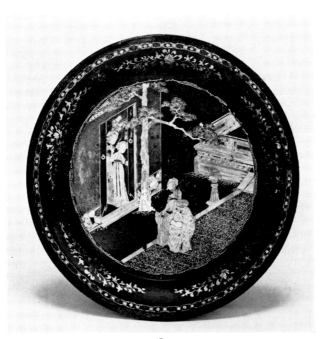

187

186, 187. A PAIR OF DISHES, each decorated with figures in a garden
scene
17th century. Diameter 12·5 cm
Victoria and Albert Museum

the seventeenth century and this seems to be very reasonable. The screen therefore throws a new light on the dating of the small vessels typical of the Ch'ing dynasty. The dishes in Plates 186 and 187, decorated with ladies and children in garden scenes, show new techniques, including the use of sprinkled silver as well as gold and silver foil. The two cups in Colour Plates G and H show a remarkable variety of colour in the mother-of-pearl. Here the colours are applied to the backs of the minute fragments, which are mounted on a white composition to enhance the colour effect. These small vessels never seem to bear reign marks, although they generally bear inscriptions in mother-of-pearl on the bases, either in the form of short poems or with the seal marks of the maker. The absence of reign marks is surprising, when one bears in mind the large number of pieces of carved red lacquer, some of quite ordinary quality, which are known with the Ch'ien-lung mark. Comparison of these small vessels with the Berlin screen suggest that some of them may be as early as the seventeenth century.

The tiered box illustrated in Plate 188, decorated with a basket of flowers on the top and floral borders on the sides, is of high quality and has generally been regarded as of Chinese origin. It was included in the Exhibition of the Arts of the Ch'ing Dynasty held by the Oriental Ceramic Society in 1964.[31] But it has features in the construction, such as the use of twisted wires for strengthening the edges, which are not to be found in the Ch'ing mother-of-pearl wares, and we cannot rule out the possibility that the box was made in the Ryukyu Islands. A further reference to this box will be made later in this chapter.

These fine miniature pieces, it must be confessed, are limited in their range and this suggests that there must have been closely controlled factories for their manufacture, although they were not made especially for the court. But in contrast with these pieces there exists a group of five boxes enclosed in a cabinet which show a more individual treatment. The cabinet, decorated with four-clawed dragons in painted lacquer and inlaid in gold and silver, is fitted to take the five boxes, all differently decorated and containing ink-cakes and other decorative objects. This set has been preserved in the Drottningholm Palace, Stockholm since the first half of the eighteenth century. Among the objects is an ink-cake bearing the date corresponding to 1718 and the view expressed by Gyllensvärd that the cabinet and its boxes are datable to the end of the reign of K'ang-hsi seems to be unassailable.[32]

Two of the boxes are illustrated in Plates 189 and 190. One is shaped in the form of a lotus leaf and decorated with fishes and crustacea in mother-of-pearl and with details of the leaf depicted in gold. The other is decorated with two phoenixes in mother-of-pearl against a lightly depicted background in gold. Some of the internal fittings are seen in the illustration, including a large ink-cake dated to 1718. The other three boxes are decorated, one with the Queen of the Western Heaven, Hsi Wang-mu and her attendants, another with insects and the third with *chih* dragons, all in mother-of-pearl and gold.

The very individual treatment of these five boxes is in marked contrast with that of the cups and trays in Colour Plates G and H. There is a good deal of evidence

[31] *Transactions of the Oriental Ceramic Society*, Vol. 35, 1963–4, No. 383.
[32] The cabinet and boxes are fully described and illustrated by Bo Gyllensvärd, 'Lo-tien and laque burgautée' (Ref. E38), pp. 122–3, Plates 11–14.

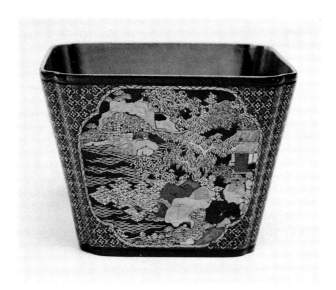

G. SQUARE CUP of mother-of-pearl lacquer, decorated with
landscapes
First half of 18th century. Width 6·1 cm
Victoria and Albert Museum. See page 240

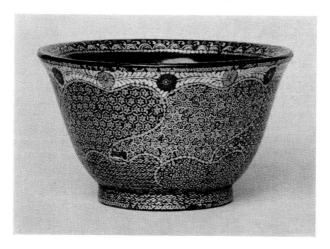

H. ROUND CUP of mother-of-pearl lacquer, decorated with
diapers set in overlapping petal panels
First half of 18th century. Diameter 5·7 cm
Victoria and Albert Museum. See page 240

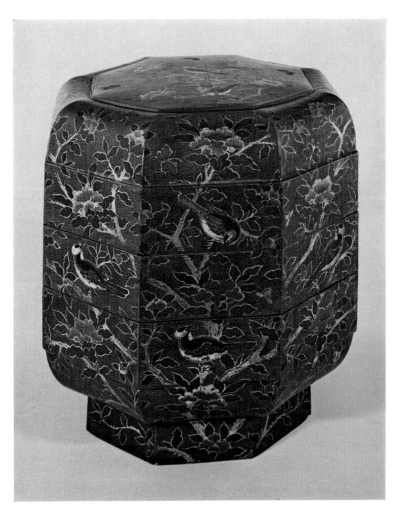

I. OCTAGONAL TIERED BOX, decorated in painted lacquer, with birds on
camellia branches
Ryukyuan, 17th–18th century. Height 28·2 cm
British Museum. See page 254

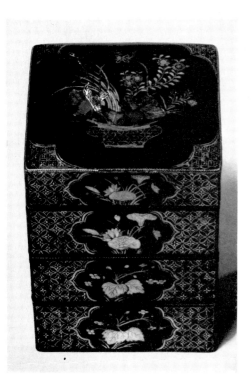

188. TIERED BOX decorated with a basket of
flowers on the top and floral borders
18th century. Height 7·4 cm
Victoria and Albert Museum

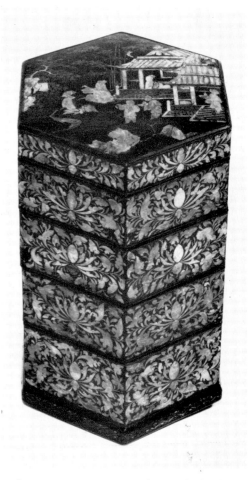

196. TIERED HEXAGONAL BOX decorated with land-
scapes on top and with floral borders
Ryukyuan, late 18th century. Height 22·6 cm
Victoria and Albert Museum. See page 247

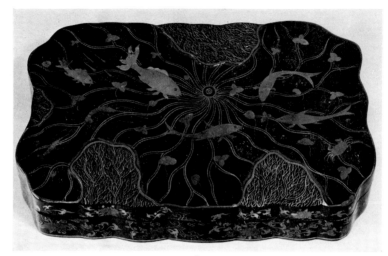

189

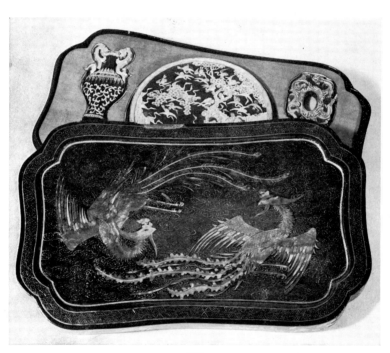

190

189, 190. TWO BOXES from a set of five, in mother-of-pearl and gold, one in the
form of a lotus leaf decorated with fishes (Plate 189), and the other
rectangular with phoenixes (Plate 190). Interior fittings, including an
ink-cake dated 1718
K'ang-hsi period. Each box 24 cm long
Drottningholm Palace, Stockholm

from Chinese sources of the great interest of the Chinese in the gold-decorated Japanese lacquerwares in the eighteenth century. The most factual account is that given by the Jesuit priest Père d'Incarville in his paper published in 1760.[33] It may be argued that there is some Japanese influence in the decoration of these boxes, but the gold work, although of high standard, is only lightly depicted and there are no signs of the *makie* technique which one would expect in Japanese work. As far as I am aware, these pieces are unique, and there is nothing resembling them in China itself.

<div align="center">THE RYUKYUAN LACQUERWARES</div>

The Ryukyuan lacquerwares made in the *ch'iang-chin* technique have already been discussed in Chapter 8. While this type of lacquer was the most important single contribution of the Ryukyu Islands to East-Asian lacquer, mother-of-pearl wares of distinction were also made there. There was a well-established industry of lacquer manufacture in Okinawa before the Japanese annexation of the Ryukyu Islands in 1608. An account compiled in 1612 attributed the setting up of an organization known as the Kaizuri Bugyō, literally 'The Shell-works Office', to the family of a certain Shō Ren and refers to the appointment to the post of director made in the reign of Shō Nei, *circa* 1592. No other evidence on the early history of the Kaizuri Bugyō is known, nor are there any pieces known of mother-of-pearl lacquer which can be dated as early as the sixteenth century. There is, however, one piece, a document-box, which is said to have been made by the Kaizuri Bugyō, c. 1700, to which I shall return later (Plate 191).

The account of the Kaizuri Bugyō and the fact that it was, as the title implies, particularly associated with mother-of-pearl lacquer, makes a careful assessment of the mother-of-pearl wares in the Ryukyu Islands a question of some importance. Fortunately a good deal of supplementary information comes from a paper written by Ishizawa Hyōgo in 1889.[34] This gives an account of the state of the lacquer industry, made as part of a survey of industries in Okinawa at that time. The discussion in the paper of the early history of lacquer manufacture is largely circumstantial, but the paper is of extreme importance because of its detailed description of the methods of manufacture, with dated drawings, which go back to the early eighteenth century. Drawings of some sixty pieces, dated from 1714 to 1869, are reproduced in the paper. These patterns, without doubt used as instructions to the craftsmen, are drawn in great detail, and, in a few instances, even give information on the different stages of manufacture. More than half the designs are of the mother-of-pearl lacquerwares and it is clear that this type of lacquer occupied a special position in the lacquerwares of the Islands in the eighteenth and nineteenth centuries.

The details of manufacture of three pieces of mother-of-pearl lacquer are given in the paper. The details form the most complete record of the manufacture of lacquerwares in any country of East Asia that have survived. In one piece, a table, five different types of shell and seven types of undercoating, including fabric, paper

[33] Ref. E6.

[34] Ishizawa Hyōgo, *Ryukyu shikki ko*, 1889. See also the author's paper Ref. E35 for a full discussion of the subject in English.

and leather, are recorded. Three grades of polishers, defined as master shell-polishers, first and second class shell-polishers, were employed in the manufacture. The workmen were paid partly in money and partly in rice. The total cost is given as 1367 *kan* of which about one third covered the wages of the craftsmen, one third the cost of the shell, one tenth that of the raw lacquer and the rest that of other materials. The date when these particulars were compiled is not clear, but it was probably in the mid-nineteenth century. If so, the cost of manufacture would be the equivalent of more than one hundred and fifty pounds sterling today.

It is clear from this account that the standard of workmanship in the mother-of-pearl lacquerwares made in the Ryukyu Islands in the eighteenth and nineteenth centuries was exceptionally high, and comparable to that of the best contemporary Chinese and Japanese wares. But all the exhibitions of Ryukyuan lacquerwares that have been held in Japan and elsewhere up to the present have included only a relatively small proportion of the mother-of-pearl wares. It is evident that a number of pieces made in the Ryukyu Islands are at present wrongly given either a Chinese or Japanese provenance. One notable group of wares, which should be mentioned here, although it is somewhat outside the scope of the Chinese and associated lacquerwares laid down for this book, has already been discussed by the author at some length.[35] Among the sixty pieces included in the designs in Ishizawa's paper there are four *inro*, ranging in date from 1742 to 1786, all decorated in mother-of-pearl with landscapes in Chinese style. The designs are drawn in great detail and the very high standard of craftsmanship is evident. Many such *inro* are known, particularly in Western collections, and they have all, up to the present, been given Japanese attributions both in the West and Japan. A considerable readjustment in the attribution of these pieces will be needed in the future.

We now turn to the actual mother-of-pearl pieces that can be attributed with some confidence to the Ryukyu Islands. Undoubtedly the most important of these is the document-box already mentioned. It has been preserved in the Shuri Museum (now known as the Okinawa Prefectural Museum) and it is the only piece known that has a traditional association with the Kaizuri Bugyō. It is said, in the *Ryukyu Cultural Survey* of 1960, to have been made by the Kaizuri Bugyō round about 1700 and it is described as the finest surviving example of Ryukyu lacquer. It was registered at the time of the Survey as an Important Cultural Property, First Class. It is now in poor condition, but we can still admire the beautiful design of geese disporting themselves by the side of a lake, with skilfully depicted reeds in the foreground and middle distance. The complete box, which is fitted with an internal tray, is shown in Plate 191 and a detail in Plate 192. The decoration has a quality not found in any other Ryukyuan piece of mother-of-pearl lacquer, although we should not, when we bear in mind the *ch'iang-chin* wares, place it in quite the same place as that accorded by the *Ryukyu Cultural Survey*. It is certainly the earliest mother-of-pearl Ryukyuan piece yet recorded and it may well be earlier than the traditional date of *c.* 1700. It should be noted that the chamfered edges are strengthened by the use of small triangular and rhomboidal pieces of pearl, a device that was to become popular in the later mother-of-pearl wares.

[35] Ref. E35.

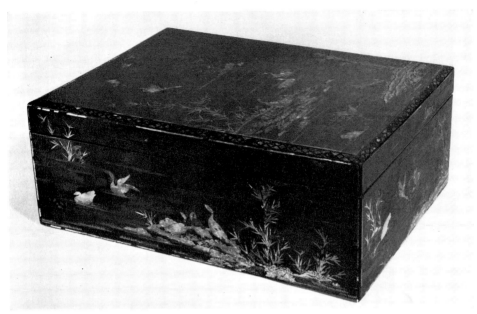

191

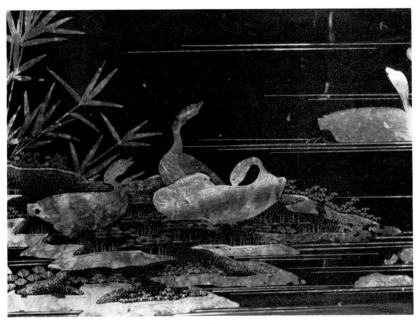

192

191, 192 (detail of Plate 191). DOCUMENT-BOX decorated with geese on a lake with water-plants.
Ryukyuan, c. 1700. Length 41·5 cm
Shuri Museum

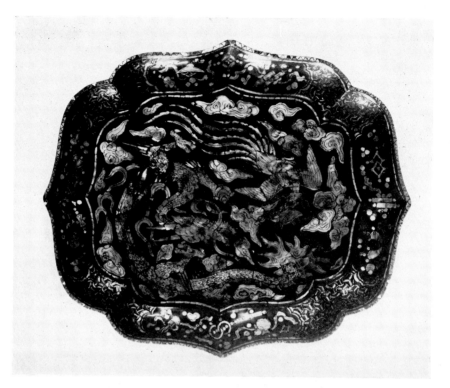

193. OVAL FOLIATED TRAY, red lacquer decorated with a dragon and phoenix
Ryukyuan, 17th–18th century. Length 22·9 cm
British Museum

194. RECTANGULAR TRAY, red lacquer, decorated with pine branches and
characters
Ryukyuan, 18th century. Length 32 cm
Victoria and Albert Museum

An interesting feature of many of the Ryukyuan mother-of-pearl wares is the use of red lacquer. Red is hardly used at all in the Chinese mother-of-pearl wares and Yang Ming, in one of the prefaces to the *Hsiu shih lu*, points out that red is an unsuitable colour to be used in conjunction with mother-of-pearl decoration.[36] The lobed oval tray in Plate 193, decorated with a dragon and a phoenix among clouds, set against a red ground, provides an attractive combination and we can regard Yang Ming's adverse comments on red grounds as the result of Chinese conservatism. The tray has another feature common in Ryukyuan lacquer, the use of small pieces of shell massed together to provide a protection to the rim, already noted in the document-box illustrated in Plate 191. This device, an alternative to twisted wires, is to be seen in a number of the designs illustrated in Ishizawa's paper, including two table-screens dated 1714 and 1747 respectively. The tray is one of the earliest of the pieces decorated on a red ground, belonging to the late seventeenth or early eighteenth century.

Another tray, rectangular in form with curved sloping sides, also decorated on a red ground, is decorated with pine branches on the long sides and *shou* characters on the short ones, set in ogival panels on a diaper ground (Plate 194). In this tray twisted wires are used for strengthening the edges and they are also used, unusually, to outline the ogival panels. A third tray, rectangular in shape, in the Honolulu Academy of Arts, is decorated with a single pine branch on a red ground which shows traces of gilding.[37]

The table-screen in Plate 195 is mainly decorated on a black ground, but there are details in red lacquer and the unusual openwork panel is built up of cane strips in the form of a square diaper decorated in red and gold. The screen, like two of those illustrated by Ishizawa, is strengthened by small pieces of pearl along some of the edges.

The uncertainty of the provenance of the tiered box illustrated in Plate 188 has already been referred to. It has a number of qualities not found in any Chinese mother-of-pearl wares of the eighteenth century. As I have said, a Ryukyuan provenance cannot be ruled out on grounds of quality, as it certainly would have been some years ago. The attribution to China in the Oriental Ceramic Society's Exhibition in 1964 would have received at that time universal acceptance.

A second tiered box, hexagonal in section, decorated with a landscape on the top and floral borders, illustrated in Plate 196, page 241, has been accepted as Ryukyuan without question. It is lower in quality and shows less Chinese influence than the box in Plate 188, and is undoubtedly much later. Large pieces of shell are used, particularly in the floral borders. A similar box was exhibited in an exhibition of Ryukyuan art in the Tokugawa Collection in 1968,[38] and there are a number of others in Japanese collections. Like the earlier box, the edges are strengthened with twisted wire, a technique not found in contemporary Chinese wares.

From the eighteenth century onwards, throughout the whole of the nineteenth, a large number of mother-of-pearl lacquerwares were made in Okinawa. A typical nineteenth-century piece, consisting of a square tray with separate stand, is

[36] Ref. C7, Section 103.
[37] Ref. E35, Plate 8c.
[38] Exhibition at Tokugawa Art Museum, Kyoto, 1968, No. 54.

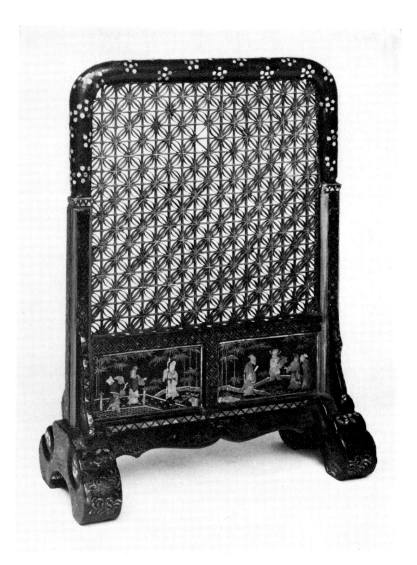

195. TABLE-SCREEN in black and red lacquer, the upper part with perforated
cane diaper, and the lower landscapes in mother-of-pearl
Ryukyuan, 18th century. Height 26·2 cm
Victoria and Albert Museum

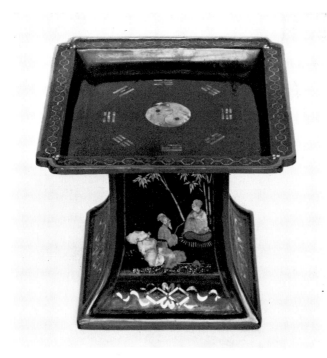

197. SQUARE TRAY ON STAND, decorated with emblems and landscape
panels
Ryukyuan, 18th–19th century. Height 8·4 cm
British Museum

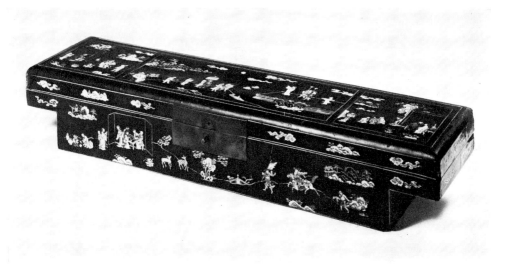

198. DOCUMENT-BOX inlaid with bone, decorated with landscapes
Chinese, 17th century. Length 69·7 cm
Royal Ontario Museum

illustrated in Plate 197. A great variety of techniques was used in the later wares, particularly in the association of mother-of-pearl with painting in gold and poly- chrome. The wares are difficult to distinguish from the more ordinary of the Japanese wares and the similarity is partly responsible for the persistent view in Japan that Ryukyuan lacquer was an inferior offshoot of Japanese lacquer. In fact, as far as decoration is concerned, the influence down to the end of the eighteenth century was almost entirely Chinese. Only in the shapes of the vessels, as befits a country in which the people sit on the floor, is there an absence of Chinese influence. The latest wares, showing strong Japanese influence, fall outside the scope of this book.

Lacquerwares with inlays of other materials than mother-of-pearl were made in China and the Ryukyu Islands. These included hardstones, soapstones, ivory, horn and bone. The materials were often carved in great detail and the study of pieces so decorated falls within the scope of hardstone and other carvings rather than lacquer. However, a group of pieces decorated in bone bear a close resemblance to the mother-of-pearl lacquerwares and are worthy of mention here. A typical piece, probably belonging to the seventeenth century, is the document-box in the Royal Ontario Museum illustrated in Plate 198. The decoration, of landscape and figures, is applied with great skill. In addition to the main scenes, a number of delightful landscape vignettes provide the border decoration. The shape of this box, with the ends cut away underneath, suggests that the boxes had a special use. The number of such boxes known today, decorated in mother-of-pearl and painted techniques as well as bone, is quite large. It has been suggested that they were made for presentation to men of distinction. However, a search for boxes of this shape in paintings of audience scenes has met with no success.

CHAPTER 12

Painted Lacquer of the Ming Dynasty

We saw in Chapter 3 that painted lacquer decoration started in China round about the fifth century B.C. Its rapid development culminated in such pieces as the splendid funerary chests excavated at Ma-Wang-tui in the second century B.C. and it was associated with the development of similar paintings on silk. These paintings were destined to lead to the introduction of landscape painting in China. Thus the painted lacquerwares may be regarded as the most important single achievement in the whole range of Chinese lacquer.

After the end of the Han dynasty there is little evidence of the development of lacquer for many centuries and it would have seemed, until the recent discovery of the painted panels at Ta-t'ung dated to the Northern Wei dynasty, that the manufacture of painted lacquer had come to an abrupt end. The evidence from Ta-t'ung, however, suggests that painted lacquerwares following the Han traditions, such as we find in the famous 'painted basket', continued to be made over a long period. Indeed the wealth of Chinese Buddhist paintings on silk from about the fifth century A.D. onwards makes it inconceivable that similar paintings on lacquer were not made at the same time. Except for the Ta-t'ung panels no further evidence of lacquer painting at this time has come to light in China, but recent excavations in Korea have unearthed wooden panels with painted decoration which have been dated tentatively to the fifth or sixth century A.D.[1] There is no evidence of painted lacquerwares in polychrome after the sixth century for another long interval, but gold-painted boxes from the Pagoda at Jui-an dated to the eleventh century give us another link in the rather tenuous chain of evidence. These boxes are discussed in Chapters 5 and 10, the first in connection with their moulded decoration and the latter with their gold-painted designs.

It is remarkable that no lacquerwares with polychrome-painted decoration have yet come to light between the sixth century and the late Ming dynasty. More than ten years ago, when I was studying closely the group of painted lacquerwares associated with basketry, I recall that Dr. Laurence Sickman said that he had no doubt that painted lacquer boxes were made in the Sung and Yüan dynasties.[2] His views were based on the evidence of Chinese paintings, in which such boxes are often depicted. The gold-painted boxes from Jui-an, already mentioned, provide the only factual evidence that has come to light of painted

[1] *Special Exhibition of Newly Excavated Silla Treasures*, Seoul, 1974, Figs. 15–17.
[2] 'A group of Chinese lacquers with basketry panels', *Archives of Asian Art*, XX, 1966–7 (Ref. E29).

251

decoration at this period, but it is extremely likely that further examples in poly-chrome as well as gold will be unearthed in future Chinese excavations.

The study of the Ming polychrome lacquerwares is complicated by the close resemblance between the painted wares and the filled-in wares made by the 'wet process' described in Chapter 9. The small box illustrated in Plate 130 may be one of these and there is a second example in the Royal Scottish Museum.[3] These pieces may well be earlier than the basketry pieces already mentioned.

The group of painted lacquerwares with basketry panels, which comprise most of the pieces discussed in this chapter, are of special importance in that many of them, and particularly boxes made for presentation, bear precise dates, or cyclical dates that can generally be accurately assessed. The discussion below gives only a short account of the available evidence and the reader is referred for further information to the paper already mentioned in which many illustrations, not only of the pieces themselves, but also of the inscriptions, are given.

One of the most important of the painted lacquerwares is the large rectangular box in the Victoria and Albert Museum illustrated in the two views of Plate 199. The top of the box, on the right, is decorated with three garden scenes in which are many figures, on a red ground, separated by ogival panels of gold diaper. The central scene, with an archer shooting at a screen on which are depicted two peacocks, can be identified from the *Biography of Empresses and Royal Concubines of the T'ang Dynasty* as representing a competition for the hand in marriage of the Princess Tou. The Emperor Kao Tzu, who succeeded in shooting two arrows, each of which penetrated an eye of each peacock, was the successful competitor.[4] Several lacquer boxes are known with this scene, but generally the figural subjects depicted on most of the boxes have not been identified.

The interior of the base of the box, seen on the left, is also painted on a red ground, with rocks and peonies by the side of a stream, with numerous birds of different species in pairs. The sides of the box and cover are fitted with basketry panels of simple weave. On the inside of the cover is a seal mark in gold on a black lacquer ground giving a date corresponding to A.D. 1600 and a second seal reading *Chin ch'ên-shan yin*, 'The seal of Chin Ch'ên-shan'. The use of the character *yin* suggests that Chin Ch'ên-shan was the artist who painted the scene rather than the maker of the box. Another box, in the British Museum, also bears the seal of Chin Ch'ên-shan, but no date mark. The resemblance in the style of the painting of the two boxes suggests that they were painted by the same artist.[5]

The box illustrated in Plate 200, in the Brundage Collection, is another fine piece in the basketry group, decorated on the top with a horseman and his attendants approaching a pavilion in which is seated a potentate with his staff. The basketry panels on the rounded sides are plaited with a continuous *wan* diaper. A feature of this box is the skilful depiction of the floral borders in gold that frame the main picture. There are similar borders round the vertical sides of the box. The combination of gold-painted borders and panels to supplement

[3] Exhibited in the 'Arts of the Ming dynasty', *Transactions of the Oriental Ceramic Society*, 1955–7, Vol. 30, No. 267.
[4] See note 2 above for further information on this.
[5] Note 2 above, Fig. 9.

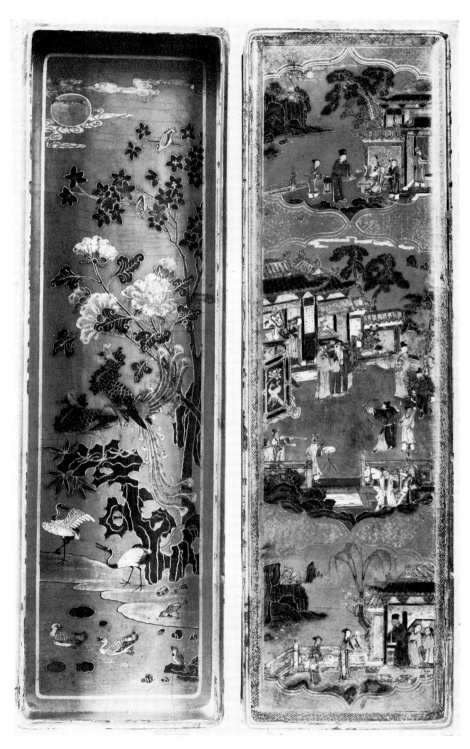

199. BOX, red lacquer, painted on the outside with figures in landscapes (*right*) and
on the inside with birds and water-plants in a river scene (*left*)
Dated 1600. Length 71·1 cm
Victoria and Albert Museum

the main decoration in polychrome is a feature of many of the basketry pieces and examples of the gold painting in these have been discussed in Chapter 10 as part of the general development of the gold-painted wares (Plates 147 and 148). A few pieces are found with the decoration entirely in gold. A box of this kind, in the collection of Dr. Laurence Sickman, is similar in construction to the Brundage box, but is painted with landscapes in gold, on a black ground on the outside and a red one on the inside. It bears the cyclical date *Chin-shên*, which corresponds to either 1584 or 1644, almost certainly the former. Painted lacquer of good quality continued to be made throughout the first half of the seventeenth century. The rectangular tray in Plate 201, with figures in a river scene painted in polychrome on a red ground, bears a T'ien-ch'i date (1624). The border is painted in gold with dragons on a black ground.

Our increasing knowledge of Ryukyuan lacquer in the last few years has led to the view that lacquer vessels with basketry panels were made in the Ryukyu Islands. Indeed, as long ago as 1960, a small cupboard decorated with painted lacquer and with simple basketry panels was attributed to the Ryukyu Islands by the *Ryukyu Cultural Survey*. This cupboard, formerly in the Knudsen Collection, is now in the Honolulu Academy of Art. But the possibility of much finer pieces than this being made in the Islands was hardly envisaged at that time. A box in the British Museum with basketry borders and with an elaborate basketry swing handle, discussed at some length by the author in 1966,[6] is a piece which now seems to have strong claims to a Ryukyuan provenance. The top of the box, decorated in polychrome on a red ground with a camellia tree and two parrots, is illustrated in Plate 202. It bears an inscription which reads 'Made in the 48th year of the Wan-li period in the cyclical year *kêng-shan*, (corresponding to 1620) on an auspicious day in an autumn month for the overseas residence of Wang. I-shan mark.' The four characters referring to Wang, *Wei-yang Wang chai*, are difficult to interpret, but the most likely meaning is that the box was made for a man named Wang, who lived overseas, and we may conjecture further that it was made in Okinawa for a Chinese resident there. A recent close comparison of the decoration of the box with that of the Chinese box painted by Chin Ch'ên-shan in the British Museum, already mentioned, has revealed marked differences in style and palette. The box in Plate 202 has a much narrower palette than that of the Chin Ch'ên-shan box, and it is much closer to that of a tiered box of undoubtedly Ryukyuan provenance. This handsome box, octagonal in section, is illustrated in Colour Plate I. An unusual feature is the use of sprinkled gold on the red ground, clearly influenced by the Japanese *nashiji* technique. This box is later than the box in Plate 202, probably belonging to the late seventeenth century. A number of still later Ryukyuan pieces are known in somewhat similar style, in which painted lacquer is associated with *ch'iang-chin* decoration. Several of these in Japanese collections are illustrated by Arakawa.[7]

The round box and cover in Plate 203, decorated on the top with a pomegranate spray on a black ground and with basketry panels on the rounded sides

[6] Note 2 above.

[7] Arakawa Hirokazu, *Ch'iang-chin, Chinkin and Zonsei*, 1971, Plates 142–5.

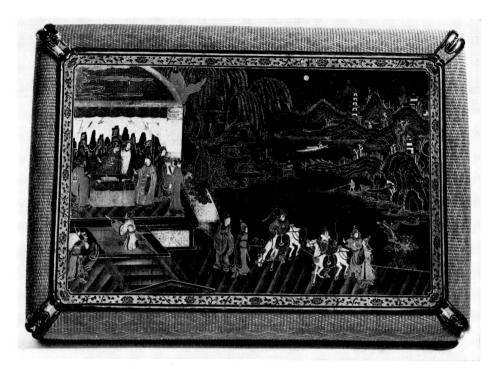

200. BOX painted with audience scene, with a river landscape in the background, surrounded by a gilt border and with basketry panels
c. 1600. Length 47·4 cm
Asian Art Museum of San Francisco, Brundage Collection

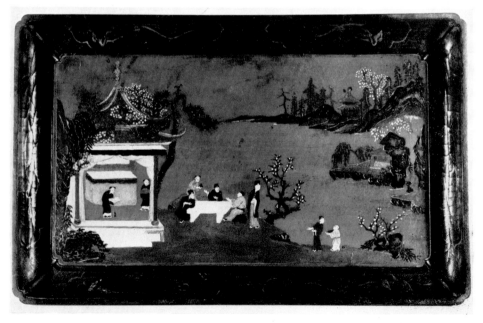

201. RECTANGULAR TRAY painted with figures in a landscape on a red ground with a border of dragons in gold on a black ground
Dated 1624. Length 47·5 cm
Victoria and Albert Museum

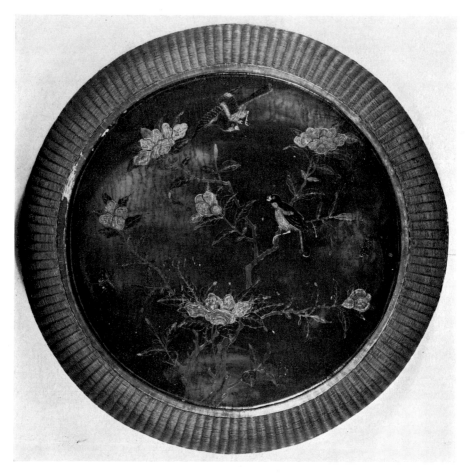

202. BOX painted with birds on camellias, with basketry borders
Ryukyuan, c. 1600. Diameter 46·7 cm
·British Museum

203. BOX painted with pomegranate spray, with basketry border
Possibly Ryukyuan, c. 1600. Diameter 20 cm
British Museum

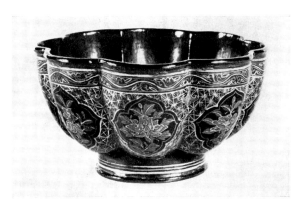

204. EIGHT-LOBED BOWL painted with flowering and fruiting
sprays
Chinese, early 17th century. Diameter 12·5 cm
British Museum

may also be of Ryukyu provenance, although a Chinese origin is perhaps the more likely. It belongs to the late sixteenth or early seventeenth century.

The eight-lobed bowl in Plate 204 belongs to a quite different group of painted lacquerwares, with boldly painted ogival panels of flowering and fruiting sprays in red, green and yellow, set in gold diaper grounds. This is almost certainly Chinese and probably belongs to the late Ming dynasty.

CHAPTER 13

Coromandel Lacquer

The term 'Coromandel' is applied today in the West to a type of lacquer that was first made in China in the seventeenth century. The technique, with a combination of carving, lacquering and polychrome painting, which appears to have been generally in oil pigments rather than lacquer, is a complex one and was the last lacquer technique to have been invented by Chinese craftsmen.

The solid wooden boards forming the basis of the screens and other objects were first covered by a composition of whiting mixed with an adhesive, which probably contained a certain amount of lacquer. The thickness of this composition was about one centimetre. This was smoothed and then covered with a few layers of black or brown lacquer. The carved decoration was obtained by cutting the lacquer away down to the surface of the composition and then applying pigments of different colours. Sometimes the lacquer surface was carved so as to leave thread-like lines in relief. The detail of a large screen shown in Plate 205 shows both techniques, the raised decoration in the figures, the trunks of the trees and the veins of the leaves being visible in black outlines. On a fine screen in the Historical Museum, Peking, to which I shall return later, the process is described as 'coloured lacquer, carved and filled in', which seems to be a broad description rather than a specific term.[1]

It is not surprising that the finished pieces, in all their complexity, are fragile. Moreover, the pigments were easily damaged, so that many pieces and particularly the large screens have had much of the pigment removed and have lost some of their former splendour. But some of the screens, like that in Plate 205, have survived in good condition and these, as well as the interior of cabinets, which have been protected, give some idea of the original brilliance of the Coromandel lacquerwares.

Coromandel work is best known to Western collectors from the wares exported to Europe in the seventeenth and eighteenth centuries. The wares were first known by the term 'Bantam work', named after the Dutch East India Company's port in Java through which they were exported. They reached Europe certainly as early as 1682, when it is recorded that Elihu Yale, an East Indian merchant, presented a six-fold screen to Joshua Edisbury of Erthig, Denbighshire, North Wales. The screen, preserved at Erthig today, is illustrated by Jenyns in *Chinese Export Art*.[2] There is an excellent account of Coromandel lacquer in this book, with many illustrations of screens and cabinets. But a number of important screens

[1] *Wên-wu*, 1957, No. 7, p. 54.
[2] Margaret Jourdain and Soame Jenyns, *Chinese Export Art*, 1950.

bearing dated inscriptions have been found since 1950, which throw new light on the development of the wares.

The term 'Coromandel' like 'Bantam', is derived from another export centre, the Coromandel Coast in South-East India. The term, applied to the coast and derived from Colamandalam (the land of the Colas), has been in use in European languages in various forms since the sixteenth century. No early use of the term 'Coromandel' applied to lacquer has so far been discovered, in spite of a thorough study of descriptions in catalogues and other literature by Reitlinger, whose exhaustive studies of the history of Chinese and European decorative works of art are well known.[3] In Europe the term used in the seventeenth and eighteenth centuries to describe the lacquerwares, as well as the European copies, was 'Bantam work'. It is described in some detail by Stalker and Parker in 1688, who stated that at that time the carved process of Bantam work had become out of fashion and was being replaced by painted lacquer.[4] The painted lacquer on which the European copies were based came, of course, from Japan and not China.

The term 'Calamander', one of the variants for 'Coromandel', was used in the early nineteenth century to describe a very hard and decorative wood specifically akin to ebony. In a reference dated 1804 the 'beautiful calamander tree' is said to be indigenous to Ceylon.[5] But there is no evidence of the term being applied to lacquer. Even in Bushell's time, in the early twentieth century, there is no record of its use, although Bushell was very familiar with the lacquer, and describes the technique of decoration accurately and in some detail.[6] In fact the earliest reference to 'Coromandel lacquer' in English seems to be in 1913, when it occurs in a catalogue of an exhibition of Chinese art held in the City of Manchester Art Gallery. The earliest reference in French seems to be later still, in an album recorded by Séguy datable to 1922.[7] The introduction states that the name 'Coromandel' is 'an expression sanctioned by use and of commercial origin, as the lacquers were embarked in the ports of the Coromandel Coast by the ships of the Compagnies des Indes'. It is surprising that no earlier references than these to the term 'Coromandel lacquer' have come to light.

Coromandel work is undoubtedly seen at its best in the large folding screens. They are usually in twelve or six folds, the latter being often in pairs. The screens, as Jenyns has pointed out, were not made in the first place for export, but they soon became extremely popular in Europe, and the export, not only of screens, but also of large cabinets, took place on a large scale. But these decorative objects were far surpassed by the screens made for presentation to Chinese high-ranking military officers and officials, which bear long inscriptions which include dates recording the presentations. When Jenyns's account was written in 1950 he was only able to record one dated screen, a fine twelve-fold screen in the Metropolitan Museum of Art, New York, bearing the date 1690. Since then three other dated

[3] Gerald Reitlinger, *The Economics of Taste*, 1963 (Vol. II). See especially Chinese art p. 351 *et seq.*

[4] John Stalker and George Parker, *A Treatise of Japanning and Varnishing*, 1688.

[5] *Oxford English Dictionary*, 1933.

[6] Stephen W. Bushell, *Chinese Art*, Vol. I, 1903.

[7] E. A. Séguy, *Les Laques du Coromandel*, Librairie Centrale des Beaux Arts, Paris.

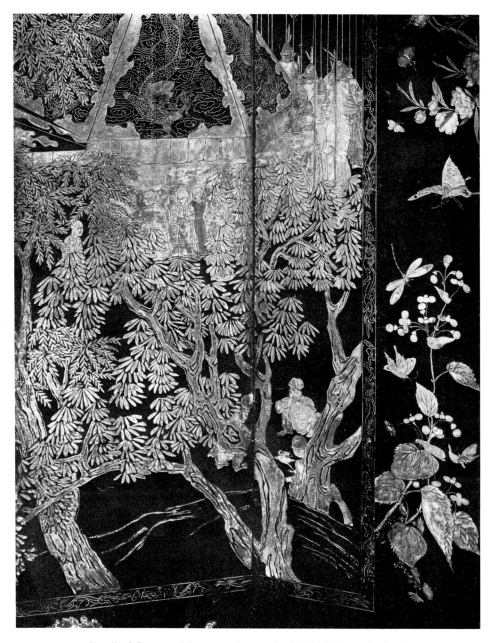

205. Detail of Coromandel SCREEN, decorated with Buddhist and other figures
in a landscape and floral border
Dated 1659
Freer Gallery of Art

screens have come to light, bearing the dates 1659, 1670 and 1672 respectively, as well as a screen very similar to the last of these, in the Historical Museum, Peking.[8] The earliest screen, to which the detail of Plate 205 belongs, was presented in the reign of Shuh-chih (1644-61) and is the only piece of Coromandel lacquer than can be positively dated earlier than the reign of K'ang-hsi. The screen was a birthday present to one Yin-t'ai Lao from numerous relatives whose names are given in detail. The screen dated 1670, in the Asian Art Museum, San Francisco, was made as a present to one Li in his old age. The third screen, dated 1672, in the Freer Gallery of Art, was bought by Charles Lang Freer in 1906, the year in which the deed of gift of his Collection to the Smithsonian Institute was made. This splendid screen has hardly received the attention it deserves and the illustration of three panels of the screen in Plate 206 cannot be said to do it full justice. The screen was made as a present to K'ung Yang-chên to commemorate his retirement from the Governorship of the Province of Yunnan and the inscription, which covers the whole of the back of the screen, describes his virtues and achievements. The scene depicted on the front of the screen is described as *Han-k'ung ch'un-hsiao*, 'Spring morning in the Palaces of Han'. The Spring Festival took place entirely in the women's quarters of the Imperial Palace, and there are no less than a hundred and sixty-two female figures depicted on the screen. The scene shown in the screen in Peking, already mentioned, is very similar and it also bears the title *Han-k'ung ch'un-hsiao*. This screen, as I have said, does not appear to be dated and no information on an inscription recording its presentation is available.[9] It is ascribed to the Ming dynasty, but in the absence of an inscribed date it would be rash indeed to accept a Ming attribution.

The absence of any imperial pieces of Coromandel lacquer is surprising, in view of the quality of the finest of the screens and the fact that some of them were made as presents to distinguished officials such as governors of provinces and so must have been familiar to the court. But, as we have seen with other artifacts, there is an absence of imperial pieces with the K'ang-hsi mark in the seventeenth century generally, which conflicts with the information of the setting up of factories by the Emperor in 1680.

All the known dated screens were made before 1700, but the manufacture of a large number of Coromandel wares in the eighteenth and nineteenth centuries is well established on historical and stylistic grounds. It would seem that these later wares were made entirely for export.

[8] See note 1 above.
[9] It would be surprising if a screen of this importance had no inscription.

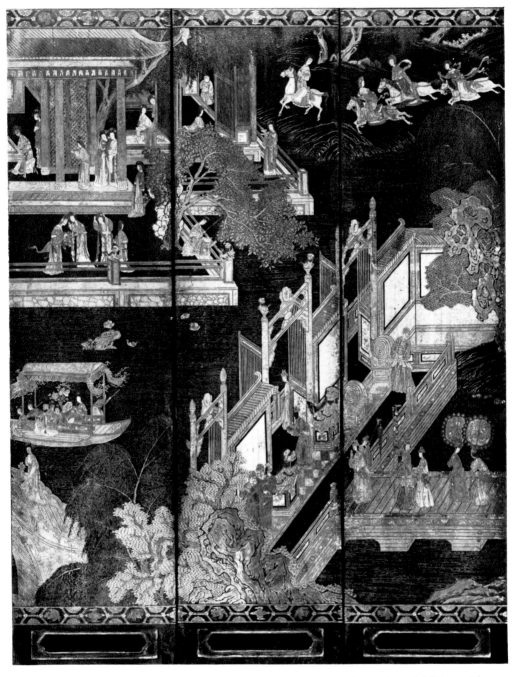

206. Three panels of Coromandel SCREEN, decorated with a scene in the Imperial Palace with numerous female figures
Dated 1672. Height 216·5 cm
Freer Gallery of Art

CHAPTER 14

South-East Asian Lacquer

The manufacture of lacquerwares in most of the countries of South-East Asia, including Vietnam, Laos, Cambodia, Thailand and Burma, is well established at the present time. But the origins of manufacture are quite obscure and very little material known today can be dated further back than the eighteenth century. There can be no doubt that vessels of basketry and wood covered with lacquer to render them watertight were made throughout South-East Asia from prehistoric times, but there is no reliable evidence on when sophisticated objects were first made or whence they were derived.

In other countries of East Asia, notably Japan, Korea and the Ryukyu Islands, the manufacture of sophisticated lacquerwares is known to have been introduced from China, but while there are traditions of the introduction of decorated lacquerwares from China to Vietnam, Thailand and Burma, there is little contemporary literary evidence to support them. There is one point however that supports a Chinese origin for the decorative wares, in that the pigments used for colouring the lacquer, including cinnabar, the red mercury sulphide, were always imported from China.

We know that a large proportion of the ceramic wares of South-East Asia show strong Chinese influence and indeed the Annamese wares made in the country now known as North Vietnam include blue and white wares which until comparatively recently were given a Chinese attribution. It would be surprising if there were not the same influences in the lacquerwares. The lacquer tree from which the lacquer of North Vietnam is derived is *Rhus Succedanea* and not *Rhus Verniciflua*, the tree from which Chinese, Korean and Japanese lacquerwares were made. But *Rhus Succedanea* grows in South China and it is likely to have been used in the extreme south for the manufacture of the local lacquerwares.

In considering the lack of evidence on the early lacquerwares of South-East Asia one must bear in mind that the tropical conditions were exceptionally bad for the survival of the wares. Bhirasri records that the perishability of wooden artifacts in Thailand is so great that libraries have to be built over ponds to prevent the woodwork from being destroyed by termites.[1] Libraries with panels decorated with figurative compositions, formerly existing in some numbers, are now so scarce that he can only record one library of outstanding quality in existence today. This library, originally in Ayudhya, was preserved from almost certain destruction by Prince Chumbhot. It was moved several times before it was finally

[1] Silpa Bhirasri, *Thai Lacquer Works*, Bangkok, 1961.

264

installed in the Suan Pakkad Palace in Bangkok. Many of the panels, however, have lost their gold decoration and have been restored.

The political borders in South-East Asia today are very different from those that existed in the past and any attempt to divide the lacquerwares between different countries as they exist today is likely to lead to misleading conclusions. It is not even possible to be certain of the species of lacquer tree used in the manufacture of specific lacquerwares. As we saw in Chapter 2, *Melanorrhoea usitata* is a native of Burma and Thailand and *Melanorrhoea laccifera* of Cambodia. But no doubt these trees overlapped a good deal, as did *Rhus verniciflua* and *Rhus succedanea* in Southern China and Annam.

In this brief and tentative discussion of the lacquerwares therefore, it seems preferable to treat them according to the technique adopted rather than country by country. The main categories are four in number:

1. Wares decorated in gold on a black ground.
2. Wares with incised decoration, filled in with different colours.
3. Wares with designs in relief, moulded with a black lacquer composition and gilded.
4. Wares inlaid with mother-of-pearl.

The gold-decorated wares, mainly from Thailand, may perhaps claim to be the finest of all the South-East Asian lacquerwares. The ground colour is almost always black, but a few pieces are known with a red or brown ground. A comprehensive study of the wares by Bhirasri[2] traces the history of development from the seventeenth century down to the present time, although it must be pointed out that no attempt at even approximate dating is generally attempted. Only a brief account is given of the nineteenth-century wares which, unlike the earlier ones, are claimed to show some Chinese influence. The earliest known wares were made in Ayudhya, the capital of Thailand in the seventeenth and early eighteenth centuries. Manufacture was afterwards moved to Dhonburi and then to Bangkok.

The technique of manufacture of the gold-decorated wares is different from that used in any other of the wares made in East Asia. The wooden base is covered with a few layers of black lacquer—as I have pointed out, the use of red lacquer is rare—and the design is then traced on the lacquer surface. The parts which are to form the background are first covered with a yellow gummy paint and the whole of the piece is then covered with a thin layer of lacquer to which gold leaf is attached. After a short interval of less than twenty hours the piece is washed with water, which removes the gold leaf attached to the paint, leaving the rest of the surface covered with the gold design. The technique is called *lai rod nam*, literally 'ornaments washed with water'.

Although a few vessels, such as small boxes, were made with this decoration, most of the pieces were large bookcases and chests made for the storage of religious books and vestments for Buddhist monasteries. Panels decorated with Buddhist scenes were made to decorate the walls of monasteries and I have mentioned the set of panels that have fortunately survived and are now in the Suan Pakkad Palace in Bangkok. The subjects of the decoration of the bookcases and chests are

[2] Note 1 above.

mainly, like the panels, of Buddhist scenes but there are a few pieces decorated entirely with woody landscapes which provide a setting for birds and animals. The back of a typical bookcase in the National Museum, Bangkok is illustrated in Plate 207. It shows two celestial beings against a background of formalized leafage of a type known as *lai konak*. A detail of the door of another bookcase is shown in Plate 208. This bookcase, according to Bhirasri, is accepted in Thailand as the finest specimen extant of Thai lacquer. The landscape of flowering trees with squirrels and birds is most attractive. The trees spread out from the flamboyant *lai konak* leafy scrolls below. These scrolls were probably first used in landscapes and afterwards introduced into Buddhist scenes, as we find in Plate 207. The decoration of these lacquerwares seems to be entirely South-East Asian in spirit, owing little to outside influence, although Bhirasri claims that Chinese influence is to be found in the nineteenth-century bookcases made in Bangkok.

The dating of these attractive *lai rod nam* wares is uncertain and there are some very conflicting attributions. For example, the bookcase illustrated in Plate 207, which was shown the Exhibition of the Arts of Thailand in the Victoria and Albert Museum in 1964,[3] was ascribed to the seventeenth or eighteenth century, although one of the side panels is illustrated by Bhirasri as an example of nineteenth-century work.[4]

There are stylistic grounds for accepting the view that the landscape decoration, such as that shown in Plate 208, is strongly influenced by Persian design and there are historical grounds for thinking that this influence may go back to the early seventeenth century. As early as 1605-10 a wealthy Persian merchant was directing the two ports of Ayudhya, and he was succeeded in this position by his descendants for five generations. A report dated 1685 from a Persian ambassador to Thailand refers to a large Persian community with their own mosque in Ayudhya. The French traveller J. B. Tavernier in 1679 writes that Persian and Arab merchants monopolized the foreign trade of Thailand. The main items exported included silk, musk, sandalwood, ivory and 'gomme lacque'. A definite connection is thus established with lacquer painting in Persia which was extensively used in the Safavid period for bookbinding. Examples from the sixteenth century show landscapes with trees, birds and clouds, strikingly similar to the upper part of the bookcase door reproduced in Plate 208, whereas, of course, the lower area is filled with the typical local motif known as *lai konak* which appears always to represent a growing plant firmly rooted to the ground.[5]

The next most important group of the South-East Asian lacquerwares is that with incised and coloured decoration which mainly came from Burma, where it is known by the term 'Pagan ware', named after the town of Pagan in North Burma, one of the main centres of manufacture.[6] The wares range from large boxes to small cups. Typical examples are the cylindrical box illustrated in Plate 209 and

[3] *The Arts of Thailand*, March–April 1964, No. 217.

[4] Note 1 above, Fig. 3.

[5] I am greatly indebted to Mr. Basil Gray for information on the relationships between the Persians and South-East Asia in the seventeenth century.

[6] A. P. Morris, 'Lacquer ware industry of Burma', *Journal of the Burma Research Society*, Vol. X, 1919, pp. 1–13.

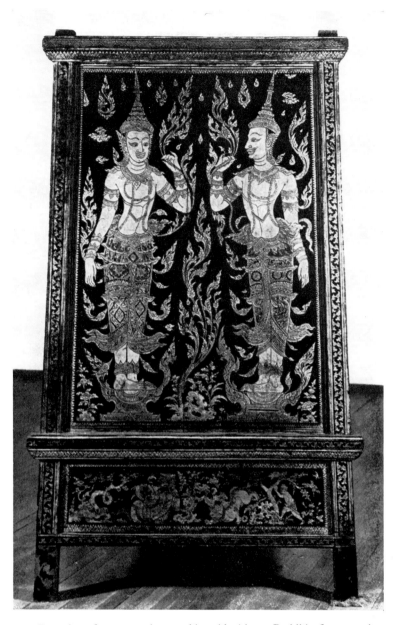

207. Rear view of BOOKCASE decorated in gold with two Buddhist figures against
a background of formalized foliage. Landscape panel below
Possibly 18th century
National Museum, Bangkok

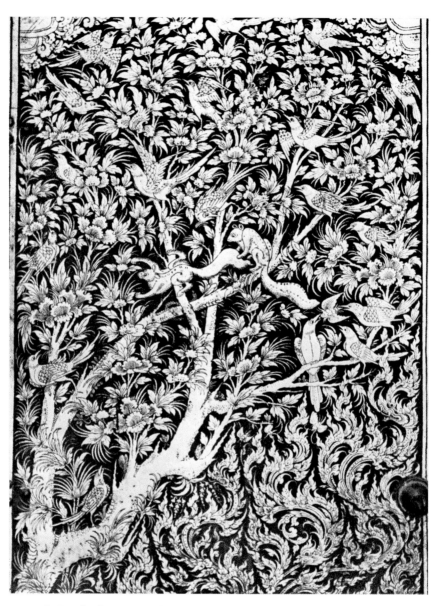

208. Detail of BOOKCASE decorated in gold with flowering trees, birds and animals
Possibly 18th century
National Museum, Bangkok

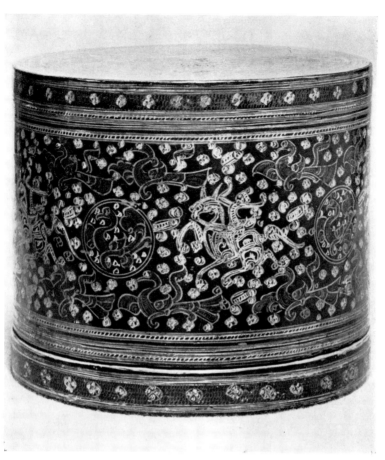

209. BOX, Pagan ware, inlaid with horses and riders with a background of birds
18th–19th century. Diameter 15·3 cm
Victoria and Albert Museum

the two cups in Plate 210 and 211. All the pieces are very lightly constructed. The cup in Plate 210 has lost its outer skin and the basic construction is seen to be of flat bamboo strips radiating from the centre of the foot and up the sides, with circumferential rings of horsehair. Nothing resembling this method of construction seems to exist in China or Japan, although the so-called 'dry-lacquer' process, making use of fabric, in these countries, achieves a similar light construction. The very light bowls, dishes and boxes produced in China for the Emperor in the Ch'ien-lung period, such as those illustrated in Plates 97 and 98, are said to have been built up on a silk ground. These seem to be the closest approach, structurally, to the Burmese wares.

The light structure of the Pagan wares is first covered with a few layers of brown, red or black lacquer and then incised with designs of birds, animals or human figures. The incisions are then filled in with lacquer of different colours including yellow and green as well as the brown, red and black already mentioned. The surface is then polished to remove the surplus lacquer that was accidentally applied outside the incisions. Some of the pieces have part of the design shallowly carved and covered with an indigo-blue pigment, which is almost certainly not lacquer. The cup in Plate 211, decorated with a procession of carriages drawn by horses mounted by riders, is painted in this way, as seen in the dark patches in the illustration of the horses and riders.

The technique of these Pagan wares is quite different from that of the Chinese filled-in wares described in Chapter 9. As we saw, the Chinese polychrome decoration is essentially detailed by incised lines filled in with gold, a development of the *ch'iang-chin* wares, whereas the decoration of the South-East Asian wares depends entirely on coloured lacquer incisions. Nor do the designs owe anything to Chinese influence. Nevertheless, it seems likely that the polychrome decoration based on lacquer coloured with such pigments as the red cinnabar and the yellow orpiment originated in China, which even today is the source of the basic colouring materials used in South-East Asia.

The Pagan wares are traditionally said to have had their origin in the Southern Shan State of North-East Burma and Laikha, in that State, is one of the main centres of manufacture today.[7] The Shan and the Lao peoples have a close ethnic relationship and it is thought that the craft came originally from Laos. Some of the Pagan wares have been given a Thai attribution and it is consistent with the Laos theory that their manufacture should have taken place in districts to the east of the present boundaries of Burma. No attempt has been made here to distinguish between the Pagan wares made in Burma from those made in Thailand.

The third group of South-East Asian wares, in which a moulded black composition is used, corresponds to the type of lacquer described by the Chinese as *tui-hung*. The story of the development of this type of lacquer, which was superseded in China by true carved lacquer in the fourteenth century, has been fully discussed in Chapters 3 and 6, from its origin in the second century B.C. True carved lacquer was never made in South-East Asia, but the relief-moulded lacquerwares reached a higher standard than was achieved in China. Two Chinese examples belonging to the Ch'ing dynasty are illustrated in Plates 95 and 96. A

[7] See note 5 above.

210. CUP, Pagan ware, showing method of construction
18th–19th century. Height approx. 8 cm
Victoria and Albert Museum

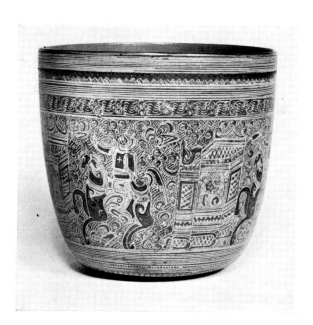

211. CUP, Pagan ware, inlaid with a procession of carriages
drawn by horses with riders
18th–19th century. Height 8·1 cm
Victoria and Albert Museum

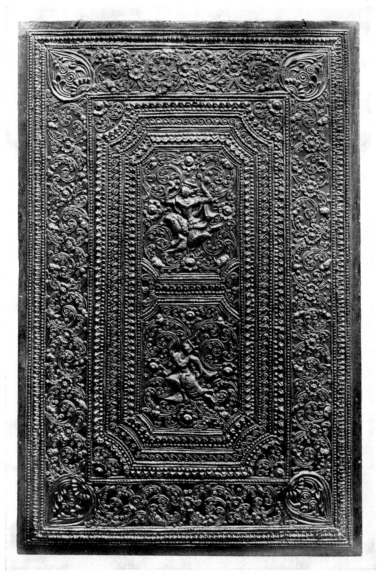

212. RECTANGULAR PANEL decorated in black *appliqué* moulded lacquer with
dancing figures surrounded by scroll borders, and then gilt
19th century. 45·5 by 30·5 cm
Victoria and Albert Museum

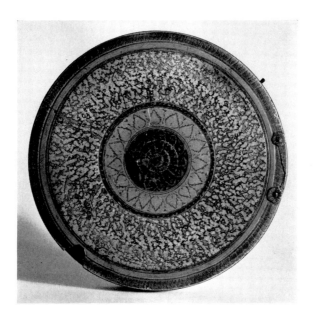

213. FLAT CIRCULAR BOX inlaid with formal designs
18th–19th century. Diameter 18·1 cm
British Museum

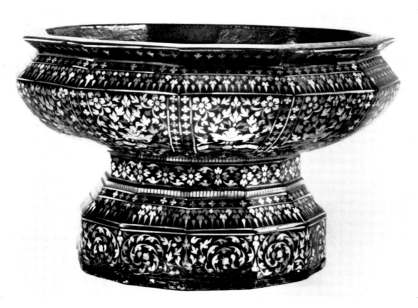

214. TWELVE-SIDED PEDESTAL BOWL inlaid with mother-of-pearl designs of floral
scrollwork
18th century. Diameter 21·8 cm
British Museum

typical piece of South-East Asian relief-moulded lacquer is the panel illustrated in Plate 212. The wooden base is covered by a moulded composition made from lacquer and black ash. In the finest pieces the ash was made from paddy-husk. The mixture gives a fine plastic material which is easily moulded and sets in a hard substance which is considered superior to wood in having no grain and so not liable to crack. Most of the decoration is made separately and is attached to the base by lacquer. The panel in Plate 212 is made in this way, the scrollwork being made separately and built up of small individual pieces. Most of the pieces, like the panel, are finally covered in gold. The panel is thought to have been made in Mandalay, one of the main centres of manufacture of the moulded wares. The pieces existing today do not seem to go back earlier than the nineteenth century.

The last of the techniques to be mentioned here is decoration in mother-of-pearl. A typical example is the twelve-sided pedestal bowl illustrated in Plate 214. The bowl is built up from rings of cane, attached to each other by lacquer, and then covered with a few layers of black lacquer to which the pearl decoration is applied. The decoration, in formal panels and scrollwork, is unlike any other mother-of-pearl decoration and is entirely South-East Asian in style. These wares are generally attributed to Thailand and ascribed to the eighteenth or nineteenth century (see also Plate 213).

The brief study in this chapter of the existing lacquerwares of South-East Asia has failed to find any that can be dated earlier than the eighteenth century. This is not surprising when we consider the bad climatic conditions, so unsuitable for the preservation of the wares. The surviving lacquerwares themselves cover quite a wide range of techniques and show a remarkable originality, not only in the decoration, which appears to have been little influenced from outside, but also in the techniques adopted. In gold-painted lacquer, inlaid lacquer and moulded lacquer particularly, the techniques adopted differ widely from those in China. This originality has to be considered in the light of the strong traditional beliefs that lacquer manufacture was introduced into South-East Asia from China in the Ming dynasty or even earlier. Although there appears to be no contemporary evidence to support the traditions, it is extremely likely that the earliest manufacture of lacquer in South-East Asia was derived directly from China and that after some time, probably measured in centuries, Chinese influence declined and new developments to meet local conditions took place. It may never be possible to trace the early developments of lacquer in South-East Asia. But it is just possible that pieces were exported to outside countries such as Japan, where the conditions for preservation were ideal, and so would enable our knowledge of these most interesting wares to be extended.

Bibliography

C. THE CHINESE LITERATURE

C1. *Ch'i-shu,* 漆書 (The Book of Lacquer), by Chu Ch'i-ch'ien, 朱啟鈐 . Printed 1957.

This book was compiled in 1924-5 by Chu Ch'i-ch'ien, whose interest in lacquer was stimulated by his studies of ancient architecture. In 1950 the book was shown to Wang Shih-hsiang, who proposed that it should be submitted to the Central Bureau of Handicrafts in Peking for publication as one of a series of books on the Chinese industrial arts. A mimeographed edition was printed in 1957, more than thirty years after it was originally compiled.

The work consists almost entirely of extracts from Chinese works, without comments. It has more than 80,000 words and contains extracts from some hundred works, some of which extend to many pages. More than three-quarters of the space is devoted to works of the Ming dynasty. The survey of the early lacquerwares is brief and was written before the excavation of the Ch'ang-sha lacquerwares had begun, so that this part of the *Ch'i-shu* is not of great value. The rest of the work is of supreme importance for any studies of the later lacquerwares. Chu, while not a lacquer specialist, was a careful and reliable scholar. Where occasion has arisen to consult the original documents mentioned in the *Ch'i-shu*, the extracts have been found to be quite accurate.

Although printed in 1957, the work has apparently never been issued. The only copy in the West, as far as can be ascertained, was sent to Sir Percival David from China in 1958—at that time the author was eighty-seven years of age—and it is now in the possession of the Percival David Foundation. Photostat copies of the work have been sent to a few libraries in Great Britain and the United States. The reason for the suppression of the work is not known.

The most important of the works included in the *Ch'i-shu* are listed and described below, the less important ones being omitted. A few works not mentioned in the *Ch'i-shu* are also given. Further study of the work is essential to anyone wishing to study the Yüan and Ming lacquerwares in depth.

C2. *Ko-ku yao-lun,* 格古要論 (The Essential Studies of Antiquities), by Ts'ao Chao, 曹昭 . Published 1388, in three chapters. The first edition.

This is by far the most important work on Chinese lacquer of the fourteenth century. The Chinese text is reproduced in full, with a translation, in Sir Percival David's *Chinese Connoisseurship* (Ref. E33).

C3. *Ko-ku yao-lun* (as above, C2). Published 1462, rearranged and extended by Wang Tso, 王佐 , to thirteen chapters. The second edition.

This adds a few points on lacquer for the period from 1388 to 1462, but there is little of great importance added to the account in the first edition. For information about the many subsequent editions of the *Ko-ku yao-lun*, Ref. E33 should be consulted.

C4. *Nan-ts'un cho-kêng lu*, 南村輟耕錄 (Notes Written in the Intervals of Ploughing), by T'ao Tsung-i, 陶宗儀 . Published 1366.

This has three important paragraphs on lacquer, the first on *hsi-p'i* lacquer (this is a quotation from the *Yin hua-lu*, see Ref. C5 below) and the other two on the details of manufacture of contemporary lacquer. The work is generally known by the shorter title *Cho-kêng lu*. *Nan-ts'un* was a soubriquet of T'ao Tsung-i.

C5. *Yin-hua-lu*, 因話錄 (Records of Conversations), by Chao Lin, 趙璘. Written in the ninth century.

This work contains the earliest reference to *hsi-p'i* lacquer.

C6. *Hsiu shih lu*, 髹飾錄 (Account of the Decoration of Lacquer), by Huang Ch'êng, 黃成 , with a preface and commentaries by Yang Ming, 楊明 , dated 1625. The manuscript was handed down in Japan and published for the first time in Shanghai in 1927, with a preface by Chu Ch'i-ch'ien, the author of Ref. C1 above.

This is a technical treatise on manufacturing processes in lacquer, which gives a full account of all the processes used in the second half of the sixteenth century. It is by far the most important Chinese work in this field. No copy of the work is recorded to exist in China, but some information on the author, who was a celebrated lacquerer of the Lung-ch'ing period (1567-72), is given in the *Tsun-shêng pa-chien*, published in 1591 (see Ref. C8 below, as well as Chapter 4). Apart from the very valuable account of technical processes, there are a few references to Sung lacquer, which are unreliable.

C7. *Hsiu shih lu*, as above (Ref. C6). Published in 1959. This is the second edition, in mimeograph, prepared in China, with a preface by Wang Shih-hsiang, 王世襄 , with many long commentaries.

The commentaries are useful in giving the views of a modern Chinese writer, but they add little to what can be found in the earlier Chinese works. In some places the comments are misleading.

In addition to the manuscript from which the 1927 and 1959 editions were prepared, there were at least two other manuscript copies in Japan, one of which is now in the Tokyo National Library. The other was destroyed in the earthquake and fire in Tokyo in September 1923.

Note: The 1959 edition, like the *Ch'i-shu*, seems to have been suppressed. There are very few copies of this in the West (one is in the Percival David Foundation). The 1927 edition, on the other hand, is readily available in most Western libraries.

C8. *Tsun-shêng pa-chien*, 遵生八牋 (Eight Discourses on the Art of Living), by Kao Lien, 高濂 . Published in 1591.

This is a work much quoted by Chinese writers, with some useful references to ceramics. On lacquer, the accounts of Yüan and early Ming lacquer are entirely

unreliable. The work has, however, some useful information on contemporary lacquer, for example on the famous sixteenth-century lacquerer Huang-ch'êng, on filled-in lacquer and on Yunnan lacquer (see Chapters 4 and 9).

C9. *Ch'ing pi-ts'ang,* 清祕藏 (Collection of Artistic Rarities), by Chang Ying-wên, 張應文 . Published in 1595.

This work consists mostly of quotations from earlier writers and generally is of little value. It appears to quote extensively accounts that also appear in the *Tsun-shêng pa-chien* (Ref. C8), published four years earlier. The work, however, has an important account of an exhibition of bronzes, jades, paintings and ceramics held in 1570, which deserves further study.

C10. *Yeh-huo-pien,* 野獲編 (Gathered from the People), by Shên Tê-fu, 沈德符 . Published in the Wan-li period (1573-1619).

This has information on Yunnan lacquer not found elsewhere and an interesting account of the sale of carved and filled-in lacquerwares stolen from the Palace in Peking.

C11. *Yên-fan-lu,* 演繁露 (Drowning the Myriad Dewdrops), by Ch'êng Ta-ch'ang, 程大昌 (1123-95). Sung dynasty. Author's preface dated 1181. This provides evidence of *hsi-p'i* lacquer being made in the Sung dynasty. It also refers to the *Yeh-chung chi* (see C12, below). The quotation from the *Yeh-chung chi* has a serious error which has led to erroneous deductions (see Chapter 5).

C12. *Yeh-chung chi* 鄴中記 (Notes on Yeh), by Lu Hui, 陸翽 . Chin dynasty, fourth century.

This refers to carved wood, decorated with lacquer of different colours and not, as Ch'êng Ta-ch'ang suggests in Ref. C11 above, to *hsi-p'i* lacquer. Ch'êng Ta-ch'ang omits a character *hua* (painted), which completely alters the meaning of the original text. The question is fully explored by Chêng Kuo-hsün, *Lung-ch'i ching-she ts'ung-shu,* 1917.

C13. *T'ing-yü chi-t'an,* 聽雨記談 (Jottings while Listening to the Rain), by Tu Mu, 都穆 . Published Ming dynasty, sixteenth century.

The only reference to lacquer is a fanciful interpretation of the term *hsi-p'i.*

C14. *Po-wu yao-lan,* 博物要覽 (General Survey of Art Objects), by Ku T'ai, 谷泰 . Written in the T'ien-ch'i period. (1621-7).

Included here because of the importance attached to it by Bushell, who mentions that the last of the sixteen chapters was devoted to lacquer. The only surviving edition that can be traced, however, has only twelve chapters.

C15. *Chin-ao t'ui-shih pi-chi,* 金鰲退食筆記 (Notes Written after Court Assembly), by Kao Shih-ch'i, 高士奇 . (1684).

This gives a long account of filled-in lacquer.

C16. *Hsüan-ho fêng-shih Kao-li t'u-ching,* 宣和奉使高麗圖經 (Illustrated Record of the Hsüan-ho Envoy to Korea), by Hsü Ching, 徐兢 (1091-1153). Written 1124 and printed 1153.

Best known for its description of Korean celadon wares, which are compared

with the recently made Ju wares. But it is also important for its references to the contemporary Korean mother-of-pearl lacquerwares (see Chapter 11).

For further information on this work and its author, reference should be made to Sir Percival David's paper, 'A commentary on Ju ware', *Transactions of the Oriental Ceramic Society*, Vol. 14, 1936-7.

E. The Literature in European Languages

E1. Louis le Comte, *Nouveaux mémoires sur l'état présent de la Chine*, 2 vols., Paris, 1696. Each chapter is in the form of a letter addressed to a member of the French nobility. Lacquer is described in a letter to the Duchess of Bouillon.

E2. Louis le Comte, *Memoirs and Observations made in a Late Journey through the Empire of China and published in Several Letters*. Translated from the Paris edition (E1) and illustrated with figures, London, 1697, pp. 152–4.

E3. Filippo Buonanni, *Vera vernix Sinica, Musaeum Kircherianum Romae*, 1709. Contains a letter referring to lacquer dated 1679.

E4. Filippo Buonanni, *Trattato sopra la vernice detta communemente cinese*, Rome, 1720.

E5. Filippo Buonanni, *Traité de la composition des vernis*, Paris, 1780.

E6. Père d'Incarville, 'Mémoire sur le vernis de la Chine', *Mémoires de Mathématique et de Physique présentés à l'Académie Royale des Sciences*, Tome III, Paris, 1760. The paper is more readily available as a chapter in Watin, *L'art du peintre*, in various editions from 1772 onwards.

E7. Stephen W. Bushell, *Oriental Ceramic Art*, 1899.

E8. Stephen W. Bushell, *Chinese Art*, Vol. I, 1904. The second edition of 1909 and its reprints of 1911 and 1914 are more readily available.

E9. E. F. Strange, *Catalogue of Chinese Lacquer in the Victoria and Albert Museum*, 1925.

E10. E. F. Strange, *Chinese Lacquer*, 1926.

E11. O. Maenchen-Helfen, 'Materialen zur Geschichte des Chinesischen Lacks', *Ostasiatische Zeitschrift*, Vol. XXIII, 1937.

E12. O. Maenchen-Helfen, 'Zur Geschichte der Lackkunst in China', *Wiener Beiträge zur Kunst- und Kulturgeschichte Asiens*, Vol. XI, 1937.

E13. Yoshi S. Kuno, *Japanese Expansion on the Asiatic Continent*, Berkeley, 1937.

E14. R. S. Jenyns, 'Chinese lacquer', *Transactions of the Oriental Ceramic Society*, Vol. 17, 1939-40.

E15. M. Jourdain and R. S. Jenyns, *Chinese Export Art*, 1950.

E16. F. Low-Beer, 'Chinese lacquer of the early fifteenth century', *Bulletin of the Museum of Far Eastern Antiquities*, No. 22, 1950.

Bibliography

E17. F. Low-Beer, 'Chinese lacquer of the middle and late Ming period', *Bulletin of the Museum of Far Eastern Antiquities*, No. 24, 1952.

E18. Wang Yi-t'ung, 'Official relations between China and Japan, 1368-1549', *Harvard-Yenching Institute Studies*, IX, 1953.

E19. Harry M. Garner, 'Lacquer and furniture', *The Arts of the Ming Dynasty*, 1954, pp. 33-43.

E20. Harry M. Garner, '*Guri* lacquer of the Ming dynasty', *Transactions of the Oriental Ceramic Society*, Vol. 31, 1957-9.

E21. George H. Kerr, *Okinawa. The History of an Island People*, 1958.

E22. K. Herberts, *Oriental Lacquer*, 1962.

E23. John Figgess, 'A letter from the court of Yung-lo', *Transactions of the Oriental Ceramic Society*, Vol. 34, 1962-3.

E24. R. Soame Jenyns and William Watson, *Chinese Art, The Minor Arts*, 1963. Chapter VI, Lacquer and Chapter VII, Furniture.

E25. Sammy Y. Lee, *Chinese Lacquer as Exhibited at the Royal Scottish Museum*, 1964.

E26. John Figgess, 'A group of decorated lacquer caskets of the Yüan dynasty', *Transactions of the Oriental Ceramic Society*, Vol. 36, 1964-6, pp. 39-42.

E27. Werner Speiser, *Lackkunst in Ostasien*, 1965.

E28. Harry M. Garner, 'Diaper backgrounds on Chinese carved lacquer', *Ars Orientalis*, VI, 1966.

E29. Harry M. Garner, 'A group of Chinese lacquers with basketry panels', *Archives of Asian Art*, XX, 1966-7.

E30. Beatrix von Ragué, *Geschichte der Japanischen Lackkunst*, 1967; translation, *History of Japanese Lacquerwork*, 1977.

E31. John Figgess, 'Ming and pre-Ming lacquer in the Japanese tea ceremony', *Transactions of the Oriental Ceramic Society*, Vol. 37, 1967-9.

E32. *A Persian Embassy to China. An Extract from Zubdatu't Tawarikh of Hafiz Abru*, translated by K. M. Maitra, Lahore, 1934. Reprinted under the editorship of L. Carrington Goodrich, 1970.

E33. Sir Percival David, *Chinese Connoisseurship. The Ko ku yao lun. The Essential Criteria of Antiquities*, 1971.

E34. Harry M. Garner, 'The export of Chinese lacquer to Japan in the Yüan and early Ming dynasties', *Archives of Asian Art*, XXV, 1971-2.

E35. Harry M. Garner, 'Ryukyu lacquer', *Percival David Foundation Monograph*, No. 1, 1972.

E36. Lee Yu-kuan, *Oriental Lacquer Art*, 1972. Included here in the European Bibliography as it is written in English, although with copious Chinese references.

E37. Jan Wirgin, 'Some Chinese carved lacquer of the Yüan and Ming periods', *Museum of Far Eastern Antiquities Bulletin*, No. 44, 1972, pp. 93-114.

E38. Bo Gyllensvärd, 'Lo-tien and laque burgautée', *Museum of Far Eastern Antiquities Bulletin*, No. 44, 1972, pp. 115-31.

E39. Harry M. Garner, 'Two Chinese carved lacquer boxes of the fifteenth century in the Freer Gallery of Art', *Ars Orientalis*, IX, 1973.

E40. Hin-cheung Lovell, 'Sung and Yüan monochrome lacquer in the Freer Gallery', *Ars Orientalis*, IX, 1973.

E41. *Chinese and Associated Lacquer from the Garner Collection, the British Museum*, October–December 1973, with introduction and descriptions by Sir Harry Garner.

E42. Beatrix von Ragué, 'The Moon-Palace', *Oriental Art*, XXII (2), 1976.

E43. F. Low-Beer, 'Carved lacquer of the Yüan dynasty: a reassessment', *Oriental Art*, N.S., XXIII (3), 1977.

Index